ICONS

PORTRAITS

Icons or Portraits?

IMAGES OF JESUS AND MARY
FROM THE COLLECTION OF MICHAEL HALL

Ena Giurescu Heller, Editor

With contributions by Charles Avery, Timothy Clifford,
Karl Fugelso, Michael Hall, Jennifer Montagu, Patricia Pongracz,
Kathryn Rudy, and Jonathan Unglaub

The Gallery at the American Bible Society
July 26–November 16, 2002

This catalog accompanies the exhibition
*Icons or Portraits? Images of Jesus and Mary
from the Collection of Michael Hall*, on display
from July 26–November 15, 2002, at

The Gallery at the American Bible Society
1865 Broadway (at 61st Street)
New York, New York, 10023
www.americanbible.org
tel 212.408.1500 fax 212.408.1456

*This exhibition was curated by Ena Heller,
Director of the Gallery and Michael Hall.*

CONSULTING EDITOR Michael Hall
CONTRIBUTING EDITORS Mihaela Georgescu,
Ute Schmid
CATALOG DESIGN Kara Van Woerden
EXHIBITION DESIGN Lou Storey
PHOTOGRAPHS Sandor Acs

Printed in the United States by
Frantz Lithographic Services, Inc.

FRONT COVER
Head of Christ, Crowned with Thorns (detail)
Italian, Naples (?), third quarter 18th century
Shell cameo
Michael Hall Collection

Madonna and Child with Cherubim (detail)
Circle of Agostino di Antonio di Duccio
(1418–after 1481)
Italian, late 15th century
Stucco relief, polychromed
Michael Hall Collection

BACK COVER
Corpus Christi (back view)
Attributed to Gabriel Grupello (1644–1730)
German, c. 1700–1710
Ivory, with scroll
Michael Hall Collection

Item 112708
ISBN 1-58516-682-0

Table of Contents

President's Preface

THE GOSPELS ACCORDING TO Matthew, Mark, Luke, and John vividly relate Jesus' actions and words. The stories are compelling for the messages they contain. Jesus is and has been an appealing and effective protagonist in part because of his humanity. Today, we identify with Jesus, the man, as the Scriptures' past audiences have: grateful for and keenly aware of the sacrifice that led to our salvation. In an effort to further understand Jesus' humanity and its significance, we wonder, as generations before us have, what did Jesus look like?

The American Bible Society is pleased, therefore, to present *Icons or Portraits? Images of Jesus and Mary from the Collection of Michael Hall*. The 114 works on display, dating form the twelfth through the twentieth centuries, illustrate how artists have responded over time to the question of Jesus' appearance. Dr. Ena Heller, Director of the Gallery and co-curator for the exhibition, looks at the various artistic portrayals of Jesus' physiognomy identifying the trends and their sources in her introductory essay for the catalog. The illustrated entries that follow are grouped according to their particular subject. Each entry discusses the object and its particular artistic and historical significance. The result is a fascinating journey through the artistic tradition that developed in an effort to clarify, emphasize, and explain Jesus' role in the Scriptures.

The exhibition and its catalog are the work of many hands. First and foremost, the American Bible Society thanks Michael Hall, Esq. for making his collection available for display. We are grateful for his generosity as a lender and co-curator; his knowledge of the field and of the individual works on display resulted in the richness that you see. We thank the individual contributors to the catalog who shared their scholarship so that we might better understand the tradition of picturing Jesus. Finally, we thank our own Gallery staff. Our director, Dr. Ena Heller acted as co-curator, organizer, and editor with the support of her staff: Patricia Pongracz, Ute Schmid, and Kim Aycox.

Eugene Habecker, Ph.D.
President, American Bible Society

Director's Preface

JESUS OF NAZARETH and his mother Mary are among the most frequently depicted figures in the history of art. From symbolic Early Christian to modern interpretations, iconic as well as narrative images have served dually as objects of devotion and aesthetic appreciation. Today, as through history, we readily identify Jesus in artistic depictions. Many of us think we "know" what he looked like. Since the Bible provides no information on this topic, where did this artistic tradition find its source and what provided the face of Jesus with such recognizable qualities? Is it the extrapolation of familiar narratives that extends to the non-narrative image? Or is it a mental construct built on a centuries-long tradition whose continuity has fed the imagination of artists and patrons alike? Does a similar typology exist for representations of the Virgin Mary?

The exhibition *Icons or Portraits? Images of Jesus and Mary from the Collection of Michael Hall* seeks answers to some of these questions. Recently there has been a resurgence of research on issues of reception, likeness and archetype, and imaging the body of Christ. A number of exhibitions on both sides of the Atlantic have investigated how artists tried to solve, over the centuries, the pictorial problems posed by representing Jesus. Our exhibition hopes to contribute to that discourse by analyzing representations of Jesus and Mary in the context of the history of prototypes. The 114 works displayed, illustrating many styles and media and spanning almost eight centuries, are from the private collection of Michael Hall. Many are unique in American collections and have never been exhibited or published before. Others relate to works we have seen many times. Collectively they witness the fascination of artists and patrons with the depiction of sacred figures and help us trace the evolution of familiar figures and iconographies. The exhibition aims to illustrate how all these images belong to the same family of symbolic representation. Different as they necessarily are, we behold them as related in purpose, message, and, in the case of the adult Jesus, even details of physiognomy.

Exhibitions are by definition a team effort. *Icons or Portraits?* has been in the making for more than three years, and many talented people have shaped it with their knowledge, expertise, and support. First and foremost, my thanks go to Michael Hall, whose incredible collection has made this exhibition possible, and whose connoisseurship, desire to educate, and enthusiasm made it come together. The contributors to the catalog established a level of scholarly excellence which informed all our work on this exhibition, and from which the readers of this book will benefit. Their work is intended, in many cases, as a starting point; we trust that the catalog will spark new research on some of the less known objects and artists represented here, research which will confirm, reject, or offer new points of view for some of the attributions. Charles Avery, Timothy Clifford, Karl Fugelso, Michael Hall, Jennifer Montagu, Patricia Pongracz, Kathryn Rudy, Jonathan Unglaub shared their knowledge and enthusiasm about the objects on display. I am grateful to all of them for teaching me about iconography, symbolism, style, and looking at sculpture.

9

Special thanks go to The Samuel H. Kress Foundation, whose generous support contributed to the high quality of the reproductions and design of this splendid catalog. Their confidence in our project at an early date was a significant encouragement.

At the American Bible Society, we received substantial support from our leadership and Board of Directors, without whom we would not have been able to organize the exhibition and publish the catalog. Robert L. Briggs, Senior Vice President for Organizational Marketing, has been a tireless advocate of this project on behalf of the Gallery. David Burke, Dean of the Eugene A. Nida Institute for Biblical Scholarship, kindly read the introductory essay. Liana Lupas, Curator of Rare Scriptures, provided needed expertise in the translation of Latin inscriptions. Ester Vargas-Machuca read and revised the text in accordance to American Bible Society standards, while Mildred Mas guided the production and printing process. At Michael Hall Fine Arts, Gregory Muenzen made sure everything ran smoothly and on time, and cheerfully took on a multitude of tasks.

Last but most certainly not least, I would like to thank the staff of the Gallery. Their expertise, dedication, constant support and good sense of humor brought the project to fruition. Patricia Pongracz, Curator; Ute Schmid, Curatorial Assistant; Kim Aycox, Gallery Assistant, helped me in more ways than I can count, and I am grateful to have such a wonderful team. Special thanks also go to Kathryn Rudy, who helped in considerable ways with research and editing the catalog, and to Mihaela Georgescu, our copy editor, whose suggestions refined and gave strength to the text. On the creative side, Kara Van Woerden transformed pages of text, footnotes and illustrations into a graphically exquisite and eminently readable book, while Lou Storey designed the exhibition with flair and an unparalleled capacity to find the right spot and the right way to display every one of the objects. Sandor Acs photographed the entire collection, lending his artistry to the reproductions in this catalog. To all of them, and to our art handlers, security, engineering and maintenance staff, and everybody else who has contributed, in ways both large and small, to the success of this exhibition, my sincere gratitude.

Ena Giurescu Heller, Ph.D.
Director, The Gallery at the American Bible Society

Introduction

AS A FOUR YEAR OLD in an Episcopal Bible class, I saw a color illustration of Christ as a young man. It was painted by a German Nazarene painter of the nineteenth century. Jesus was shown with bright blue eyes, long strawberry blond hair and beard, and looked very much like my father. This prompted me to ask if his family was originally from the same part of the world as Jesus. Father explained that Christ came from a very different land, was born of Hebrew faith, and probably would have looked quite different.

When I started collecting Italian medals of the *quattrocento* and later periods, I remembered my father's words. On many of these medals, Christ in profile is depicted with a large aquiline nose, heavy eyelids, long curly hair and beard and very full lips. Overall these features give him a Semitic appearance. I started being fascinated by the various representations of Christ which, across the centuries, recall the so-called Lentulus letter, a medieval forgery believed for centuries to be a first century eye-wittness account of Jesus' appearance (see the introductory essay, p. 19).

By contrast, no particular description of Mary has been left to us. Usually she is depicted with a beautiful countenance, a complement to the Savior's handsome physiognomy. Both mother and Son always possess a calm spirituality in their expressions. They are somehow recognizable, all through various cultures: Italian, French, English, Spanish, German, African, Asian. At times these artists used their own ethnic identities in their depictions of Mary and Christ.

The fascination with these representations has led me to collecting icons and portraits of Jesus and Mary over the course of sixty years.

What did Jesus and Mary truly look like? The question, although impossible to answer, is central to this exhibition. The span of eight centuries represented here and the range of materials – from stone and ivory to wood, ceramic, shell and metal – will help us to understand the world's fascination with the likenesses of Jesus and the Virgin Mary throughout the ages.

I wish to thank the Gallery at the American Bible Society for their benevolent sponsorship. I would expecially like to thank Ena Heller for her scholarship and limitless patience in helping me to realize what has been a life-long dream: to exhibit all these beloved works together for the first time. Her splendid staff and mine, Phillip Mezzatesta, and particulary Gregory Muenzen, have also proved invaluable in forming the catalog and exhibiting the works of art.

Michael Hall

The Image of Jesus: Icon or Portrait?

by Ena Giurescu Heller

T HE IMAGE OF JESUS OF NAZARETH is among the most pervasive representations in the history of western art. Through the centuries, the depiction of Christ changed in ways that reflected religious and socio-political developments, stylistic evolutions, aesthetic and ethnic preferences. On the other hand, it has always maintained a certain recognizable quality that at times supersedes the identifiable narrative episode or attribute. Many of the works in this exhibition illustrate this notion well. For instance, a late medieval *Crucified Christ* shows a

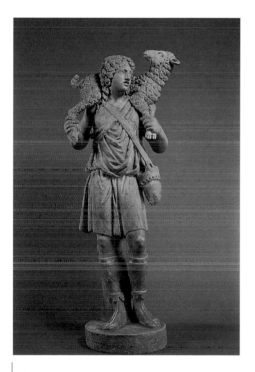

figure 1

**The Good Shepherd, late 3rd/
early 4th century**

Marble sculpture

**Museo Pio Christiano, Vatican Museums,
Vatican State**

dying figure with long, wavy hair and a short-cropped beard framing an elongated face (see cat. no. 71). A sixteenth-century relief of *Christ Derided* depicts the protagonist's face as more rectangular, with a stronger jaw and prominent cheekbones (see cat. no. 56). Later still, a seventeenth-century *Bust of Christ* shows a softened version of the elongated face with wavy hair, a furrowed brow and a curly, forked beard (see cat. no. 50).

The three works do not look alike and yet we know what they depict. They are all icons of Jesus, represented in different moments during his Passion.[1] Furthermore, while the iconography of the first two reveals the identity of the protagonist, the third is devoid of attributes and any narrative props. Yet when we, as Christians (as well as non-Christians familiar with the history of artistic representation), look at this slightly inclined head with characteristic long hair and beard, and with an expression both sorrowful and serene, we easily identify it as Jesus. Today, as in the Middle Ages, most people "know" what Jesus looked like.[2]

In the rich and complex tradition of Christian art, we most often identify Jesus based upon the narrative context or his attributes (such as the crown of thorns and the other instruments of the Passion), themselves derived from the story of his life. Yet even non-narrative images of Jesus remain recognizable (see cat. nos. 50, 91). This of course does not imply that all representations of Christ look alike, but rather that many of them (enough to permit generalizations) share what one may call a family resemblance.[3] It seems that they all follow – with varying levels of detail and accuracy – a common prototype.

This essay proposes an investigation of the origin and historical evolution of this prototype, the context in which it first appeared, and the reasons why it acquired such fame and lasting impact. The prototypical "portrait" of Christ evolved from a compilation of visual and textual sources.

13

Its enduring influence in Christian art is due primarily to its origins in an image said to be "not made by human hands," one that resulted, rather, from direct contact with Christ. Incorporated in different stories throughout the ages, the crux of the legend is that Christ used a cloth to wipe his face and the trace of his features were miraculously imprinted on the cloth. The relic may be thought of as an ancestor to modern photography, as the image depicted Christ's features with unparalleled accuracy: it was Christ's likeness rather than a later reproduction of it.

A comprehensive history of Christ's portrayal in art is yet to be written. This essay is merely a beginning chapter. The works in the accompanying exhibition illustrate the recurrence of this prototype across time and in different cultures, and the way in which it was used, transformed, and adapted in iconic and narrative images alike. Their diversity attests to the special status of Christ's portrait, derived from the miraculous imprint of his features so long ago.

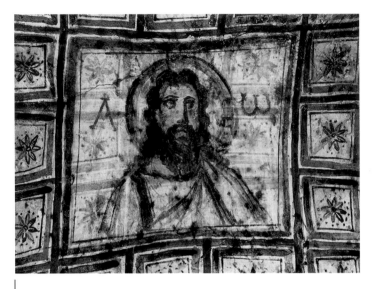

figure 2

Head of Christ, c. 375

Fresco in the Cubiculum Leonis in the catacomb of St. Comodilla, Rome

What did Jesus really look like? The Bible does not provide any information about his physical appearance. The implication may be that he was recognizable through his acts; hence there was no need to describe what he looked like. Yet many early Christian theologians broached this topic, possibly addressing a need for visualization (at a time when image-makers had not yet started to portray Christ).[4] Justin Martyr (d. c. 162–168), the first post-apostolic writer to record details of the life and teachings of Christ (some not mentioned in the New Testament), thought that Christ must have been either deformed, or not of a comely appearance. This was in accordance with the Christian interpretation of the prophecy in the Book of Isaiah.[5] According to Isaiah,

...he [the Messiah] had no dignity or beauty to make us take notice of him. There was nothing attractive about him, nothing that would draw us to him. We despised him and rejected him; he endured suffering and pain. No one would even look at him – we ignored him as if he were nothing.[6]

Moreover, "many people were shocked when they saw him; he was so disfigured that he hardly looked human."[7] Justin Martyr elaborates on that passage, describing Jesus as so misshapen and covered with plagues that people would avert their eyes if they happened to fall upon him. This face and body marked by suffering not only refers to the biblical prophecy, it also expresses Christ's burden to take on all of humanity's faults and sins.[8]

Although many early Christian writers (Clement of Alexandria (c. 150–c. 215), Tertullian (c. 160–c. 230), and Cyprian (c. 200–258), among others) supported Justin's view, this portrayal of Christ was not destined to have a long life in Christian literature.[9] Nor did it have much impact on art, most likely because it did not coincide with the ideal, archetypal figure that Christ represented. Christ's appearance had to reflect his persona. Consequently, other early Christian writers took the opposite view, possibly based on Psalm 45: "You are the most handsome of men." Christ is described as a smiling youth, radiating beauty and light. In the apocryphal *Acts*

of John (late second century), for instance, Drusiana recounts how Christ appeared to her "like John and as a youth."[10] *The Passion of Ss. Perpetua and Felicity* (c. 202) also describes a vision of Christ as "white-headed, having hair like snow, youthful of countenance."[11]

This second literary "portrait" of Christ does resonate in art: paintings from the Roman catacombs and sculptures dating from the early Christian centuries show a youthful beardless Christ with short curly hair, usually in the guise of the *Good Shepherd* (fig. 1 and cat. no 90).[12] Christ is depicted as eternally young, embodying the concept that age was not relevant since he was wise from birth. Yet this type of representation did not dominate the repertory of early images of Christ, a repertory characterized by the variety inherent in an incipient art form, still searching for images that would become lasting prototypes.[13] Nor did it become such a prototype: the youthful Christ was gradually replaced by another type, probably elaborated around the same time but which gained more popularity as time went by.

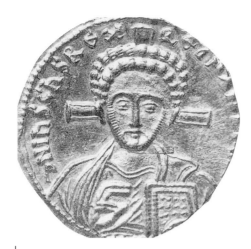

figure 3
Solidus of Justianian II (2nd reign: 705 711)
Harvard University Art Museums,
Whittemore Collection

The latter type shows a more mature, bearded figure with long, parted hair. Depicting Jesus as a grown man, the portrait borrows heavily from ancient representations of philosophers: emphasizing wisdom and knowledge, it depicts Christ as teacher.[14] The late fourth-century wall painting in the Catacomb of Commodilla, Rome (fig. 2) is one of the earliest extant examples of this type. Based on such early representations, the image of the bearded Christ was disseminated through coins starting in the late seventh century. Two different sub-types were developed: the "Hellenic" Christ, idealized in the tradition of portraying the Greek gods, and the "Semitic," more ordinary looking Christ, whose physiognomy and hair show ethnic features. The latter type (fig.3) was largely abandoned after the iconoclastic controversy in the Eastern Church (eighth century).[15] Some of its features, however, would reappear in late medieval and Renaissance representations, especially on medals (see cat. nos. 92, 96). The Hellenic type (fig. 4), by contrast, had a remarkable endurance in subsequent centuries, informing what would become the

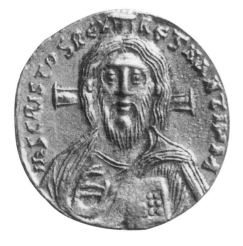

figure 4
Solidus of Justinian II (1st reign: 685–95)
Harvard University Art Museums,
Whittemore Collection

archetypal depiction of Christ. This depiction, which people have come to "recognize" as Jesus, is at the heart of many of the works in this exhibition.

The fame and authority of any prototype in the history of religious art are connected equally with theological and aesthetic notions. If descriptions of an unattractive, plagued Christ did not translate well into art, that was due to the aesthetic inappropriateness in relation to the symbolism of the figure. The same is true of the original image imprinted on cloth which came to be considered the "true likeness" of Christ. Its pedigree, so to speak, was impeccable, since tradition claims that the original prototype was "not made by hands," but had resulted from direct contact with Christ during his lifetime.

The history of this prototype, however, is not linear. Nor is it unique or universally accepted. I here

15

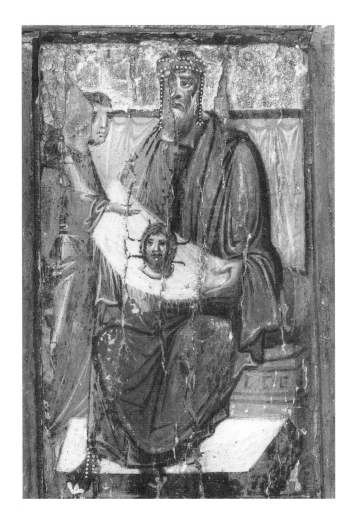

figure 5

King Abgar and the Mandylion of Christ (detail), 10th century
Icon
Monastery of St. Catherine, Sinai

are several painted images – and more than a few different legends for each of them – that claim to be Jesus' "true likeness." Not surprisingly, the stories have much in common: details overlap, parts of the narrative are retold in a different context, changed ever so slightly but charged with the same symbolism. Indeed, they all borrow liberally from their predecessors and contemporaries. Two among these stories were to acquire most renown and establish themselves, at different times and in different parts of the Christian world, as archetypes of Christ's likeness: the *Mandylion of Edessa* and the *Veil of Veronica*.[16]

The *mandylion* (from the Greek word for "cloth"), also known as *The Holy Face of Edessa*, was probably the most famous image "not made by hands" (*acheiropoieton*) in the Christian world from the late sixth through the early thirteenth century.[17] Its legend tells of King Abgar of Edessa who, afflicted by leprosy and having heard of Christ's miraculous healings, sent an emissary to Jerusalem to ask for help (or, in another version, for a painted portrait). Instead, Christ gave the emissary a towel with which he had dried his face, and on which the trace of his features had remained imprinted (fig. 5).[18] It is interesting to note that one of the versions of the legend specifies that the reason the emissary could not paint Christ was that he was blinded by the brilliance radiating from the holy face – a detail reminiscent of apocryphal writings describing Christ as a vision of light.[19] Upon seeing the image, King Abgar was healed and he and his people immediately converted. Christ's likeness subsequently protected the city through wars and other disasters, until 944 when it was transferred with great pomp to Constantinople, to be housed in the Imperial Treasury. Shortly after that event a feast homily was written; possibly either authored or closely supervised by the Byzantine emperor Constantine Porphyrogenitus (905–959), the text included a detailed "description" of the *mandylion*.[20]

Not surprisingly, once the image was brought to the capital and an annual feast instituted in its honor, the miracles associated with it multiplied, and its importance among all sacred art soared. Numerous copies also began to appear. The established iconography was to play an important role in the production of images for many centuries henceforth.[21] *The Holy Face of Edessa*, in these tenth-century versions (see fig. 5), shows a frontal, rather round face with clearly outlined features. The face, depicted as an imprint on the cloth, is framed by strands of hair and a full, rounded beard. In later renditions, starting with the eleventh and twelfth centuries, the head of Christ undergoes a transformation which has been linked to the aesthetics of the time: the round face gives way to a more ascetic physiognomy with leaner cheeks and a pointed

beard.[22] The pointed, often forked beard is at the same time a return to the early representations of Christ as teacher and a harbinger of later developments.

At least three copies of the *mandylion* showed up in Western Europe in the later Middle Ages, claiming to be the original long after the real one had been lost. Two are still extant, one in the monastery of San Bartolomeo degli Armeni in Genoa, the other at the Vatican. The third one, once the pride relic of the Sainte Chapelle in Paris, was lost during the French Revolution. With them, the influence of the *mandylion* and the particulars of its symbolism extended to most of Europe.

The *mandylion* continued to hold a unique place in the hierarchy of holy images: as late as the eighteenth century, *The Painter's Manual* compiled by Dionysus of Furna still considered it the source for all sacred art.[23] Its fame and pre-eminence as the true likeness of Christ, however, were to be replaced in Western Europe by another image, the *sudarium* (Latin for "handkerchief") or *Veil of Veronica*. The rise of the cult of Veronica coincides with the disappearance of the *mandylion* from Constantinople (possibly connected to the conquest of the city by crusaders in 1204). Not coincidentally, the legend of *Veronica's Veil* is remarkably similar to that of the *mandylion*.[24]

The earliest mentions of this most famous of Rome's relics date from the eleventh century.[25] The *Ordo* (a calendar used in the daily celebration of Mass) of Benedictus Canonicus (1143), as well as a contemporary description of the church of St. Peter, record the cloth as being

the one with which Jesus wiped his face on the way to Calvary, but do not mention an image. The earliest known source to mention Christ's features imprinted on the *sudarium* is the *Cronica maiora* of Matthew of Paris, dated to 1245.[26] The face of Christ, this source records, was visible on the cloth "as if it were present."[27] Thus in one step, we go from no image at all to a fully detailed likeness, so clearly delineated as to be recognizable.

Pope Innocent III (1198–1216) was the first ardent promoter of the cult of Veronica and jumpstarted its extraordinary dissemination throughout Europe. The Pope witnessed a miracle in 1216, when the *sudarium* turned itself upside down during an Epiphany procession from St. Peter's to the Hospital of the Holy Ghost. Taken to be a sign of the image being displeased with its current status, this miracle led to the composition of a special prayer and the granting of ten days' indulgence, or remission of time in purgatory, for its recital.[28] For the first time in history, the indulgence was not limited to praying in front of the relic in Rome, but extended to copies. The practice made *Veronica's Veil* a universally known image by encouraging the proliferation

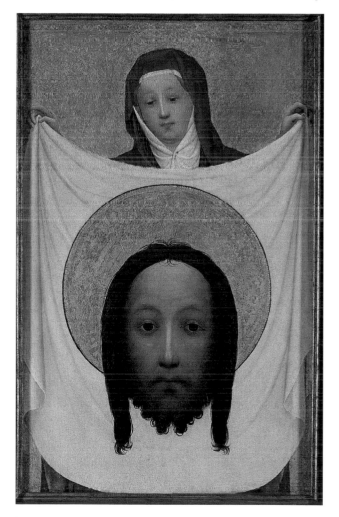

figure 6
Master of St. Veronica
St. Veronica, c. 1400
Oil on wood
National Gallery, London, Great Britain

of copies (see cat. no. 107).[29] This explains why, of all the images claiming to be "the true like-ness" of Christ, this became the most influential. Countless other indulgences followed, contribut-ing to the extraordinary development of the cult; according to a late fourteenth-century English pilgrims' guidebook, foreigners traveling to Rome to venerate *Veronica's Veil* could gain thousands of years' indulgence. Those traveling from afar would be rewarded the most: while Romans could obtain 3,000 years and other Italians, 9,000 years, foreigners could be granted as many as 12,000 years' indulgence for having come to venerate and pray in front of the *sudarium*.[30]

The legend evolved as the fame of the image grew. Clearly influenced by the story of the *mandylion*, the cloth was considered early on to have been used by Christ to wipe his face during the *Agony in the Garden of Gethsemane*. Later a female protagonist appeared, Berenice or Veronica.[31] Sometimes identified with the biblical *hemorrhissa* (the woman with the issue of blood), Veronica preserved Christ's likeness miraculously imprinted on the cloth.[32] It is interest-ing to note that one of many versions of the legend goes on to say that as a sign of gratitude for being cured, the woman erected a bronze statue of Christ, and sent the likeness imprinted on the cloth to the emperor Tiberius to cure him of leprosy.[33] The origin of this story in the Eastern legend of King Abgar of Edessa is indisputable.

Later on, the legend changes once again and Veronica, no longer in need of healing, shows up on *Via Dolorosa* (the way to Calvary) during Christ's Passion and offers him a cloth to wipe his face.[34] This became the authoritative version, which informed artistic representation for centuries to come. As a group, the numerous copies of the image show a resemblance of type and main features, but not a consistency of detail. Starting in the fourteenth century, two different pictorial types emerge. The first, directly influenced by the iconography of the *mandylion*, depicts the head of Christ in strict frontality against the cloth: a figure unmarked by suffering, calm and serene, surrounded by a halo and not wearing the crown of thorns (fig. 6). The second, whose earliest known examples date from the beginning of the fifteenth century, shows a dark-faced Christ displaying signs of his Passion, including the crown of thorns, thus placing the image firmly within the narrative of Christ's walk to Calvary.[35] The two versions have been linked to the two most popular prayers associated with the image: the thirteenth-century "*Ave facies praeclara*" (*Hail, splendid face*) which mentions the face "darkened by fear and stained with holy blood," and the slightly later "*Sale sancta facies*" (*Hail, holy face*), which speaks of "the vision of divine splendor which was imprinted on the white cloth."[36] Whether sorrowful or serene, however, Christ appeared with an oval or elongated face framed by shoulder-length brown hair, wavy and always parted in the middle, and a curly forked beard; a strong nose, defined cheek-bones and brown eyes looking straight at the beholder.

This portrait is remarkably similar to that of the *mandylion*. Surely, one would not mistake one for the other; yet, when analyzed side-by-side, they reveal how much they have in common: from elements of the narrative to the significance of the image and the actual physiognomy. Despite obvious differences in the rendition of Christ (reflecting not only the two groups but also, within each group, differences of style, period, and geographic origin), most of these representa-tions bear a certain resemblance, a family air. More to the point, the figure in all cases (with or without the help of attributes or narrative details) is recognizable. It always possesses a certain familiarity: the *mandylion* and *Veronica's Veil* do not necessarily look like one another, but they both portray the same person. And since they both claim to derive from "true likenesses," images resulting from direct contact with Christ's face, the argument may well be made that they both resemble the historical Jesus, the person they are meant to portray.

The fact that both these images claim to have been painted, or otherwise fashioned, free of the agency of human hands and artistic imagination, comprises an extremely important component of their history. The miraculous origin explains their archetypal status; the unequivo-cal authenticity, by virtue of their physical contact with Christ's face, makes them worthy to be venerated and copied. Whether it happened in Jerusalem, in the Garden of Gethsemane, or on the way to Calvary, the story is about Jesus wiping his face on a piece of cloth, which miraculously

preserved a clearly delineated portrait. This portrait of photographic accuracy would not only prove beyond any doubt the historical existence of Jesus, but it would also give the faithful an accurate image of what he really looked like. Since Christ willingly sent the emissary back to Abgar with the cloth bearing his likeness, the legend of the *mandylion*, as well as the early versions of *Veronica's Veil*, became a key argument in favor of representational Christian art.[37] Moreover, since the image imprinted on the cloth cured Abgar of his affliction, the story also documents the power of images (which in turn supports their legitimacy).[38]

Around the time when the cult of Veronica was being developed, a literary source also emerged as an authoritative account of Jesus' likeness. The Lentulus Letter was popularized in the *Vita Christi* (The Life of Christ) by Ludolphus of Saxony (c.1295–1377), among other sources. It was believed to be an eyewitness account of Jesus' appearance given by Publius Lentulus, Governor of Judea. The enormous popularity of the letter and its impact on art was largely due to the fact that the *Vita Christi* was one of the most widely read texts on the life of Christ in the Middle Ages.[39] The pertinent part of the letter reads:

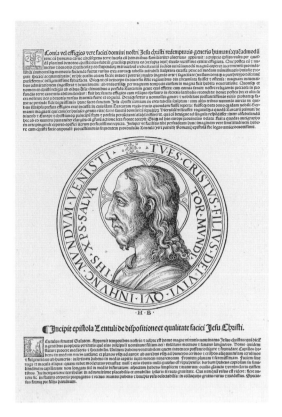

figure 7
Hans Burgkmair der Ältere
Die Büste des Erlösers (Bust of the Savior), c. 1515
Woodcut
Staatliche Graphische Sammlung München

In these days there appeared, and there still is, a man of great power named Jesus Christ, who is called by the Gentiles the prophet of truth, whom his disciples call the Son of God, raising the dead and healing diseases – a man in stature middling tall, and comely, having a reverend countenance, which those who look upon may love and fear; having hair of the hue of an unripe hazelnut and smooth almost down to his ears, but from the ears in curling locks somewhat darker and more shining, flowing over his shoulders; having a parting at the middle of his head according to the fashion of the Nazareans; a brow smooth and very calm, with a face without wrinkle or any blemish, which a moderate red color makes beautiful; with the nose and mouth no fault at all can be found; having a full beard of the color of his hair, not long, but a little forked at the chin; having an expression simple and mature, the eyes gray, flashing, and clear; in rebuke terrible, in admonition kind and lovable, cheerful yet keeping gravity; sometimes he has wept, but never laughed; in stature of body tall and straight, with hands and arms fair to look upon; in talk grave, reserved and modest, fairer than the children of men.[40]

This description would easily fit most images of the *mandylion* and/or *Veronica's Veil* known to late medieval Europe. Indeed, the letter, far from being a first-century original, was composed most likely in the fourteenth century.[41] Existing "portraits" of Christ in art, primarily the *acheiropoieta* which by that time had acquired archetypal status, surely informed the detailed description. Supported by its claim of authenticity, the Lentulus Letter in turn influenced the way artists portrayed Christ henceforth. In other words, it both summed up and legitimized a visual tradition and assured its future evolution.

The Lentulus Letter addressed a need for a written description of what Jesus looked

like, just as artistic representations before it had struggled with the need to crystallize a portrait.[42] As regards its impact on subsequent artistic representations, recent research has rightly pointed out that it would be hard to construct a portrait based upon the description of Christ in the letter, which is quite vague and gives little useful information other than the color and style of Jesus' hair and eyes.[43] However, starting in the fifteenth century there is a distinct depiction of Christ, usually (but not exclusively) in profile, which is linked to the Lentulus Letter. Some examples are actual illustrations of the letter, pairing the text (either in Latin or in a vernacular language) with a painted profile of Jesus. Most of these, in both painting and engraving, are Northern European and date from the fifteenth and early sixteenth centuries (fig. 7).[44]

Similar images are connected with an ancient profile of Christ carved in an emerald, which arrived in Western Europe in the early fifteenth century. This portrait may have provided the specifics of the physiognomy left vague by the literary description. The legend recounts that the treasury of Constantinople numbered among its precious relics an emerald onto which the

figure 8
Bust of Christ
Andrea del Verrocchio (1435–1488)
Florentine, after 1483
Gessoed, painted, and gilded terra cotta
Michael Hall Collection

profile of Christ had been carved. In 1492, the Ottoman Sultan Bajazet II (1481–1512) gave it to Pope Innocent VIII (1484–1492), in exchange for the Pope's promise to keep the Sultan's brother imprisoned in the Vatican.[45] The gem does not survive, but starting in the late fifteenth century it was copied in numerous medals and plaquettes representing Christ in profile.

A number of late fifteenth- and sixteenth-century medals in this exhibition, depicting Christ with a pronounced brow, straight nose and long, wavy hair, illustrate this type (see cat. nos. 92, 93, 96). Many of these medals accentuate the figure's fleshy lips and prominent, at times bulbous, nose.[46] Possibly underscoring Jesus' ethnicity, these medals connect with the much earlier coins depicting the "Semitic" type of Christ portrait. Some works in other media, also derived from the image on the emerald, preserve these features; an example in this exhibition is the extremely rare sixteenth-century triptych from Northern Italy, carved in walnut (see cat. no. 95). A very similar likeness of Christ is also present on an English painted portrait from the first half of the sixteenth century, which bears an inscription relating the story of the emerald (see cat. no. 97). The painting displays a more subtle treatment of the physiognomy, softening, as it were, Christ's ethnic attributes. The eyes are less deeply set, the lips are less fleshy, and the hair and beard are carefully groomed. These characteristics are shared by most contemporary and later portrayals of Christ. It can be argued that monumental art idealizes the face of Christ, shedding its ethnic traits and transforming it into an ideal of beauty shared by Christians in all parts of Europe.[47]

These portraits, allegedly based on the emerald likeness, are remarkably similar to those paired with the Lentulus Letter.[48] In turn, they both recall the face of Christ as depicted on the *mandylion* and *Veronica's Veil*. These different prototypes, each with their own claim to veracity, combine to create what has become, through time and repetition, the most recognizable "portrait" of Christ. Perhaps best embodied in Andrea del Verrocchio's *Bust of Christ* (fig. 8, see cat. no. 91), this type is also recognizable in many other works in this exhibition. The main

features, as described in the Lentulus Letter, recur in both narrative and symbolic representations of Christ, across the centuries, and in various media. And since the letter describes Jesus' features already made familiar by the numerous copies of the Eastern *mandylion* and its Western version, the *sudarium*, an argument can be made that the "true likeness of Christ," with origins in the images "not made by hands," informed all these representations.

This overarching generalization does not mean to imply that every image of Christ, in the present exhibition or elsewhere, conforms to one or all of the mentioned prototypes. It merely suggests that some recurring features, which make numerous representations of Christ familiar and recognizable, can be traced back to these prototypes. It also proposes that their endurance in the history of Christian art is at least partly due to their origin in the allegedly authentic portrayals of the historical Jesus.[49]

Ultimately, what did Jesus look like? Since the Bible is silent on the issue, we may never be able to answer that question. The question that this exhibition investigates is, rather, "What did Jesus look like in art?" The answer surely varies depending on period, style, geography, and ethnicity. Several African and Asian sculptures on display are a case in point (see cat. nos. 24, 108, 114). Yet, as the majority of works assembled in "Icons or Portraits?" illustrate, European Christian art through the centuries reproduces one predominant, and hence recognizable, image of Jesus.

This image resulted from a compilation of legend, history and myth. It functioned as an emblematic representation, neither portrait nor icon, claiming authenticity but in fact being a composite of sources, both artistic and literary. Its claim of undisputed accuracy contributed to its being considered the "true likeness" of Jesus, informing an astounding number of artistic representations. The repetition provided an element of constancy, which helped equate the image with the "one and real" Christ. Ultimately, the "true likeness" is neither fully portrait nor icon, but the artistic transcription of a mental construct combining the image of Jesus (enriched and informed by a long historical tradition), the historical Jesus (affirming his existence) and the essence (or, in the context of this exhibition, the icon) of Jesus.[50]

1 The term icon, in its broadest sense, means image; in the more restricted sense in which it is generally understood, it signifies a holy image to which special veneration is given. In this essay (and in the title of the exhibition) the term is used in the latter sense, and with the additional connotation of stylization characteristic of Eastern Orthodox icons (thus contrasting the concept of "portrait").

2 David Morgan recently documented the response of about five hundred people to a twentieth-century depiction, the *Head of Jesus* by Warner Sallman: many viewers "…repeatedly report that this image *looks* like Jesus. Many correspondents expressed in letters how the *Head of Christ* comforted them as children (…) and served to transmit the faith to Christian youth – all because this picture of Jesus presents a portrait, what some even consider a photograph of the man." See David Morgan, *Visual Piety. A History and Theory of Popular Religious Images* (Berkeley, Los Angeles and London, 1998), 125.

3 Neil Mc Gregor and Erika Langmuir, *Seeing Salvation. Images of Christ in Art* (London, 2000) 93.

4 The earliest known representations of Christ only date from the mid-third century, in catacombs, on sarcophagi, and in the frescos at Dura Europos, cf. Peter and Linda Murray, *The Oxford Companion to Christian Art and Architecture* (Oxford and New York, 1996), 103–4.

5 See L. W. Barnard, *Justin Martyr. His Life and Thought* (London, 1966), esp. 58–65.

6 Isaiah 53.1–3. All biblical quotations are from the *Good News Bible, Today's English Version*, American Bible Society (New York, 2nd edition, 1992).

7 Isaiah 52.14.

8 See *Saint Justin Apologie*s, ed. Andre Wartelle, Etudes Augustiniennes (Paris, 1987), 165.

9 Clement of Alexandria even argues that admiring Christ's looks would detract from his works, cf. David Freedberg, *The Power of Images. Studies in the History and Theory of Response* (Chicago and London, 1989), 211.

10 See P. J. Lalleman, "Polymorphy of Christ", in Jan N. Bremmer, ed., *The Apocryphal Acts of John* (Kampen, 1995), 98.

11 *The Passion of Ss. Perpetua and Felicity. A New Edition and Translation of the Latin text together with the Sermons of S. Augustine*, trans. W. H. Shewring (London, 1931), 34.

12 The frequency of this image at the time may not necessarily be related to the literary descriptions mentioned above. The *Good Shepherd* was a familiar image in Greek art, and hence an available model for Christian artists formulating their own iconography.

13 Hans Belting, "In Search of Christ's Body. Image or Imprint?" in H.L. Kessler and G. Wolf, eds. *The Holy Face and the Paradox of Representation. Papers from a Colloquium held at the Bibliotheca Herziana, Rome, and the Villa Spelman, Florence, 1996* (Bologna, 1998), 10. See also Thomas Mathews, *The Clash of Gods. A Reinterpretation of Early Christian Art* (Princeton, 1993), 142, and Paul Zanker, who points out that the coexistence of various types may also be a deliberate "…attempt to capture the totality of Christ's nature through an accumulative process." See *The Mask of Socrates. The Image of the Intellectual in Antiquity* (Berkeley, Los Angeles, and Oxford, 1995), 299.

14 Zanker (as in note 13), 300–7.

15 Hans Belting conjectures that this choice was not based on aesthetic judgment, but rather the concept of a successful archetype. See *Likeness and Presence. A History of the Image before the Era of Art* (Chicago and London, 1994), 134–5.

16 Others include the Christ image at Kamuliana (an image perhaps older than the *mandylion* but for which no description is preserved), cf. Belting (as in note 13), 8; the sculpture preserved in Lucca, known as the *Volto santo* (the Saintly Face); see McGregor (as in note 3), 96–7; the portrait kept in the Roman Pretorium in Jerusalem and described by the traveler known as the *Pilgrim from Piacenza* in the late sixth century; see F. E. Peters, *Jerusalem. The Holy City in the Eyes of Chroniclers, Visitors, Pilgrims, and Prophets from the Days of Abraham to the Beginnings of Modern Times* (Princeton, 1995), 167.

17 The earliest recorded version of the *mandylion* legend is in Eusebius's *Church History* (early fourth century), which does not mention the image; the first reference to an image is the late sixth-century *Ecclesiastical History* by Evagrius. For a detailed history and analysis of the image, see Averil Cameron, "The Mandylion and Byzantine Iconoclasm," in Kessler and Wolf (as in note 13), 33–54.

18 For the Abgar legend, see Belting (as in note 15), 209-215; for the historiography of the image, see Han J. W. Drijvers, "The Image of Edessa in the Syriac Tradition," in Kessler and Wolf (as in note 13), 13–4.

19 See, for instance, "The Acts of Andrew," in J. K. Elliott, *The Apocryphal New Testament* (Oxford, 1993), 278.

20 Gerhard Wolf, "From Mandylion to Veronica: Picturing the 'Disembodied' Face and Disseminating the True Image of Christ in the Latin West" in Kessler and Wolf (as in note 13), 157.

21 Cameron (as in note 17), 35.

22 Kurt Weitzman, "The Mandylion and Constantine Porphyrogenetos," *Cahiers Archeologiques* 11 (1960), 168.

23 Herbert L. Kessler, "Configuring the Invisible by copying the Holy Face," in Kessler and Wolf (as in note 13), 141.

24 The *mandylion* has been recognized as a direct source for the Veronica. See, among others, André Chastel, "La Veronique," *Revue de l'Art* 40–1(1978), 71.

25 Gabriele Finaldi et al, *The Image of Christ*, exh.cat., National Gallery, London (London, 2000), 75.

26 Matthew Paris was an English chronicler and manuscript illuminator best known for his historiated historical works such as the *Cronica maiora* and the *Historia Anglorum*; see Suzanne Lewis, *The Art of Matthew Paris in the Chronica Maiora* (Berkeley and London, 1987).

27 Wolf (as in note 20), 167.

28 Flora Lewis, "The Veronica: Image, Legend and Viewer," in W. M. Ormrod, ed., *England in the Thirteenth Century. Proceedings of the 1984 Harlaxton Symposium* (Wodbridge and Dover, NH, 1986), 100.

29 So widespread was the commerce of this image, that in the fifteenth century specialized groups of artists and merchants were dedicated exclusively to the production and sale of Veronica images. See Finaldi et al. (as in note 25), 90.

30 McGregor and Langmuir (as in note 3), 92.

31 Wolf (as in note 20), 172 makes the point that the fundamental role of a woman in the western story illustrates a most telling difference between the Eastern and Western traditions.

32 The early Greek tradition names her Berenike, explaining the etymology of Veronica. Although subsequently the name was held to derive from the Italian *vera icona* (true icon), that seems to have been a coincidence. Cf. Finaldi et al (as in note 25), 76. For the story of the *hemorrhissa*, see The Gospel according to Matthew 9.20-22.

33 McGregor and Langmuir (as in note 3), 90.

34 Wolf (as in note 20), 169. On the evolution of the devotion of the *Stations of the Cross* (which follows Christ's walk to Calvary), see Ena Heller, *The Stations of the Cross. Don Justin Meserve in Dialogue with Eric Gill* (New York, American Bible Society, 1999), 1–3 (with bibliography).

35 Wolf (as in note 20), 172-3; also Chastel (as in note 24), 74.

36 Finaldi et al (as in note 25), 80.

37 Cameron (as in note 17), 43–4.

38 On the power of images, see Belting (as in note 15), 41–46 and 144–46; and the engaging analysis by David Freedberg (as in note 9).

39 Henk van Os, with Hans Nieuwdorp, Bernhard Ridderbos, Eugene Honee, *The Art of Devotion in the Late Middle Ages in Europe 1300–1500* (Princeton, 1994), 40.

40 Cf. the translation from the Latin by E. von Dobschütz (Leipzig, 1899), reprinted in J. K. Elliott, *The Apocryphal New Testament* (Oxford, 1993), 543. Elliot points out that the part describing Christ is not found in all manuscripts of the letter. The original text is in Latin, but Syriac, Persian and Armenian translations also exist.

41 The letter was written no earlier than the thirteenth century, see Finaldi et al (as in note 25), 94; van Os (as in note 39), 40.

42 The Lentulus Letter is not the only literary description of Christ, but it is the one that had most impact on the development of art. According to Hill, the earliest known description is that by John of Damascus (d. c. 754). See G. F. Hill, *The Medallic Portraits of Christ* (Oxford, 1920), 9 ff.

43 Finaldi et al (as in note 25), 94.

44 See the Netherlandish painting with Latin text included in the exhibition *The Image of Christ*, in Finaldi et al (as in note 25), 94–97. Finaldi also notes the existence of a print that has the text both in Latin and German.

45 C. W. King, "The Emerald Vernicle of the Vatican," *Archaeological Journal* 27 (1870), esp. 184–5; Finaldi et al (as in note 25), 96.

46 See also the examples analyzed by Hill (as in note 42), esp. 16–21.

47 It is only in the seventeenth century that certain artists started representing Jesus as distinctively Jewish. See Morgan (as in note 2), 124.

48 This large group is obviously far from homogenous; within it, numerous sub-groups and type variations can be found. See the comprehensive analysis of medals by Hill (as in note 42).

49 Although with the spread of Christianity other races represented Jesus in their own ethnicity (see cat. no. 108), it is noteworthy that even non-western representations preserve at least part of the "codes of recognition," by perpetuating a bearded, ascetic, subdued Christ. See Morgan (as in note 2), 35.

50 See the perceptive analysis of "The Psychology of Recognition" by Morgan (as in note 2), 34–50.

Bibliography

Belting, Hans. *The Image and its Public in the Middle Ages: Form and Function of Early Paintings of the Passion* (New York, 1990).

----. *Likeness and Presence: A History of the Image before the Era of Art*. Translated by Edmund Jephcott (Chicago, 1994).

Chastel, Andre. "La Veronique." *Revue de l'Art* 40–1 (1978), 71–82.

Dagron, G. "Holy Images and Likeness," *Dumbarton Oaks Papers* 45 (1991), 23–33.

Elliott, J. K. *The Apocryphal New Testament. A Collection of Apocryphal Christian Literature in an English Translation* (Oxford, 1993).

Fagiolo dell'Arco M., ed. *L'iconografia della Veronica a Roma* (Rome, 1984).

Finaldi, Gabriele et al. *The Image of Christ*. Exh. cat., National Gallery, London (London, 2000).

Freedberg, David. *The Power of Images. Studies in the History and Theory of Response* (Chicago and London, 1989).

Goa, David J., with Linda Distad and Matthew Wangler. *Anno Domini. Jesus through the Centuries*. Exh. cat., The Provincial Museum of Alberta (Edmonton, Alberta, 2000).

Grabar, André. *Christian Iconography. A Study of its Origins* (Princeton, 1968).

Hill, G. F. *The Medallic Portraits of Christ* (Oxford, 1920).

James, M.R., ed. *The Apocryphal New Testament* (Oxford, 1924).

Katz, Melissa R., and Robert A. Orsi. *Divine Mirrors. The Virgin Mary in the Visual Arts*. Exh. cat., Davis Museum and Cultural Center (Oxford and New York, 2001).

Kessler, Herbert L. and Gerhard Wolf, eds. *The Holy Face and the Paradox of Representation. Papers from a colloquium held at the Bibliotheca Herziana, Rome, and the Villa Spelman, Florence, 1996* (Bologna, 1998).

King, C. W. "The Emerald Vernicle of the Vatican." *Archaeological Journal* 27 (1870), pp. 181–90.

Kitzinger, E. "A Virgin's Face: Antiquarianism in Twelfth-Century Art." *The Art Bulletin* LXII/1 (1980): 6–19.

Lewis, Flora. "The Veronica: Image, Legend and Viewer." In W. M. Ormrod, ed. *England in the thirteenth century. Proceedings of the 1984 Harlaxton Symposium* (Woodbrigde and Dover, 1986).

Mathews, Thomas. *The Clash of Gods. A Reinterpretation of Early Christian Art* (Princeton, 1993).

Mc Gregor, Neil, and Erika Langmuir. *Seeing Salvation. Images of Christ in Art* (London, 2000).

Morgan, David. *Visual Piety. A History and Theory of Popular Religious Images* (Berkeley, Los Angeles and London, 1998).

Pelikan, Jaroslav. *The Illustrated Jesus Through the Centuries* (New Haven and London, 1997).

Tudor-Craig, Pamela. "Times and Tides" *History Today* 48 (4) (May 1998): 8–10.

Van Os, Henk, with Hans Nieuwdorp, Bernhard Ridderbos, Eugene Honee. *The Art of Devotion in the Late Middle Ages in Europe 1300–1500* (Princeton, 1994).

Weitzmann, Kurt. "The Mandylion and Constantine Porphyrogenetos." *Cahiers Archeologiques* 11 (1960): 163–84.

Zanker, Paul. *The Mask of Socrates. The Image of the Intellectual in Antiquity*. Translated by Alan Shapiro (Berkeley, Los Angeles, and Oxford, 1995).

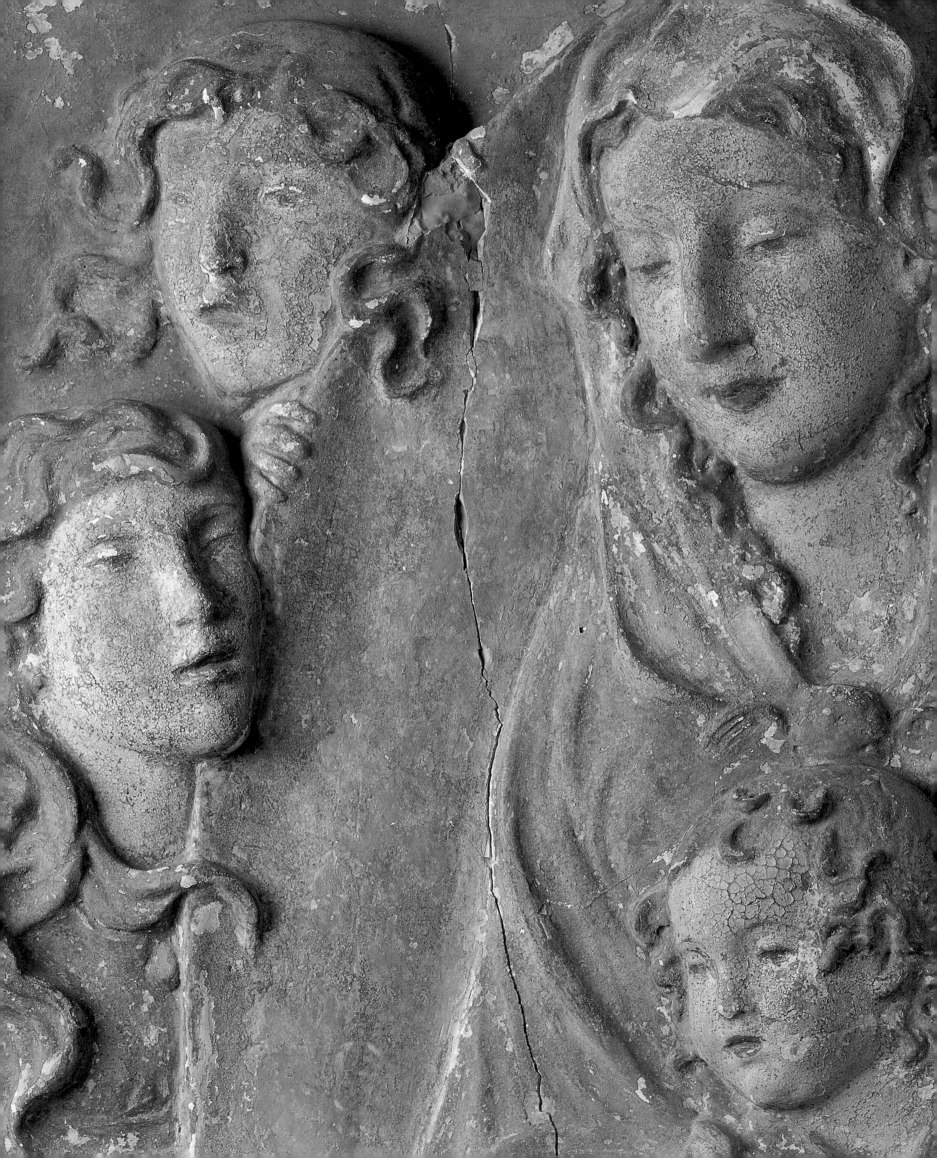

The angel said to her, "Don't be afraid, Mary; God has been gracious to you. You will become pregnant and give birth to a son, and you will name him Jesus."
Luke 1.30–31

The *Madonna and Child* is one of the most familiar Christian images, tracing its legendary origins to the portrait from life painted by St. Luke. Sanctioned by the fifth-century Council of Ephesus, the Virgin as *Theotokos* ("God-bearer"), shown together with her son, became extremely popular. Several iconographic types were developed through the centuries, emphasizing in turn the mystery of the Incarnation, the majesty of the figures, or the tenderness of the mother and child relationship.

The works in this exhibition, spanning seven centuries, witness iconographic and stylistic variety. The protagonists are identified by their relationship and attributes, rather than a physiognomic type. Their facial features change according to time period, style, and artist. The Christ child is depicted in turn as a miniature adult and a chubby, more naturalistic-looking child, in playful interaction with his mother. The only constant in the portrayal of the Virgin Mary is her interaction with the child: the beautiful young woman, often veiled, gazes lovingly at her son. Sometimes her gaze is sad, filled with the premonition of his impending sacrifice.

1 | Madonna and Child

Venetian, 13th century
Gilt copper *repoussé*
11 x 5 x 1⅛ inches (27.7 x 12.7 x 0.3 cm)
Integral frame 14 x 12 x 5½ inches (35.5 x 30.5 x 14 cm)

The *Virgin Hodegetria*, named after the Monastery of the Hodegon where the most venerated icon in Constantinople was housed, depicted Mary holding her son in her left arm and gesturing to him with her right. According to tradition, St. Luke painted the original icon; consequently, he became the patron saint of painters in the late Middle Ages. The Empress Eudocia supposedly sent the original icon from Jerusalem to Constantinople, where it was carried in processions and in battles and worked many miracles, until it was lost in the sack of 1453. Many copies survive of both Eastern, and later, of Western production, and the image made its way into objects with a variety of functions.

Here the image appears on a gilt copper *repoussé* plaque, originally used as the central image of a book's back cover. The two sets of nail holes on either side of the Virgin's head indicate that some decorations have been removed. Judging from the way in which the delicate engraved tracery bulges outward at these points, these decorations probably formed part of the original decorative scheme of the book cover. The book that this plaque protected was likely a missal, which contains all the prayers and readings for mass and is used by a priest to perform the service. Intact Italo-Byzantine book covers usually display a more highly ornamented and bejeweled design on their front covers, often representing *Christ Crucified*.[1] The images of Christ's *Infancy* and *Passion* would have created a tension between the beginning of his life at the back of the book, and the end of his life at the front.

This image recalls an influential and monumental mosaic from Torcello, an island in the Venetian archipelago. The mosaic, set by a Greek artist around 1180, depicts the standing Virgin with the Child in her arms and probably replaced a figure of *Christ Enthroned*, a choice which reflects a new wave of Marianic piety in the late twelfth century.[2] Unlike the mosaic, this plaque includes a *clipeus*, the round form in which the child is framed. The *clipeus* is usually positioned at the center of the Virgin's body to refer to her womb. Here the drapery is pulled through the bottom of the *clipeus* and is positioned off-center to frame her nourishing breast. **KR**

Bibliography: *Medieval Art from Private Collections*, exh. cat., The Metropolitan Museum of Art, The Cloisters (New York, 1968), no. 103.

1 Yvonne Hackenbroch, *Italienisches Email des frühen Mittelalters* (Basel/Leipzig, 1938), 44–48.

2 Otto Demus, "Studies among the Torcello Mosaics III," *Studies in Byzantium, Venice and the West* II (London, 1998), 233–238 and plates XXIV.1–XXIV.5.

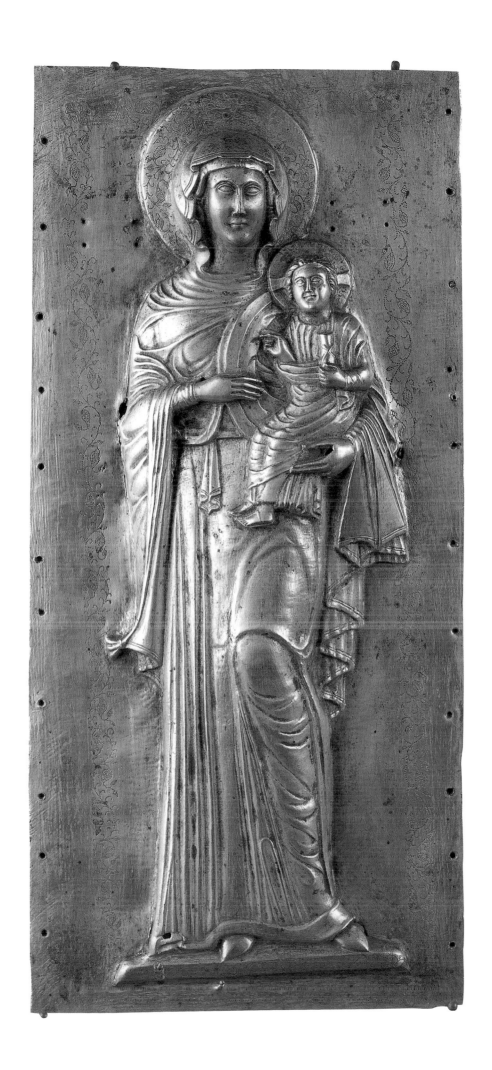

2 | Madonna and Child with Music Making Angels

Donatello (1386–1464)
Florentine, 1430s
Pigmented stucco in original frame (gessoed, painted, and gilded)
15⅛ x 11⅝ x 2¾ inches (38.5 x 29.5 x 7 cm); with frame 24¼ x 18¾ x 2¾ inches (61.6 x 47.6 x 7 cm)

The present polychromed stucco relief may be the most important sculpture by the master in the United States, its only rival a carved marble relief of the *Madonna of the Clouds* in the Museum of Fine Arts, Boston.[1] The Hall relief remains in the original frame in which it was cast. A contemporary master provided the gold ground, painted the red and blue seraphim, and embossed the frame and halos. As such, this work is an extraordinary example of collaboration among painters and sculptors in early Renaissance Florence.[2]

There are two variants of the present relief; a marble in the Victoria and Albert Museum, London, and another stucco version in which the standing figures are saints rather than angels, also in the same collection. Early scholars, such as Bode and Schottmüller, believed without doubt that the present relief was modeled by the hand of Donatello himself.[3] Both Janson and Pope-Hennessy erroneously assumed that the present relief was cast from the marble and even delegated the composition itself to a sculptor who worked in the style of Donatello in the middle of the fifteenth century.[4] The marble and the Hall examples have slightly different measurements, and the architectural conception of the composition is far superior in the latter. Indeed, the style of the painted frame, clearly conceived integrally with the relief, suggests a date earlier than Donatello's work in Padua at mid-century.

Andrew Butterfield convincingly argues that the present work is the earliest and best of the three versions, noting numerous parallels with Donatello's most famous reliefs.[5] Donatello was the most accomplished artist in the medium of *schiacciatto* sculpture, or very low relief. In the present work, the subtly receding planes create the illusion of majestic depth in space. Indeed, the vaulted arches behind the *Madonna and Child* recall nothing so much as the elaborate loggia of the bronze *Feast of Herod* (Museo dell'opera del duomo, Siena), the sculptor's *tour de force* of perspective in low relief. The subtly modeled *Madonna and Child* do not portray any idiosyncratic facial features, yet the overall composition establishes the grandeur of their presence. The enthroned Mary remains symbolically the Mother of God protecting the infant Jesus. **MH**

Bibliography: W. Hildburgh, "A Marble Relief Attributable to Donatello, and Some Associated Stuccos," *Art Bulletin* 30 (1946): 11–19; H. W. Janson, "The Hildburgh Relief: Original or Copy?" *Art Bulletin* 30 (1946): 143–145; C. Avery, "Donatello's Madonnas Reconsidered," *Apollo* 124/295 (1986): 174–182; A. Rosenauer, *Donatello* (Milan, 1993), 314; J. Pope-Hennessy, *Donatello: Sculptor* (New York, 1993); Andrew Butterfield, *Masterpieces of Renaissance Sculpture*, exh. cat., Salander-O'Reilly Galleries (New York, 2001), no. 1.

1 Charles Avery, *Donatello: An Introduction* (New York, 1994), 43–44, fig. 35.

2 Lawrence Kanter has attributed the elaborate gilded frame with painted seraphim to the Pseudo-Ambrogio di Baldese, a Florentine painter collaborating with Donatello in the final presentation. Both Kanter and Butterfield agree that the collaboration must date before Donatello's departure to Padua c. 1443. For Kanter's attribution, see Andrew Butterfield, *Masterpieces*, no.1, notes 3–4; idem., *Early Renaissance Reliefs*, no. 1, note 1.

3 Wilhelm Bode, *Florentiner Bildhauer der Renaissance* (Berlin, 1902); Frida Schottmüller, *Donatello* (Munich, 1904), 20.

4 H. W. Janson (see bibliography), and *Donatello* (Princeton, 1957), 242; John Pope-Hennessy, *Catalogue of the Italian Sculpture in the Victoria and Albert Museum* (London, 1964), I: 91–95.

5 Andrew Butterfield, *Masterpieces*, no.1; idem., *Early Renaissance Reliefs*, no. 1.

3 | Madonna and Child

School of Jacopo della Quercia (c. 1374–1438)
Italian, early 15th century
Marble
24 x 6¾ x 6¾ inches (61 x 17.2 x 17.2 cm) (including integral base)

The small size of this statuette indicates that it was probably part of a house-altar in a matrimonial bedroom, a common furnishing in the late Middle Ages and the Renaissance. Generically its style is that of Jacopo della Quercia, the famous Sienese sculptor of the early Renaissance. Schottmüller attributed it with a question mark to an associate of his on the Baptistry Font in Siena Cathedral, Giovanni di Turini (c. 1385–1455).[1] It was more likely carved by an assistant of

della Quercia, such as the one who executed the statuettes depicting Saints John, Paul, and Peter for the small niches on the main portal of San Fortunato, Todi.[2] Jacopo della Quercia was asked to advise on this project in 1418, and Beck relates their style to that of one of the sculptor's principal documented commissions, the altarpiece of the Trenta family in San Frediano, Lucca (1411–22).

Traces of color, visible in the interstices, indicate that the sculpture was once polychromed. The Child's head has been broken at the neck and re-fastened. A small section of the drapery hanging at the bottom of the bundle held in the Madonna's right hand has been recently repaired with a composition of powdered marble.

Within the extensive *oeuvre* of Jacopo della Quercia there are many analogies for the rotund facial types and the densely folded and sinuous drapery of this *Madonna and Child*. Closest are the figure of Mary handing the baby Jesus to the High Priest in the *Presentation in the Temple*, a relief found on the lintel above the main portal of San Petronio, Bologna and the enthroned *Madonna and Child* in the center of an altar triptych in the Museo Civico, Bologna (c. 1427–28).[3] In any case this serene small sculpture is a great rarity, and its re-emergence from obscurity is of significant benefit to the study of early *quattrocento* sculpture. **CA**

1 F. Schottmüller, *Bildwerke des Kaiser-Friedrich-Museums: Die Italienischen und Spanischen Bildwerke, I: Die Bildwerke in Stein, etc.*, Berlin/Leipzig, 1913, 99, no. 245 (not in 2nd edition, 1933); E. Richter, "Turino di Sano," in J.Turner, ed., *The Dictionary of Art* (London, 1996–8), vol. 31, 450.

2 J. Beck, *Jacopo della Quercia* (New York, 1991), 189, figs. 151–2.

3 Ibid., figs. 94 and 131.

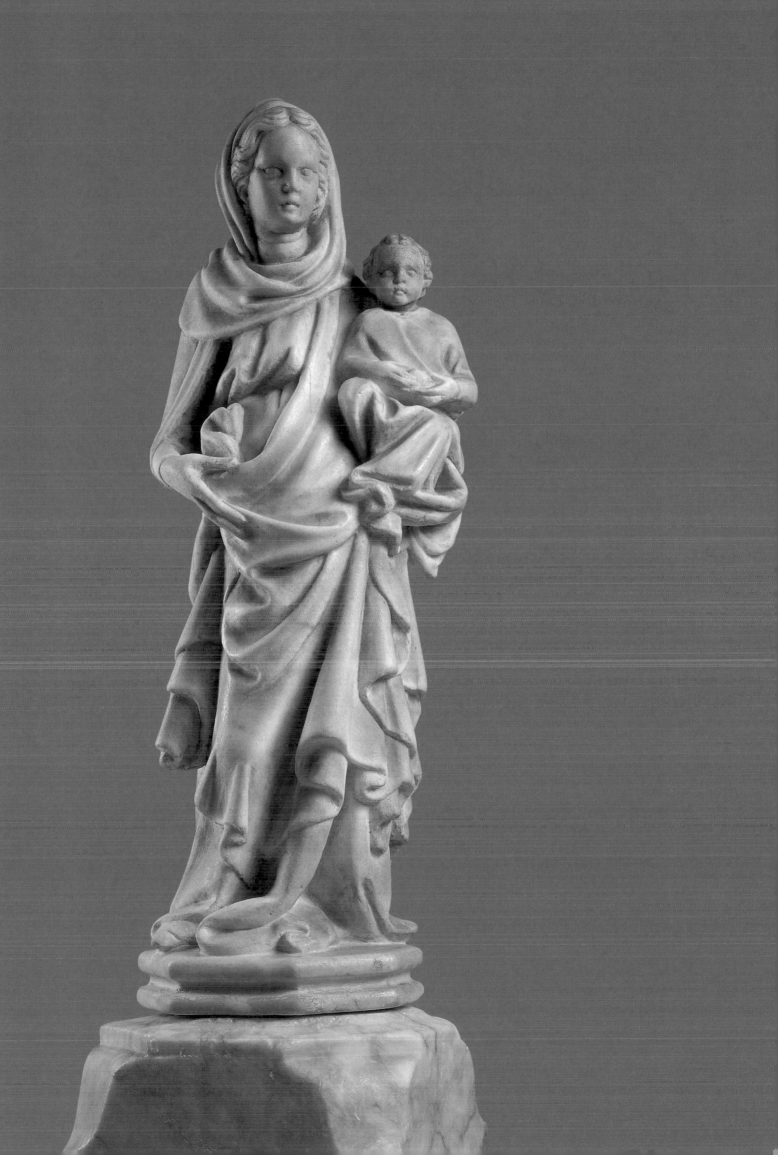

4 | Madonna and Child Enthroned with Saints

Follower of Donatello (1386–1466)

Paduan, 1450–1475

Bronze plaquette

4¾ x 3⅜ x ⅝ inch (12.2 x 8.8 x 0.3 cm)

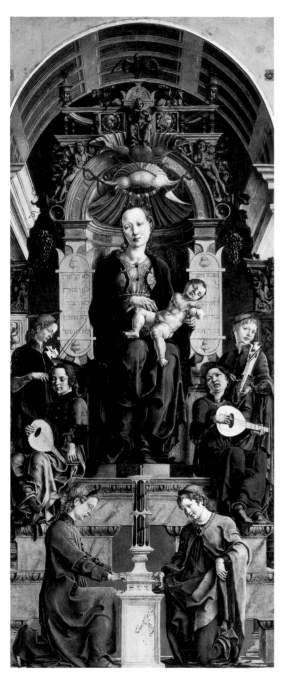

figure 1

Cosmè Tura

***Virgin and Child Enthroned* (Roverella Altarpiece)**
Mid-1740s

Oil and egg tempera on poplar

National Gallery, London, Great Britain

The authorship and place of origin of this popular Donatellesque plaquette are unknown. Until the 1920s it was, sensibly, regarded as "Paduan c. 1500–25." Since then Middeldorf suggested that it was Sienese, though Pope-Hennessy, dismissing this as "tenuous," equally tenuously proposed a connection with the art of Cosmè Tura (before 1431–1495) in Ferrara.[1] Pope-Hennessy cited similarities with Tura's *Roverella Madonna* in the National Gallery, London (fig. 1). It is true that Donatello had connections with both Siena and Ferrara, but neither is known as a center for the production of plaquettes, while Padua is. It seems sensible to revert with Jestaz to this great center of bronze sculpture as a putative place of manufacture.[2] Donatello's assistant, Giovanni da Pisa (active c. 1444–60) may actually have been responsible for its design.

A woodcut diagram of a closely similar composition is featured in a French treatise on perspective, *De artificiali perspectiva*, published by Jean Pélerin (called Viator) in 1505 in Toul (fig. 2).[3] The woodcut image appears within an outer, architectural frame, complete with a ground plan of the complex spatial arrangement. Both designs might descend from an as yet unidentified, or lost source, perhaps a painted altarpiece. Yet, given that Pélerin's diagram is simplified and lacks all the incidental figures of playful *putti*, it seems likely that it is later than the plaquette and may be derived directly from an example circulating in France. The date of publication of his book would then furnish a *terminus ante quem* of 1505 for the plaquette.

Some examples mounted for use as a pax are known without the frame molding and

1 J. Pope-Hennessy, *Renaissance Bronzes from the Samuel Kress Collection* (London, 1965), no. 303, fig. 29.

2 B. Jestaz, "Le placchette e i piccoli bronzi," *Catalogo del Museo Civico di Belluno: Le sculture* (Belluno, 1997), 85–86, no. 70.

3 M. Collareta, "Testimonianze letterarie su Donatello, 1450–1500," *Omaggio a Donatello*, exh. cat., Museo Nazionale del Bargello (Florence, 1985), 15, 17, pl. VI.

figure 1

Sketch by Thomas Moran, 2002

After: Pélerin, *De artificiali perspectiva,* Toul 1505

In: M. Collareta, "Testimonianze letterarie su Donatello, 1450–1500," *Omaggio a Donatello*, exh. cat., Museo Nazionale del Bargello (Florence, 1985), pl. VI

anthemion finial above. Three *niello* plaques decorate the frame of one in the Victoria and Albert Museum, London (Dept. of Metalwork, 4408– 1857); while another in silver and believed to date from the first half of the sixteenth century has a donor portrait inserted lower right (private collection).[4] CA

Bibliography: V. Krahn and J. Lessman, *Italienische Renaissancekunst im Kaiser-Wilhelm-Museum Krefeld* (Krefeld, 1987), 75–76, no. 22; M. Collareta, "Placchette," *Arti del Medio Evo e del Rinascimento: Omaggio ai Carrand*, exh. cat., Museo Nazionale del Bargello (Florence, 1989), 397–400, no. 182.

4 G. Toderi and F. Vannel Toderi, *Placchette, secoli XV–XVIII*, exh. cat., Museo Nazionale del Bargello (Florence, 1996), 132, nos. 238–39.

5 | Madonna and Child

Desiderio da Settignano (c. 1429/32–1464)
Florentine, mid-15th century
White marble relief
12 ⅞ x 9 x 1 inch (32.7 x 22.8 x 2.5 cm)

1 Whether or not Desiderio was technically an apprentice in Donatello's studio, Vasari notes that Desiderio "imitated the style of Donato" and furnished the marble base for the master's bronze *David*, now in the Bargello. See G. Vasari, *The Lives of the Painters, Sculptors & Architects*, trans. Gaston du C. de Vere (New York, 1996), vol. I, 473.

2 Such as the *Ascension with Christ Giving the Keys to Saint Peter*, and a *Madonna and Child*, both in the Victoria and Albert Museum; see John Pope-Hennessy, *Catalogue of Italian Sculpture in the Victoria and Albert Museum* (London, 1964), nos. 61, 70.

3 Pope-Hennessy, op. cit., cat. no. 114; for other variants, see Ida Cardellini, *Desiderio da Settignano* (Milan, 1962), 246–7, figs. 298–303. The Dudley version has also been attributed to Donatello by Francesco Caglioti, in P. Barocchi, ed., *Il Giardino di San Marco: Maestri e compagni del Giovane Michelangelo*, exh. cat., Casa Buonarotti (Florence, 1992), 72–78, no. 14.

Unusual in shape and outline, the elliptical form of this relief is almost unknown in *quattrocento* Italian sculpture. It was, however, a convenient and common shape for Greek and Roman carved gemstone cameos. This particular shape, less rounded on either side, but identical in size and curvature at top and bottom, also appears in Donatello's *Madonna and Child* (see cat. no. 2). This format clearly originated from the studio of Donatello, where Desiderio da Settignano likely received his early training.[1] The younger sculptor's *schiacciato*, or extremely shallow relief style, also derived from works attributed to Donatello.[2]

The present example relates compositionally to the *Dudley Madonna* in the Victoria and Albert Museum, London, a rectangular relief also attributed to Desiderio (fig. 1).[3] Nonetheless, the quality of the Hall relief, its finesse of conception, and its subtle details of execution are superior to the *Dudley Madonna* and its variants. The Hall collection also contains a bronze relief plaque in this rectangular format, cast after the Victoria and Albert example (fig. 2). We know that Michelangelo possessed a version of this composition, perhaps in stucco, which he kept in his studio. His *Madonna of the Steps* (Casa Buonarotti, Florence), carved in higher relief, takes Desiderio's invention as a point of departure.

The reverse is meticulously scored, as was typical of *quattrocento* reliefs intended to be attached with a plaster adhesive to the wall (fig. 3). An elaborate eighteenth-century gilt bronze frame was fashioned to rest on the deepest background level of the relief. This, unfortunately, necessitated that the quarter-inch recess be

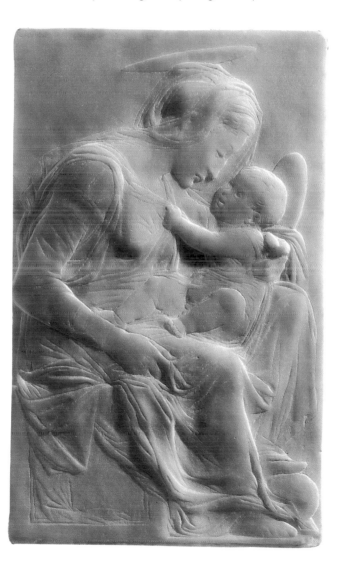

figure 1
Desiderio da Settignano
***Virgin and Child*, c. 1460**
Marble relief
Victoria and Albert Museum, London, Great Britain

chiseled away at the lower edge. This alteration also required the truncation of the wreath below the groundline of the composition.[4]

Desiderio communicates tenderness through subtle but precise detailing. The planarity of the relief does not interfere with the physical structure beneath the drapery. Both mother and child have relief halos carved in an innovative foreshortening, probably invented by Desiderio. The embroidery at the biceps, cuff, and sleeve of the right arm is delicately incised, a detail absent in the Dudley relief. The sculptor precisely articulates the infant's facial features, as well as his fingernails and toenails. Desiderio conveys maternal intimacy in the way the Virgin gazes lovingly at the Christ child, the gentle caress of her hands on his body, and the infant's playful tug on the crease of the Virgin's bodice. Her foot rests on a real cushion rather than the balloon form in the Dudley version. MH

4 The elliptical shape of the present relief gives the figure of the Madonna more freedom of space – floating within the format in contrast to the Dudley version where the rectangular format cramps the figural composition.

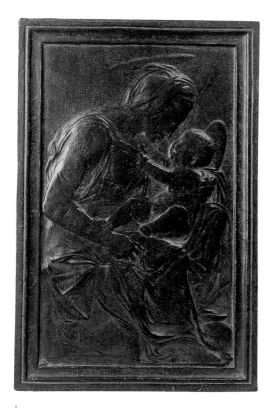

figure 2
After Desiderio da Settignano
Madonna and Child, **late 16th century**
Bronze plaque
Michael Hall Collection

figure 3
Reverse of relief with 18th-century frame

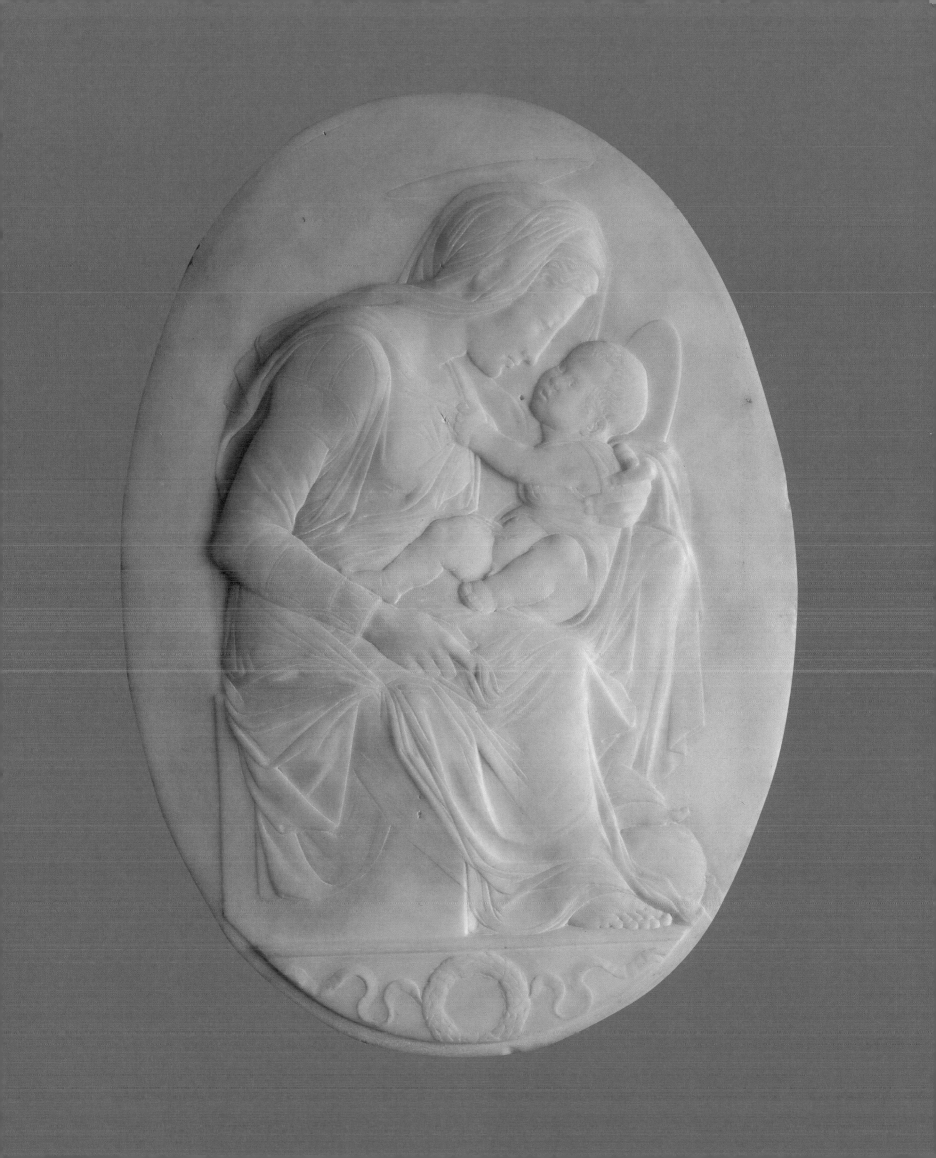

6 | Madonna and Child

After Desiderio da Settignano (c.1430–1464)
Florentine, late 15th/early 16th century
Marble relief
17⅜ x 13¾ x 3 inches (44 x 35 x 7.6 cm)

This relief is a simplified and schematic copy of Desiderio da Settignano's *Foulc Madonna* in Philadelphia, described by John Pope-Hennessy as "Desiderio's finest and most inventive Madonna relief."[1] That panel, like all Madonnas attributed to Desiderio, is not documented, and its provenance goes back only to 1877, when it was recorded at Santa Maria Nuova, Florence. Two casts in painted stucco indicate the popularity of the composition and prove beyond reasonable doubt that it dates from the middle third of the fifteenth century. The marble relief itself has recently been rejected as a *quattrocento* original and considered instead a nineteenth-century copy.[2]

Gabrielli recently rejected another marble relief in Turin known as the *Sabauda Madonna*.[3] These two scholars are rashly flying in the face of the assembled expertise of all the great connoisseurs of Italian sculpture, including Wilhelm von Bode, John Pope-Hennessy, and, more recently, Shelley Zuraw.[4] The edifice of scholarship therefore remains untouched by an "informed rule of thumb" held unilaterally by Strom: "It seems certain that when two or more gesso or terra cotta versions of a motif have survived, an original marble made is not to be sought, for it never existed."[5]

The late David Du Bon wrote eloquently of the *Foulc Madonna* in 1973:

This carving of the Virgin and Child is said to be from the Hospital of Santa Maria Nuova in Florence, where it may have adorned a small chapel. Desiderio da Settignano was known for his reliefs and busts of smiling young women and children, and his tender, lyrical approach can best be seen in a group of his Madonna reliefs. The Virgin is interpreted here in the humanizing Renaissance spirit as a smiling young mother playing with her child, and only the halos identify them as holy figures. Their youth and freshness are enhanced by the smooth finish of the delicately shaded marble. Even in his lifetime Desiderio was famous for his beautifully subtle technique of low relief. An extraordinary effect of distance is achieved by the many, minutely varied levels of carving. The angels in the background have the delicacy of a drawing, while the hands and faces of the foreground figures stand out more boldly in comparatively high relief – and all achieved in less than one inch of actual depth.

More recently, Victor Coonin has stated sensibly, "Doubts raised by D. Strom about the authenticity of the Foulc relief are unfounded. The relief was purchased by Edmond Foulc directly from the hospital of Santa Maria Nuova.[6] The authenticity of the relief has been otherwise generally accepted."[7]

The present marble version conforms with the *Foulc Madonna,* save for the closed lips, while the flanking cherubim in the sky behind are omitted, just as they are in the painted stucco casts in Berlin and Florence. The Virgin's hair is also treated as a series of corkscrew curls hanging down her cheek, rather than being swept back beneath her veil. These features may eventually provide a clue as to the identity of its carver, who may have worked for one of the Ferrucci dynasty of sculptors well after Desiderio's premature death. **CA**

1 J. Pope-Hennessy, *Italian Renaissance Sculpture* (1958), 302–5, pls. 61–68. Painted stucco reliefs of the composition exist in Berlin, Staatliche Museen (inv. no. 2015) and Florence, Bardini Museum (inv. no. 1196).
2 D. Strom, "Desiderio and the Madonna Relief in Quattrocento Florence," *Pantheon* XL (1982): 130–35.
3 N. Gabrielli, *La galleria sabauda, maestri italiani* (Turin, 1961), 131.
4 S. Zuraw, "Desiderio da Settignano," J. Turner (ed.) *The Dictionary of Art* (London, 1996–8), vol. 8, 797–800.
5 Strom, op. cit., 152.
6 Gaston Migeon, "La Collection de M. Edmond Foulc," Les Arts, 1902, 2–9.
7 A.V. Coonin, *The Sculpture of Desiderio da Settignano* (Ph. Dissertation), Rutgers, The State University of New Jersey, New Brunswick, N.J., 1995. University Microfilms (Ann Arbor, MI.), 1996, 194–95.

Bibliography: I. Cardellini, *Desiderio da Settignano* (Milan, 1962), 242–3, 289, figs. 292-4, 376; D. Du Bon, *Treasures of the Philadelphia Museum of Art* (Philadelphia, 1973), 37; E. Neri Lusanna and L. Faedo, *Il Museo Bardini a Firenze: Volume Secondo: Le Sculture* (Milan, 1986), 259, pl. 230.

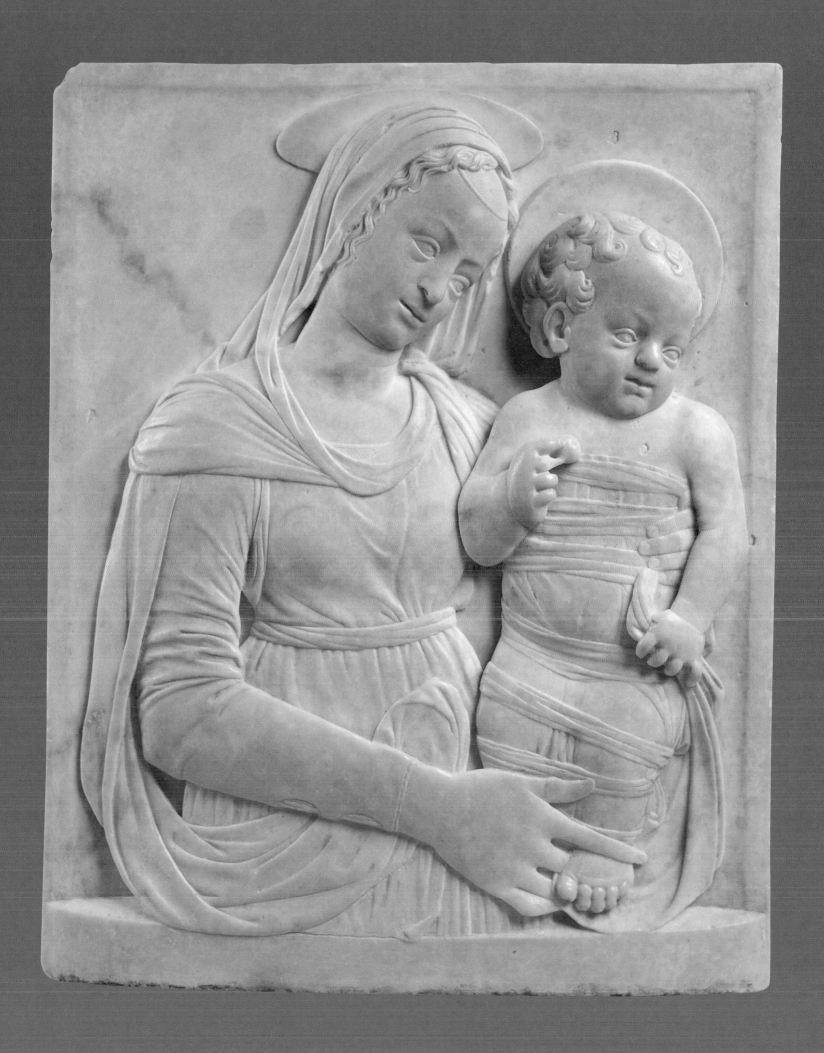

7 | Madonna and Child with Cherubim

Circle of Agostino di Antonio di Duccio (1418–after 1481)
Italian, late 15th century
Stucco relief, polychromed
40 ¼ x 39 x 4 ¾ inches (102.2 x 99 x 12 cm)
Inscribed on a banderole, center above the parapet: AV[E] M[ARI]A GR[AT]IA PL[ENA] ("Hail Mary Full of Grace")

Her face framed by animated corkscrew curls, the Virgin gazes out of the confines of the frame while she restrains the Christ Child in her graceful arms. Color enlivens the polychromed stucco relief. The Virgin wears a white veil over a blue mantle and crimson habit, which stand out from the saffron yellow mandorla. Since both Virgin and Child are dressed in crimson, color also shows metaphorically their bond. Four spirited angels with long-flowing hair tuck into the interstices around the Virgin and hold back the curtain that creates and reveals a mandorla around the exalted pair. One angel holds a tall trumpet-shaped vase of lilies; another rests its hands on a heraldic shield.

Judging from the direction of the gaze of both the Virgin and the Christ Child, the relief was conceived to be positioned high up. The coat of arms (the dexter shield erased, the sinister *azure* with a bend dexter *gules*) has yet to be identified, but does not appear to correspond with any notable Florentine family.

Another contemporary stucco cast of this model is in the Bargello Museum, Florence.[1] Both were presumably executed after a clay master model produced in Agostino di Duccio's shop.

However, this type is stylistically unlike Agostino di Duccio's documented work in the Tempio Malatestiano in Rimini (completed in 1457),[2] or his great cycle of polychromed relief decorations on the façade of the Oratorio di San Bernardino in Perugia (completed in 1462).[3] In fact, this relief has no parallels in the marble sculptures of Duccio's Florentine contemporaries such as Desiderio da Settignano (1429/32–1464), or even the della Robbias (see cat. no. 30). Rather, it finds its nearest point of comparison with paintings. The assembly of angels with their long faces, prominent chins and hair modeled as if tossed and tousled by a celestial zephyr, are indeed remarkably similar to paintings made in the late 1470s or early 80s by Sandro Botticelli (1444/45–1510), which in turn derive from maenads on antique sarcophagi. TC

1 C. Gamba, "Due Opere d'Arte nella regia villa di Castello," *Rassegna d'Arte* VI (1903).
2 C. Brandi, *Il Tempio Malatestiano* (Turin, 1956), 29–47.
3 A. Zanobi, *Oratorio di San Bernardino*, Bologna, 1963). For general works on Duccio, see A. Pointer, *Die Werke des Florentinischen Bildhauers Agostino d'Antonio di Duccio* (Strasbourg, 1909); M. Bacci, *Agostino di Duccio*, (*I Maestri della Scultura*), (Milan, 1966).

Paduan, late 15th century
Terra cotta
27 x 19½ x 8½ inches (68.6 x 49.5 x 21.6 cm)

This charming relief depicting the *Madonna and Child* descends ultimately from similar works by Donatello and his circle.[1] In manufacture and modeling it recalls a mid-century relief of the same subject ascribed by Pope-Hennessy to a Paduan follower of the Florentine master. However, the present piece departs from the intensity of that early relief and approaches the gentle wistfulness of later works by Donatello's Florentine followers. Rather than clutching the child and staring at him in a profile *tête-à-tête*, here the Virgin enthrones her son and joins him in facing towards our right. In the gentle incline of her smiling face and in the tenderness with which she holds him, she radiates maternal love. Yet her drooping brow and downcast eyes suggest a foreknowledge of his impending sacrifice. She seems to gaze directly at the goldfinch, a bird whose diet of thistles and other spiny weeds symbolizes Christ's crown of thorns. The Virgin's sad but expressive eyes contrast with the child's alert, wide-open gaze.

figure 1
Desiderio da Settignano
Marsuppini Monument, **detail of the Virgin and Child, 1453-64**
Santa Croce, Florence, Italy

The Child prefigures his role as Redeemer not only by clutching the bird and making a blessing gesture with his now broken right hand, but also through his preternatural maturity. Although his chubby limbs and cheeks are those of a toddler, his thin waist and thick hair belong to the refined physiognomy of an older child. His long, thin nose, highly articulated mouth, and crisply outlined eyes, all framed in his wide face, recall Desiderio da Settignano's standing Christ Child above the tomb of Carlo Marsuppini (fig. 1). The style of the Virgin's dress, the pose of her arms, and details of her physiognomy – such as her thin nose, prominent dimpled chin, and subtle smile – recall those of Desiderio's Madonnas. But the naturalism of her squatter proportions, the ease with which she rests her right elbow on the arm of the throne, and the tousled locks of the child bespeak a somewhat later naturalism. The delicate, incisive *sgraffito* work along the border of her veil resembles ornate embroidery and even imitates needlework. The Virgin's extremely high forhead, reminiscent of the plucked foreheads fashionable in Italy around 1490–1500, could indicate the approximate date of the relief. **KF & MH**

Bibliography: John Pope-Hennessy, *Catalogue of Italian sculpture in the Victoria and Albert Museum* (London, 1964), no. 361, pl. 353.

1 The relief is said to have hung over the bedroom door of the cottage belonging to the Hearst castle San Simeon. Quickly modeled in terra cotta, this figure may have served as *bozzetto* or *modello* for a marble relief. The Hearst Inventories mention that it was severely damaged in a fall sometime in the 1940s. The broken relief has been carefully reassembled with little or no inpainting, and there are few surface losses. A hint of color on the lips and eyes of both figures suggests that the sculpture was originally polychromed.

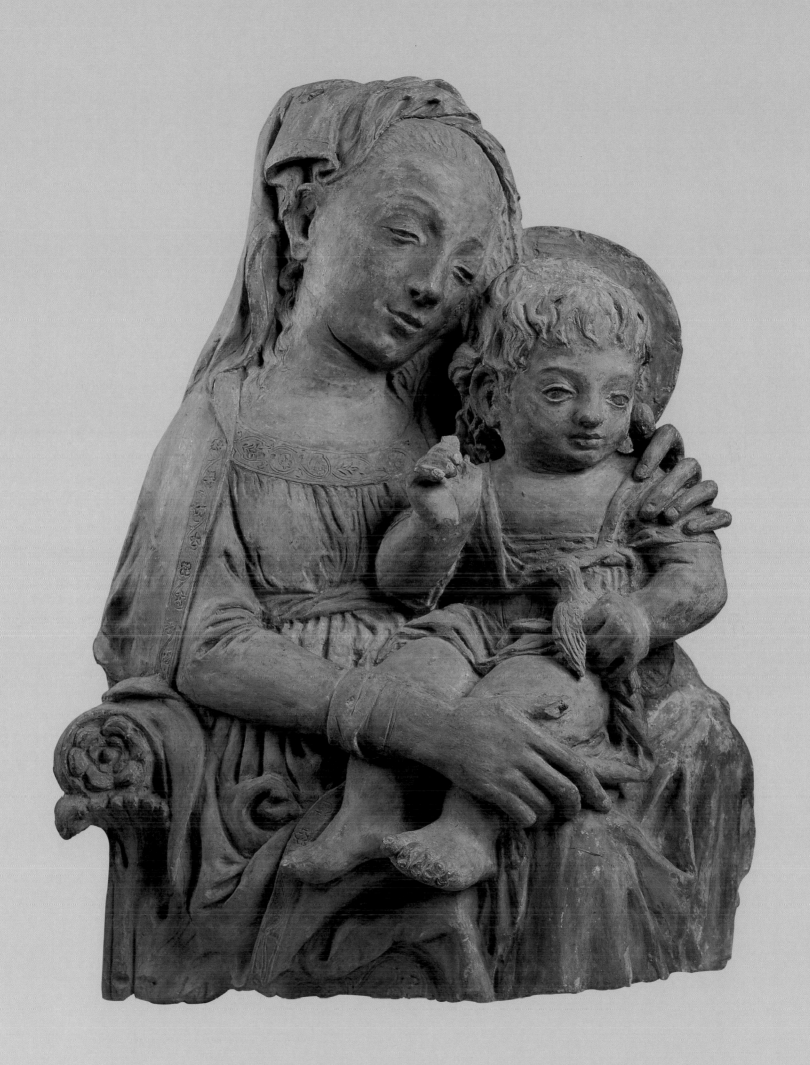

9 | Madonna and Child

Follower of the Master of the Marble Madonnas
Italian, late 15th century
Marble relief
20⅞ x 16⅝ x 4 inches (52.5 x 42 x 10 cm)

The *Madonna and Child*, carved in low relief, appear inside a molded cove frame. The drapery around the Madonna's hips, presumably meant to be spread out over her throne, falls outwards over the frame and rests on the lower plinth, which is carved integrally with the relief. At the bottom of the marble is a horse-head shield bearing the coat-of-arms of the Gaffarelli family of Padua. Except for chips at the edge, this relief is in excellent condition.

The heavily lidded eyes and almost Asian quality of the epicanthic folds of the eyelids, the exceptionally heavy under-lids, and the overly linear stylization of drapery folds, are hallmarks of the Master of the Marble Madonnas. Wilhelm von Bode coined the name the Master of the Marble Madonnas in 1886 to describe a prolific but anonymous sculptor (or workshop) active towards the end of the fifteenth century in Tuscany.[1] The compositions of the *Virgin and Child* with accompanying cherubim present a number of variations on themes established in the middle of the century by the partnership of Antonio Rossellino (1427/28–1479) and Desiderio da Settignano (1429/32–1464), while the simplification of forms and crisp linearity of handling reflect the style of Mino da Fiesole (1429–1484).

The identity of the sculptor still defies scholars, for earlier attempts to attribute the whole group to Tommaso Fiamberti (d. 1524/25) and/or Giovanni Ricci (c. 1440–1523), sculptors active in and around Ravenna, are no longer credited.[2] More than one hand and style are discernible within the broad, generic grouping, as many more examples and subjects are known today than in the middle of the twentieth century, when the last publications were issued. Some may be by imitators of the anonymous Tuscan master.

Two examples of marble carvings which represent the *Madonna and Child* by this master are in the Victoria and Albert Museum, London.[3] The sweet, slightly pursed, undulating smile follows the same format in each of the three *Madonnas*. Their hands (the design of which derives ultimately from Donatello) touch the infant's feet in each case, with the long tapering fingers placed flatly against the drapery. This latter, formed by broken straight lines, and in low relief, flows over the architectural frame, and is similar in each of the three works.

The present composition, with the Virgin's left hand – rather than her right – reaching across under the Child's toes, and with the Child held to the viewer's left, is closer to a panel in the Musée Jacquemart-André, Paris.[4] This is regarded as Florentine, around 1480 to 1490, perhaps a decade later than one might expect. Another example of the same general composition is in the State Hermitage Museum, St. Petersburg.[5] **CA**

Bibliography: C. Avery in Christie's sale catalogue, London, 20 April 1988, lot 58; Christie's, *Review of the Season* (London, 1988), 350.

1 W. von Bode, in *Jahrbuch der Preussischen Kunstsammlungen* VII (Berlin, 1886): 29–32.

2 A. Bellandi, "Master of the Marble Madonnas," A. Butterfield and A. Radcliffe (eds.), *Masterpieces of Renaissance Art: Eight Rediscoveries,* Salander-O'Reilly Galleries (New York, 2001), 34–40.

3 J. Pope-Hennessy, *Catalogue of Italian Sculpture in the Victoria and Albert Museum* (London, 1964), 151–3.

4 F. de la Moureyre-Gavoty, *Institut de France, Paris, Musée Jacquemart-André: Sculpture Italienne* (Paris, 1975), no. 58.

5 S. Androsov, N. Kosareva, M. Liebmann, C. Mezentseva, *Western European Sculpture from Soviet Museums, 15th and 16th centuries* (Leningrad, 1988), 28–29, no. 7.

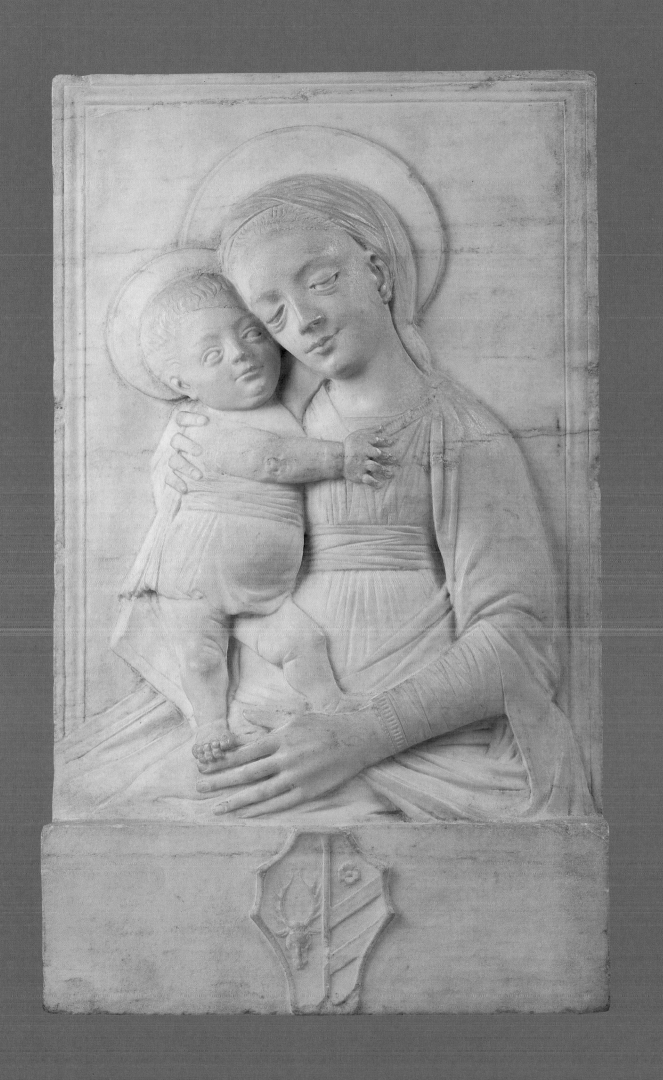

10 | Madonna and Child

Italian, late 15th/early 16th century
Marble
24 x 16½ x 6 inches (61 x 42 x 15.3 cm)

The systematic – almost mechanical – construction of the pearl border frame, which reveals disciplined carving, contrasts starkly with Christ's unruly akimbo posture, with his body and head extending beyond the periphery of the frame. The features of both figures suggest real-life models possibly from the sculptor's family circle.

This sense of realism continues in the subtle and well-organized folds of the Virgin's tunic, the complicated but delicately defined creases along the right arm, and the bodice above the belt which define and reveal the anatomy of the breasts. The Virgin's flattened right hand recalls reliefs by Donatello (1386–1466) and Desiderio da Settignano (1429/32–1464). The artist seems here to have carefully observed the physiognomy of the baby's face, with a rather large left ear, and his slightly wizened body with skin folds at his abdomen, elbows, wrists, and thighs. Although the flattened sole of his right foot represents a logical form revealing the underside of his toes, his left foot is less well rendered anatomically. The exaggerated scrotal sac and diminutive penis prominently displayed underscore Christ's humanity.[1] Furthermore, the faces are not idealized, but show an almost homely aspect of humanity.

The piece's understated beauty indicates that it is not the work of a nineteenth-century copyist such as Giovanni Bastianini (1830–1868), Odoardo Fantacchiotti (1811–1877), or even the later Alceo Doccena.[2] These artists without exception produced works of sentimental sweetness in Florence which were often accepted as original sculptures of the Renaissance.

The marble of this *Madonna and Child* is probably Carrara with grey veins throughout. Imperfections such as iron deposits, which, after being exposed to air, have patinated differently than the rest of the marble. The overall design and execution of this unusual relief point to a provincial artist, removed from sophisticated centers such as Florence, the Veneto, or Rome. Perhaps it is the work of an artist from Southern Italy or even Dalmatia, where artists such as Francesco Laurana (d. 1502), sculptor and medallist born in Croatia, and Giovanni Dalmatia (c. 1440–after 1509) created idiosyncratic works decidedly different from those of mainland Italy. **MH**

Bibliography: John Pope-Hennessy, *The Study and Criticism of Italian Sculpture* (New York, 1980), 135–154.

1 See Leo Steinberg, *The Sexuality of Christ in Renaissance Art and in Modern Oblivion*, 2nd ed. (Chicago, 1996).

2 See Giancarlo Gentilini, "Giovanni Bastianini e i falsi da museo," *Gazetta Antiqua* 2 (1988): 35–47; 3 (1988): 27–43; and *Fake? The Art of Deception*, exh. cat., British Museum, ed. M. Jones (London, 1990).

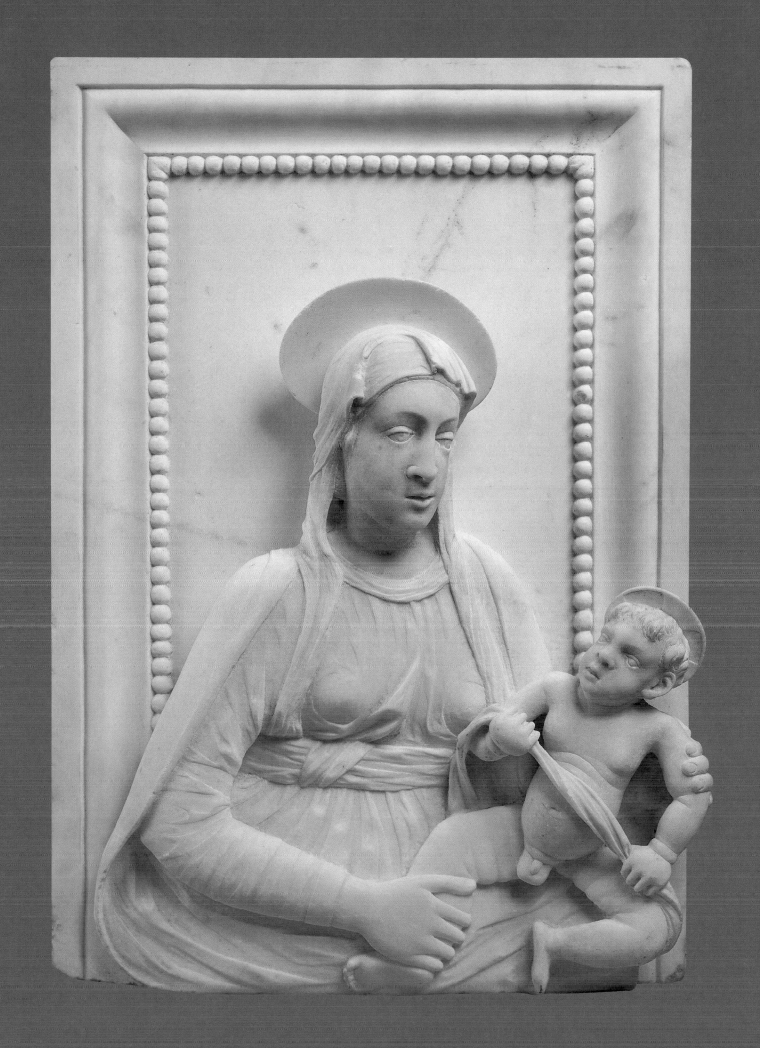

11 | Madonna and Christ Crowned and Enthroned

German, early 16th century
Gilt copper *repoussé*
7 x 6 x ⅜ inch (17.3 x 14.5 x 0.9 cm)

This gilt copper *repoussé* depicting the *Madonna and Christ Crowned and Enthroned* was produced in early sixteenth-century Germany but harks back to much earlier prototypes. The *Coronation of the Virgin* had been a major theme in European art since at least the first half of the sixth century when *Maria Regina* was painted on a wall of Santa Maria Antiqua, the oldest Christian building in the Roman Forum. Such depictions represented a substantial advance in Mary's reputation and echoed the growth of her cult, for they promoted her from a mere flesh-and-blood vehicle of Christ's Incarnation to the Queen of Heaven. Later works, such as the mosaic of 1140 in the apse of Santa Maria in Trastevere, Rome, present the Virgin crowned and seated next to Christ, similar to the scene in the present work, thus suggesting that she had greater parity with him.

That is not to say that Mary was Christ's equal, but, rather, that she could function effectively as an intercessor. In the present work, the humility of the Virgin's submissive bow and her gesture of prayer towards him represent not only sixteenth-century ideals of female behavior, but also suggest her willingness and suitability to seek our salvation from her son. He wields the ultimate power of decision, as indicated by the *orbis mundi* (orb of the world) in his left hand, the gesture of acknowledgment he makes with his right hand, and his Trinitarian halo. But, in accordance with the thriving cult of the Virgin in the early sixteenth century, the original audience of this work probably would have viewed her as a conduit to Christ.

When the image was hung from the small hole at the top, viewers undoubtedly appreciated its outstanding workmanship and exceptionally bold composition. From the rippling lines of the foreground to the bulging cheeks of the Virgin, the relief displays a remarkable range of depth, and many of its passages have been carefully and selectively finished to enhance the illusion that the figures have volume and occupy a somewhat realistic space. At the same time, however, the texturing of the surfaces, as in the background stippling and the convolution of the folds in the drapery, activate that space. KF

12 | Madonna and Child with Angels

Circle of Hans Schwarz (1492–1532?)
German, 16th century
Brass plaquette
5⅛ x 3⅞ x ¼ inch (13 x 19.6 x 0.6 cm)

This plaquette is from the circle of Hans Schwarz, a sculptor who worked in wood carving and metal casting in the early decades of the sixteenth century.[1] During his somewhat peripatetic career, Schwarz worked in Nuremberg in 1519, was expelled to the German frontier in 1520, returned to Nuremberg in 1523, visited Poland and Denmark in 1527, appeared in Paris in 1532, and probably died in the Netherlands. Despite all these travels, Schwarz is most closely associated with work from his hometown, the affluent city of Augsburg. There, he and his colleagues began casting portrait medals and established themselves as "the earliest and most characteristic practitioners of miniature works (*Kleinkunst*) at the start of the German Renaissance."[2]

Their precocious mastery of Italian sources is evident in the pilasters flanking the throne and framing the work as a whole; the classical motif of *putti* with garlands; the relatively realistic proportions of those frolicking figures; and the fairly convincing, albeit extraordinarily heavy, drapery of the Virgin. The sculptor's northern roots, however, shine through in the stylistic choice of the rubbery neck and arm of the Virgin, as well as in her physiognomy, particularly the heavy brow, the prominent second chin, the blunt nose, and the tiny mouth. She calls to mind the ideal of feminine beauty represented by Albrecht Dürer (1471–1528) or even Lucas Cranach (1472–1553), refracted through the style of Leonardo da Vinci (1452–1519) or Raphael (1483–1520).

Other bronze casts of this work survive in the Historisches Museum, Basel; Fitzwilliam Museum, Cambridge; Museo Nazionale, Florence; Bibliothèque Nationale Cabinet des Médailles, Paris; and National Gallery, Washington. A colorfully painted paste-card relief survives in Augsburg. **KF**

Bibliography: I. Weber, *Deutsche, Niederländische und Französische Renaissanceplaketten 1500–1650* (Munich, 1975), 114–15, no. 125 (with further bibliography).

[1] Wilhelm Vöge dated this plaquette around 1520 and assigned it to an Augsburg workshop in the circle of Hans Schwarz; see "Ein Steinrelief des Hans Schwarz im Germanischen Museum zu Nürnberg," *Monatshefte für Kunstwissenschaft* II (1909): 395. Pope-Hennessy would only admit that it was from Augsburg, see *Italian High Renaissance and Baroque Sculpture* (London, 1970), no. 437, fig. 453.

[2] P. Grotemeyer, "Hans Schwarz," Thieme-Becker, *Allgemeines Lexikon der bildenden Künstler von der Antike bis zur Gegenwart* (Leipzig, 1909–1966), XXX (1936), 362–363.

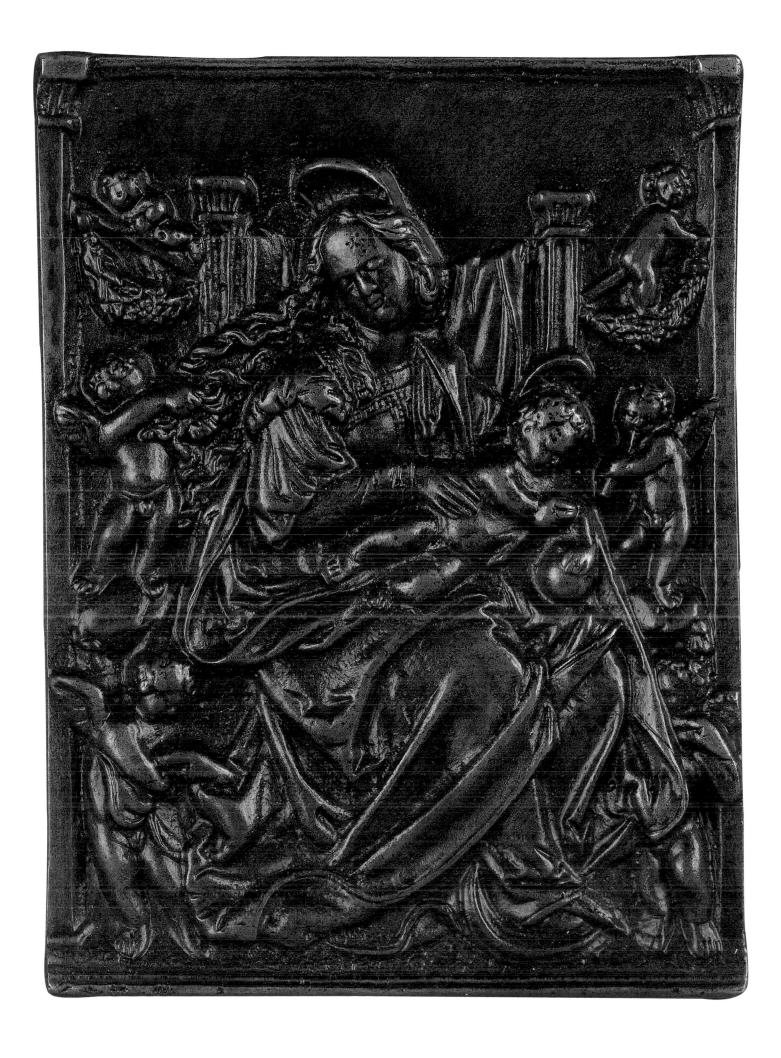

13 | Madonna and Child with Radiant Nimbus

German, 16th century
Bronze plaquette
5¼ x 4¼ x ⅜ inch (13.1 x 10.6 x 0.9 cm)

Cast in southern Germany in the early sixteenth century, this bronze relief represents the subordination of nearly contemporary Italian influences to indigenous northern traditions. Christ's musculature and relative sveltness recall Venetian depictions of the Child from at least the time of Giovanni Bellini's *Madonna and Child* of approximately 1455 (Metropolitan Museum of Art, New York). However, the friskiness and even mischeviousness of the Child, as he steps on his mother's arm and grasps her cheek, invoke a tradition of playfulness that is far more common in French and German depictions of the subject than in those from late fifteenth- or early sixteenth-century Italy. Like the squirming figure of Christ in the *Madonna of Krumau* (Kunsthistorisches Museum, Vienna) from circa 1400, the Child in this relief seems to be little different from any merely mortal child, a resemblance that both elicits empathy from the viewer and underscores Christ's mortality. We are invited to view his sacrifice as one of flesh and blood, as a truly painful and merciful redemption for our sins.

That juxtaposition with the abstraction of the Virgin's overt idealization emphasizes the immediacy of his humanity. She has the long nose, rosebud mouth, and tiny, delicate hands of the so-called "Beautiful" (*schöne*) Madonna type represented by the *Madonna of Krumau* and popular throughout France and Germany during the late Middle Ages and early Renaissance. But it is the flow of her cascading hair and of the deep folds in the drapery that distinguish her from mere mortals. As her locks spill from beneath her veil and down her shoulder, they meld with the creases in her dress to create the effect of a waterfall. We are given the impression that the Virgin is almost completely submerged in torrents of hair and drapery that subjugate her corporeality to the beauty of their pattern. The silvery patina of the work makes it difficult to discern not only the substance and volume of her body, but also the relative depth of the folds in her dress. In contrast to the far more volumetric child, she comes across as a beautiful, highly linear design, not so much the flesh-and-blood mother of Christ as an object of veneration in and of herself. **KF**

14 | Virgin Hodegetria

Italian, 16th century
Tempera on wood
9⅛ x 7 x 2¾ inches (23.2 x 17.8 x 7 cm)

This icon is one of the most commonly represented Mariological images in the Byzantine period: the *Virgin Hodegetria*, in which Mary holds her son in her left arm, inclines her head slightly and gestures toward him, while he holds a scroll (signifying the *logos*, the "Word"). This type was associated with a portrait allegedly painted by St. Luke and kept in Constantinople. According to the Letter of Theophilos, written in 836, the Virgin expressed her satisfaction with the portrait and said, "My favor will be with it." The apocryphal statement spurred the popularity of the image. Innumerable pilgrims came to Constantinople to venerate the icon, witness the weekly procession associated with it, and request favors and miracles from it. As the object of profound veneration, it was copied frequently.[1]

This icon was probably made in Italy, where Greek artists had been recruited since the end of the twelfth century to paint frescos, icons, illuminated manuscripts and to work in mosaic, until local artists adopted the *maniera greca* (the Greek manner).[2] Rectangular icons, which were produced in large numbers in Italy, may have been intended for private or side altars. The theme of the *Hodegetria* was popular because of the efficacy of the prototype, with its origins in Christ's lifetime, as well as the emotional immediacy of the Byzantine style.[3] An icon makes present the subjects represented. Here, the fully frontal gaze, space-defying background, and formulaic drapery pattern push the subject close to the surface, while more ephemeral effects emphasize the divine.

Thick straight black lines, highlighted in white, define the jagged drapery folds along the Virgin's shoulder. They give the drapery a turbulent effect that is at odds with the figures' calm, static stares and equally composed almond eyes and long straight noses. The shattered quality of the drapery suggests Mary's ambivalent mood: she is both happy to have imparted the Son of God to humanity, and at the same time she is already anticipating his painful death. She exudes slight melancholy, rather than maternal affection.

Christ's thin neck supports an oversized head, purposefully represented that large to symbolize the vast knowledge it contains. His receding hairline further symbolized his advanced years and accumulated wisdom. **KR**

1 Robin Cormack, "Miraculous Icons in Byzantium and their powers," *Arte Cristiana* 724 (1988): 55–60, esp. 58.

2 Patrizia Angioline Martinelli, *Le icone della collezione classense di Ravenna* (Bologna, 1982).

3 Hans Belting, *Likeness and Presence: A History of the Image before the Era of Art* (Chicago, 1994), 349–76.

15 | Madonna and Child with Saint John

Pierino da Vinci (1503–1574)
Italian, mid-16th century
Polychromed stucco
13½ x 9¼ x 1¼ inches (34.2 x 23.4 x 3.2 cm)

figure 1
Pierino da Vinci (1503–74)
The Holy Family
Bronze relief
Victoria and Albert Museum, London, Great Britain

This relief relates closely to a bronze version in the Victoria and Albert Museum, London (fig. 1), but eliminates the figures of the slumbering St. Joseph and an airborne angel drawing back a curtain. This basic three-figure composition differs from all other versions in a variety of media.[1] The arrangement of the Christ Child astride the Virgin's lap relates to the design of Michelangelo's *Medici Madonna*.[2] Another Michelangelesque feature of the Hall version is that the Virgin centers her balance on her right foot, much like the *Libyan Sibyl* on the Sistine Chapel vault. Other variations from the Victoria and Albert design include the position of the book and the right supporting hand above the child's head. Also, the cross that the young St. John grasps with his right hand recedes behind his left shoulder and neck, in a display of perspectival expertise. The drapery swag is supported at both corners at the top and appears to be in fuller relief than the bronze version.

The relief is made of pink tinted stucco with remnants of a plaster adhesive on the heavily combed verso surface, through which, in all likelihood, it was installed onto a wall. The polychromed surface has been cleaned and was found to be old, but rather clumsily applied with background gilding in a quatrefoil design. The drapery was also once gilded, but now rubbed through to the stucco surface. A ruffled bodice frames the Virgin's neck and a broach secures the garment to the breast. The drapery folds, the facial features, and the edge of the bodice are more logically modeled than in the London example, where the neckline anticipates Giambologna's sharp, prismatic folds. There is a strong possibility that both the angel and St. Joseph are later additions to the original, simpler, three-figure composition. MH

1 John Pope-Hennessy, *Catalogue of Italian Sculpture in the Victoria and Albert Museum* (London, 1964), cat. 473, pl. 469. Other versions in stucco, marble, and bronze are in Berlin (former Kaiser-Friedrich-Museum) and various private collections (Cigli-Campana, Loeser, Azay-le-Rideau).

2 Ludwig Goldscheider, *Michelangelo: Paintings, Sculptures, Architecture*, 4th ed. (London, 1962), 18, pl. 202 (side view).

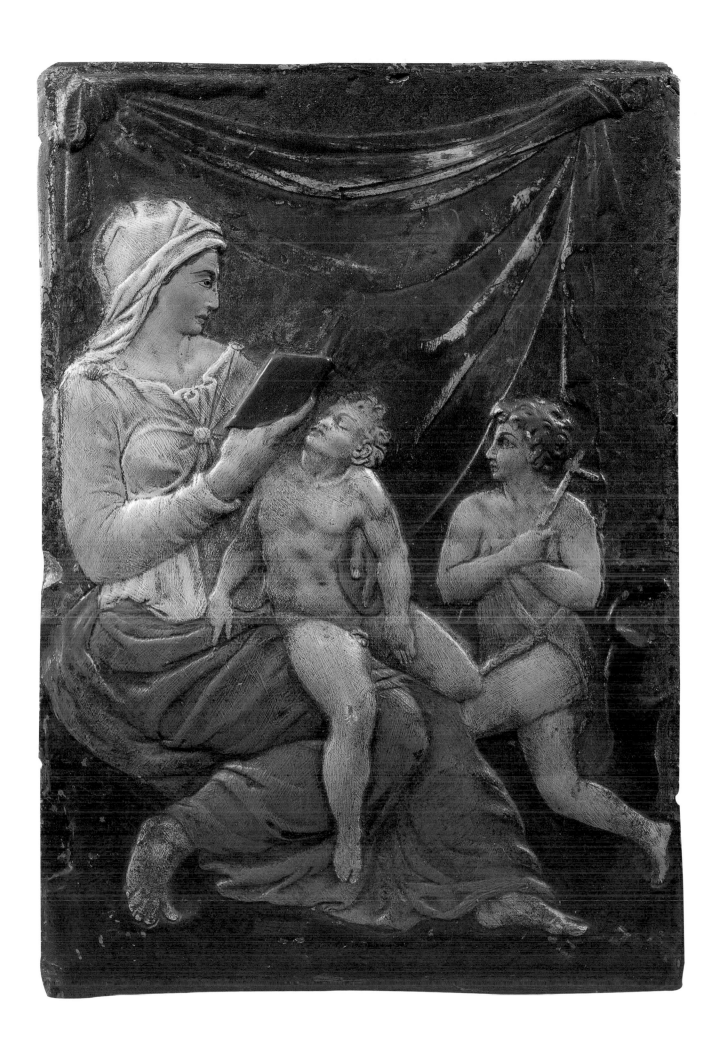

16 | Madonna and Child with Saints

Circle of Jacopo Sansovino (1486–1570)
Venetian, mid-16th century
Bronze relief
8⅛ x 6½ x 1⅜ inches (20.6 x 16.7 x 3.8 cm); integral frame 12⅝ x 10⅞ x 1¾ inches (32.1 x 27.6 x 4.5 cm)

This silhouetted bronze relief recalls the work of Jacopo Sansovino and his circle. The composition, with Christ on his mother's lap passing something to John the Evangelist as they are observed by Elizabeth and Joseph, has no exact precedents. However, the figural types occur throughout early sixteenth-century Venetian work. The Virgin's aquiline profile, wavy hair, and drapery closely recall Sansovino's figure in the Chiesetta dell'Anticollegio in the Doge's Palace. Furthermore, Christ's abundantly curly hair and pudgy muscularity appear in countless sculpted children of the time, including the child in the arms of Sansovino's Virgin. Similarly, the severely strained turn of Joseph's head appears in many other figures. Examples include a standing figure in Tiziano Minio's relief of the *Baptism of Christ* for the baptismal font of San Marco in Venice, and a figure in the *Miracle of the Child Parisio* carved by Antonio Minello and Sansovino for the Chapel of the Arca, in which the figure displays a beard nearly as curly as Joseph's in the present relief (fig. 1).

figure 1
Antonio Minello and Jacopo Sansovino
Saint Anthony revives a child, **(detail)**
1520–36, Chiesa del Santo, Padua, Italy

Although the Hall relief is somewhat abraded, many of its passages retain a fine patina that helps articulate the work's extraordinary sense of depth. In fewer than four millimeters of thickness, the sculptor has created a lap deep enough for Christ to sit on, while offering the illusion that he is closer to us than the figures of Elizabeth and Joseph. To some degree this effect is merely the product of layering the figures, so that Mary's right arm overlaps Elizabeth's torso and Mary's left side overlaps Joseph's right side. However, the artist also employs more sophisticated devices to convey depth: by swelling the contour at Mary's left foot, he gives the impression that her leg protrudes into our space; by employing carefully modulated relief, he underscores the difference in surfaces from Christ's back, to Mary's torso, to the shallow, nearly etched lines of drapery above her right foot. Perhaps anticipating that the work would be abraded, the artist has employed a dark brown patina that seems to deepen the recesses of the relief and to cast long shadows. By doing so, the work highlights the main objects of our devotion, Mary and Christ, while enhancing the narrative setting for this fundamentally iconic image and achieving greater illusionism and verisimilitude. **KF**

Bibliography: J. Pope-Hennessy, *Italian High Renaissance and Baroque Sculpture* (London, 1970), 42–3, 78–85, 350–53, 404–10; B. Boucher, *The Sculpture of Jacopo Sansovino*, 2 vols. (New Haven and London, 1991).

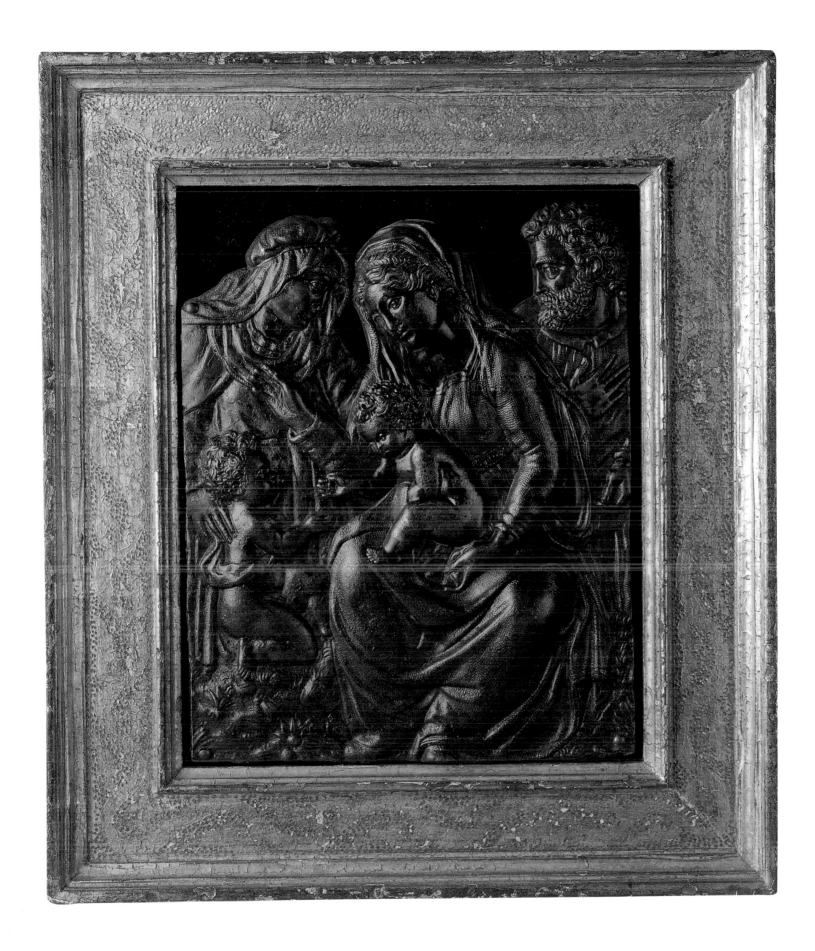

17 | Madonna and Child with the Young Saint John

Follower of Jacopo Sansovino (1486–1570)
Venetian, second half of the 16th century
Bronze gilt plaquette, rectangular within a scrolling, *ajouré* frame
7⅞ x 5 x ⅜ inch (19.5 x 12.6 x 1 cm)

This composition, extant in a variety of frames and formats, was extremely popular during the later Renaissance as an image for private devotion. It often includes elaborate details of architecture or clothing, in this case the Virgin's robe.[1] The model has been ascribed to various Venetian artists: Jacopo Sansovino (1486–1570), Girolamo Lombardi (c. 1505/10–1584/1589), Antonio Minello (c. 1465–1528) and Tommaso da Lugano (active 1537–c. 1561). Others have identified a Florentine origin, as a result of the obvious iconographic connection to Donatello and Luca della Robbia. Rossi has pinpointed Sansovino's pupil, Tommaso da Lugano, as the author. This attribution is based on a comparison with Tommaso's *Madonna with Saint John* in San Sebastiano and his *Charity* for the tomb of Doge Venier in San Salvatore.[2]

But this analogy has not proven conclusive, and the composition is now generally accepted as Venetian school of the sixteenth century from the circle of Jacopo Sansovino. The dominant scale of the central group of figures, set against a background of Venetian architecture, is reminiscent of Sansovino's work, in particular his reliefs for the pair of *Singing Galleries* in St. Mark's, Venice.

A unique example cast in bronze and set into a gabled wooden frame exists in the Museo Civico Amedeo Lia in La Spezia, Italy. It has an ornamental cresting centered with an eagle and cockleshell motif and an unidentified coat-of-arms flanked by the initials 'A.L.', clearly those of a particular patron. The whole is painted naturalistically in order to create a house-altar for domestic prayer and meditation.[3] Two other examples in Paris provide approximate parameters for the production of the plaquettes. One of them, a poor cast in the Bibliothèque Nationale, is dated 1564, and the other has the year 1607 incised on the reverse, along with an unidentified coat-of-arms.[4] **CA**

Bibliography: E. Bange, Staatliche Museen zu Berlin: *Die italienischen Bronzen der Renaissance und des Barock*, zweiter Teil: *Reliefs und Plaketten* (Berlin, 1922), no. 946; A. Norris and I. Weber, *Medals and Plaquettes from the Molinari Collection at Bowdoin College*, (Brunswick, Maine, 1976), no. 361; D. Banzato and F. Pellegrini, *Musei Civici di Padova: Bronzi e placchette* (Padua, 1989), 79–80, no. 55; D. Banzato, M. Beltramini and D. Gasparotto, *Fondazione Giuseppe Roi, Placchette, bronzetti e cristalli incisi dei Musei Civici di Vicenza* (Vicenza, 1997), 93, no. 91.

1 P. Cannata, *Rilievi e Placchette dal XV al XVIII secolo*, exh. cat., Palazzo Venezia (Rome, 1982), 70, no. 64, argues convincingly that this is present on nearly all the examples, and must therefore have been executed by the artist in the original wax model, rather than being the result of chiselling after casting. Consequently, he dates the examples with blank backgrounds to a later period. W. Wixom, *Renaissance Bronzes from Ohio Collections*, exh. cat., Cleveland Museum of Art (Cleveland, 1975), no. 103, dates such a plaquette in Cleveland as early sixteenth century.

2 F. Rossi, *Musei Civici di Brescia: Placchette, secoli XV–XIX* (Vicenza, 1974), 99, no.144, fig. 51.

3 C. Avery, *La Spezia, Museo Civico Amedeo Lia: Sculture, Bronzetti, Plachette, Medaglie* (La Spezia, 1998), 278–79, no. 198.

4 B. Jestaz, *Catalogo del Museo Civico di Belluno, Le placchette e i Piccoli Bronzi* (Belluno, 1997), no. 71

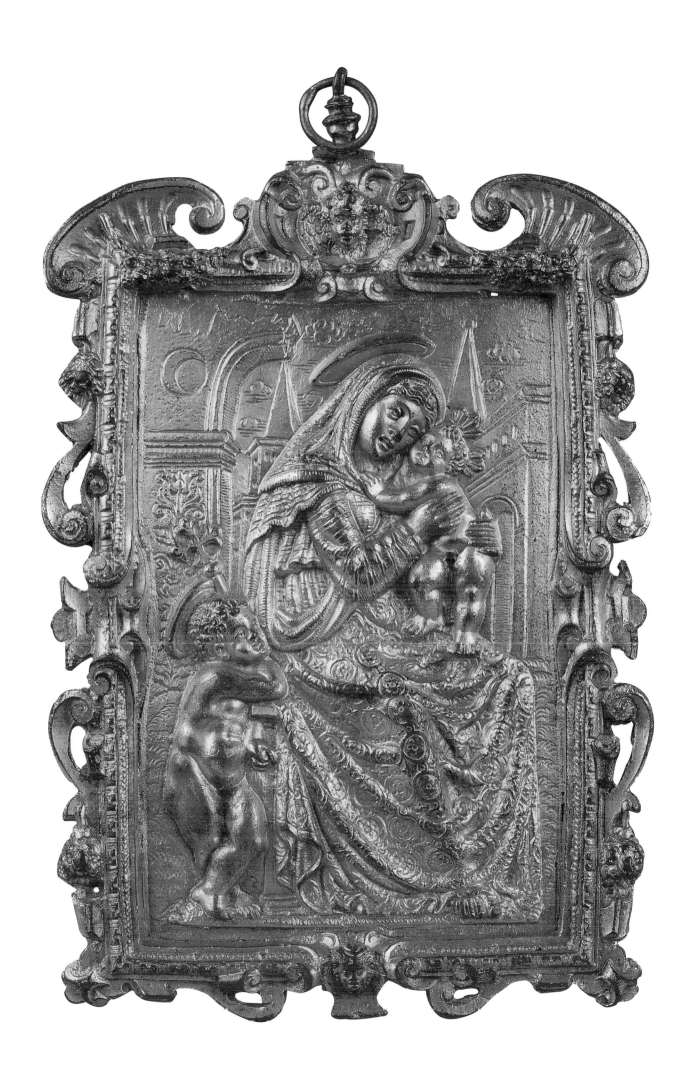

18 | Madonna and Child with the Young Saint John

Attributed to Battista Pittoni of Vicenza (c. 1520–c. 1583)
Paduan, mid-16th century
Hand-modeled terra cotta plaque
23½ x 23½ x 3½ inches (59.7 x 59.7 x 9 cm) (with integral frame)

This attractive unpublished plaque was modeled by hand in clay and then baked in a kiln into terra cotta. No serious attempt to attribute it has been made hitherto, only a generic suggestion of a parallel with another terra cotta plaque of a similar subject by Niccolò Roccatagliata. This is not persuasive, and Dr. Claudia Kryza-Gersch, the current expert on that sculptor, has verbally rejected the attribution.

Battista Pittoni, designer of the magnificent wood stalls in the retrochoir of the Basilica of Santa Giustina in Padua, may have modeled this clay plaque between 1558 and 1572 as a sculpted "preliminary sketch." One Riccardo Taurino, a French wood-carver from Rouen in Normandy whose real name was Richard Taurin or Taurigny, received payment on 29 May 1558 for a model of one of the stalls, presumably as a sample of his carving ability. On 22 September 1558 the Benedictine friars, evidently satisfied, drew up a contract with Taurin's father-in-law, Battista Pittoni, a well-established printmaker from Vicenza who had settled in Venice that year.[1] Pittoni provided models in clay for all the works that the monks ordered to be carved in wood by Taurino ("*facèndo prima esso maestro Battista, il schizo in creda*": "first made by master Battista in clay"), who had apparently agreed to this division of labor, on the grounds that he was a wood-carver and neither a sculptor nor a painter capable of designing the numerous scenes required. Lomazzo highly praised Taurino as the premier wood-carver in the world.[2]

An attribution of the present terra cotta to Pittoni depends on stylistic comparisons with the parallel work in wood by Taurino. There are many similarities of detail and correspondences of motifs between those panels.[3] For example, in *Abraham and David Foresee the Incarnation of Christ*, points of comparison include the face of the Virgin; her elegant hands with slim fingers; the lanky body of Christ with disproportionately small head; and the cloth of state. The motif of the cloth of state is omnipresent in the narrative scenes and seems to have been much favored in Santa Giustina, for it also appears in some marble carvings by Francesco de Surdis of 1562: the *Arca di San Mattia* and the *Altare degli Innocenti*. In the latter relief a *Virgin and Child* is framed by a cloth of state very similar to the present terra cotta. Similar cloths are suspended behind two other panels showing pairs of infants slain at King Herod's command, and one with an infant angel supporting a cross.[4]

This plaque provides a glimpse into the production of an important series of narrative wood carvings of the High Renaissance in northern Italy. Relatively few of these are illustrated in the literature; there may even be a carving of the present composition among the plethora of images in Santa Giustina. If not, the style is unmistakable and the relief might be a type of design provided by Pittoni to the friars, or simply a by-product of his work for the Benedictine friars. **CA**

Bibliography: A. Bacchi, *La scultura a Venezia dal Sansovino al Canova* (Milan, 2000), pls. 139–41, p. 793; G. Ericani, "La scultura lignea del Seicento nel Veneto," A. M. Spiazzi (ed.), *Scultura lignea barocca nel Veneto* (Milan, 1997), 30.

1 Françoise Jestaz, "Pittoni," J. Turner ed., *The Dictionary of Art* (London, 1996), 25.

2 Lomazzo, *Idea del Tempio della Pittura* (Milan, 1590), chap. 38.

3 See N. Ivanoff, "Sculture e Pitture del Quattrocento al Settecento," G. Fiocco (ed.), *La Basilica di Santa Giustina a Padova* (Venice, 1970).

4 See Ivanoff, as in note 3, 232–79, 427, and pl. 13, 17–18.

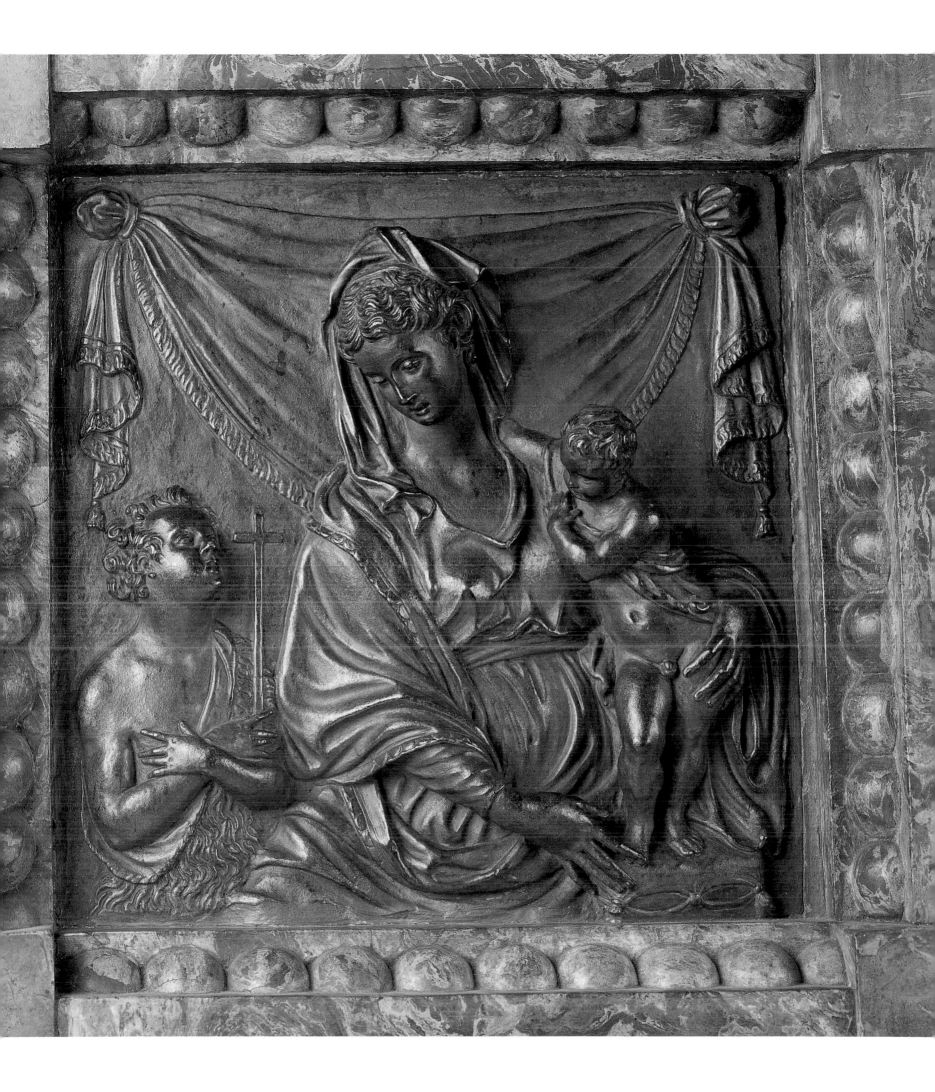

19 | Madonna of the Rosary

Venetian, second half of the 16th century
Bronze, chestnut brown patina, oval, with *ajouré* border and loop for suspension
7 x 3¾ x ½ inch (17.8 x 9.8 x 1.25 cm)

The sharp cast of this oval pendant makes it easy to read. The Virgin and Child are enthroned on a raised platform in front of a plain strip of material. She holds the Christ Child on her lap with her left hand, while in her right she offers a rosary to St. Dominic, who kneels at her feet and presses the rosary to his lips. St. Catherine of Siena, wearing the habit of the Dominican Order, kneels at the right. Worshippers, encircling the sides of the throne, throng behind both saints: male to the left, including a pope and an emperor, a king and a doge of Venice, recognizable by their headgear; and female to the right in monastic garb, one crowned. An ornate design of piercing and volutes frames this lively scene, while the sinuous play of drapery and pious gesture of hand enrich it. Rosettes decorate these scrolls and a cherub crowns the whole composition.

Another version in La Spezia, Italy, more complex and harder to read, has a handle for use as a *pax*. Instead of an empty background, the La Spezia version features winged cherubim hovering on either side of the Virgin's head. The material on the platform is decorated with a lily.

This iconography, first represented in art towards the end of the fifteenth century and more popular during the sixteenth century, is known also as *The Vision of St. Dominic*. The Dominicans particularly favored the subject. According to legend, the Virgin appeared to St. Dominic and granted him a chaplet of beads that he named "Our Lady's Crown of Roses." St. Dominic subsequently instituted the devotion to the rosary, and the rosary became his special attribute. St. Catherine of Siena often accompanies him, for not only was she one of the great Dominican saints, but she too had a vision of the Virgin and frequently appears with a rosary as an attribute. The commission for the present composition probably came from a member of the Dominican Order, or a lay person in one of their confraternities, for devotion to the rosary was popular with private patrons too.

The inclusion of the doge of Venice, with the distinctive shape of his *cornu* (doge's hat) silhouetted against the neutral background, alongside the other more important male dignitaries, strongly suggests that this piece is Venetian in origin. The style also points to Venice. The group of the Virgin and Child is distantly indebted to those made during the High Renaissance by Jacopo Sansovino (1486–1570), especially the monumental renderings in the Loggetta, Venice, and in the Chiesetta dell'Anticollegio in the Doge's Palace, where the Virgin leans down to one side towards a figure below.[1] From an iconographic standpoint, the image was most likely produced during the last quarter of the century. Of Sansovino's important followers active at that time, Girolamo Campagna (1549–c. 1625) is a good candidate for this superbly organized and modeled miniature composition. Particularly similar is the kneeling Virgin from his *Annunciation*, a bronze group of figures in relief in Verona: the distinct, swinging, long curves of the folds that visually bind the composition together, while leaving the figures palpable beneath, are very close in conception.[2] **CA**

Bibliography: C. Avery, *I Cataloghi del Museo Civico Amedeo Lia, 4, Sculture, Bronzetti, Placchette, Medaglie* (La Spezia, 1998), 280, no. 199.

1 Leo Planiscig, *Venezianische Bildhauer der Renaissance* (Vienna, 1921), pls. 407–8.
2 Ibid., pl. 584.

20 a & b | Madonna and Child

Circle of Gianlorenzo Bernini (1598–1680)
Roman, mid-17th century
Gilt bronze reliefs
4 x 5¼ x ¼ inch (10.2 x 13.3 x 0.6 cm)

The Hall collection includes two similar unpublished bronze plaquettes of the Madonna and Child. They differ in the chasing of the background, with only one showing buildings and clouds. They constitute two of six known versions of a composition that came from the circle of Gianlorenzo Bernini, the master-sculptor of the Roman Baroque.

A large version in marble (55 x 70 cm) was listed in the collection of Taddeo Barberini as early as 1648 and is still in the Barberini Palace, Rome (inv. no. 2248) (fig. 1).[1] A pen and sepia ink sketch of the composition in the Chigi Archive in the Vatican (inv. no. 24936), though very damaged, is executed in a technique of cross-hatching to create depth of shadow which recalls that of two other drawings, one of them a portrait of Gian Lorenzo himself. This suggests that all three are by the same hand, that of an artist operating within the closest circle of Bernini. There are also casts in wax (Church of St. Paul's Shipwreck, Malta) (fig. 2), and in bronze (Museo Civico, Pesaro, Italy).

1 M. Worsdale, "Le Bernini et la France," *Revue de l'Art* 61 (1983): 61–72, esp. 68, fig. 1. Dr Jennifer Montagu kindly supplied this reference, as well as the photograph reproduced here in figure 2.

2 Ibid., fig. 5.

figure 1
Circle of Gianlorenzo Bernini
Madonna and Child
Marble
Barberini Palace, Rome

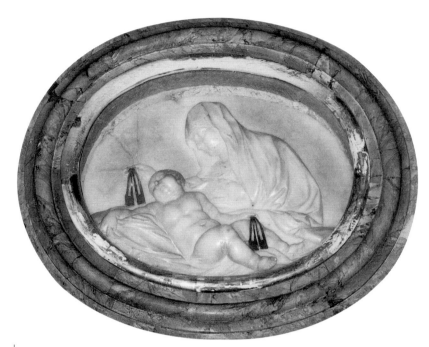

figure 2
Madonna and Child
Wax cast
Church of St. Paul's Shipwreck, Valetta, Malta

A similar, graphic rendering of the theme definitely by Bernini is recorded in a contemporary engraving.[2] The subject and oval form also recall those of an elliptical marble relief depicting the *Christ Child with a Carpenter's Toolbox* by Gianlorenzo and his son Paolo Bernini (1665), found in the Louvre, Paris. The child's plump little body is very close to the infant in the Hall relief. This composition also inspired a French sculptor, Pierre-Etienne Monnot (1657–1733), who went to Rome in 1687, and in 1700 executed a marble relief of the same theme for the Fifth Earl of Exeter (see cat. no. 21, fig. 1).[3] **CA**

3 Burghley House, Cambridgeshire; see H. Honour, "English Patrons and Italian Sculptors in the first Half of the Eighteenth Century," *The Conoisseur* CXLI (1958): 220–26, plate 26.

Bibliography: M. Fagiolo dell'Arco ed., *Bernini in Vaticano*, exh. cat. (Vatican 1981), no. 7.

21 | Madonna and Child

From the circle of Pierre-Etienne Monnot (1657–1733)
Franco-Roman, late 17th/early 18th century
Ivory relief
4½ inches diameter x ¾ inch (10.8 cm diameter x 1.8 cm)

This superb, unpublished miniature carving has an obvious and interesting relationship with the oval plaques of the same subject (see cat. no. 20 a & b). The composition is in mirror-image. This establishes an indirect connection with the work of Bernini. Although its ground is circular, the curve of the lower edge of the figurated area would fit equally well within an oval. Surprisingly few reliefs of the Madonna and Child date from the Roman Baroque period (compared with the early Renaissance period, for instance). The galaxy of saints – many of them figures from the period of Counter Reformation who had been canonized recently – seem to have supplanted the Virgin in the public imagination. This may account for the small scale of these plaques intended for intimate contemplation and domestic devotion. In the Roman context the use of ivory is also highly unusual, for it was more in vogue in northern Europe.

The composition also echoes Bernini, via the marble *Charity* that Antonio Raggi carved to his

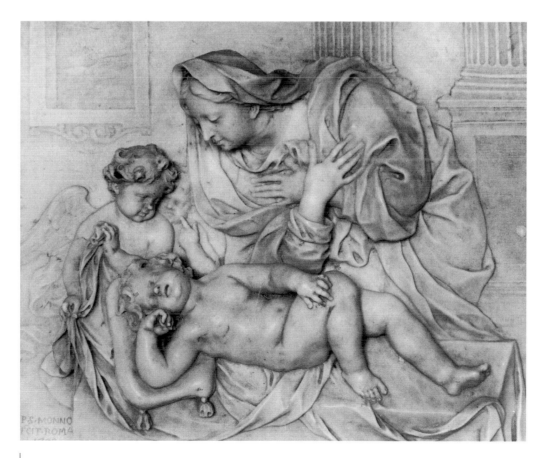

figure 1
Pierre-Etienne Monnot
Madonna and Child or Nativity
Marble relief
From the Burghley House Collection

design for the tomb of Cardinal Pimentel (d.1653) in Santa Maria sopra Minerva, Rome.[1] The sculptor in whose *oeuvre* one finds the most similar rendering of the Virgin and Child, albeit on a monumental scale, was a Frenchman, Pierre-Etienne Monnot, who, after a decade of working in Paris, moved to Rome in 1687. Between 1695 and 1699 he carved two large marble reliefs depicting the *Adoration of the Shepherds* and the *Flight into Egypt* for the Capocaccia Chapel in Santa Maria della Vittoria, Rome, both of which are relevant to our ivory.[2] A terra cotta model for the *Flight*, signed and dated 1695, recently resurfaced at Sotheby's, New York (29 January 1998, lot 47); it shows an angel gently helping the Virgin to descend from a donkey with her precious burden, the baby Jesus, at her breast. The modeling of her upper body, solicitous glance and the recumbent child are indebted to Bernini's composition as recorded in the plaquettes, and even more closely to an oblong drawing after Bernini now in the Uffizi Gallery, Florence.[3] Furthermore, the encircling arm and supporting hand of the Virgin in the terra cotta reappears in the ivory, although the composition is in reverse. The companion marble relief in Santa Maria della Vittoria, the *Adoration of the Shepherds*, shows the Virgin looking tenderly down at the Child, whom she is displaying in the corner of the manger, in a way very similar to the present composition. Monnot went on to produce one of the rare independent marble reliefs of the *Virgin and Child* of this period one year later, in 1700, for the Fifth Earl of Exeter. It is in Burghley House, Cambridgeshire (fig. 1), while the original terra cotta model is preserved in Rome, in the sacristy of Santa Maria in Trastevere.

These points of comparison suggest that the ivory carving comes from the circle of Monnot and may record a lost, major composition by him. A source in devotional paintings of the period, by an artist such as Carlo Maratta (1625–1713), may also emerge. **CA**

Bibliography: R. Enggass, "Monnot," J. Turner, ed., *The Dictionary of Art* (London, 1996), vol. 21, 889–90.

1 O. Ferrari and S. Papaldo, *Le Sculture del Seicento a Roma* (Rome, 1999), 274.
2 Ibid., 353.
3 M. Worsdale, "Le Bernini et la France," *Revue de l'Art* LXI (1983): 61–63, fig. 7 (incorrectly captioned).

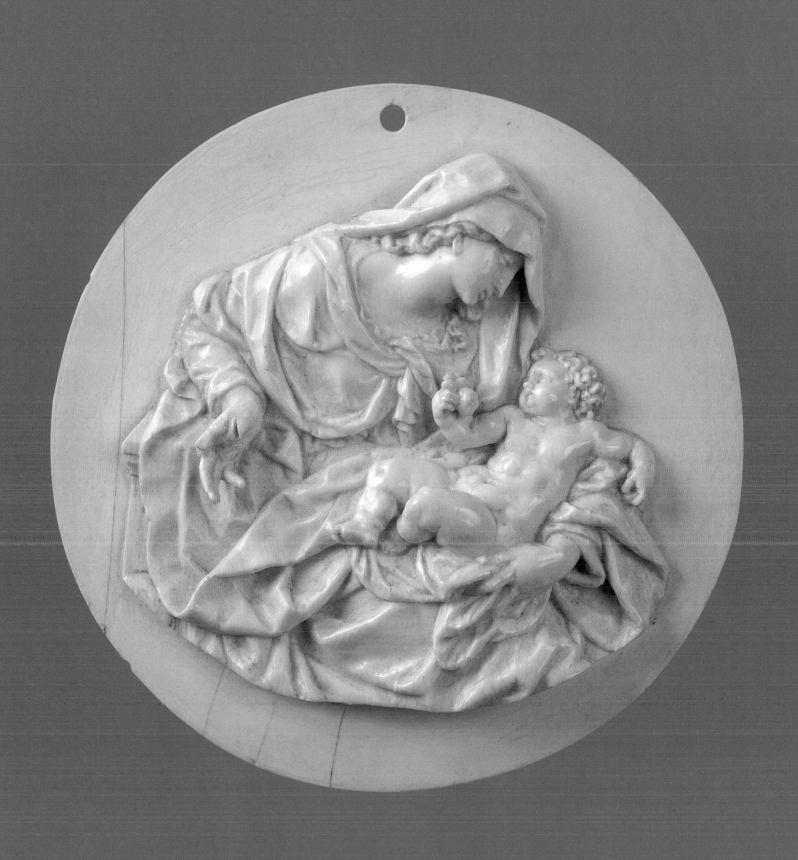

22 | Madonna and Child

Venetian (?), late 17th/early 18th century
Horn or tortoise shell relief, with mirrored cut glass mounts
5⅛ x 3⅞ x ¾ inches (13 x 9.8 x 1.9 cm)

Artists began using tortoise or, rather, turtle shell in the seventeenth century. A natural shell yields seventeen plates of usable material, four of them quite large. These plates can be shaved flat and then softened by boiling in order to be bent into different shapes or pressed into a mold, as here, to make a variety of attractive works of art, ranging from reliefs or medallions to ornamental drinking cups and even to crucifixes.

Tortoise shell was treasured as a rare material with an attractive, warm color, a degree of translucency, and a surface which takes a high polish. Tortoise shell objects often numbered among those found in a *Kunstkammer*, or art collector's cabinet, which appeared with increasing frequency in the palaces of royalty or nobility during the seventeenth century in cities such as Copenhagen, Florence, Munich, Uppsala, and Vienna.[1]

The size, subject and technique of molding relate the Hall piece to plaquettes in precious metal or bronze. The origin of its design has, however, not come to light, though the general style and ornamentation recall such plaquettes as that by a follower of Sansovino (see cat. no. 17). The artist could have used a mold from a composition dating from an earlier period into which to press the tortoise shell. **CA**

Bibliography: G. Hanlon, "Tortoiseshell," in J. Turner, ed., *The Dictionary of Art* (London, 1996), vol. 31, 194–95.

1 E. von Philippovich, *Kuriositäten/Antiquitäten* (Braunschweig, 1966), 469–73.

23 | Madonna and Child

Alexandre-Louis-Marie Charpentier (1856–1909)
French, late 19th century
Bronze plaquette
12¼ x 7⅝ x ½ inch (31 x 18.7 x 1.25 cm)

Signed at lower left, this plaquette represents one of the finer designs by the famed medallist, sculptor and decorator, Alexandre-Louis-Marie Charpentier.[1] Ranging from monumental ceramic friezes to tiny bronze medallions, his reliefs favor diurnal subjects in a natural and robust style. Yet, as the present work demonstrates, they also comprise biblical subjects in refined, historicized styles (see fig. 1).

This plaquette representing the *Madonna and Child* brilliantly distills various fifteenth-century Italian reliefs. At its core is an emotional relationship as moving as that found in many of Donatello's works (1386–1466). Like Donatello's *Pazzi Madonna* (Florence), for example, Charpentier's Virgin returns the Child's clutch with a tender embrace that suggests foreknowledge of his ultimate sacrifice. Yet, she does so in a very different spirit from that of Donatello's figure. Whereas the latter has an intense melancholy borne of her direct gaze into the child's face and her timeless, dramatic classicism – her full jaw, aquiline profile, and downturned mouth, not to mention heavy drapery – Charpentier's figure suggests a bittersweet wistfulness. As she turns slightly towards us, her downturned eyes convey humility and establish an intimacy with us. They render more immediate the maternal love of her embrace and her consolation in knowing the reward that will be reaped from her son's impending sacrifice.

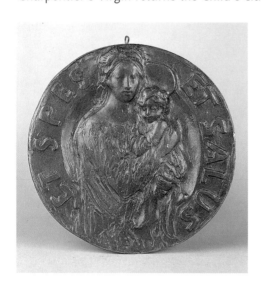

figure 1
Alexandre-Louis-Marie Charpentier
Lead roundel relief
Michael Hall Collection

Indeed, Charpentier's relief could be seen as the monumentality of Donatello's compositions refracted through the "sweetness" of Desiderio da Settignano's style (1429/32–1464). The Christ child in the plaquette is far more playful than the Christ child greeting us from the roundel above Carlo Marsuppini's tomb in Santa Croce, Florence (see cat. no. 8, fig. 1). But the rather pointed nose, dimpled upper lip, and facial proportions of Charpentier's child are comparable to those of his counterpart in Desiderio's relief. Moreover, both figures are cherubically chubby and have stocky limbs that contrast sharply with those of their mother. Her willowy arms and fingers suggest that her ample drapery hides an elegantly elongated body, that her face is not the only fulfillment of mid fifteenth-century ideals of feminine beauty. Charpentier preserves the perfection of the Virgin while humanizing Donatello's classical icon, "modernizing" it for a nineteenth-century audience. **KF**

Bibliography: M. Bascou, "Une Boiserie Art Nouveau d'Alexandre Charpentier," *Revue du Louvre* 3 (1979): 219–28 (with additional bibliography); A. Pingeot, "A. Le Normand-Romain and L. de Margerie," *Catalogue sommaire illustré des sculptures*, Musée d'Orsay Catalog (Paris, 1986); C. Matthieu, *Guide to the Musée d'Orsay* (Paris, 1987), 232–3.

1 Born in Paris on June 10, 1856, Charpentier studied with the medal engraver Hubert Ponscarmé prior to exhibiting his own work at the Salon of 1879. He went on to execute free-standing sculpture and was a key figure in the *fin-de-siècle* revival of the decorative arts, but his most enduring fame came from his reliefs.

A. CHARPENTIER F. BARBEDIENNE, FONDEUR.

24 | Madonna and Child (Guanyin)

Chinese, late Ming Dynasty (1580–1644)
Ivory
9¾ x 4 x 2¾ inches (24.8 x 10.2 x 7 cm);
Rosewood base 1¼ x 5¼ x 3½ inches (3.1 x 13.3 x 8.9 cm)

Although ivory had been carved in China since the Neolithic era (c. 6500–c. 1600 BC), its production expanded considerably in the sixteenth century when commercial relations with Europe created markets for Chinese carved ivories. Near the end of the Ming dynasty, contact with Spanish and Portuguese merchants led to the production of human figures carved in ivory, which had been extremely rare before the Ming dynasty. By the late seventeenth century, a large ivory figure-carving production arose in Guangzhou, Beijing, Shanghai and Xiamen (Amoy).[1] Figures from the Buddhist and Taoist pantheons were the ones most frequently produced.

This ivory figure represents Guanyin, the Chinese goddess of mercy (see cat. no. 25). Celebrated in popular cults, Guanyin grants couples children and therefore appears holding a child. Because Guanyin closely resembled the Virgin Mary with Christ, the image was often mistaken as a Christian figure. During the late Ming dynasty (c. 1580–1644) Chinese ivory carvers produced large numbers of Guanyin figures for the home market, but called them images of the *Virgin and Child* for the European market. Ming Guanyins usually measure 24–34 cm high, while later Guanyins, made during the Qing dynasty (1644–1911) often measure as high as 76 cm.

The style of the drapery folds, with the exquisitely detailed incised patterns on her sleeves and hem, are related to other late Ming examples. The figure's calm, rather ample face mirrors the child's physiognomy. The refinement in the elegantly cascading drapery and the blossoming lotus at the base resemble details in the best examples of the type. Though originally carved in pale ivory, the Hall figure displays a rich coloration. Sometimes carvers rubbed the elephant tusk ivory with tobacco juice or incense smoke to achieve this warm glowing quality. MH

1 W. E. Cox, *Chinese Ivory Sculpture* (New York, 1946).

25 | Madonna and Child (Guanyin)

Chinese, late Ming Dynasty (?) (1580–1644) reflecting Tang Style
Bronze
7¼ x 5⅛ x 2½ inches (18.4 x 13 x 6.3 cm)

Guanyin is the compassionate Bodhisattva, whose full name is Guanshiyin, which means "she who hears the cries of the world." Buddhism came to China through India, where Guanyin was a male Bodhisattva called Avalokitesvara. During the Tang and Song Dynasties (seventh to thirteenth centuries), he was represented as a male, but by the Ming Dynasty, she appeared as a woman, possibly because there were so few female deities in the Buddhist pantheon who appealed to woman votaries.[1] Tang examples of the Bodhisattva never have babies, while Ming examples nearly always do. Christian missionaries and traders who arrived in China in the sixteenth century interpreted the Guanyin as an image of the Virgin and Child. Because of this, they commissioned Guanyins in a variety of media to bring back to Europe.

Trade routes with the West opened during the late Ming Dynasty (1580–1644), which stimulated production of decorative arts, including bronzes. New bronze foundries produced images of archaistic design, reviving Tang and Song forms.[2] The artist of this piece, for example, has applied agate-like jewels to the diadem and pendant of the figure. The style of the jewelry and the arrangement of the drapery are characteristic of the Tang period. The overall composition relates to the large polychromed wood or modeled stucco figures of the Bodhisattva from these epochs.[3] Bronzes made in this period often have a bright red or yellow finish and are usually solidly cast. MH

1 Rose Kerr, *Later Chinese Bronzes* (London, 1990), 82; R. Soame Jenyns and William Watson, *Chinese Art: The Minor Arts*, II (New York, 1965).

2 Rose Kerr, "A Preliminary Note on Some Qing Bronze Types," *Oriental Arts* 36/4 (1980–81): 447–456; P. Moss and G. Hawthorn, *The Second Bronze Age: Later Chinese Metalwork* (London, 1991).

3 See William Watson, *The Art of Dynastic China* (New York, 1981), 446–9, nos. 92-8.

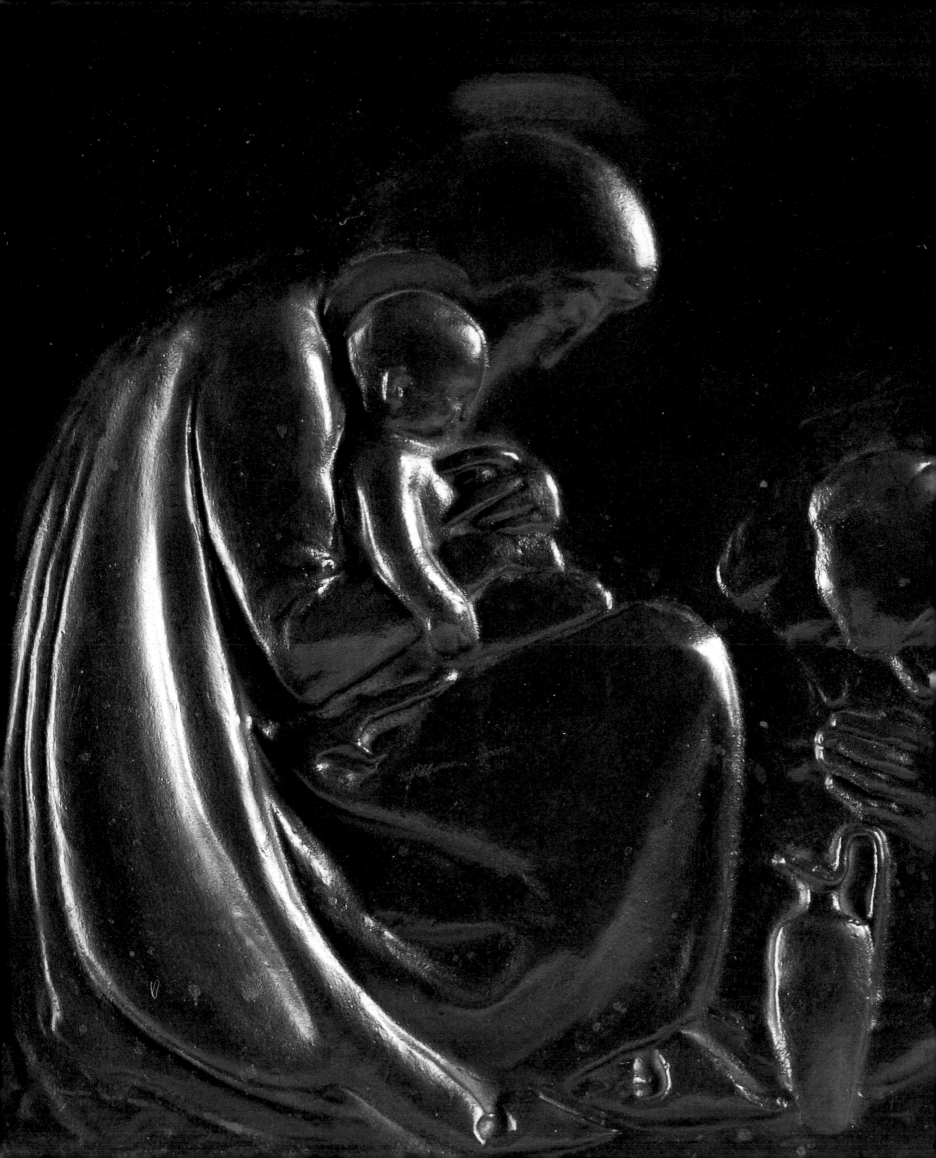

I have come in order
that you might have life –
life in all its fullness.

John 10.10

The most important events in the life of Jesus
are usually depicted in art as narrative cycles. The
Scriptures provide enough information to sketch
the narrative of Jesus' adult life and ministry. They
are, however, rather scarce on Jesus' childhood, and
almost silent on Mary's life. The exception is the
Gospel according to Luke, which dedicates two
chapters to the birth and infancy of Christ. Mary
is mentioned only eight times in the other three
Gospels, and only once in the Acts of the Apostles.
This paucity of information is compensated by the
many apocryphal writings, especially the "Infancy
Gospels," which provide a wealth of additional
stories and picturesque details about both Mary
and Jesus. These writings, together with later
patristic texts and medieval legends, informed
artistic imagination and played a decisive role in
elaborating iconographic types.

This exhibition includes several Marian narratives,
from the scriptural *Annunciation* and *Visitation* to
the apocryphal *Birth*, *Dormition* and *Assumption
of the Virgin*. Consistent with representations of the
Madonna and Child, the Virgin is recognizable in
virtue of the standard iconography and attributes,
such as her blue mantle and the lily, a symbol of
her purity. The Christological narratives are largely
from Jesus' early life, representing him as a child or
young adult in a wide variety of physiognomic and
stylistic types.

Circle of Pierre II Veyrier (active 1528–1558?)
French, Limousin, mid-16th century
Limoges enamel
8⅜ x 11 x ⅝ inch (21.2 x 27.8 x 1.3 cm)

This plaque depicts the *Birth of the Virgin* in a domestic interior. St. Anne, the Virgin's mother, having just given birth, passes the newborn to a midwife while other midwives bring a golden bowl and prepare the swaddling clothes. Joachim, Anne's husband, sits at the foot of the bed and, with an emphatic gesture made with his long thin fingers, expresses his awe that God has miraculously given the elderly couple a child.

Around 1500 painted enamel replaced *cloisonné*, *champlevé*, and *bassetaille* techniques as the predominant medium of enamel production in Limoges. Most enamel works of the sixteenth century depicted secular subjects and drew upon Italian mannerist models, as production was dominated by artists working at the French court at Fontainebleau.[1] The work of this artist resembles, stylistically, the work of Léonard Limosin (active 1530–40), who brought drapery highlights to a nearly all-white surface. It shows a preference for rendering figures in profile, and employs a thin gold line for shimmering highlights and haloes. It also shares similarities to the work of Pierre II Veyrier, who depicted more religious subject matter, including a series of nine plaques depicting the *Passion of Christ*.[2] In the series Veyrier employs square floor tiles, uses a brick wall as a backdrop, and displays several sitting figures, including Judas, from the rear, a position that mirrors Joachim's. The artist of the *Birth of the Virgin*, who signs his name "G" just under Joachim's bench, remains anonymous, however.

The birth of the Virgin made tangible the doctrine of the Immaculate Conception, a controversial notion that stated that Mary was chosen to be the vessel of Christ's Incarnation, and therefore was born without original sin. The lavers and white linens refer to her purity. Whereas at scenes depicting Christ's birth, artists often show his *pudenda* – or even depict his mother fondling them – in order to underscore Christ's humanity, here the Virgin's *pudenda* are quietly covered, for it is her purity, and not her humanity, that are essential for the doctrine of the Immaculate Conception.[3]

The chips on the lateral and bottom edges of the plaque indicate that it may have been mounted into a frame, or possibly into a box. The painted enamel medium, with its rich colors and luminous quality, became a favorite for domestic decorative arts, and the imagery of fecundity would have been appropriate for the marriage chest of a courtly woman. KR

1 Philippe Verdier, *Catalogue of the Painted Enamels of the Renaissance*, exh. cat., Walters Art Gallery (Baltimore, 1967), *ix-xv*.

2 Baltimore, Walters Art Museum. See Verdier, as in footnote 1, fig. 121–129.

3 Leo Steinberg, *The Sexuality of Christ in Renaissance Art and in Modern Oblivion* (New York, 1983).

27 | Annunciation

French, 17th century (?)
Oil on copper
7½ x 6½ inches (19.5 x 16.5 cm)

MARIAN AND CHRISTOLOGICAL NARRATIVES

86

This exquisite painting on copper gleams with jewel-like intensity. Here, the *Annunciation* to the Virgin Mary reads as both an intimate encounter and a universal experience. The Archangel Gabriel glides into the scene atop a cloud, his hair rustled by the breeze. His gesture indicates that he announces to the Virgin that she, "blessed among women," will bear the Son of God (Luke I.26–38). Mary looks up, astonished, her one hand still marking her place in her devotions, the other raised in a gesture of both surprise and acceptance. At the same moment, the spirit of the Lord descends from the heavens, rendered here in a burst of golden impasto that reads both as the dove of the Holy Spirit and a prefiguration of the cross. While the *Annunciation* often takes place in an elaborate domestic setting, the artist has reduced the encounter to its quintessence: the protagonists, a lectern, and the lily symbolic of Mary's virginity.

The scale and simplicity of this refined work preclude any firm attribution. The composition reflects the grand Giustiniani *Annunciation* by Simon Vouet (1590–1649), once in Berlin (Kaiser-Friedrich-Museum), but alas now destroyed.[1] While the facial types and setting of the Hall *Annunciation* echo the Vouet, the brushwork is much looser than his lapidary approach to surfaces. The fluid application of paint points instead to Jacques Blanchard (1600–1638) and Claude Vignon (1593–1670). A Blanchard *Annunciation*, known only through an engraving, adopts a similarly reductive approach and nebulous setting bathed in light. In a small, tender *Madonna and Child* (French Private Collection), the profile of the Virgin and the liquid painted surface of her rose and blue garments resemble the Hall *Annunciation*.[2] Vigorous brushwork and fluid pigment were Vignon's trademarks. A painting of St. Catherine of Alexandria in Dieppe (Musée des Beaux Arts, Paris) features a profile and gesture identical to the Virgin's in the Hall *Annunciation*.[3] In both paintings, the artist similarly renders the garments with streaks of paint. The tapered fingertips, like those of the angel in the Hall copper, occur frequently in both artists' works. JU

1 William R. Crelly, *The Paintings of Simon Vouet* (New Haven, 1962), 150, no. 7.

2 Jacques Thuillier, *Jacques Blanchard 1600–1638*, exh. cat. (Rennes, 1998), 262, 268, nos. 90, 94. Thuillier, 336, also records a lost *Annunciation* on copper in an 18th century inventory. While its oval format precludes any relation to the present work, it documents Blanchard's use of this support.

3 Paola Pacht Bassani, *Claude Vignon 1593–1670* (Paris, 1992), no. 471.

Chinese, late Ming Dynasty, c. 1620
Enamel on copper
3¼ x 3⅛ inches (13 x 8.3 x 4.1 cm)

This rare pilgrim's bottle is of the traditional flattened gourd shape derived from early Chinese vessels of the Han period (206 BC–AD 9), when long-distance trade routes were established. This stylized form was repeated in later dynasties and provided the form for enameled vessels made from the Ming Dynasty (1368–1644) to the Qing (1644–1911).[1] The Jesuits, who began coming to China in 1540, taught Western art aesthetic principles, such as *chiaroscuro* and one-point perspective, and encouraged enameling, which was not an indigenous technique.[2] The voluminous correspondence from Jesuits in China such as Père François Xavier d'Entrecolles (1664–1741) raised interest in Europe for *chinoiserie* and stimulated its consumption and consequently, its production. Canton, the city that had the most contact with the non-Chinese world, produced the most enamelware, although several enameling factories were established throughout China.

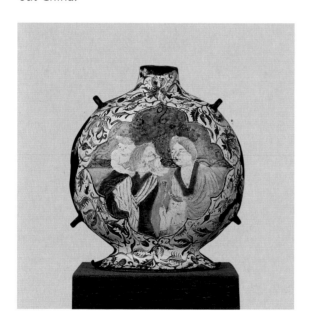

The imagery on both faces of the flask is highly unusual, in terms of its iconography and choice of color. This may have resulted from confusion by a Chinese enameler unfamiliar with the traditions of Christian iconography. One side of the painted surface depicts the *Annunciation*, where Mary, behind a green curtain, wears an atypically bright yellow gown with a scooped neck. The angel Gabriel, with the countenance of a *putto*, gesticulates towards the Virgin with a long reddish-brown wand-like cross. The reverse side of the flask shows the crowned Virgin wearing a soft turquoise dress with a dark blue collar. She holds a nude infant at her waist. A man who wears the garb of a traveler – a dark blue cloak with a white scarf knitted at his waist – supports another nude infant, possibly the Christ child, although he does not bear a cruciform halo. The image may represent St. Christopher, who bears the Christ Child on his shoulders, meeting the Virgin and Child; alternatively, it may constitute a misunderstanding of the *Flight into Egypt*, in which case the man would be Joseph. In either case, the imagery involves traveling and safe passage, appropriate messages for a pilgrim's flask. MH

1 R. Soame Jenyns and William Watson, "Cloisonné and Champlevé Enamels on Copper," in *Chinese Art: The Minor Arts*, II (New York, 1965), 105–142; see examples in A. Lutz and H. Brinker, *Chinese Cloisonné: The Pierre Udry Collection*, exh. cat., The Asia Society Galleries (New York, 1989), nos. 136, 138.

2 J. E. McCall, "Early Jesuit Art in the Far East," *Artibus Asiae* (1947), 10/1: 121-137; 10/2: 216-233; 10/3: 283–301; (1948), 11/4: 45-69.

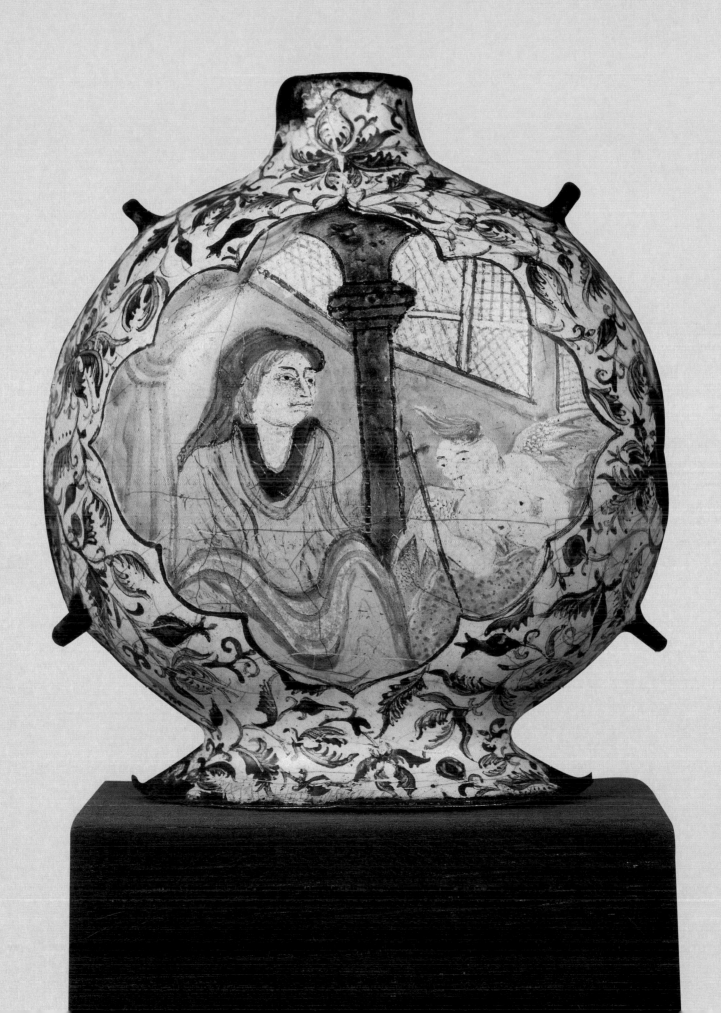

29 | Visitation

After Carlo Maratta (1625–1713)
Italian (?), late 17th century
Copper *repoussé*, mounted in modern gilt frame
13 x 11½ x 1¼ inches (33 x 29.2 x 3.2 cm); framed 12¾ x 11½ inches (32.4 x 29.2 cm)

The Gospel according to Luke narrates that Mary, heavy with child, visited her older cousin Elizabeth, herself miraculously pregnant with St. John the Baptist. After Elizabeth addressed her cousin as the Mother of God, Mary felt the Christ child leap jubilantly inside her womb (Luke I. 39–45). In this relief, Mary and Elizabeth clasp hands, their arms forming an arch that underscores Mary's womb. The fingers of Mary's other hand are splayed upon her belly, detecting the sensations within. Her face expresses a simple joy that is taken up by the other figures, including Zaccharias at right, and Joseph carrying a bundle in the background. One senses that Mary gleefully rushed ahead to greet her cousin and display her miraculous pregnancy.

Among the Roman painters of the later seventeenth century, Carlo Maratta reigned supreme. He bore the mantle of the classicizing tradition of baroque painting, looking back to Annibale Carracci (1560–1609), and ultimately to Raphael (1483–1520), for inspiration. This copper panel records one of Maratta's most celebrated compositions. It corresponds to an altarpiece of the *Visitation* for the Church of Santa Maria della Pace, Rome, painted between 1659–1666. Maratta also made an autograph etching of this design that enjoyed wide circulation.[1] Numerous preparatory drawings relate to the project.[2] While the compositions of famous paintings were often replicated as bronze plaquettes, the Hall *Visitation* was created through the far more labor-intensive technique of *repoussé*. In this process, the artist hammers the design onto a copper sheet, made pliant through the repeated exposure to heating and cooling agents. After achieving the basic relief, he then sculpts, pounces, and burnishes refinements on the surface. Many details, such as the mossy foliage dispersed over the ground, the number and density of the clouds, and the way the house has been transformed into a rocky ledge, sprouting weeds, are virtuoso embellishments unique to this format.

The physiognomy of Maratta's Virgin conforms to one of her most enduring portrait types, that of the late Raphael. The elegant slope of the forehead and nose, the delicately pulled back and bound hair, the high cheekbones, small chin, and long, elegant neck appear in works such as the *Holy Family of Francis I* (Louvre, Paris), and the Raphael School *Visitation* (Prado, Madrid) – the basis for Maratta's composition.[3] Nothing could be more suited to this drama of understated joy than the idiom of Raphael, whose beauty was long upheld, by Maratta and others, as the supreme expression of divine grace. JU

1 See Stella Rudolf's entry on the Visitation in *L'Idea del Bello: Viaggio per Roma nel Seicento con Giovan Pietro Bellori*, exh. cat., Palazzo delle Esposizioni (Rome, 2000), 460–1, no. 4.

2 For drawings relating to the *Visitation*, see Ann Sutherland Harris and E. Schaar, *Die Handzeichnungen von Andrea Sacchi und Carlo Maratta: Kataloge des Kunstmuseums Düsseldorf* (Düsseldorf, 1967), nos. 201–8; Peter Dreyer, *Römische Barockzeichnungen aus dem Berliner Kupferstichkabinett. Staatliche Museen Preussischer Kulturbesitz* (Berlin, 1969), no. 108.

3 Konrad Oberhuber, *Raphael: The Paintings* (Munich and New York, 1999), 214, 220, pls. 191, 193.

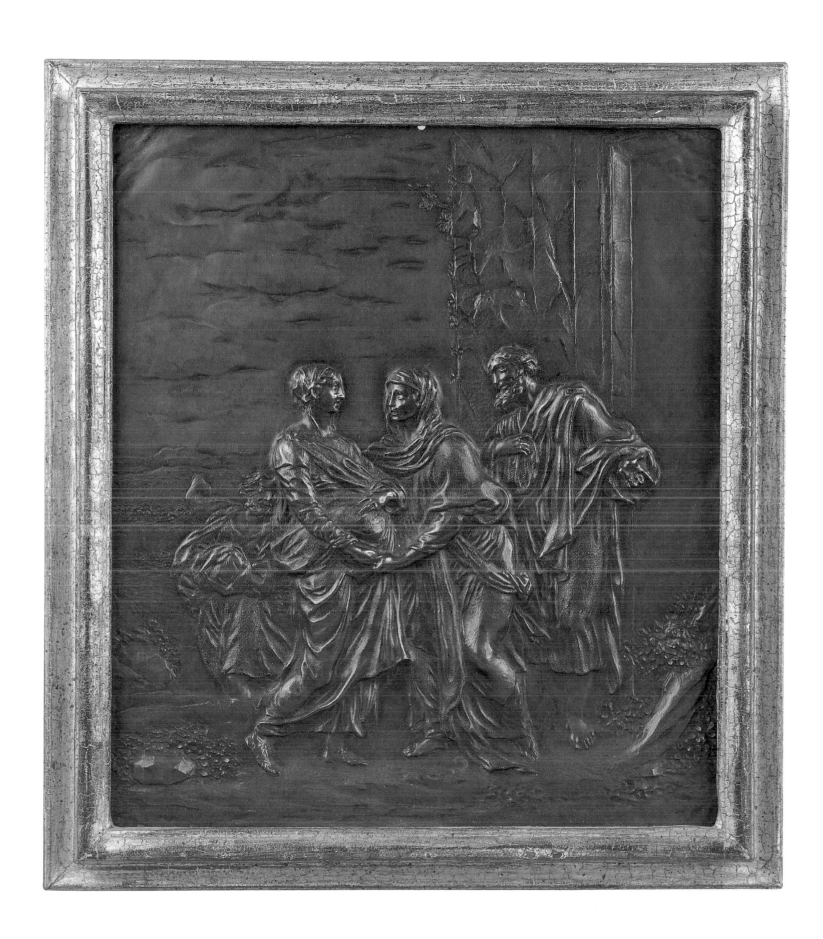

30 | Infant Christ in Swaddling Clothes

Circle of Andrea della Robbia (1435–1525)
Florentine, late 15th century
Bronze statuette
4¼ x 2⅞ x 1¼ inches (10.8 x 6.8 x 3.2 cm)

This unique bronze statuette is closely related to the glazed terra cotta reliefs made by Andrea della Robbia and his workshop around 1470–1480 for the Ospedale degli Innocenti (Piazza Santissima Annunziata, Florence). The wealthy Guild of Silk Merchants, as an act of charity, commissioned Filippo Brunelleschi (1377–1446) to design the foundling hospital. His design included an arcaded façade with nine roundels in the spandrels between the arches, but the rather complete accounts for the building (1419–51) do not indicate that sculptures were filled in during Brunelleschi's lifetime. The hospital went bankrupt in 1483, and many of the orphans starved. Andrea della Robbia's sculptures were installed only in August 1487. The ten original roundels all show foundling boys, standing with their arms outstretched diagonally downward. Their swaddling clothes are depicted in various states, from well bound up, to loosely coming undone, to falling down, so as to reveal the private parts. The particular pose of these figures recalls Christ in his shroud displaying the wounds in his opened hands.

The Hall bronze figure closely resembles one of della Robbia's terra cotta foundlings whose swaddling clothes are coming loose around his midriff.[1] The Hall bronze may have been intended to portray an image of the infant Christ, rather than one of the foundlings. Whereas all the della Robbia infants look downward, since they were mounted high above eye-level, the child cast in bronze looks up slightly, as if gazing at a viewer at closer range. Similar to the figures of the terra cottas, this figure is flattened in the back, to be applied to a planar background. It may have formed part of an insignia of the foundling hospital. No other example is known.

As to its authorship, while Andrea della Robbia concentrated on the family business of sculpture in glazed terra cotta, his uncle Luca had also made designs for the bronze doors of the north sacristy in Florence Cathedral (1445–74). Andrea may have also been familiar with the art of bronze founding. Making this cast from a small wax model would not have presented any particular technical problems. CA

Bibliography: G. Gentilini, *I della Robbia: La scultura invetriata nel Rinascimento* (Florence, 1993), 215–16.

1 See A. Marquand, *Andrea della Robbia* (Princeton, 1922), 13, fig. 8.

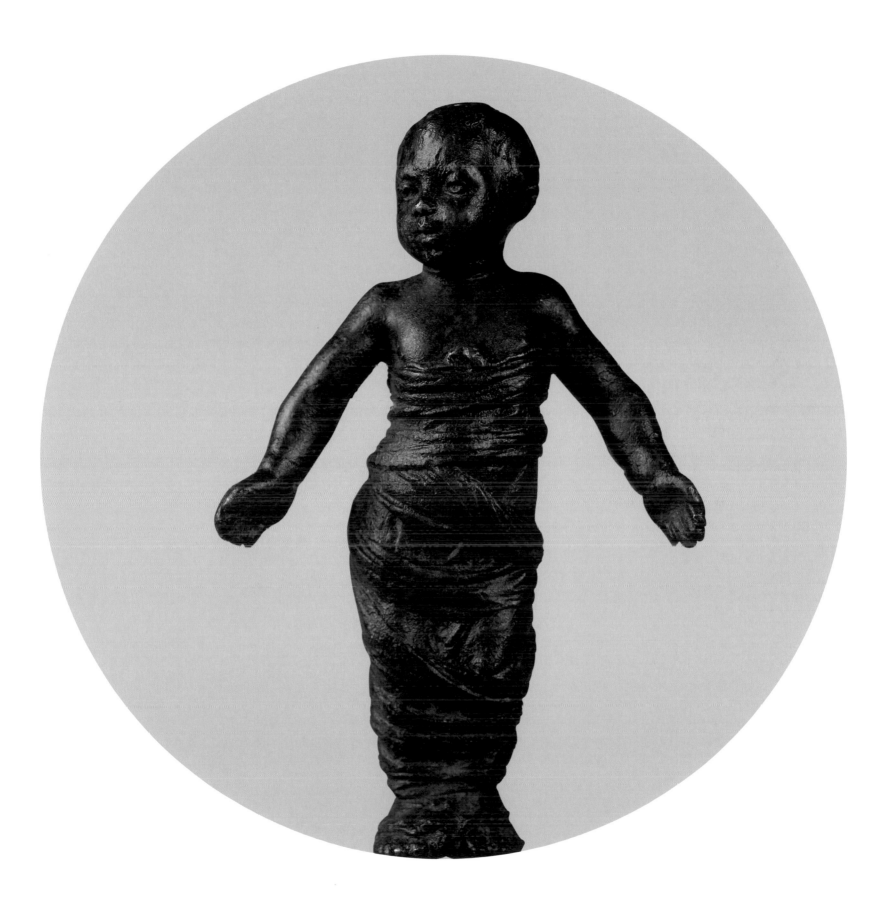

Leonhard Kern (1588–1662)
South German, mid-17th century
Ivory
7⅞ x 3½ x 2 inches (20 x 9 x 5 cm); base 9½ x 4¾ x 2¾ inches (24.2 x 12.2 x 7.2 cm)

<div style="writing-mode: vertical-rl">MARIAN AND CHRISTOLOGICAL NARRATIVES</div>

94

figure 1
Infant Christ Asleep on a Cross
Circle of François Duquesnoy
Franco-Flemish, 17th century
Bronze
Michael Hall Collectiuon

An image such as this, at the same time charming and lugubrious, was designed as a reminder of human mortality, a *Memento Mori*. Without the cross it is an ancient motif, derived from the Roman image of *Cupid*, the *Infant Hercules* asleep, or the infant god of sleep, *Hypnos*. Alessandro Algardi (1598–1652) and François Duquesnoy (1597–1643), two of the pioneers of the Roman baroque style, copied these subjects, of which good examples were in the Borghese Collection, Rome. Duquesnoy even specialized in producing enchanting depictions of innocent *putti* asleep, without further meaning, in terra cotta, bronze and ivory.[1]

The artist replaced the lion skin symbolic of the infant Hercules, or the bunch of poppy heads of Sleep, with a cross, thereby adding Christian meaning to the imagery. The knowledge that the peaceful sleeping baby will die a tortured death as an adult lends extra pathos to the image. His Resurrection, however, brings hope of salvation. The little sculpture would have been used most likely in prayerful contemplation in the home.

The slight, deliberate abstraction of the forms of the infant body with all its baby fat and the tightly curled hair are characteristic of the famous ivory carver Leonhard Kern from the province of Swabia in southern Germany. A member of a dynasty of provincial sculptors, Kern's career ran in parallel with that of Duquesnoy, the master of sculpted *putti*. One of fourteen children, Kern was in a good position to know about the appearance of infants asleep or at play, and he exploited this almost as much as Duquesnoy did (see fig. 1). Indeed, one of the most famous German bronzes of the period is a small group by Kern depicting naked boys playing piggy-back. The image is known also in a boxwood carving of 1635–45, which was once in the collection of Goethe.[2] Closest in type and subject to the present figure is a tightly-knit ivory group depicting the *Christ Child and Infant St. John Embracing*.[3] Both have curly hair, and the baby Jesus, treading on a snake, particularly resembles the present rendering. **CA**

Bibliography: E. Grünenwald, *Leonhard Kern, ein Bildhauer des Barock* (Schwäbisch Hall, 1969), *passim*; H. Siebenmorgen (ed.) *Leonhard Kern: Meisterwerke der Bildhauerei für die Kunstkammern Europas*, exh. cat., Hällisch-Fränkisches Museum, Schwäbisch Hall (Sigmaringen, 1988), nos. 110–14.

1 Musées royaux d'art et d'histoire, *La sculpture au siècle de Rubens*, exh. cat., Musée d'Art Ancien (Brussels, 1977), 73, no. 40.

2 The sculpture measure 14.8 cm high. See Stadt Forchtenberg, *Die Künstlerfamilie Kern, 1529–1691*, (Sigmaringen, 1998), 151–57, esp. 153.

3 This sculpture, in a private collection, measures 17.3 cm high. See *Die Künstlerfamilie Kern*, as in note 2, no. 110.

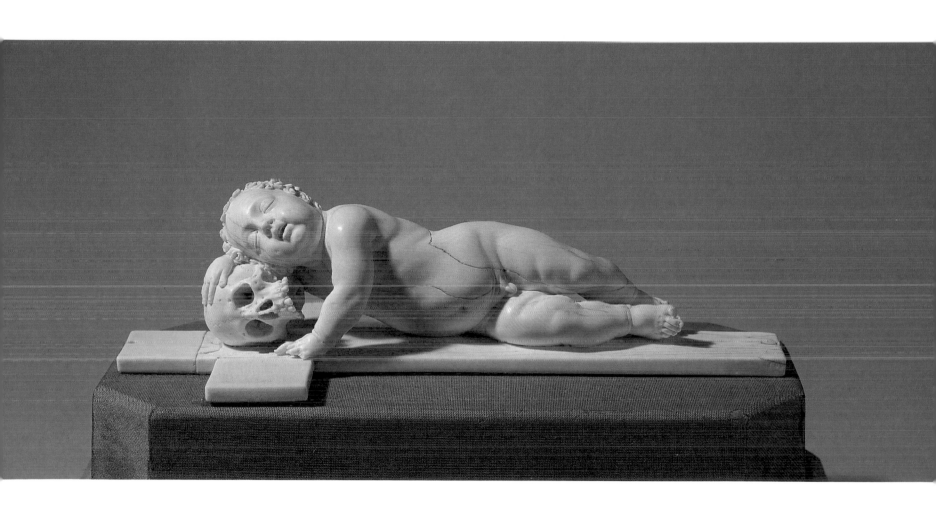

32 | Infant Christ as Salvator Mundi

Manner of Alessandro Algardi (1598–1654)
Roman, late 17th century
Bronze
13¾ x 6½ x 5 inches (35 x 16.5 x 12.7 cm)

The image of the *Infant Christ as Salvator Mundi* embodies a paradox. The tender, vulnerable infant body adopts a decisive gesture of benediction and a bold *contrapposto* stance, infused with the power of God. The child rests his hand upon an orb, thereby expressing his omnipotence over the world. In no other iconographic type is Christ so physically human and so potently divine.

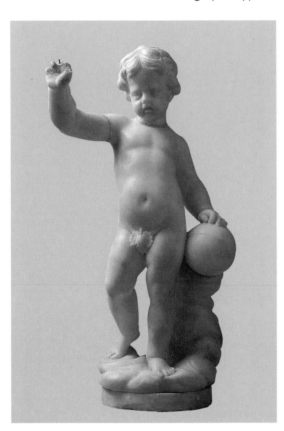

figure 1
Infant Christ as Salvator Mundi, late 17th century
Manner of Alessandro Algardi
Marble
Michael Hall Collection

The type, proportions, and modeling of the figure resemble several well-known bronze works by Algardi, the leading sculptor, after Bernini, of the Roman baroque. The most conspicuous feature of the child's physiognomy is his high, protruding forehead that slopes down to the brow. Below this, the eyes are deeply set and all the facial elements are rather densely concentrated between the chubby jowls. This arrangement, especially the pronounced forehead, appears in the Christ child of the *Rosenkranz Madonna* in Berlin, and its many variations.[1] This child extends his arm in a fashion and form similar to the Hall bronze. It also features the same elongated torso with a markedly distended abdomen and ample navel. This type of torso occurs in many of Algardi's representations of infants, such as the *Infant Hercules* (Burghley House, London), *Putto on a Hippocamp* (Walters Art Gallery, Baltimore), the *Rest on the Flight into Egypt* (see cat. no. 36), the *Baptism of Christ* (Cleveland Museum of Art), and the stucco reliefs in the vestibule of the Villa Doria Pamphili, Rome.[2] These various infants also exhibit the thick wavy hair, pudgy legs, and swollen ankles and wrists of the Hall *Salvator Mundi*.

The Hall collection also contains a marble version of the *Salvator Mundi* (fig. 1). It probably was carved after the same wax or clay model used for the bronze cast. Despite its alabaster-like quality, the marble fails to capture the supple texture of puerile flesh as effectively as the gleaming bronze surface and its fine patina. JU

1 Jennifer Montagu, *Alessandro Algardi* (New Haven, 1985), II: 348–50, nos. 43.C.1–43.D.5, pl. 195; For further illustrations, see Jennifer Montagu, *Algardi: L'altra faccia del barocco*, exh. cat., Palazzo delle Esposizioni (Rome, 1999), 224–7, nos. 57–60.
2 Jennifer Montagu, 1985, nos. 127.C.3, 104.C.1, 4.C.1–4.E.1, 8.C.21, A.201.

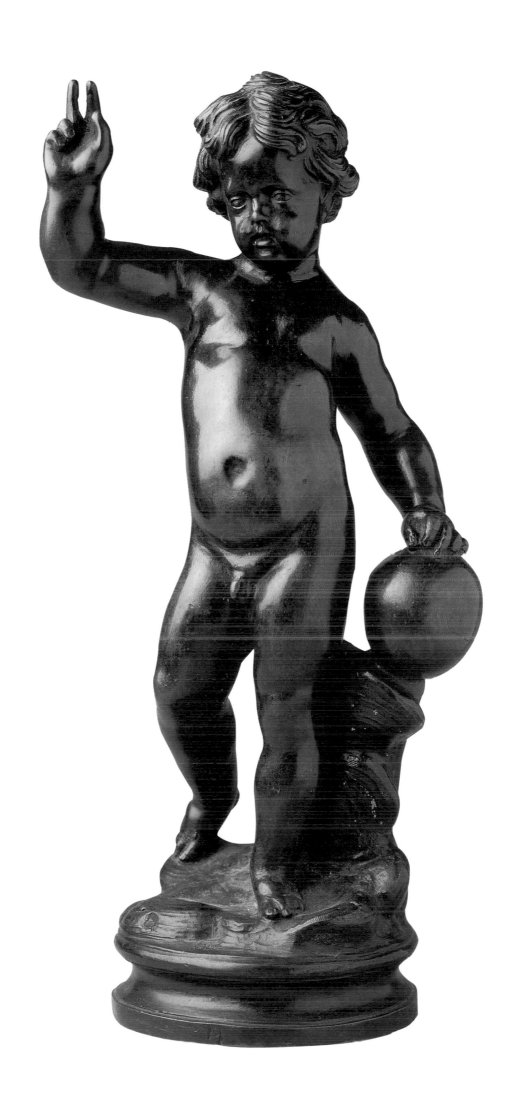

Circle of Ercole Ferrata (1610–1686)
Italian, late 17th/early 18th century
Sliver, with gilt nimbus and orb
14 x 7½ x 5 inches (34.3 x 19 x 12.7 cm)

This silver figure embodies the energy, spirit, and tactility of the best baroque sculpture. Sculpted in clay or wax, it was cast in a high silver alloy. The founder cast the right arm, head, upper body, and lower body separately and almost imperceptibly soldered them together. Through variations of modeling and surface work, the silver assumes an amazing range of textures.[1] The silversmith has burnished the fluttering drapery around the arm and between the legs to a high degree of polish. This catches highlights like the sheen of satin. The flesh, though still lustrous, has a uniform matte finish. The artist has achieved this through a subtle stippling of the surface. One receives the sensation of an infant's soft, pudgy flesh that would yield to the touch. The same finish, without stippling, is employed for the hair, styled in densely matted curls. The vigorous *contrapposto* stance and dramatic benedictory gesture endow the figure with an immanent energy, as if infused by the Holy Spirit. The radiating nimbus and globe, both gilt, add a spark of color to the swirling movement of the figure. The panoply of surface textures, the dynamic pose, and the use of color are hallmarks of the sculpture of Gianlorenzo Bernini (1598–1680). The Hall *Salvator Mundi* closely relates to the bronze and gilt bronze cherubs that populate the *Baldacchino* and the *Cathedra Petri* at St. Peter's, in Rome, as well as the countless stucco versions that adorn the basilica and Bernini's other churches.

In his huge Vatican projects, Bernini codified a cherub type that influenced the next two generations of sculptors, especially those in his circle. This fact hinders the precise attribution of the Hall *Salvator Mundi*, despite its exquisite quality. One possible candidate is Ercole Ferrata, who worked on some of Bernini's last projects and also collaborated with Alessandro Algardi (1598–1654). The cherubs that flank the monument to Giulia Ricci Parravicini (San Francesco a Ripa, Rome) have the same body type – pudgy breasts, stocky legs, and swollen ankles – as the Hall figure. The facial features are even closer. The cherubs and the *Salvator Mundi* feature high, slightly protruding foreheads. The eyes are deeply set with heavy lids. Instead of the thick wavy coifs of most baroque *putti*, there are wisps of hair, parted to reveal much of the forehead. Each of these figures has a pug nose, a small, almost puckered mouth and cheeks inflated like those of a jazz trumpeter. Swaths of drapery weave dynamically around certain parts of the anatomy. The same features characterize Ferrata's cherubs sculpted in relief, such as the stucco *Angels with the Attributes of St. Cecilia* (Sant'Agnese in Agone, Rome). The arrangement of the hair and facial features in the silver *Salvator Mundi* also resemble the host of cherubs at the base of the statue of St. Elizabeth in Wroclaw Cathedral, Poland.[2] Despite the compelling similarities with works by Ferrata, the *Salvator Mundi* may also derive from the circle of the next generation of Florentine sculptors: Giovanni Battista Foggini (1652–1725) and Massimiliano Soldani Benzi (1656–1740). Their works abound with infants of the same generic type as the Hall figure, though the closest analogues are the gilt bronze cherubs on the sarcophagus of St. Maria Maddalena Pazzi in the Carmelite Convent at Careggi, a joint project.[3] JU

1 On cast silver figures during this period, see Jennifer Montagu's accounts of the master silversmiths, Giovanni Giardini, Francesco Giardoni, and Giuseppe Gagliardi, in *Gold, Silver, and Bronze: Metal Sculpture of the Roman Baroque* (Princeton, 1996), 117–176.

2 Andrea Bacchi, *Scultura del '600 a Roma* (Milan, 1996), 803–5, pls. 372, 376, 391–2.

3 Klaus Lankheit, *Florentinische Barockplastik: Die Kunst am Hofe der letzten Medici* (Munich, 1962), 46–7, pl. 15.

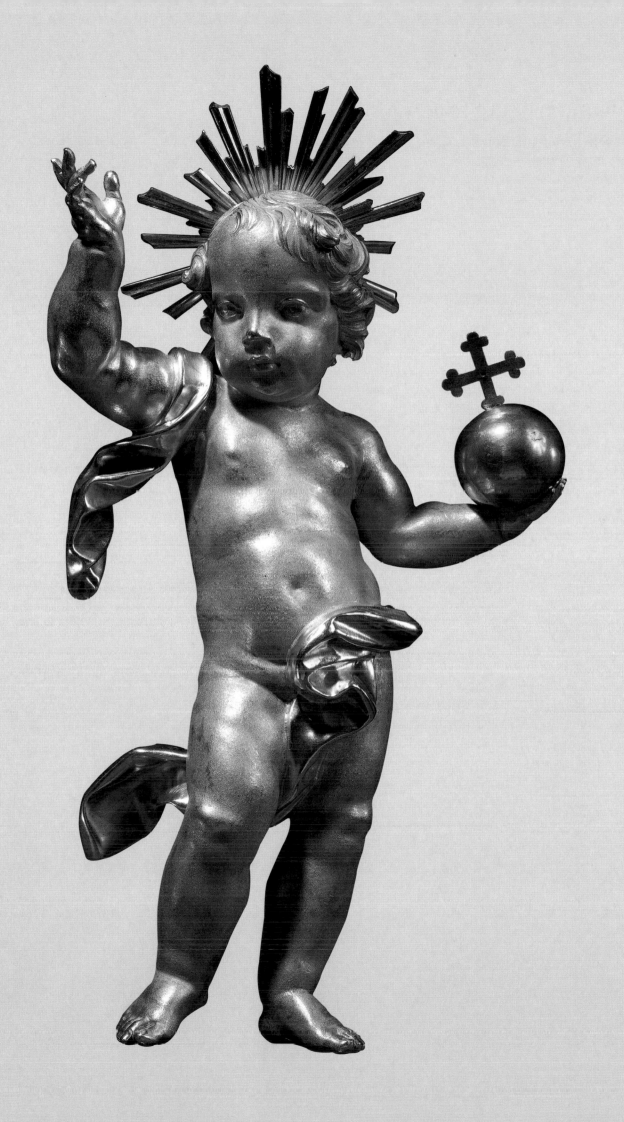

34 | Adoration of the Magi

Attributed to Matteo Cesa of Belluno (c. 1425–c. 1495), or his son Antonio (active c. 1500), after Galeazzo Mondella, called Moderno (c. 1467–1528/29)
North Italian, mid-16th century
Polychromed wood
19¾ x 14½ x 2¼ inches (50.2 x 36.8 x 5.7 cm)

This polychromed wood carving demonstrates the interface that existed in the Renaissance between painting and relief sculpture: its composition is derived from a plaquette in bronze by Moderno, which is itself lifted from an earlier painting by Vivarini of c. 1445, with further debts to Mantegna (1431–1506). Plaquettes and engravings were two media for serial reproductions invented during the Renaissance which disseminated artistic imagery far and wide (as photographs have done more recently). Douglas Lewis has conducted fundamental research into Moderno's influences, identifying Antonio Vivarini's similar cycle of six panels of the *Life of the Virgin* (now in Wiesbaden), as a direct source for a number of compositions.[1]

The wood-carver has simplified Moderno's rather congested composition by removing a pageboy and the infant St. John the Baptist from the lower corners, as well as some of the lengthy *cortège* behind the Magi. The most startling change, and one that betrays a knowledge of another of Moderno's renderings of Christian themes, is the substitution of his thatched, gabled "northern"-looking stable with a magnificent open arcade from a ruined classical building. The collapsed dome with blue sky showing through the jagged masonry must have drawn upon the similar, though more logically disposed, feature in Moderno's *Flagellation of Christ* (see cat. no. 51).

These debts to Moderno suggest, although they do not predicate, an origin in the north of Italy. Artists more often carved wood in the southern foothills of the Alps than further south in the peninsula, so the choice of material helps to locate the relief. The panel may have formed part of a more extensive retable, with other scenes from the lives of Christ or of the Virgin Mary.

Since Moderno's source was a painting by Antonio Vivarini, a possible candidate for this work is Matteo de Cesa of Belluno, a panel painter and wood carver who on another occasion produced a copy of Alvise Vivarini's high altarpiece from Santa Maria dei Battuti, Belluno. His son Antonio is known from one painted altarpiece in Visome, Belluno, dated to 1500. A highly gifted local artist, with strong leanings towards the novel style of the Renaissance – perhaps Matteo or Antonio de Cesa – is the likely author of this *Adoration*. **CA**

Bibliography: G. dalla Vestra, in *Dizionario Biografico degli Italiani* (Rome, 1980), XXIV, 116–18; R. Pallucchini, *I. Vivarini* (Venice, 1961), 102, no.49, fig. 49; G. Ericani, "La scultura lignea del Seicento nel Veneto", in A. M. Spiazzi (ed.), *Scultura lignea barocca nel Veneto* (Verona, 1997), 20, 22, 24, pl. 7.

1 Douglas Lewis, "The Plaquettes of 'Moderno' and His Followers," *Italian Plaquettes. Studies in the History of Art* 22 (1989): 105–141, esp. 119 ff.

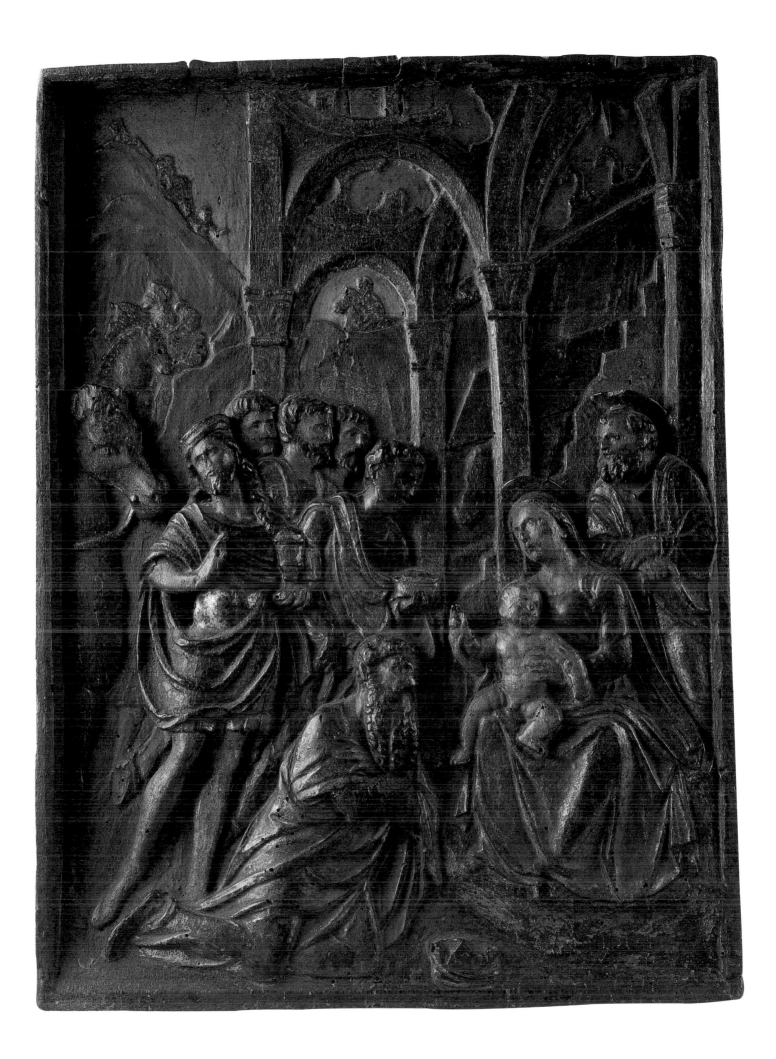

35 | Adoration of the Magi

After a design by John Flaxman (1755–1826)
British, c. 1800
Bronze relief, cold gilding
14⅛ x 20 x 1⅛ inches (35.8 x 51 x 2.8 cm)

figure 1
John Flaxman
Adoration of the Magi **(detail)**
Pen and ink wash
The British Museum, London

It is hard to believe that the bronze relief of the *Adoration of the Magi,* after a design by John Flaxman, was not created in the first half of the twentieth century. The stark simplicity of the design and the broad planes of voluminous drapery belie its origins in the eighteenth century. Flaxman, a precursor of William Blake (1757–1827), specialized in Neoclassical designs for sculpture, Wedgwood bisque, and graphic works. An economy of form and gesture, an elegance of line, and a serenity of expression characterize his works. Flaxman's style finds echoes in modern works by Ernst Barlach (1870–1938) and Eric Gill (1882–1940).

The composition is a formal arrangement of broad curves. All vectors lead to the *Lekythos*-shaped vase in the center containing one of the offerings to the infant Christ. Its formal perfection connotes the austere simplicity of the entire design. The overlapping volumetric forms, the isocephalic arrangement of the genuflecting Magi, and their eloquent gestures of submission recall Giotto's frescoes in the Scrovegni chapel, Padua, from the early fourteenth century.

The Hall relief follows the composition of a pen and wash drawing in The British Museum, London (fig. 1). A plaster relief after this design once adorned University College, London, but was destroyed during World War II.[1] The Hall relief, the only known bronze version, may derive from this lost model. Cast in one piece with an integral frame, it has a rich patina with subtle gilded haloes. MH

1 David Bindman, *John Flaxman*, exh. cat., Royal Academy (London, 1979), 123, no. 145. Another example of the plaster relief was discovered some years ago in Sir John Soane's Museum, London, with a dedicatory inscription to Soane.

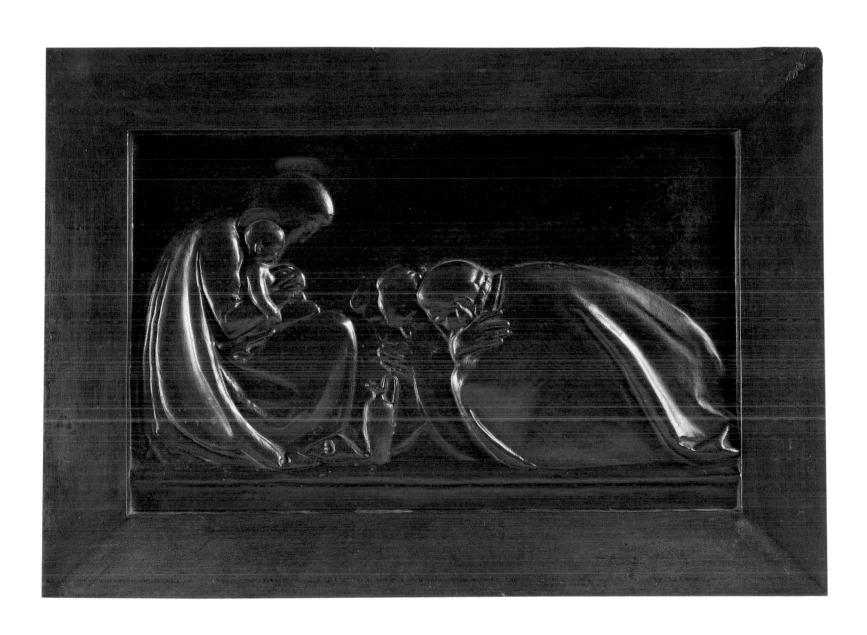

36 | Rest on the Fight into Egypt

Alessandro Algardi (1598–1652)
Roman, 1632–37
Bronze
13¾ x 11⅝ inches (34.5 x 29.6 cm); integral marble frame: 18¾ x 20½ x 3⅛ inches (47.6 x 52 x 7.9 cm)

104

There is no reference to such a model by Algardi in the known early inventories, but its author-ship is documented by an engraving by Edward Le Davis (c. 1640–1684?) inscribed *"Alexander Algardi inu – franc Chauveau excudit C.P.R. – Edwardus le Davis fecit"* ("Alexander Algardi designed it – Franc Chauveau engraved it – Edwardus le Davis executed it"). This print, in reverse, omits the angel and shows the Holy Family in an octagonal field. Most of the numerous casts of this relief include the angel, although some depict only the Holy Family, and they vary in shape, with some being oval and others octagonal.

This subject, as well as other representations of the Holy Family related to this relief, reappear in a number of drawings by Algardi. Copies of the *Rest on the Flight* also exist in marble and silver. Pietro Cannata has recently pointed to similarities with the same subject in works by the sculptor's teacher, the painter Ludovico Carracci (1555–1619), and other Bolognese painters such as Guido Reni (1575–1642), with whom Algardi was compared as "the new Guido in marble."[1] The composition appears to flow in gentle rhythms across the surface of the bronze, and the cloth stretched out by the angel behind, masks off any recession into the distance. Only the tree with its bunch of foliage indicates the rural setting. A similar use of a cloth behind the principal figures appears in a relief by François Duquesnoy (1597–1643) depicting *Sacred and Profane Love*, and two early paintings by Poussin depicting *Bacchanals of Putti*. Algardi certainly knew Duquesnoy, and he is said to have accompanied Poussin in drawing after the antique during their early years in Rome. It was at this time that Algardi usually composed his reliefs on the surface, projecting from it rather than receding into depth. A certain awkwardness would also suggest an early date, probably in the mid-1630s; this is particularly evident in Joseph's uncom-fortable pose (and his rather indeterminate spatial position), and the unresolved distinction between the Virgin's veil and the cloth behind, which is indicated differently in various casts. While the background is frequently punched, the heavy gouging on this cast, both there and on the drapery, is highly unusual. Indeed, the afterwork here is generally lacking in subtlety.

The relief exudes a sense of calm and tenderness, as the Virgin gently holds the hand of the sleeping Child while raising the cloth to fold it over him, and the angel shades them with a drapery, perhaps to hide them from any searching soldiers. Joseph (the patron saint of libraries) holds a book while gazing thoughtfully at Mary. It is customary to depict the Virgin holding a cloth over the sleeping Christ Child as an indication of the shroud in which his corpse will be wrapped; but here, if Algardi intended to allude to such a premonition of Christ's future sacrifice, he certainly did not emphasize it, although one might discern a hint of melancholy in the expres-sion of Joseph. Jesus, the focus of attention for both the Virgin and the angel, sleeps peacefully in his fully incarnate humanity, secure in the loving care of his mother. JM

Bibliography: *Roman Baroque Sculpture. Five College Roman Baroque Festival*, exh. cat., Smith College Museum of Art (Northampton, 1974), no. 16; Jennifer Montagu, *Alessandro Algardi* (New Haven, 1985), 2 vols, II, 308, cat. 4.C.9.

1 Pietro Cannata, "Flagellazione di Gesù," *Algardi: L'altra faccia del Barocco*, exh. cat., J. Montagu, ed.(Rome, 1999), 122.

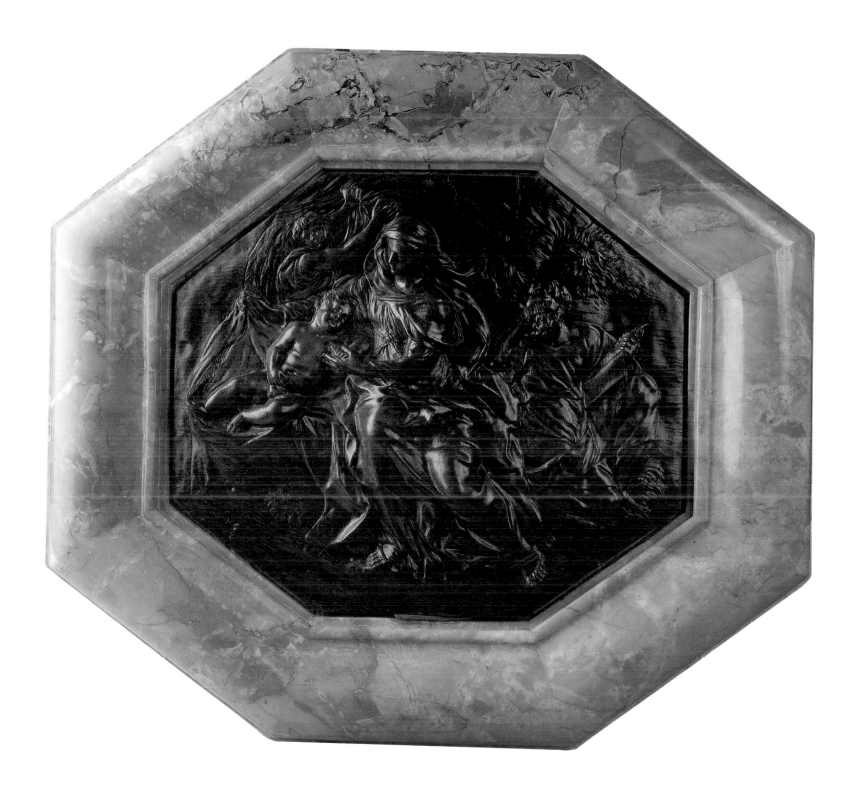

37 | Holy Family adored by Saints John the Baptist, Francis, Anthony (?) and George (Rest on the Return from Egypt)

Attributed to Francesco di Virgilio Fanelli (1577–1661)
Genoese (?), early 17th century
Bronze plaque
9½ x 7¾ x 1½ inches (24.1 x 19.6 x 3.8 cm) (in integral frame)

Several variants of this general composition have come to light recently. The earliest of these reliefs to appear on the market was acquired by the Royal Ontario Museum in Toronto in 1975. This image lacks the saints, apart from the infant St. John with his lamb, and shows instead on the right an open landscape with a lake and distant promontory, a lighthouse and city behind. Two cherubim descend, bearing a wreath and a bouquet of roses, presumably alluding to the doctrine of the rosary. The types of *putti* – faces, hair and anatomy – recall Florentine mid-seventeenth-century artists such as the Taccas or Francesco Fanelli.[1]

Another piece appeared on the market in 1980.[2] This plaque is gilded, of fine quality, and closer to the present composition with its additional saints and rather claustrophobic crush of figures. It bears the initials GAM on its verso, which were taken, erroneously, to be those of the Milanese medalist and coin engraver Giacomo Antonio Moro, who was Master of the Papal Mint between 1610 and 1624 under Paul V and Gregory XV. The piece also had an old Milanese provenance, which appeared to corroborate that attribution. However, the initials could have indicated the owner and not the artist.

The Hall piece is most closely comparable in technique to the work of Francesco Fanelli: it is thinly cast, and there are traces of no fewer than twenty one sprues on the reverse, which is characteristic of his careful casting methods.[3] Its waxy-looking surface covered in a dark patina is also more readily associated with Fanelli. The treatment of the fruit tree and the helmet of St. George are analogous to documented works by Fanelli. To further corroborate the attribution, it may be noted that St. George was a favorite saint in Genoa; the republic of Genoa even adopted his coat of arms, a red cross on a white background.

Fanelli seems to have manufactured a number of reliefs, both religious and secular. A pair of oblong plaques with Christian themes, often with their corners chamfered to make them octagonal, had formerly been attributed to the Florentine bronze sculptor Ferdinando Tacca, but are now more usually associated with Fanelli on both stylistic and technical grounds. These represent ill-assorted subjects: an apocryphal episode from the infancy of Christ, the *Feast in the House of the Robber*, and *Christ Falling under the Cross*. In the first, the Virgin and Child closely resemble the respective figures in the Hall composition. In the last, the Roman soldiers harassing Christ – especially the one whose face appears just above the top of the cross – closely resemble the figure of St. George entering the scene from the right. **CA**

Bibliography: J. Pope-Hennessy, "Some Bronze Statuettes by Francesco Fanelli," *The Burlington Magazine* XCV (1953): 157–62 (reprinted in J. Pope-Hennessy, *Essays in Italian Sculpture*, London, 1968, 166–67); E. P. Armani, *La Scultura a Genova e in Liguria dal Seicento al primo Novecento* (Genoa, 1988), passim, 79, n. 6, pls. 32–33, 70; A. White, "Fanelli," J. Turner ed., *The Dictionary of Art* (London, 1996) vol. 10, X, 786–87.

1 The plaque, now in Toronto, was purchased in London, in 1975. See C. Avery, *Florentine Baroque Bronzes and Other Objects of Art*, exh. cat., Royal Ontario Museum (Toronto, 1975), 34-35.

2 See the sales catalog for London, Christie's, 9 December 1980, lot 170.

3 Joachim von Sandrart, *Academie der Bau-, Bild- und Mahlerey-Künste von 1675*, Arthur R. Peltzer, ed. (Munich, 1925), 235.

38 | Christ in the Temple

Circle of Donatello (1386/87–1466)
Florentine, 15th century
Limestone
12½ diameter x 1½ inches (31.75 diameter x 3.8 cm)

This limestone relief depicting *Christ in the Temple* encompasses many values of mid-fifteenth-century sculpture, particularly that by Donatello. As the precocious Christ Child elucidates subtle points of doctrine, the learned doctors on the steps below unanimously respect his discourse. Each figure responds differently to Christ's extraordinary display of erudition. The figure at the upper left, for example, clasps his hands in reverence, while the figure below and to the left seemingly struggles to understand the Child's point. The figure at that scholar's feet, who completes the arc, scans a text in preparation to confirm or challenge the child. Meanwhile, as the figure at the far right leans over the shoulder of the awestruck scholar in front of him and shares his own disbelief at this miracle, his body forms an arc that mirrors the figures at the right. Compositionally, the figures reinforce the *tondo* format of the relief.

The figures would perhaps threaten to spin out of control if not for the extensive grid under-pinning them. The vertical partition between the two groups is reinforced by the colonnettes framing the niche behind the Child, by the column at left, and by the sides of the steps beneath him. The horizontal surfaces and trim of the steps (and altar?) on which the figures sit balance those vertical elements. Nevertheless, the steps function awkwardly. The inconsistency of their recession into space, as in the slope of the two nearest the viewer, and the ambiguity of their relationship to the scholars and to the column at the left demonstrate that this relief is not the mature work of a major artist. The massive head sprouting from the stooped shoulders of the figure at lower left demonstrates that this sculptor struggled with figural proportions. Further-more, he was not averse to overly convenient shortcuts, such as the niche at that figure's feet. But he was capable of fine passages, such as the drapery on the lower half of the Christ child. In conveying the variety of responses to Christ and in exploiting the *tondo* format, the sculptor preserves the legacy of Donatello and other mid-*quattrocento* sculptors. KF

Bibliography. J. Pope-Hennessy, *Italian Renaissance Sculpture* (1958, 3rd ed., New York, 1985); M. Greenhalgh, *Donatello and His Sources* (London, 1982); B. A. Bennett and D. G. Wilkins, *Donatello* (Oxford, 1984); J. Pope-Hennessy, G. Ragioneri, and L. Perugi, *Donatello* (Florence,1985); *Italian Renaissance Sculpture in the Time of Donatello*, exh. cat., A. P. Darr, ed.(Detroit Institute of Arts, 1985); C. Avery, *Donatello: An Introduction* (New York, 1994).

39 | Baptism of Christ

Follower of Bernard Palissy (1510?–1590)
French, 17th century
Lead glazed ceramic
19½ x 15 x 3 inches (49.5 x 38.1 x 7.5 cm)

The relief in this large basin depicts the *Baptism of Christ* with St. John the Baptist and adoring angels and *putti*. The *putti* support and surround a radiant yellow nimbus emanating from a white dove with outspread wings representing the Holy Spirit. The surrounding frame is unusual, comprising a rocky background adorned with seashells, a dragonfly, beetles, moths, snakes, frogs, and little lizards. These forms were probably cast from dead specimens. The naturalistic foliage and swirling, rippling pool of water had became a convention and appear in many of Palissy's decorative reliefs. The vivid coloration of fresh greens, golden yellows, subtle clear glazes of blue and dark brown accents create a lively sensation of hyper-realism. This leads the viewer to want to touch the animals, shells, and foliage and to lift them from the frame.

The minute details would indicate considerable finishing in the soft clay after the casts had been made and applied to the damp body of the basin. The back of the basin is glazed with a mottled surface of manganese, blue, green, and yellow. Two suspension holes were added before firing. The crisp and sharp piecrust edge of the relief is an idiosyncratic facture of ceramic works by Palissy and his immediate followers. This helps establish an early date in the seventeenth century for the relief. Later examples, especially from the nineteenth century, consistently display rounded edges. Several French families, centered in Tours and later in Paris, formed workshops to produce ceramics with Palissy's style: cast naturalia with similar coloration.[1]

During the tumultuous wars of religion of the sixteenth century, Palissy designed and constructed elaborate grottoes for the arch-Catholic Catherine de' Medici. However, he also accepted commissions from Protestant patrons. Outside of the caryatids which appear to hold up the ceiling of Catherine's grotto, he made few ceramics with representations of human figures. Nor do many works, either by Palissy's close followers or his nineteenth-century copyists, depict figures from Christian iconography. In this basin, which marks a departure in that respect, the shells and aquatic creatures lend something of the "reality effect" to the watery theme of Christ's baptism in the River Jordan. **MH**

Bibliography: Leonard Amico, *Bernard Palissy: In Search of Earthly Paradise* (Paris/New York, 1996).

1 Marshall P. Katz and Robert Lehr, *Palissy Ware: Nineteenth-Century French Ceramists from Avisseau to Renoleau* (London/ Atlantic Highlands, 1996).

40 | Christ and Saint John the Baptist

Follower of Giambologna (1529–1608)
Florentine (?), 17th century
Silvered bronze
Christ: 8½ x 4 x 2¼ inches (21.6 x 10 x 5.75 cm); John: 8 x 3½ x 2 inches (20.3 x 8.8 x 5 cm)

These two figures depict Christ and St. John with arms raised above their heads and index fingers pointing towards their faces. Christ is elaborately draped in a knotted tunic with scalloped edges over a long dress and a loose neckline, fully revealing his long, slightly curled locks of hair at the back. The bronze surface is exquisitely finished with goldsmith-like quality; for example, the crown of thorns has pierced the skin leaving droplets of blood across his forehead. Both hands and feet show wounds from the nails. As Christ strides forward, his foot crushes the ends of his draped cloak. His mouth is slightly opened and his face is Praxitelean, particularly his nose, the bridge of which comes directly from the forehead. His eyes are open wide, and his bifurcated beard conforms to traditional iconography of the time.

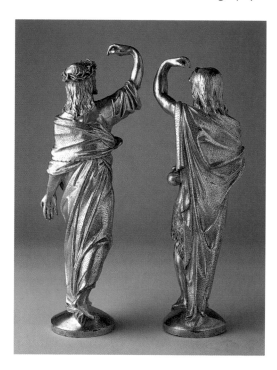

The drapery folds, which meet at right angles, are strongly reminiscent of drapery in Giambologna's *oeuvre*. The raised arm recalls Giambologna's *Bacchus*, the first bronze sculpture he created in Florence, which is now in the niche facing the end of the Ponte Vecchio. The cloak has been stippled after casting with minuscule slits, giving the appearance of the exterior of a depilated animal skin. The fingernails and toenails are meticulously articulated, and the overall finish and chasing in skin surfaces, hair, and anatomical details are highly refined.

The figure of John the Baptist is covered with a delicately chased and incised fur cloak. The crisp finish of his baptismal scallop shell matches the careful attention paid to the toenails and fingernails. The drapery flows onto the base to support the figure under the right leg. The physiognomy displays a furrowed brow, widely set eyes, and a slightly Semitic curved nose. His full moustache and beard allude to his isolation as a hermit in the desert. The drapery folds in the back cross and re-cross in a strongly Giambolognesque manner.

The iconographic origins of the statues are found in the Gospel according to John. The design served a didactic purpose, referencing Jesus's declaration in John 3.5: "... before you can get into God's kingdom, you must be born not only by water, but by the Spirit."

These miniature sculptures were meant to be seen in the round and were mostly likely used as devotional statuettes which could be removed from an altar complex.[1] **MH**

1 The undersides of the cylindrical mound bases bear no holes for attachment and are simply concave with some rust stains resulting from air escapement apertures. This indicates that they were sculpted in wax that was modeled around iron armatures covered with core material. They were rendered into bronze sculptures in the lost wax casting process, then finished, covered with silver, and burnished.

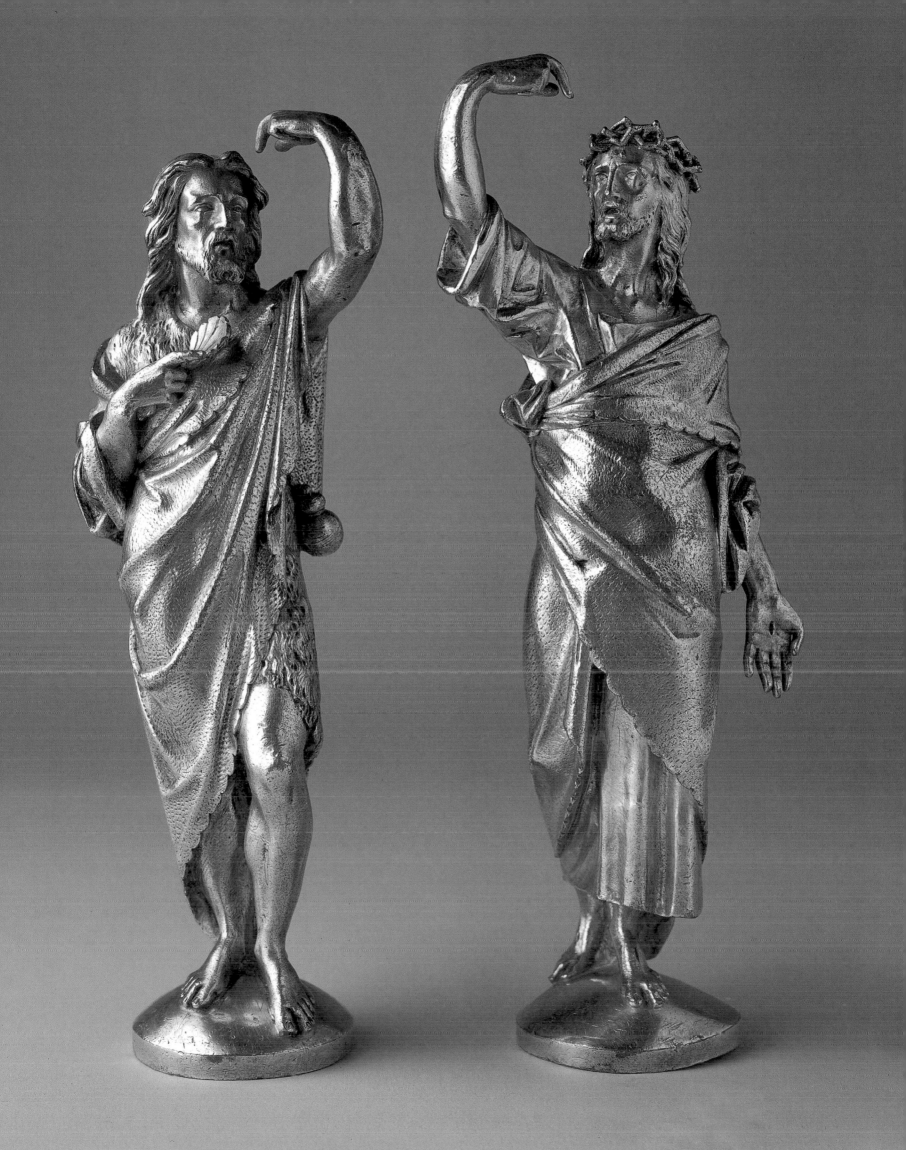

41 | Transfiguration

Master B. F. (Francesco Binasco, c.1486–1545)
Lombardic, early 16th century
Illumination on vellum
14¼ x 14 x 3 inches (36.2 x 35.5 x 7 cm)

This historiated initial depicting the *Transfiguration* is probably the work of the Master B. F., whom Paul Wescher has convincingly identified as Francesco Binasco.[1] A goldsmith and engraver as well as a painter and illuminator, Binasco is recorded as working for Massimiliano Sforza in 1513 at the Milan mint and for Francesco Maria Sforza, Duke of Milan (r. 1521–35) as court illuminator. His earliest known work is a *Liber hiemalis ordinis SS. Ambrosii* of 1486, now at the Archivio Capitolare in Milan, and his latest attributable works are three choir-books decorated after 1542, now in the Biblioteca Trivulziana of Milan. Throughout his extraordinarily long career, his style remained very much in the Lombard tradition. As demonstrated by the *Circumcision* in Philadelphia, he drew heavily on the work of Leonardo da Vinci (1452–1519) and Bernardino Luini (1480/85–1532).

Nevertheless, the present work depends on earlier versions of the subject by Raphael (1483–1520) and perhaps Giovanni Bellini (1431/36–1516). Peter, James, and John, for example, recall the poses of their counterparts in Bellini's *Transfiguration*, of circa 1475–80 (Museo di Capodimonte), particularly the reclining figure of John at right and the recoiling figure of James at left. Binasco's Christ also invokes his counterpart in Bellini's work, as he is standing on, rather than floating above, the high mountain on which Moses and Elijah appear when the voice of God declares, "This is my own dear Son, and I am pleased with him. Listen to what he says!" (Matthew 17.5). On the other hand, Christ assumes a monumental *contrapposto* stance that more closely recalls his counterpart in Raphael's famous *Transfiguration* of 1517. Like Raphael, Binasco horizontally bisects the image by surrounding the mountain top with a wreath of clouds. However, the illuminator does not slavishly imitate his illustrious model, for he does not divide the image to distinguish the moment of the *Transfiguration* from the subsequent episode of the demoniac boy whom only Christ could cure. Instead, he reserves the lower portion of the miniature for the three apostles, terrestrial witnesses to the celestial validation of Christ's sanctity. In this way he turns a historiated initial into a monumental narrative that confirms Christ's iconic status. **KF**

Bibliography: M. Harrsen and G. K. Boyce, *Italian Manuscripts in the Pierpont Morgan Library* (New York, 1953), 55–56; M. Levi D'Ancona, *The Wildenstein Collection of Illuminations: The Lombard School* (Florence, 1970), 97–105; G. Mariani, Canova, *Miniature dell'Italia settentrionale nella Fondazione Giorgio Cini* (Vicenza, 1978), 59–63; J. J. G. Alexander, "The Livy (MS. 1) Illuminated for Gian Giacomo Trivulzio by the Milanese Artist B. F.," *Yale University Library Gazette* 66 (1991): 219–34; and P. G. Mulas, *B. F. et il Maestro di Paolo e Daria* (Pavia, 1991).

1 P. Wescher, "Francesco Binasco: Miniaturmaler der Sforza," *Jahrbuch der Berliner Museen* 2 (1960): 75–91.

42 | Dormition of the Virgin

French or Italian (?)
Exact date of manufacture unknown (c. 1300?)
Ivory
5 x 8⅗ x ¼ inch (12.6 x 22 x 0.4 cm)

This ivory plaque is a closely related version of the Dormition scene in the Virgin portal on the West Façade of Senlis Cathedral (c. 1170). The scene in the tympanum depicts the *Virgin Enthroned* in heaven; the *Dormition* is depicted on the lintel below. Here, as in the Senlis portal, six lamenting angels attend the Virgin's body, holding a jeweled crown above her head.

In the treatment of the figures and style of carving, however, the two works differ. The wings of the angels on the stone portal are far more linear and sharply extended; less eccentrically drawn, they are more Italianate in structure. In the ivory they appear warmer and less austere; the overall conception and mood is more intimate, as befits the medium and much smaller scale. The ivory faces in almost every case appear to be fuller, more rounded. The stone relief has suffered damage and has deteriorated from exposure to the elements. Lost details, such as the Virgin's crown, the inside wing of the angel supporting the Virgin, and the tip of the wing of the angel holding the Virgin's feet, are reproduced in the ivory.

The frame of the ivory relief is as high as the most raised of the figures and the composition has been condensed more than the stone counterpart. The consoling angel's face nearly touches the Virgin's and the uppermost angel is drawn closer to the other angels supporting her body. The angels on the right have been brought in closer to her body as well. The angel at far right twists his drapery concentrically, similar to the stone version. The ivory angels stand on the shelf of the frame, whereas in Senlis they stand on a raked slanted platform. Romanesque arches and columns with simplified Corinthian capitals support the tomb-bed.

Though no attachments are visible, the plaque may have been used as a front for a casket with top, sides and back of the same material.

Careful examination reveals that the edges and corners have been worn away, showing considerable delamination. These are manifest in starkly wavering grainlike pattern of heavy lines running horizontally which help to determine the age of the carving. The softer grains in the ivory dry out and recede, desiccating and shrinking with considerable age leaving the harder grain of the ivory raised prominently. When the back of the relief is observed under raking light the outlines of the figures can be seen with a raised line around them. The thinner areas of the carved relief are lighter in color at the back (pale yellowish cream) than the areas behind the raised figures on the front (brownish going to orange).

These evidences of the aging process may indicate that the present ivory is not a modern reproductive copy but is an ancient version made somewhat later than the stone portal. However, further research is needed for a precise dating and attribution. The physiognomy of the Virgin in the present relief reminds one of related female types close to late thirteenth-century carvings by the Pisano family. This would suggest an artist of Italian origin but traveling and working in France. MH

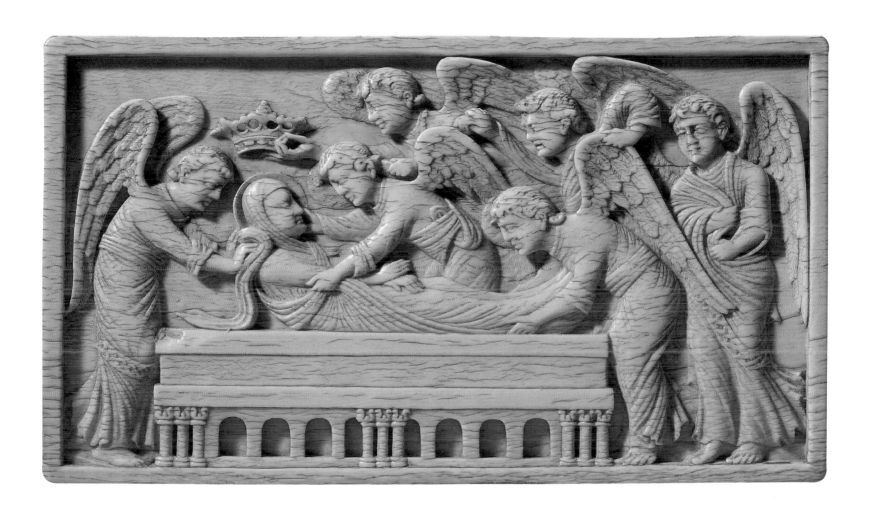

43 | Assumption of the Virgin

Attributed to Valerio Belli (c. 1468–1546)
Italian, 16th century
Opposite: Enlarged plaster cameo cast of agate intalglio carving
3 x 2¼ x ³⁄₁₆ inches (7.5 x 5.5 x 0.5 cm)

The dark gray chalcedony or agate intaglio carving (fig. 1), in its original gilt bronze frame with loop, has survived with an early plaster mold, made after the stone was cracked. Bronze plaquettes were sometimes made from engraved gems by casting them from plaster molds. The metal cast from this matrix does not survive.

In this plaster cast cameo, the eleven apostles are shown standing in a regimented fashion, with their halos forming a regular pattern. They gaze toward the ascending Mary, at the epicenter of eight *putti* heads and a crescent moon, as she is assumed into Heaven. The Virgin's hips, which sway to the right, lend the figure a beautiful *contrapposto* form. The incised design is of high quality with exquisitely minute details of hands, facial features, folds, toes, and feathered wings. There are twenty-three stars at the top and the tomb below is festooned with foliage garlands. The background and all of the recessed features are highly polished, as is the flat back of the intaglio.

Despite overcrowding, the composition is well balanced. Based on style, the carving can be attributed to Valerio Belli, an Italian gem-engraver, goldsmith, and medallist who worked in the latter half of the fifteenth and the first half of the sixteenth century. Belli lived in Rome and was a member of a literary circle to which Michelangelo (1475– 1564) also belonged. Compositionally, his work draws upon works by Raphael (1483–1520) and Michelangelo, as well as the ancient coins and gems he studied. The present relief, with its refinement of carving, probably dates from a later period in the artist's *oeuvre*. MH

figure 1
Valerio Belli
Assumption of the Virgin
Agate intalglio carving

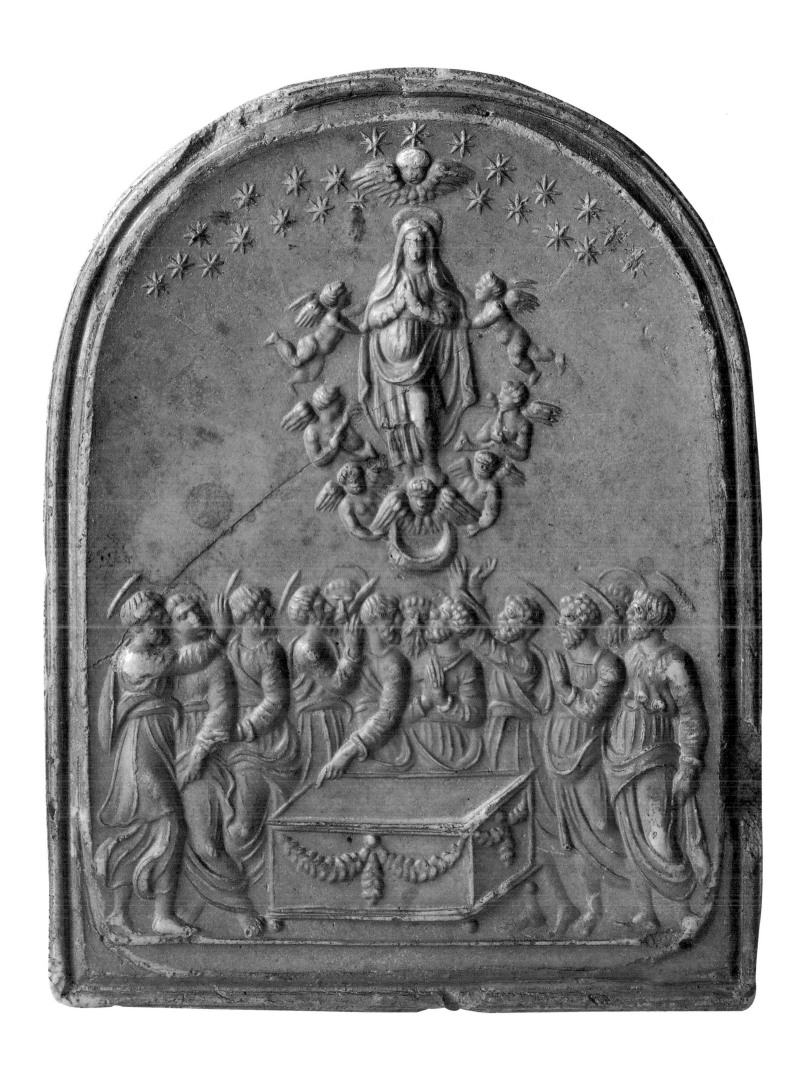

After Guido Reni (1575–1642)
Italian, 17th century (?)
Oil on copper
26½ x 19 inches (67 x 48 cm)

120

Apart from St. Luke, perhaps no artist in history was as influential in codifying a portrait of the Virgin as Guido Reni. He produced countless images of a young, veiled matron, with a gleaming alabaster complexion, whose huge eyes gaze heavenward like glistening pearls. His vision of the Madonna gained currency throughout Europe in the seventeenth and subsequent centuries, and still forms the basis for her popular imagery. I use the word "vision" deliberately, since contemporaries of the "Divine Guido" fancied that direct heavenly inspiration, not artistic ingenuity, fashioned the Christs, Virgins, and Magdalenes issuing from his brush. The popularity and authority of Reni's imagery even had theological implications. His paintings of the Virgin's *Immaculate Conception* established the definitive formula for rendering the mystery, propagating its widespread acceptance centuries before it was ratified as dogma by the Catholic Church.[1]

The Hall picture shows the complementary episode of the Virgin's *Coronation*, after her body had been assumed, uncorrupted, into Paradise. A pair of angels parts the clouds, like nebulous stage curtains, to reveal two cherubs lowering her crown into place. An angelic chorus serenades the Virgin, as she looks upward in ecstasy. The artist captures the musical harmony in the earnest musicianship of the cantors, the delicate rustling of silk, plumage, and hair, and the all-encompassing radiance.

The Hall painting is a copy of a famous *Virgin in Glory* in the National Gallery, London. The iridescent palette of the original is darkened and simplified. The faces are much more schematic in articulation. Still, there are rather competent passages, especially of drapery, which make the Hall version superior to many known copies.[2] The presence, here, of a direct follower of Reni is not out of the question. The facial types and drapery recall, for instance, works by Elisabetta Sirani (1638–1665), who is known to have painted imitations of Reni's famous compositions.[3]

The original copper was painted around 1607, at the same time Reni frescoed the Papal chapel in the Quirinal Palace, Rome, with several scenes from the life of the Virgin. The celestial vision on the dome and vault features angelic choruses, bathed in the same amber atmosphere and vivid hues as the copper. Upon seeing the completed ensemble, Pope Paul V enthusiastically responded that the artist "had succeeded in creating on earth a small model of the glory that he would enjoy in heaven."[4] Enough of Reni's spirit pervades even this copy that one cannot but concur with the Pope's assessment. JU

1 On Guido's images of the Virgin, their importance for Marian iconography, and the myth of the artist's innate "grace," see Richard E. Spear, *The Divine Guido: Religion, Sex, Money, and Art in the World of Guido Reni* (New Haven, 1997), 106–14, 128–62.

2 Reni produced two other variants of the composition, one on panel in the Prado, and another copper, now lost. For these works and their numerous copies, see D. Stephen Pepper, *Guido Reni 1575–1642* (New York, 1982), cat. nos. 14, 26; Spear, 386, note 39. The Hall version bears inscriptions on the reverse: "CSK EP 5 29" and "347 6164ET." I have not been able to indentify these with a specific sale or inventory.

3 See Sirani's *Baptism of Christ* (Bologna, Chiesa di S. Girolamo della Certosa) and *Musica* (Christie's, London, Dec. 8, 1989, lot 131). Sirani painted a *Nursing Madonna* based directly on Guido, and likely produced variations of other famous compositions, see Fiorella Friosini, "La vera Sirani," *Paragone* 29, 335 (1978): 7, fig. 10.

4 Carlo Cesare Malvasia, *Felsina pittrice*, ed. Zanotti (Bologna, 1841), 2:15–16.

As Jesus was going up to Jerusalem, he took the twelve disciples aside and spoke to them privately, as they walked along. "Listen," he told them, "we are going up to Jerusalem, where the Son of Man will be handed over to the chief priests and the teachers of the Law. They will condemn him to death and then hand him over to the Gentiles, who will make fun of him, whip him, and crucify him; but three days later he will be raised to life."

Matthew 20.17–19

Passion cycles customarily include the key events that lead to Jesus' *Crucifixion*, starting with the *Entry into Jerusalem* and culminating in the *Discovery of the empty tomb*. Sometimes the actual scene of the *Resurrection* is also included, expounding the symbol of the empty tomb.

Most of the works included in this exhibition are grouped around two seminal moments: the *Flagellation* and the *Crucifixion*. The image of Christ bound at the column, mocked by the crowd and whipped, gave artists the opportunity to portray his dignity and resignation as he fully accepts his fate. The complex symbolism of this representation builds toward the climactic scene of the *Crucifixion*, the central moment of the Christian story.

These works illustrate how artists, especially in the Renaissance and post-Renaissance periods, tended to use an established prototype for the portrayal of Christ. Whether he is part of a story or an isolated figure, Jesus is recognizable in virtue of his recurring facial features. Differences and variables, obvious over time and style changes, only contribute to emphasizing a certain "family air."

45 | Christ at the Column

Circle of Guglielmo della Porta (1500–1577)
Italian, Roman, mid-16th century
Silver figurine, silver gilt column in original tabernacle of ebony wood with gilt bronze and silver *appliqués*
Figurine 3⅛ inches (8 cm); column 5⅛ inches (13 cm); tabernacle 12½ x 8 x 2¾ inches (32 x 20 x 7 cm)

This exquisite, unpublished silver figurine may be attributed to the circle of Guglielmo della Porta on the basis of its similarity in morphology to the *Flagellation of Christ*, known in several examples. It also relates to an individual silver statuette of superior quality (8.5 cm high) in the Fitzwilliam Museum, Cambridge, England (Inv. no. MAR.M.265–1912). The finest of the *Flagellation* reliefs is a gilt bronze plaque in the Victoria and Albert Museum, London, followed by a silver cast formerly with Black-Nadeau,[1] and a plaque in plain bronze in the Staatliche Museen, Berlin. The central figure of that composition fully projects from the background in three dimensions against the column. Its proportions are elegantly elongated, and the column stands full-length and free of any structure, as it does in the Hall example, although its capital is Doric. Middeldorf points out that the composition of these *Flagellation* scenes is based on a sheet from one of della Porta's sketchbooks containing designs for a bronze door for St. Peter's, Rome, a project that he was never commissioned to fulfill.[2]

Guglielmo della Porta was a Lombard sculptor who trained in his family workshop in Milan. He was active first in Genoa (c. 1534) and later in Rome (c. 1540). Employed at the Vatican, he succeeded Sebastiano del Piombo to the office of *Piombatore* (papal seal) in 1547 and began work on his major commission, the monument of Pope Paul III, the design for which he disputed with Michelangelo. Guglielmo was an excellent craftsman in bronze and precious metals and his figural style draws upon Michelangelo's. The present figurine is certainly reminiscent of the great sculptor's marble statue of *Christ with the Cross* from the 1520s (Santa Maria sopra Minerva, Rome). **CA**

Bibliography: Werner Gramberg, "Guglielmo della Porta, Coppe Fiammingo und Antonio Gentile da Faenza," *Jahrbuch der Hamburger Kunstsammlungen* 5 (1960) 31–52; H-W. Kruft, "Porta, della," J. Turner, ed., *The Dictionary of Art* (London, 1996), vol. 25, 255–57.

1 This was in Monte Carlo in 1980 and is published in U. Middeldorf, "In the Wake of Guglielmo della Porta," *The Connoisseur* 194, no. 780 (1977), 75–84, esp. 81, pl. 8.
2 Middeldorf, as in note 1. For the sketchbook, see Werner Gramberg, *Die Düsseldorfer Skizzenbücher des Guglielmo della Porta* (Berlin, 1964), 69, no. 109, *Small Sketchbook*, fol. 82.

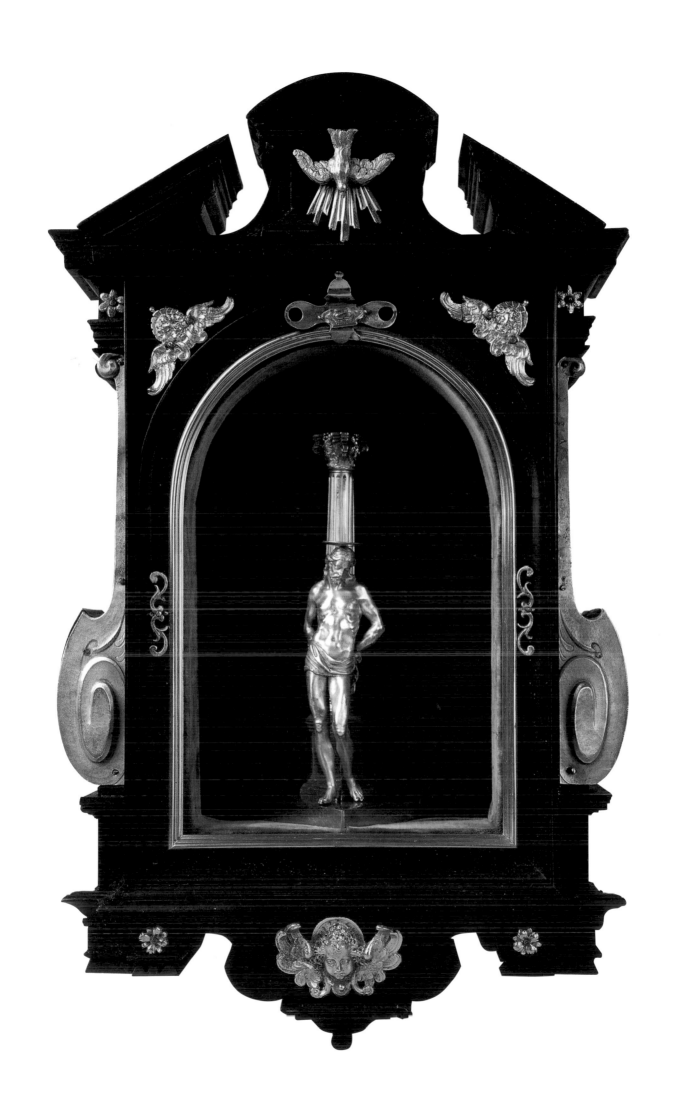

46 | Christ at the Column

Circle of Jacopo Sansovino (1486–1570)
Venetian, mid-16th century
Gilt bronze
6½ x 2¼ x 2¾ inches (16.5 x 6.3 x 7 cm); ebony base 2 x 4 inches (5.1 x 10.2 cm)

This figurine is unpublished and apparently unique. Formerly associated with Jacopo Sansovino, (1486–1570), the leader of the Venetian school of sculpture during the middle third of the sixteenth century, the sculpture is not of a quality to be compared directly with any of his work. While the artist competently conveys the musculature of the nude figure, the legs seem heavy in proportion. This is a characteristic it shares with a statuette of the *Risen Christ* formerly with Cyril Humphris, a London dealer.[1] They also have similarly textured loincloths, as well as the head, with facial features sharply gouged out with a burin. The latter statuette was unconvincingly attributed to a Veronese sculptor, Angelo de Rossi, and his foundryman Giuseppe de Levis. A third statuette, also in gilt bronze, a *Virgin and Child* in a Parisian private collection, may also be associated with them.[2] The Virgin's centrally parted wavy hair, sharply incised facial features, and matte punched tunic resemble those of the two other figures.

It is hard to suggest a specific author for these statuettes.[3] Of the documented associates of Jacopo Sansovino whose personal styles are now becoming better defined, the Paduan sculptors/bronze founders Tiziano Minio (1511/12–1552) and Agostino Zoppo (c.1520–1572) provide possible parallels for the present figure. Even so, these are not sufficiently close to justify its attribution to either of them. While sharing the same stocky proportions and bold muscular development, Minio's *Neptune in his Chariot* is a more sophisticated rendering.[4] Zoppo's equally stocky statuettes depicting *St. Peter and Paul*, of which the St. Peter stands in a rather similar pose to our *Christ at the Column*, are more convincingly modeled and characterized.[5] One of the many bronze foundries active in Venice and the Veneto, anonymous to this day, was probably responsible for producing this statuette (and its two suggested companions) to satisfy the insatiable demand for such cult figures during the fervor of the Counter Reformation. **CA**

1 Sotheby's, New York, 11 January 1995, lot 129; 28 cm; 11 inches high.

2 A. Gibbon, *A Guide to Italian Renaissance Bronzes* (Paris, 1990), 91, where it is ascribed without further comment to the workshop of Jacopo Sansovino (18 cm; 7 inches high)

3 See, for example, Leo Planiscig, *Venezianische Bildhauer der Renaissance* (Vienna, 1921).

4 Comune di Padova, *Donatello e il suo tempo. Il bronzetto a Padova nel Quattrocento e nel Cinquecento*, exh. cat., Musei Civici (Padua, 2001), no. 66.

5 Ibid., no. 70.

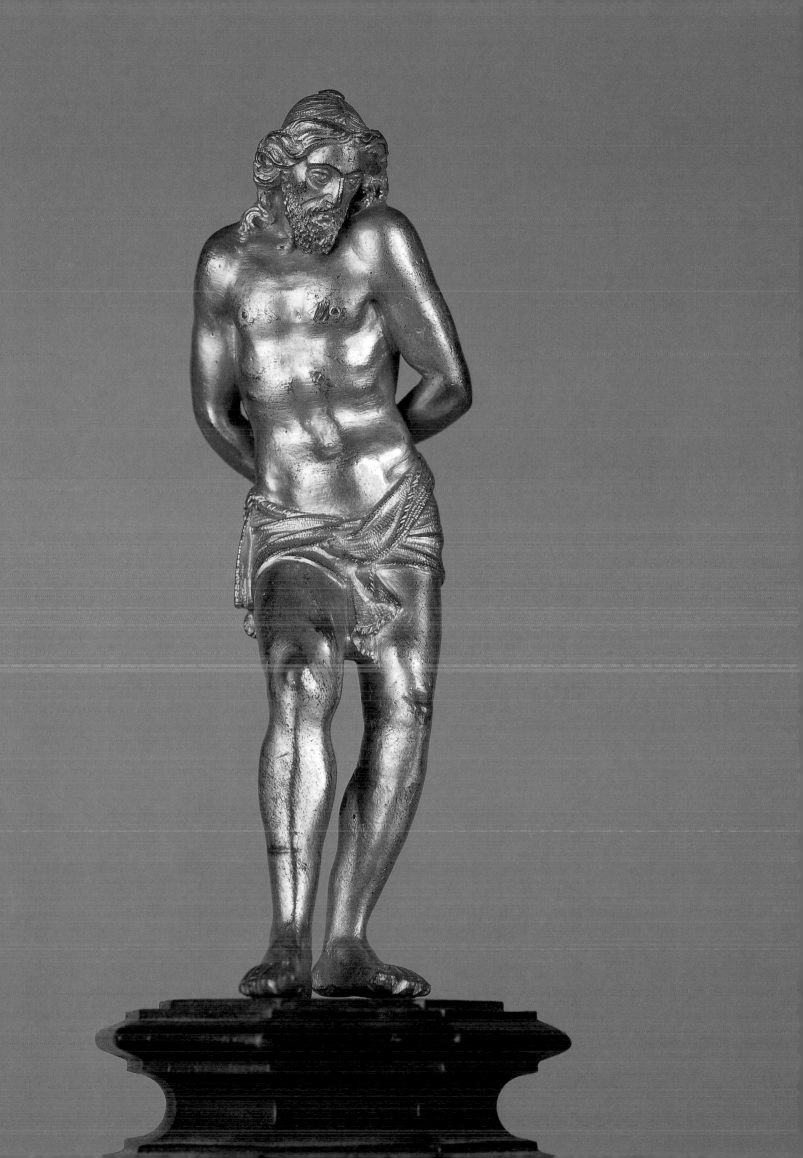

47 | Christ at the Column

Attributed to the Master of the Furies
South German (or Salzburg?), early 17th century
Ivory
8 x 2½ x 1¾ inches (20.3 x 6.3 x 4.5 cm)

PASSION NARRATIVES

figure 1
Flagellation of Christ
Flemish/German, 16th century
Bronze plaquette
Michael Hall Collection

The classical, almost Italian Renaissance treatment of Christ's body, combined with the particular, "frizzy" stylization of his hair and the scalloped hem of the loincloth, point to an anonymous ivory carver whose moniker, the Master of the Furies, comes from the subject of some of his works now in the Kunsthistorisches Museum, Vienna. He is believed to have worked in the early baroque period in south Germany and/or Austria, quite possibly in Salzburg, and maybe also in north Italy. While, as his name suggests, many of his subjects are drawn from classical mythology (*Mars, Venus and Cupid; Hercules freeing Hesione* in Berlin; *Furies* and *Hesperides* in Vienna; and a *Fury on a leaping Horse* in the Winkler collection, Wiesbaden), he also turned his hand occasionally to biblical subjects (*Elijah and the Angel*, Winkler collection). The contorted pose, as Christ writhes under the blows of his tormentors, and the careful delineation of his musculature under stress are typical of Germanic renderings of this harrowing theme; as also seen in an oval plaquette in the Hall collection (fig. 1). CA

Bibliography: Christian Theuerkauff, *Die Bildwerke der Skulpturengalerie Berlin, II: Die Bildwerke in Elfenbein des 16.–19. Jahrhunderts*, Staatliche Museen Preussischer Kulturbesitz (Berlin, 1986), 121–31, nos. 30–31; Christian Theuerkauff, *Elfenbein: Sammlung Reiner Winkler* (Munich, 1984), 49–56, nos. 21–23.

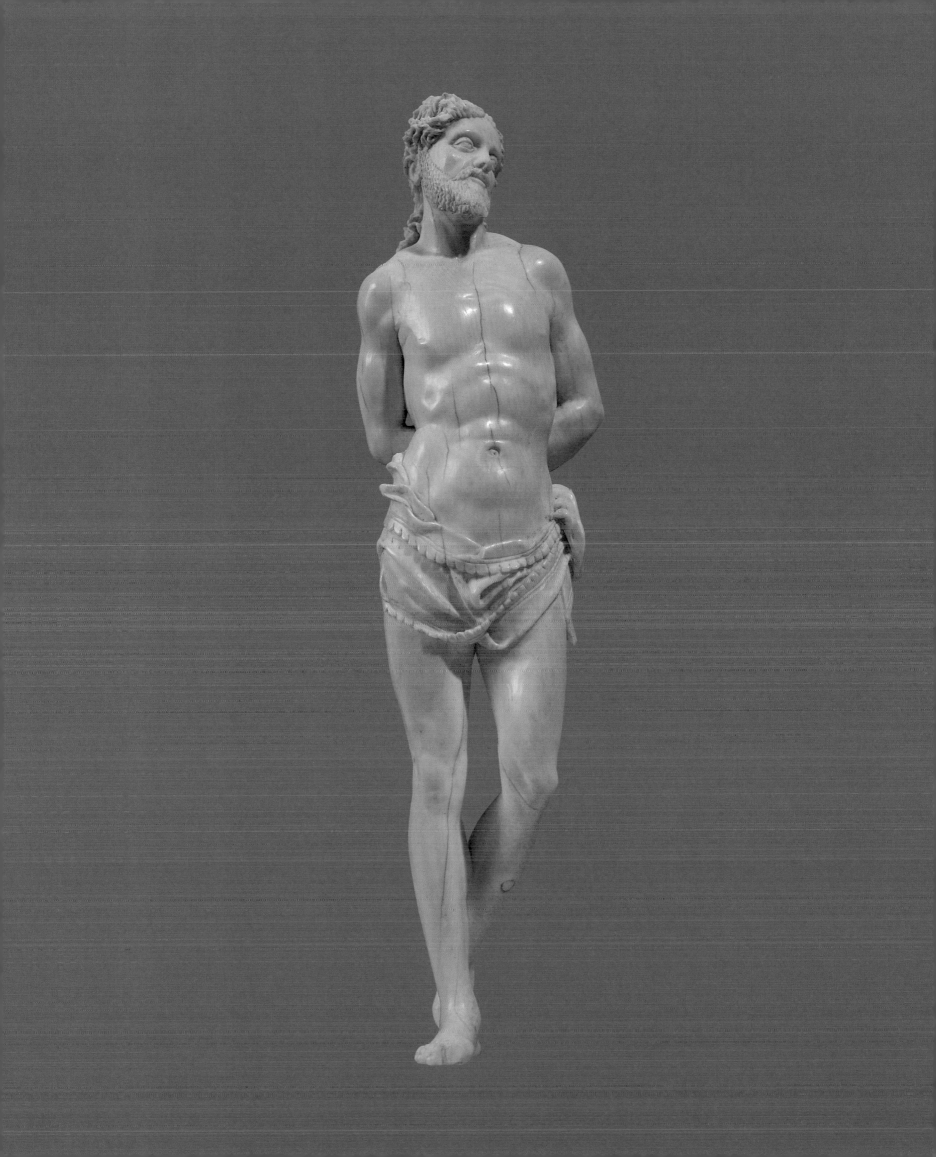

48 | Christ at the Column

Alessandro Algardi (1598–1652)
Roman, c. 1630
Silver gilt
8½ x 3½ x 3¼ inches (21.5 x 9 x 8.25 cm): marble base: 2 x 4½ x 4½ inches (5.1 x 10.8 x 10.8 cm)

This model of *Christ at the Column* was used in two different *Flagellation* groups. The same Christ is accompanied by two alternate pairs of flagellators, so different that they must have been made by different sculptors. The seventeenth-century biographer Giovan Pietro Bellori, in his life of François Duquesnoy (1597–1643), described such a group by the master: "Three figurines from his model about 22 centimeters high, which are to be found in both silver and bronze; Christ flagellated at the column between two Jews, who beat him cruelly, expresses innocence and voluntary suffering, leaving his body open to the blows, and humbly bending his head down towards his right shoulder."[1]

In 1967, I felt bound to accept that this figure, together with one of the pairs of flagellators, must be by Duquesnoy. However, by 1985 I was convinced, for stylistic reasons, that the Christ, as well as the other pair of flagellators, must be by Algardi, who is also recorded in early sources as having made such a group, and to whom most of the known casts had traditionally been ascribed. This view I still hold, and it is now widely accepted.

The rather pinched features are not typical of Algardi, but do recur in other figures he sculpted on a similarly small scale, such as his *Baptism of Christ*, or even his rather larger *Crucifix*. The hair is treated in the same manner in his early silver figure of *St. Lucy*. The torso, with its broad chest and shoulders, and the fluid modeling, are characteristic of his style around 1630, and very different from the work of Duquesnoy. The Flemish sculptor also made a marble version of *Christ at the Column*, twice as high.[2] Its modeling is more precise, but, as Pietro Cannata has expressed it, Duquesnoy shows the regality of Christ, and Algardi the humanity.[3]

If we must assume that Bellori was confused about the attribution, he is absolutely right in his description of the Christ. He was also struck by the position of the head, with an almost straight line through the shoulders and neck. This is strangely reminiscent of a favorite pose of Caravaggio (1571–1610), a painter who is not otherwise known to have influenced either sculptor. The flexed and slightly forward-leaning body is indicative of submission to the torture, rather than any attempt to avoid the blows, while the head is bent in suffering. Bellori laid great stress on Christ's humble acceptance of the role of the *Man of Sorrows*, which was clearly what the artist intended us to recognize in this beautiful and pathetic image. Here the rich material not only emphasizes the soft modeling of the body, but indicates the divinity of the suffering man.

Most casts show the loincloth treated in this manner, with a fringe below the engraved hem line, and often lightly punched. In many examples, even where Christ is shown alone, the column is included. Sometimes it is a high column, possibly with a decorative bronze capital, but it may also be very low and bulbous, rather more of a bollard, copied from the famous relic preserved in Santa Prassede in Rome. The position of the hands of this Christ, and his bending body, suggest that Algardi intended such a low column, with a direct reference to the sacred relic. JM

Bibliography: Jennifer Montagu, *Alessandro Algardi* (New Haven, 1985), 2 vols, II, 318, cat. 9.C.13.

1 Jennifer Montagu, "A Flagellation Group: Algardi or du Quesnoy?" *Bulletin des Musées Royaux d'Art et d'Histoire, 4e sér* XXXVIII-XXXIX (1966–67): 153–193.

2 The marble is reflected in a bronze in the Metropolitan Museum of Art (New York), and an engraving of a lost terra cotta in François Giradon's collection (see also cat. no. 49).

3 Pietro Cannata, "Flagellazione di Gesù," *Algardi: L'altra faccia del Barocco*, exh. cat., Jennifer Montagu, ed. (Rome, 1999), 131.

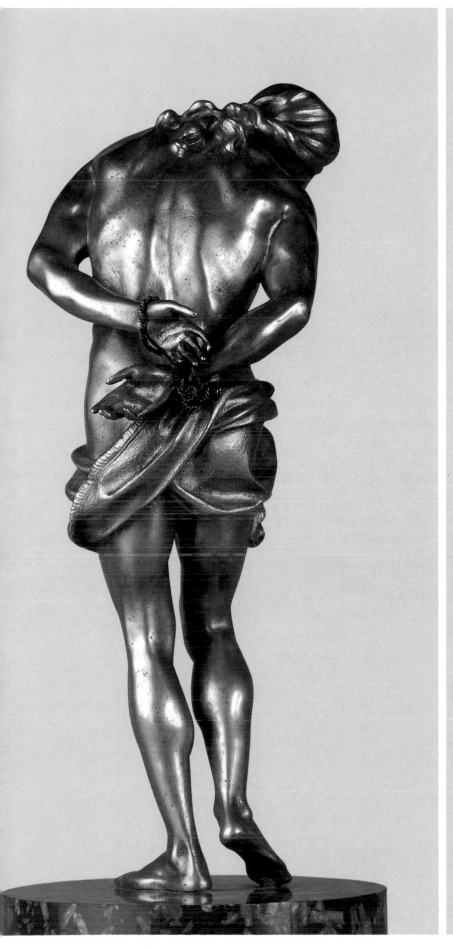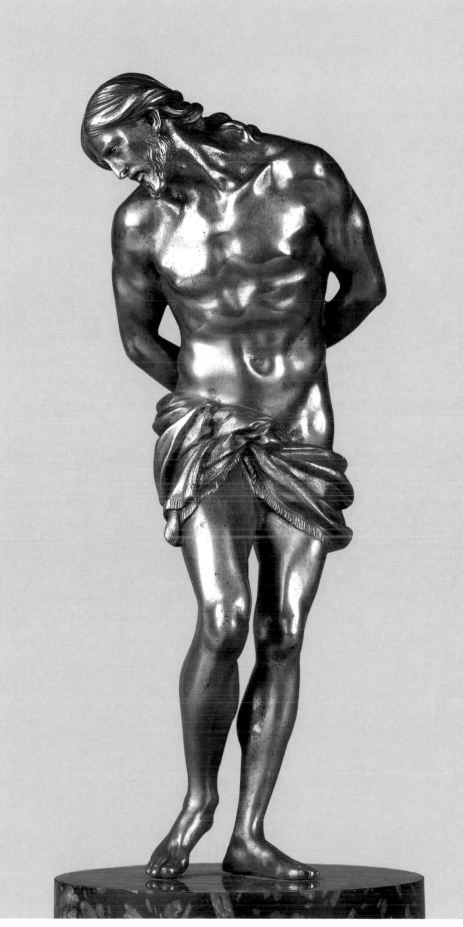

49 | Christ at the Column

After a model by François Duquesnoy (1597–1643)
French (?), late 17th or 18th century
Ivory
8¾ x 3½ x 3 inches (22.3 x 8.9 x 7.5 cm)

This image of the bound *Christ at the Column* was one of Duquesnoy's most influential inventions. Bellori records that the artist produced a miniature sculptural ensemble of *Christ at the Column*, flanked by two flagellants. He notes that Christ "expresses his innocence and willing submission to the Passion, exposing himself to the blows and turns his face with humility toward the right shoulder." This certainly describes the pose and attitude of the present figure. Bellori adds that the composition was cast in bronze and precious metal versions.[1] Many of these are known in whole or part, but the figure of Christ in every case derives from a model different from that of the Hall ivory. Compelling stylistic evidence gives authorship of the diverse Christ figure to Algardi (see cat. no. 48).[2] Bellori's attribution of the bound Christ to Duquesnoy is either mistaken, or, more plausibly, refers to an entirely different model relating to the present ivory work. In fact, he mentions elsewhere a small marble Christ, "with hands bound in front at the column," commissioned by Seigneur Hesselin, which is now lost.[3]

Duquesnoy's authorship of the type is further confirmed in the inventory and the engraved views of the collection of François Girardon, the sculptor to Louis XIV.[4] Two statues of the *Bound Christ*, a larger terra cotta and a smaller bronze, are recorded as the work of Duquesnoy, and likely reflect the Hesselin model.[5] Several French bronzes of the late seventeenth century, including one in the Metropolitan Museum, New York, follow the type engraved by Girardon in every detail apart from the arrangement of the loincloth and the height of the column.[6] The Hall ivory relates to the bronzes in its pose, stance, tilt of the head, swing of the hips, and disposition of the hands. Oddly, the carver omits the column, required by the story, and instead supports the figure from behind with a stump armature. Despite the similarity of design, the proportions of the Hall ivory are much more delicate and slender than the robust anatomy of the bronzes. The figure seems to recoil from a blow, as its weight shifts decidedly off axis to the left. The sharp rise of the right shoulder to protect the face, and corresponding slope of the left shoulder, reinforce this movement, as does the dramatically protruding hip. The lanky proportions and defensive reflex make the Hall ivory unique. Another ivory version in a German private collection, while quite close in execution to the Hall statuette, retains the more erect stance and solid musculature of the bronze versions, though it too lacks the column. While Bellori records works in ivory crafted by Duquesnoy himself, the *Bound Christ* in this collection is, like its bronze cousins, of later date and perhaps of French manufacture.[7] JU

Bibliography: Christian Theuerkauff, *Elfenbein: Sammlung Reiner Winkler* (Munich, 1984), 38–9, cat. no. 12.

1 Giovan Pietro Bellori, "Vita di Francesco Fiamingho," *Vite dei pittori, scultori ed architetti* (Rome, 1672), E. Borea, ed. (Turin, 1976), 301–2.

2 Jennifer Montagu, *Alessandro Algardi* (New Haven, 1985), 2: 315–322, cat. no. 9.; Józef Grabski, "The Corsini Flagellation Group by Alessandro Algardi," *Artibus et Historiae* 16 (1987): 9–23.

3 Bellori, op. cit., 300.

4 P. Charpentier, *Suite au Cabinet de Sieur Girardon Sculpteur Ordinaire du Roi* (Paris, 1710).

5 François Souchal, "La Collection du Sculpteur Girardon d'après son inventaire après décès," *Gazette des beaux arts* 82 (1973): 1–98, nos. 16, 57.

6 Metropolitan Museum of Art, New York, inv. no. 40.90.1. See also the *Bound Christ* based on the same model (private collection) in *The French Bronze* (New York, 1968), cat. no. 66.

7 Theuerkauff (as in bibl.) mentions the Hall version as the closest analogue to the Winkler example. This is cataloged as French, late 18th-century. He also notes other ivory versions recorded in the Warwa Auction (Vienna, 1928), and at Sotheby's, London, 4 July, 1984 (lot. 270). The latter follows the bronze even more closely, and includes the column.

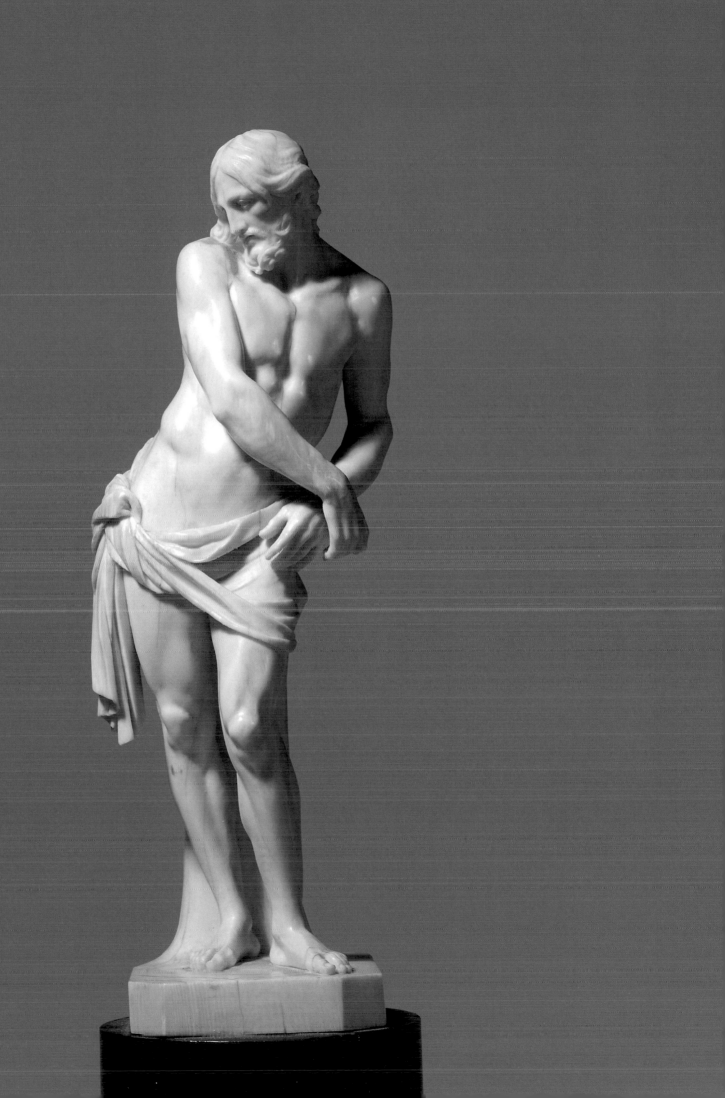

50 | Bust of Christ

Circle of Jerome II Duquesnoy (1602–54)
Italo-Flemish, mid- to late 17th century
Marble
7¼ x 5½ x 5 inches (18.5 x 14 x 12.5 cm)

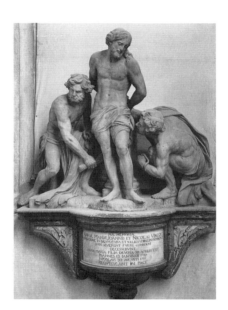

figure 1
Jerome II Duqesnoy
Resurrected Christ, 1654
Archbishop Triest Monument
St. Bavo, Ghent

In 1639, the Flemish sculptor Jerome Duquesnoy traveled to Rome to work with his older brother François, an already renowned sculptor who had resided in the Eternal City for two decades. They both decided to return North in 1643, the elder having been summoned by Cardinal Richelieu to serve King Louis XIII of France. They got only as far as Livorno, when François died suddenly and mysteriously. Jerome took charge of the crates containing his brother's artistic legacy (drawings, models, etc.), and sailed home to Brussels. In the remaining decade of his life, Jerome propagated François's style through-out Flanders, and the next generation of native sculptors would spread it even farther afield.[1] Jerome's most impressive act of fraternal homage was the sepulchral Monument to Archbishop Antonius Triest in Saint Bavo, Ghent (fig. 1). In 1654, he even moved his studio to over-see the installation of the elaborate work. But no sooner had the sculptor arrived, than authorities charged him with sodomizing young boys within the sacred confines of the Cathedral grounds. Confessing under torture, he was convicted and burned publicly at the stake in the main square of Ghent. Since rumors abounded that Jerome had poisoned his brother to appropriate his artistic franchise, the early biographers relish this ignominious demise as just desserts.[2]

Bishop Triest, the patron, had entreated the Royal Governor to spare Jerome's life, claiming an irreparable loss to the art of sculpture. While this was to no avail, Jerome's unintended last work stands as a manifesto of the Duquesnoy style. Flanking Triest's *gisant* effigy, the statue of the Virgin imitates the *Saint Susanna* in her pose, attitude, and drapery style (see cat. no. 104, fig. 1). Opposite stands a *Resurrected Christ* that evokes Michelangelo's famous statue (Santa Maria sopra Minerva, Rome) in its robust musculature and vigorous grasp of the cross. Nonetheless, the peculiar tilt of the head toward the right shoulder and the overall disposition of the body apart from the arms suggest another source: François Duquesnoy's *Christ at the Column*, known through bronze and ivory versions of a lost original marble (see cat. no. 49).[3]

The Hall marble derives from the *Resurrected Christ*, or possibly, François's lost work. The part and arrangement of the hair, the forked beard, the strained neck, and the tilt of the head toward the shoulder in the bust are nearly identical to the *Resurrected Christ*. The lock of hair cascading down the shoulder forms a minor variation. The facial expression of the Hall Christ, however, reads as more impassive and detached, since it now lacks a larger narrative context. The head likely dates from later in the seventeenth century, when the Duquesnoy idiom had permeated Flemish baroque sculpture. JU

1 For an overview, see Elisabeth Dhanens, ed., *La sculpture au siècle de Rubens dans les Pays-Bas méridinaux et la principauté de Liège*, exh. cat. (Brussels, 1977).

2 Lydie Hadermann-Misguich, *Les du Quesnoy* (Gembloux, 1970), 37–50. Giovanni Battista Passeri, *Vite de'Pittori, Scultori, ed Architetti*, in *Die Künstlerbiographien nach den Handschriften des Autors*, J. Hess, ed. (Leipzig and Vienna, 1934), 115. Giovan Pietro Bellori, "Vita di Francesco Fiamingho," *Vite dei Pittori, Scultori ed Architetti* (Rome, 1672), ed. E. Borea (Turin, 1976), 297–8.

3 On the Triest monument, see Saskia Durian-Ress, "Das barocke Grabmal in den südlichen Niederlanden: Studien zur Ikonographie und Typologie," *Aachener Kunstblätter* 45 (1974): 245–52.

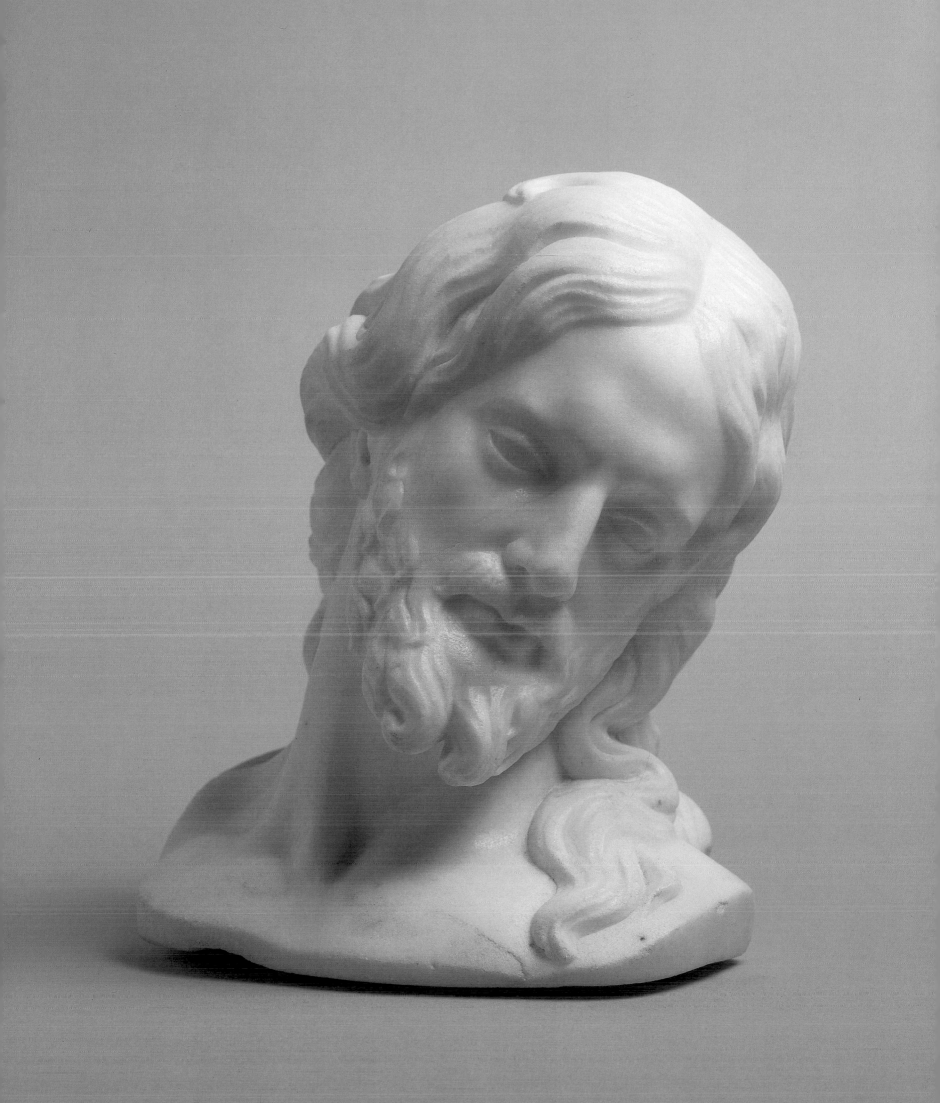

51 | Flagellation

After Galeazzo Mondella, called Moderno (c. 1467–1528/29)
Italian, 16th or 17th century
Partially gilted silver plaquette
5½ x 4½ x ¼ inch (14 x 10.3 x 0.7 cm)

The gilt silver original of this plaquette is in the Kunsthistorisches Museum, Vienna, since the Austrian government removed it from Venice in 1804. Prior to that, with its companion piece, a *Sacra Conversazione* (fig. 1), it had once been in the celebrated collection of Cardinal Domenico Grimani. This distinguished provenance is of great significance, for it was Cardinal Grimani who commissioned a bronze cast to be made from the wax model of the *Laocoön*. The cast showed how the damaged raised arm of the Greco-Roman sculptural group might be convincingly restored.[1] This very accurate bronze cast, which Grimani must have taken home on one of his frequent visits to Venice, must have been the central inspiration for Moderno. Indeed, a profile head of Grimani himself features modestly in the background as a donor in the companion plaquette of the *Sacra Conversazione* (fig. 1). Moderno is documented as having been in Venice in 1506–1507, and so that is probably when he created this pair of masterpieces.

The rationale for using the deliberately recognizable image of *Laocoön* to embody Christ's agony is that in the classical myth *Laocoön* was a priest who came to a cruel end when he warned his people of impending doom; he was therefore interpreted by the Neo-Platonic vision of the High Renaissance as an *exemplum doloris*, the quintessence of suffering.

1 Douglas Lewis, "The Plaquettes of 'Moderno' and His Followers," *Italian Plaquettes. Studies in the History of Art* 22 (1989): 105–141, esp. 129–31, pl. 1.

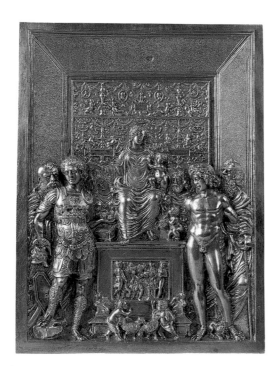

figure 1
After Moderno
Sacra Conversazione, **Viennese, 19th century**
Partially gilt silver
Michael Hall Collection

figure 2
Workshop of Moderno
Flagellation, **Italian, early 16th century**
Bronze
Michael Hall Collection

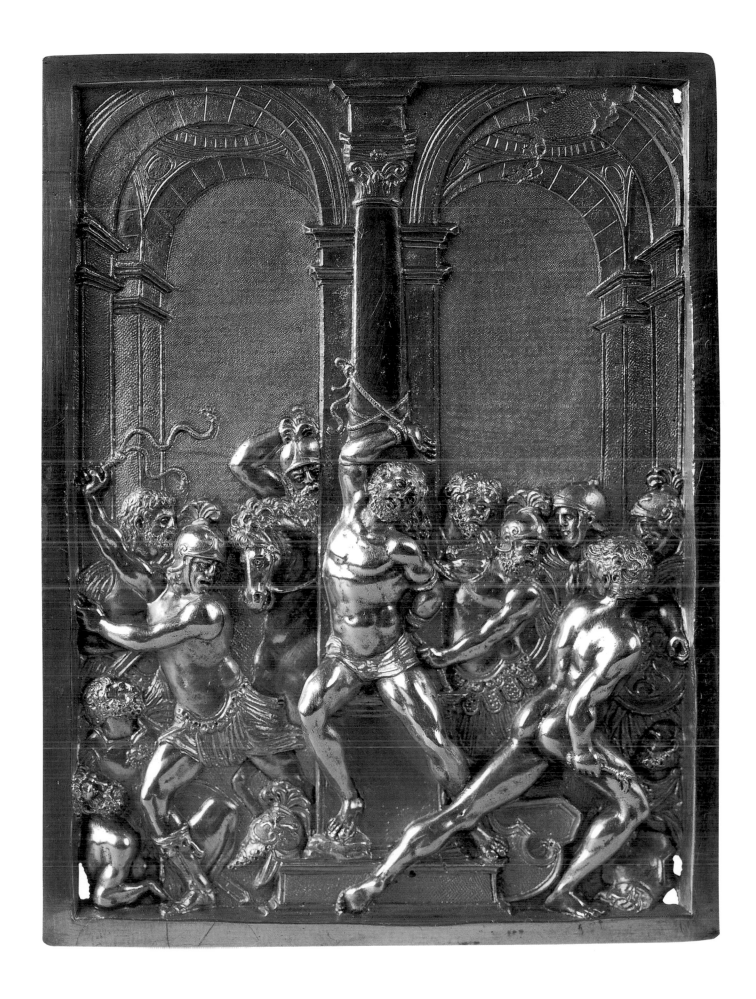

figure 3
After Moderno
Flagellation, **Italian**
Gilt bronze, with integrally cast, mid-16th century frame
Michael Hall Collection

The silver gilt example is one of three in the Hall collection. It is the most spectacular, but varies in detail from the original in Vienna. Most obviously, it lacks the prominent signature on the step in the foreground, "OP.MODERNI" (the work of Moderno). The field in the Hall plaquette is also slightly smaller than that of the original, indicating that it is probably a later cast. A cast in bronze with a simple molding as a frame is perhaps the oldest in the Hall collection (fig. 2), while one in gilt bronze, with its charming *ajouré* superstructure of strapwork and a cherub in the center and loop for suspension, is proved to date from the middle of the sixteenth century (fig. 3). **CA**

Bibliography: John Pope-Hennessy, "The Italian Plaquette," *The Study and Criticism of Italian Renaissance Sculpture* (New York, 1980), 198–201; M. Leithe-Jasper, *Renaissance Master Bronzes from the Collection of the Kunsthistorisches Museum Vienna*, exh. cat., Smithsonian Institution (Washington, D.C., 1986), 125–7, no. 25.

52 | Christ at the Column

After Michiel van der Voort (1667–1737)
Franco-Flemish, early 18th century
Ivory
10½ x 3½ x 2¾ inches (26.5 x 8.9 x 7 cm);
ebonized wood base 5¼ inches high (13.3 cm), 6 inches diameter (15.2 cm)

1 Karl Feuchtmayr and
 Alfred Schädler, *Georg
 Petel 1601/2–1634* (Berlin,
 1973); for ivories, with
 Rubens comparisons,
 see nos. 1–3, 11–14, 18.
2 Christian Theuerkauff,
 "Amerkungen zum Werk
 des Antwerpener
 Bildhauers Matthieu van
 Beveren," *Oud Holland* 89
 (1975): 19–62, fig. 19.
3 See J. Vevaets entry in
 Elisabeth Dhanens, ed.,
 *La sculpture au siècle de
 Rubens dans les Pays-Bas
 méridinaux et la princi
 pauté de Liège*, exh. cat.
 (Brussels, 1977), 200, no.
 161; Chistian Theuerkauff,
 "Addenda to the Small-
 Scale Sculpture of
 Matthieu van Beveren of
 Antwerp," *Metropolitan
 Museum Journal* 23 (1988):
 125–147, fig. 8.
4 Claude Ferment, *Les stat-
 uettes d'ivoire en Europe:
 du moyen age au XIXe
 siècle* (Paris, 2000), 151–2,
 fig. IX.24.
5 Mark Edo Tralbaut,
 *De Antwerpse "Meester
 Constbeldhouwer" Michiel
 van der Voort de Oude
 (1667–1737) Zijn leven
 en werken* (Brussels,
 1949), 162–171, figs.
 60–61; Cynthia Miller
 Lawrence, *Flemish
 Baroque Commemorative
 Monuments* 1566–1725
 (New York, 1981), 282,
 no. 111, pl. 19.

figure 1
Michiel van der Voort
***Christ at the Column* (Vincque Monument)**
St. Jakob, Antwerp

This statuette is one of the masterpieces of the Hall collection. The ivory carver expertly captures the tactile sensations of flesh, muscle, hair, and fabric. The pure, polished surface presents an ideal specimen of human anatomy, whose beauty is rendered all the more palpable in anticipation of the disfiguring violence Christ will endure. Here, Christ lowers and pivots his head, and contorts his body into a serpentine curve to deflect the first blow, as his muscles tense up reflexively. Opposed to the rigor of the body, Christ's countenance registers utter resignation to his fate. Details such as the slight fold in the abdomen just above the navel or the subtle perception of the rib cage beneath the pectorals reveal a consummate knowledge of both the human form and the representational capacities of the medium.

This is undoubtedly the handiwork of an ivory carver of the first rank. The robust physique and its tactile sensitivity recall the paintings of Rubens (1573–1640), whose images of the tortured Christ influenced a number of contemporary sculptors who worked in ivory, most notably Georg Petel (1601–34). Yet the Hall Christ transcends the fastidiousness of detail and specificity of expression characteristic of Petel.[1] Another possibility is Mattheus van Beveren (1630–1690). His stone sculpture depicting *Christ Derided* (St. Jakob, Antwerp) shares the robust musculature of the Hall figure.[2] Yet in small-scale ivory figures such as a *Resurrected Christ* (Church of the Beguinage, Antwerp) and a *Pietà* (Royal Museum, Brussels), Beveren fashions the body of Christ according to a more slender and elongated canon.[3] Another related ivory work is the elaborate *Crucifixion* group produced by Pierre Simon Jaillot (d. 1689) in 1664 (Victoria and Albert Museum, London).[4] The way Jaillot articulates the chest and abdomen of the bad thief, in particular, closely resembles the torso of the Hall Christ.

Despite these affinities, a prototype in monumental sculpture probably situates the Hall ivory well into the eighteenth century. Michiel van der Voort's monument to the Vinque family dated 1719 (St. Jakob, Antwerp) features a large marble group of Christ being bound to the column by his tormentors.[5] The marble anticipates the overall posture and physique of the ivory Christ

figure and specific details such as the way the shoulders hunch forward in response to the binding of the wrists, and how the drapery slips to reveal the right hip. The most compelling similarities emerge if we focus on the head of Christ. The thick waves of hair, parted at the center and pulled back over the earlobe, appear in each work, as does the lock that falls onto the left shoulder. The eyes, nose, and beard have the same shape, though the latter is carved more elaborately in the ivory, since it was intended to be scrutinized by a loving collector. The Hall ivory is essentially a reduction of the van der Voort Christ, which achieved such currency that it was almost immediately replicated in another sepulchral monument.[6] While there is no record that van der Voort produced ivories, one can speculate that an accomplished master of this period, such as Gabriele Grupello (1644–1730) or his workshop, may be responsible for the Hall figure. Indeed, Grupello's tendency toward elongation may account for the slightly more elegant proportions of the Hall ivory over the van der Voort marble.[7] JU

6 Jan Boeksent, *Monument to Philippus Erardud Van der Noot*, Ghent, Cathedral of Saint Bavo, 1720-30, see Saskia Durian-Ress, "Das barocke Grabmal in den südlichen Niederlanden: Studien zur Ikonographie und Typologie," *Aachener Kunstblätter* 45 (1974): 281–85.

7 Hans Peter Hilger et al, *Europäische Barockplastik am Niederrhein: Grupello und seine Zeit*. exh. cat. (Düsseldorf, 1971).

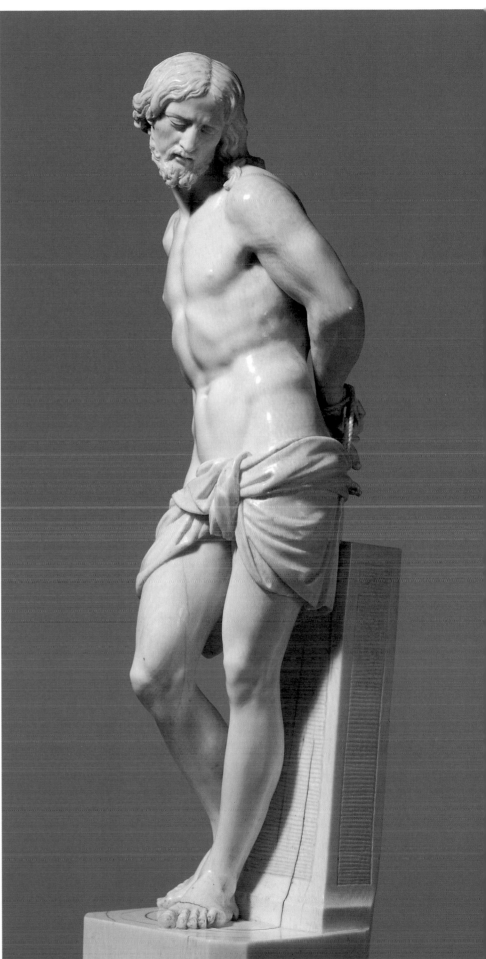

53 | Christ at the Column

Barthélémy Prieur (1540–1611)
French, early 17th century
Bronze, solid cast
10¾ x 3¼ x 3¼ inches (27.3 x 8.3 x 8.3 cm)

This exotic, almost nude *Christ at the Column* corresponds to the style of various works by Jean Goujon (c. 1510–c. 1565) and Germain Pilon (1528–1591). Barthélémy Prieur was the son-in-law and assistant of the latter, and would certainly have inherited his stylistic idiosyncrasies. These include the slender proportions of the body and the elongated face with heavy eyelids and sharp, pinched nose. Such a refined, aristocratic physique lends this Christ a distinctly northern, and particularly French, appearance. Indeed, Prieur worked principally for the Courts of Henri III and Henri IV, where he specialized in small statuettes of mythological subjects that required a marked sensuality of form. Though a Huguenot himself, and not well known for his devotional works, Prieur must have occasionally supplied religious images for the ardently Catholic Court.[1] He also may have made an exception for an important patron or even, such as King Henri IV's conversion to Catholicism in 1593.

The style of this statuette conforms to a Mannerist aesthetic equating rarefied physical beauty with spiritual sanctity. This is not to say that Prieur's Christ is devoid of religious feeling, but that it emerges through the appreciation of beauty and understatement. The sinuous, slender, but well-developed body of this small bronze displays a calm resignation to his horrible fate. Bound to an implied column, he faces the scourge. He embodies the Christian tenet to accept the humiliation without protest. Artists began representing Christ tied to a column, isolated from his torturers and from a narrative context, after St. Bridget described the image in her *Revelations* in the late fourteenth century. The image regained popularity as an object for private devotion during the Counter Reformation.[2] **MH**

Bibliography: Józef Grabski (ed.), *Opus Sacrum: Catalogue of the exhibition from the collection of Barbara Piasecka Johnson*, exh. cat., Royal Castle in Warsaw (Warsaw, 1990), 308–10, no. 57.

1 Another rare cast from this model is in a private collection in London. See Daniel Katz Ltd., exh. cat. (London, 1996), 42 no. 18. This example is 7 inches (19 cm) tall. I thank Charles Avery for this reference.

2 See Grabski (as in bibliography), 310, with further references.

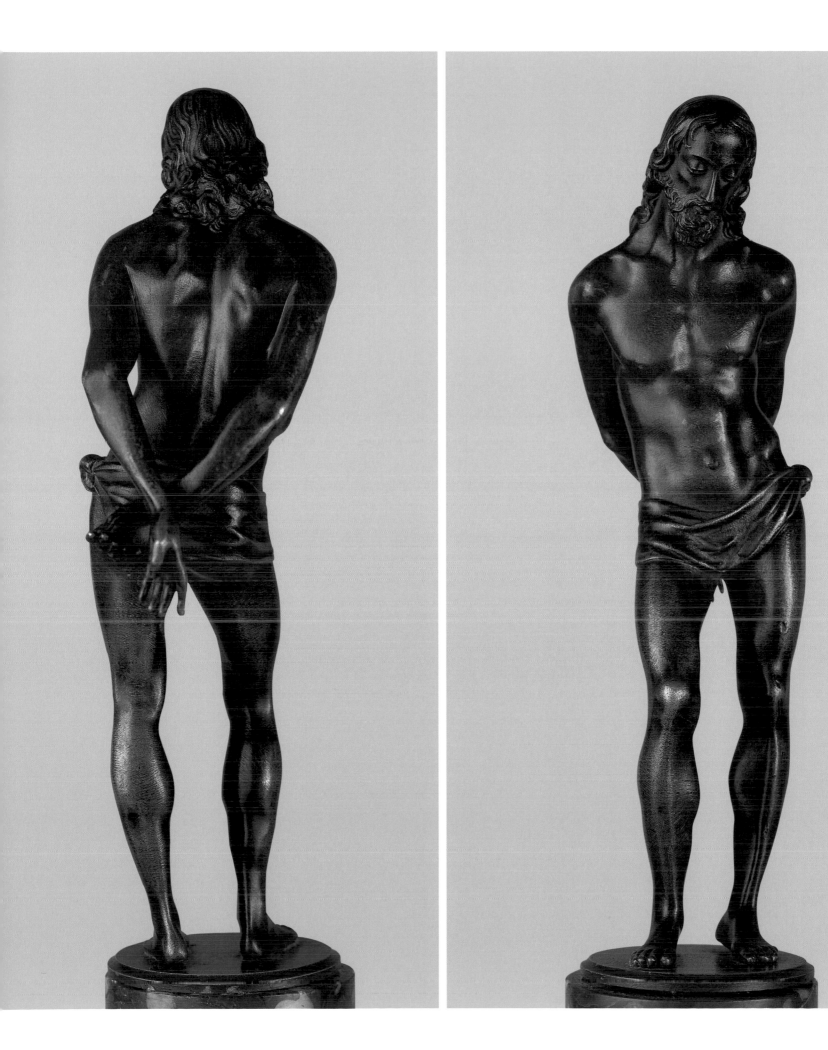

54 | Head of Christ Crowned with Thorns

After Matteo di Giovanni Civitale (1436–1501)
Florentine, date uncertain
Terra cotta, with traces of polychrome
14 x 15⅝ x 8 inches (35.5 x 39.4 x 20.3 cm)

In the absence of accurate measurements of a marble bust, now in the museum in Lucca, Tuscany, it is impossible to ascertain the precise relationship to it of the present terra cotta.[1] If the same size, our piece could be a finished working model from which the other was carved; if smaller by 5–10%, it would more likely be a cast from molds taken from the marble at an unknown date. The bust in Lucca has long been attributed to the local sculptor Matteo Civitale, who was the most important sculptor in Tuscany working outside the metropolis of Florence. Further specific research will be necessary to clarify the matter.

The Hall bust belongs to a rather large group of Florentine images depicting *Christ as Man of Sorrows* and is derived from one or more originals by Andrea del Verrocchio (see cat. no. 91). Simplified variants were produced by the less gifted, but competent Agnolo di Polo (1470–1498 (?)). The bust in Lucca differs from the Verrocchio in the inclusion of the crown of thorns and in the more agonized expression of the Savior. It would have been especially challenging to carve in marble because of the amount of piercing required: this was brilliantly executed with the careful use of a drill by Civitale, who had learned his techniques in Florence. He must also have used the drill to undercut the sinuous curls of hair that frame Christ's haggard face, before finishing them with a chisel. Typical of Civitale is the calligraphic design of the curls of hair in the mustache and beard. Especially striking is the rendering of a tear on Christ's left cheek. This was to remain unparalleled for over a century, until Bernini represented tears on the cheek of his figure of Proserpine in his marble group of her abduction by Pluto (c. 1620, Borghese Gallery, Rome). **CA**

Bibliography: J. Pope-Hennessy: *Italian Renaissance Sculpture* (London, 1963, rev. Oxford, 3/1985), 292–3; S. Bule, "Civitali," J. Turner, ed., *The Dictionary of Art* (London, 1996), vol. 7, 366–68.

1 A. Venturi, *Storia Dell'Arte Italiana, vi. La Scultura del Quattrocento* (Milan, 1908), 701–2, fig. 476.

PASSION NARRATIVES

55 | Head of Christ Crowned with Thorns

Italian (Naples?), third quarter of the 18th century
Shell cameo
2¼ x 1¾ x ⅜ inches (5.4 x 4.5 x 1 cm)

Cameos are designs engraved or carved in relief on gemstones, ceramics, glass, or other materials, which may be either opaque or transparent. Through the incised design, the various colors of the substance are revealed, thereby creating contrast. European and American patrons commissioned portraits of themselves in shell cameo from Italian gem engravers, some of whom, such as the Saulini family of Rome, gained considerable renown for their work.[1] This cameo, representing the head of Christ with the crown of thorns, participates in a long tradition of representing Christ in profile. Although the facial profile was the most common subject for cameos, this example is noteworthy because it brings religious subject matter to what was chiefly, by the late eighteenth century, a secular art.

This triple-layered colored cameo exhibits the highest quality of Italian craftsmanship in shell carving. The artist-craftsman has subtly and exquisitely worked the dark top layer to represent droplets of blood on Christ's face, which seem to roll down his neck and shoulders. The second layer forms the outer foundation of the skin, hair, drapery and the crown of thorns. The third and final underlayer forms the background. This masterpiece exhibits the highest aesthetic in a rare art form. Due to their fragility, few of the larger and more elaborate shell cameo compositions have survived. Such translucent carvings were used, in nineteenth-century Victorian England, to shield candle flames. **MH**

1 William R. Johnston, "Luigi Saulini's cameo portrait of Ellen Walters," *Walters Art Gallery Bulletin* XXX/6 (1978): 2–3.

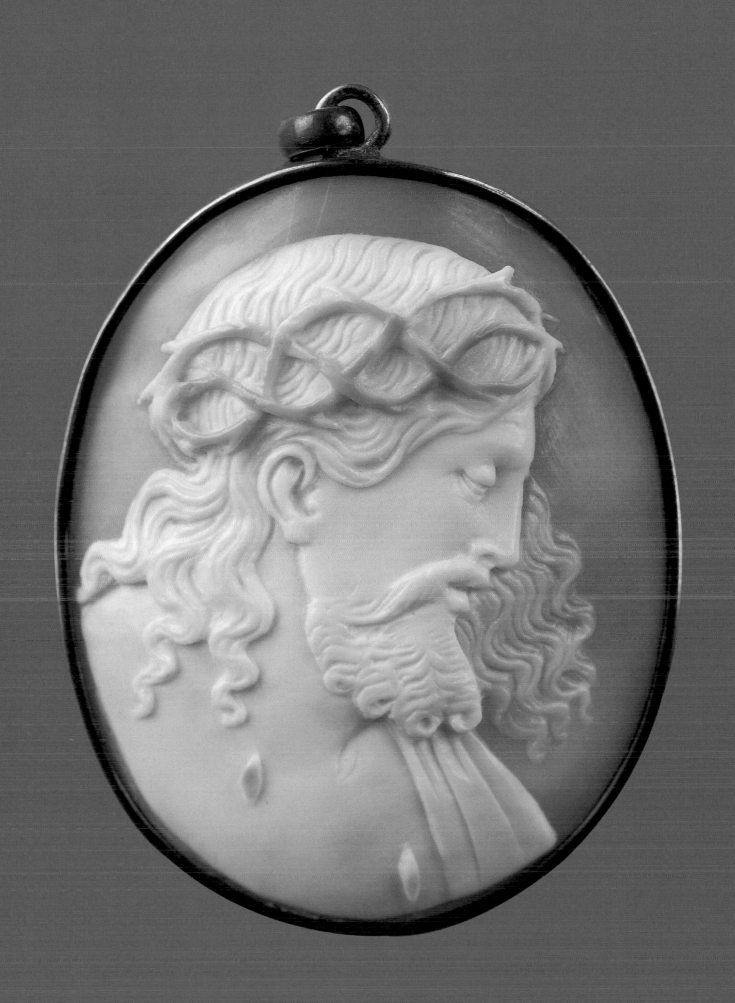

56 | Christ Derided

Netherlandish, late 16th century
Bronze plaque
10⅞ x 8¾ x 1 inch (27.6 x 22. 2 x 2.5 cm)

The design, raised in very shallow relief, like the *rilievo schiacciato* invented in Florence by Donatello around 1420, is so graphic in character that it is almost certainly copied from a drawing or engraving. Many such reliefs depicting the Life and Passion of Christ were produced in the Low Countries during the second half of the sixteenth century. Formerly connected with the famous Dutch draftsman Hendrik Goltzius (1558–1617), the present design seems not to have been taken from his engraved work, although there are a number of similarities between it and a series of *Passion* scenes that he published between 1596 and 1598. These however show the participants full-length.

The iconography appears to combine elements of several events that comprise the Passion narrative: *Christ before Pilate*, the *Ecce Homo*, the *Flagellation*, and the *Crowning with Thorns*. The image portrays Christ surrounded by ill-wishers, his hands bound and clad only in a loincloth and cloak. The High Priest, Caiaphas, remonstrates with the Savior and threatens him with a scourge of twigs and a rod, while two thuggish-looking guards of diverse racial types chat behind his back and two other low-life characters are seen over the High Priest's shoulders. Their curious headdresses and outlandish clothes are meant to approximate the garments, liturgical or otherwise, worn by Jews at the time, while the classical buildings in the background represent the palaces and the Temple of Jerusalem. Such features also appear in the engravings of the *Passion* cycle by Goltzius and his contemporary graphic artists, although a precise source has not yet been found.

The close-up view and Christ's submissive attitude indicate that this plaque was perhaps intended for personal devotion. Another version in *repoussé* silver in the Metropolitan Museum of Art, New York, corroborates this; the more precious material would have been appropriate to mount in a house altar, such as one fashioned from ebonized wood, as was the norm at the time. Indeed, the work of other Netherlandish silversmiths exhibits such scenes in low relief on a series of plaques.

One such silversmith was Arent van Bolten (1573–1633) of Zwolle, who is known principally from an album of designs in London.[1] He is also documented as having made two embossed silver plates (1621) and a statuette depicting Hercules in wax (pre-1624). A private collection in Bremerhaven houses another plaque bearing the *Crucifixion*, initialled AVB.[2] Around these data has been assembled an extensive *oeuvre*, including a dozen plaquettes depicting *The Passion of Christ* in bronze in the Rijksmuseum, Amsterdam.[3] Although considerably smaller (14.3 x 10.4 cm) and with full-length figures, they bear some similarities with engravings by Goltzius and with this plaque. **CA**

Bibliography: W. L. Strauss, ed., *The Illustrated Bartsch* (New York, n.d.), III, 37–41, no. 031; J. W. Frederiks, *Dutch Silver: Embossed Plaquettes, Tazze and Dishes from the Renaissance until the End of the Eighteenth Century* (The Hague, 1952), 184–87.

1 A. E. Popham, *Catalogue of Drawings by Dutch and Flemish Masters in the British Museum* V (London, 1932), 96–135.
2 Frederiks, (as in bibliography), 173–74, and no. 108.
3 Frederiks, no. 116.

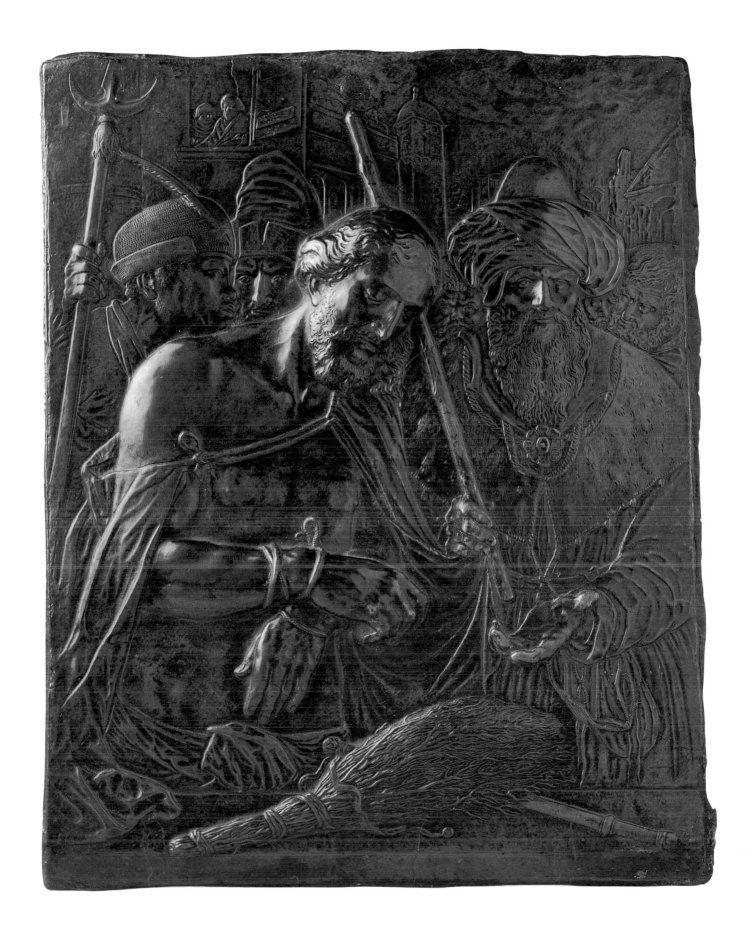

57 | Ecce Homo

After a model by Giovanni Battista Foggini (1652–1725)
Fired in Italy, mid-18th century (?); fire gilt in Russia, c. 1796–1801
White Doccia porcelain with later gilt over-glaze, on an ebonized olive wood base with the original Doccia porcelain volute supports
17¼ x 11 x 14½ inches (43.8 x 28 x 36.8 cm) (including base)

This compelling sculpture shows Christ bound, presented to the Jerusalem populace by Pontius Pilate, who pronounced, "Behold the man" (John 19.5). Christ's face, with its rising eyebrows and desperate gaze, registers a wrenching sense of betrayal as his own people renounce him. This final denial consigns Christ to his fated torture and Passion. The gleaming, fragile porcelain surface of the figure here belies the scourge Christ is known to have endured. The gilt cloak also would seem to contradict Christ's humility. The artist has, in fact, transformed a condemned and suffering body into a precious relic. This conforms with the extravagant aesthetic of the late Medici Court in Florence, which commissioned a number of lavish reliquaries fashioned from the most exquisite metals, gems, and stones from Foggini and his workshop.[1]

Foggini was the Court sculptor and furniture designer to the penultimate Medici Duke, Cosimo III (1642–1723). Foggini's posthumous reputation only increased as many of his small-scale bronze sculptures were reproduced in Doccia, the local porcelain crafted by Carlo Ginori. He founded the manufactory in Sesto Fiorentino, just outside Florence, in 1737, the very year the Medici dynasty expired. Despite the collapse of the Court, the constant demand for porcelain objects and taste for Florentine design throughout Europe ensured the success of the enterprise. The Ginori inventories record a wax model of the *Ecce Homo* by Foggini and the negative molds taken from it to fashion the porcelain.[2] Many Doccia figures replicate famous bronze sculptures by Foggini and his rival Massimilliano Soldani Benzi (1656–1740). The *Ecce Homo* likely had bronze counterparts, but none are now known. Another porcelain example, in addition to the wax model, exists in the Museo di Doccia in Sesto. The exquisite detailing of this ungilt version suggests a relatively early phase of Ginori production, about 1745–50.[3]

The Hall *Ecce Homo* has a remarkable history of facture. The reverse bears the mark used by the Imperial porcelain factory in Saint Petersburg. Its Cyrillic "P" shape refers to Czar Paul I of Russia, and was only used between 1796 and 1801.[4] The fire gilding of the cape and the gilt rope that binds Christ's hands date from this period. The quality and thickness of the porcelain, the fine translucent glaze, and the close resemblance of the modeling to the other Doccia example suggest that the Hall *Ecce Homo* may have initially been crafted at Sesto in the mid-eighteenth century, and later altered to suit Russian taste. JU

Bibliography: Jennifer Montagu, Klaus Lankheit, et al, *The Twilight of the Medici: Late Baroque Art in Florence, 1670–1743*, exh. cat. (Detroit, 1974), 416–7, no. 243.

1 Jennifer Montagu, Klaus Lankheit, et al, (as in bibliography) nos. 193, 198, 201.

2 Klaus Lankheit, *Die Modellsammlung der Porzellanmanufaktur Doccia. Ein Dokument italienischer Barockplastik* (Munich, 1982), p. 4, no. 29: "un Ecce Homo sedente di Gio. Batt.a Foggini" (reproduced pl. 109).

3 Jennifer Montagu, Klaus Lankheit, et al (as in bibliography), 416–7, no. 243.

4 Michael Hall files, written communication from Ede Dishaut.

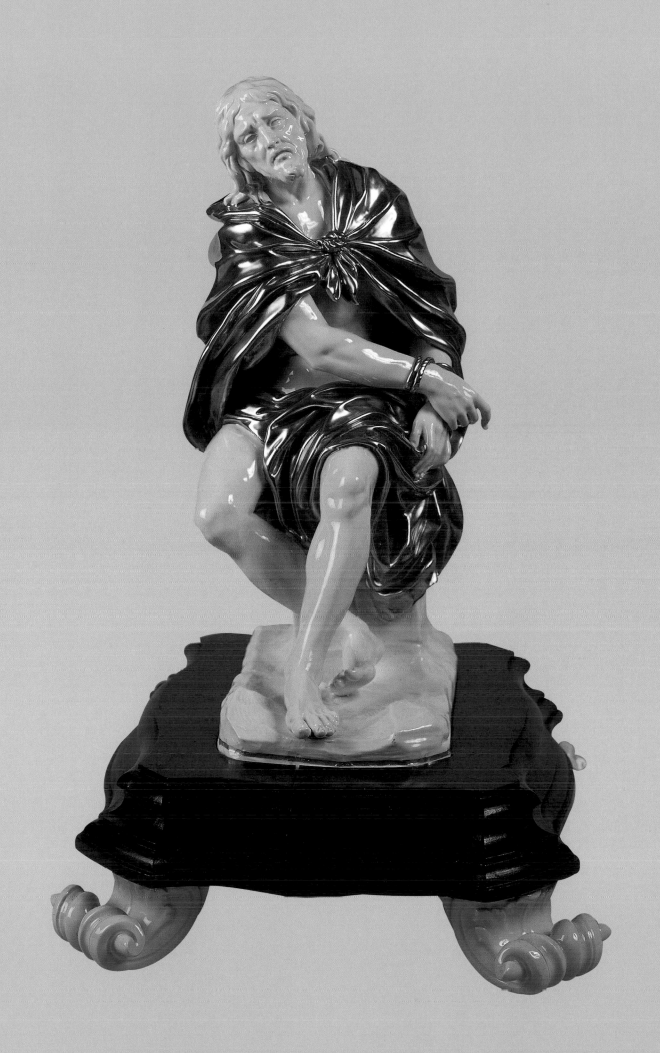

58 | Christ Falling under the Cross

Alessandro Algardi (1598–1652)
Roman, c. 1650
Bronze
7½ x 10½ x 6 inches (19 x 26.7 x 15.2 cm)
Ebonized wood base: 10⅞ x 8½ x 4½ inches (27.7 x 21.9 x 11.4 cm)

There is no early reference to this model as a work by Algardi, although a description that must refer to a similar bronze appears in the 1690 inventory of the goldsmith Antonio d'Amico Moretti. The inventory lists a number of anonymous bronzes, many of them undoubtedly replicas of Algardi's models. The attribution to Algardi must rest on style: for example, the head and hair are similar to those of a *Crucifix* indubitably by him, and the sculpture also shares features with the *Baptism of Christ*, now generally accepted as his work. Moreover, the drapery typifies Algardi's style. It falls in sinuous, broken lines and is modeled in broad planes set off by ridged folds to create a pattern of highlights enclosing deep shadows. This type of drapery, together with the sense of weight in a very small figure, appears in the sculptor's works towards the end of his life, around 1650. The only other attribution put forward in recent times was to Melchiorre Cafà, but this rested on a dubious interpretation of a word in Ercole Ferrata's inventory, and the former attribution of the *Baptism* group to this Maltese sculptor.[1]

Of the many known casts of the model, this example is among the best. It has very limited chiseling. The roughened surface of the drapery suggests a coarse and heavy material, while dulling any excessive shine on the surface. None of the existing casts retains its original cross. Christ would have grasped the cross-bar in his right hand, while bearing the weight of the cross on his back. The sculpture was clearly meant to be seen from one side, but the twisted pose emphasizes its three-dimensional form. It influenced other representations of the subject, particularly in Spain, where there was a gilt-bronze example at an early date. Such popularity is not surprising, for the sculpture combines a deep and affecting pathos with superb formal qualities. Nor, given its feeling of sincere religious conviction, is it surprising that some casts have been combined with reliquaries.

The pose is traditional for this subject, as is the stone on which Christ supports his left hand. Was Algardi aware that pilgrims were shown a stone on the *Via Dolorosa* on which Christ was said to have fallen during his walk to Calvary? Compositionally, the stone creates a triangular figure, rather than an ungainly rectangular one. The braced arm dramatically sets off the lack of strength in his exhausted body. The head is small and broadly modeled, yet the features are marked with profound grief. It would probably be fanciful to say that the limited afterwork on the bronze creates a certain vagueness, reminiscent of the image impressed on Veronica's veil, but it seems to express the sense of physical exhaustion, just as the dragged left leg can no longer support the weight of the cross, and the extended foot can walk no further. JM

Bibliography: *Roman Baroque Sculpture. Five College Roman Baroque Festival*, exh. cat., Smith College Museum of Art (Northampton, 1974), 27; Jennifer Montagu, *Alessandro Algardi* (New Haven, 1985), 2 vols, II, 323, cat. 11.C.6, fig.196.

1 Rudolf Preimesberger, "Ein Bozetto Melchiorre Cafas," *Wiener Jahrbuch für Kunstgeschichte*, XXII (1979), 182.

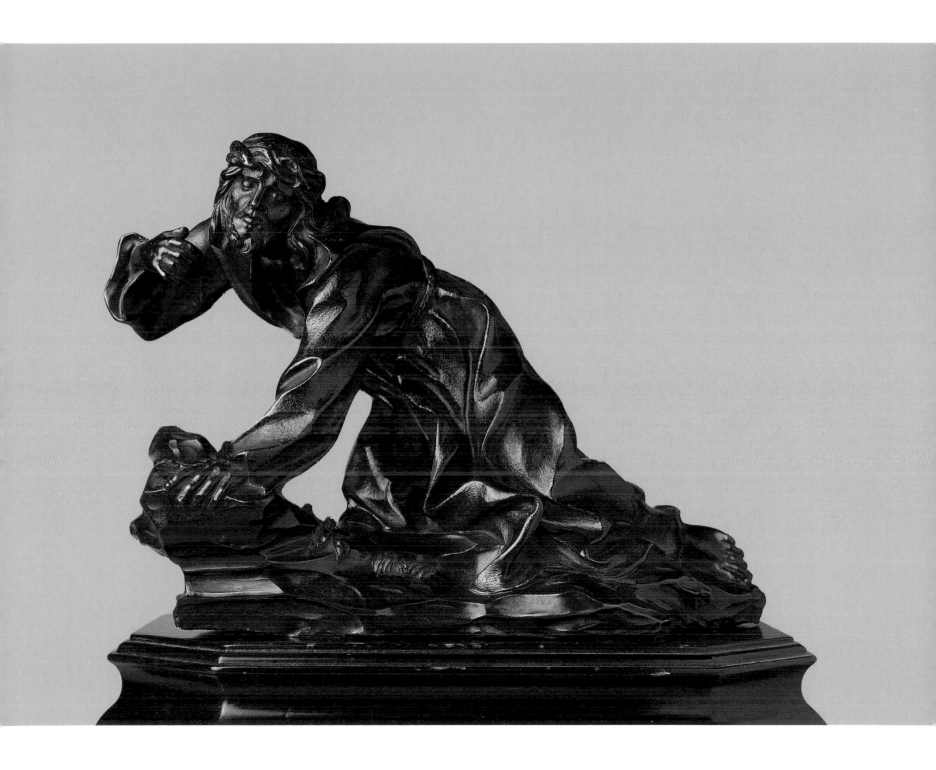

59 | Christ on the Cross flanked by the Virgin and Saint John

Front panel from a tomb complex
Spanish/French (?), c. 1120 (?)
Front panel from a tomb complex
Silver *repoussé* mounted on oak panel
19 x 42 x 1½ inches (48 x 106 x 3.8 cm)

This silver relief represents the crucified Christ, flanked by the Virgin Mary and St. John, framed within an arcade supported by columns with stylized acanthus leaf capitals. Under the central trefoil arch, the oversize body of Christ is depicted stiffly frontal, and incised curved lines define his ribs. The flat, broad folds of the *perizonium* are gathered to Christ's left. The cross is flanked by the Greek letters alpha and omega, symbolic of Christ as they mark the beginning and the end of the alphabet.

Varied ornamentation covers the entire surface. Palmette rinceau decorate the beveled edge of the frame and the space above the arcade. An incised lozenge pattern covers the interior of the arcade. Each lozenge contains a circle of eight dots with a single dot in each circle's center. The quatrefoils piercing the squinches above the arcade contain a simplified version of the lozenge design: a single *repoussé* dot marks each lozenge's center. The palmette vines and the eight dot circles inscribed in lozenges recall designs found in thirteenth-century French illumination.

This silver relief of the *Crucifixion* may have belonged to a tomb complex. Its form and style find precedent in Romanesque stone lintels and gothic manuscript painting. The figure of the hierarchically scaled Christ flanked by figures beneath an arcade recalls the twelfth-century carved stone lintels at Saint-Genis-des-Fontaines (c. 1020–1021) and Saint-Andre-de-Sorede (c. 1030).[1] In these, Christ as judge is shown in a mandorla at the center of the lintel. The Greek alpha and omega are visible on either side of Christ. Angels on bended knee support the mandorla at its base. Angels and apostles flank the central scene, while a stylized palmette rinceau frames the entire scene. The arcade's unarticulated columns are capped with acanthus leaf capitals.

Though the iconography of the tomb frontal and lintels is different, the similarity in form and design suggest that the lintels may have been models for the later frontal. The somewhat awkward stylization of the figures on the Hall piece may indicate a provincial center of manufacture. This recent acquisition awaits further research that would uncover its precise dating and place of origin. MH

1 See Robert C. Calkins, *Monuments of Medieval Art* (Ithaca and London, 1986), p 90; *The Art of Medieval Spain*, exh. cat., Metropolitan Museum of Art & Harry N. Abrams (New York, 1993), 188-89.

60 | Crucifixion

Spanish, second half of the 15th century
Carved jet
6 x 5¼ x 1⅛ inches (15.2 x 13.3 x 2.9 cm)

This scene depicts the standard elements of the *Crucifixion*. Christ nailed to the cross stands at the center of the scene flanked by the two crucified thieves. The Virgin Mary and St. John stand on the ground to either side of Christ's cross. An unveiled female figure kneels at the foot of the cross. Her position, reaching up towards Christ and fixing her gaze on him and her unbound hair, suggest her identification as Mary Magdalene.[1] Beneath Christ's outstretched arms two angles holding chalices hover, waiting to catch blood from his wounds. *Sol* and *luna*, the sun and moon, flank the crucifix in the sky. The instruments of the Passion are carved onto the frame. Clockwise from the top right they are: the hammer used to nail Christ to the cross; the scourges with which he was beaten; the ladder used to lift his body down from the cross; the dice used to cast lots for his cloak; the pliers used to remove the nails from his hands and feet; the nails used to anchor him to the cross; the column to which Christ was tied and scourged; the lance used to pierce his side; and the knife used to rend his cloak. At the apex of the frame are three circles inscribed with crosses, most likely depicting the Eucharistic wafer.

The presence of the Eucharistic wafers on axis with the figure of the crucified Christ and the relief's shape suggest that it was carved as a pax. Christ's stylized hair and beard, and the stiff, rough quality of the drapery on Mary, John and the angels recalls other jet carving made in Léon and Vallolidid in the second half of the fifteenth century.[2]

Jet carvings were made in Spain beginning in the eleventh century.[3] Jet is a type of coal from which jewelry and other small decorative objects were often carved.[4] The *Crucifixion* scene's didactic quality and the static, frontal execution of the figures suggests that it may have been carved as a pilgrimage souvenir. Santiago de Compostela, a popular pilgrimage site, was famed for its jet carving beginning in the Middle Ages.[5] By the fourteenth century, the jet carvers there were a recognized guild and the city maintained its prominence as a jet-carving center through the eighteenth century.[6] **PP**

1 For Mary Magdalene's varied iconography see Diane Apostolos-Cappadona, *In Search of Mary Magdalene: Images and Traditions*, exh. cat. (The Gallery at the American Bible Society, New York, 2002).

2 Osma y Scull, Guillermo Joaquín. *Catalogo de azabaches composteleanos precedido de apunies sobre los amuletos contra el aojo, las imagines del apostol-remero y la confradia de los azabacheros de Santiago* (Madrid, 1916). See in particular the Crucifixion in jet discussed on 184–85. For the difficulty of dating jet carving see Marjorie Trusted, *Spanish Sculpture, Catalogue of the Post-Medieval Spanish Sculpture in Wood, Terracotta, Alabaster, Marble, Stone, Lead and Jet in the Victoria and Albert Museum* (London, 1996), 143.

3 Carmen Gómez-Moreno, *The Descent from the Cross. The Jack and Belle Linsky Collection in The Metropolitan Museum of Art* (New York, Spring 1984 a), 18.

4 For other examples of jet carvings see Ferrandos Torres, José, *Marfiles y azabaches espanoles* (Barcelona, 1928). See Beatrice Irene Gilman Proske, *The use of jet in Spain* (Madrid, 1966), 6, who notes that jet carvings are most often small because of the nature of the rock; it is mined in small fragments and is brittle.

5 Gomez-Moreno, op. cit., 18.

6 Proske, op. cit., 5.

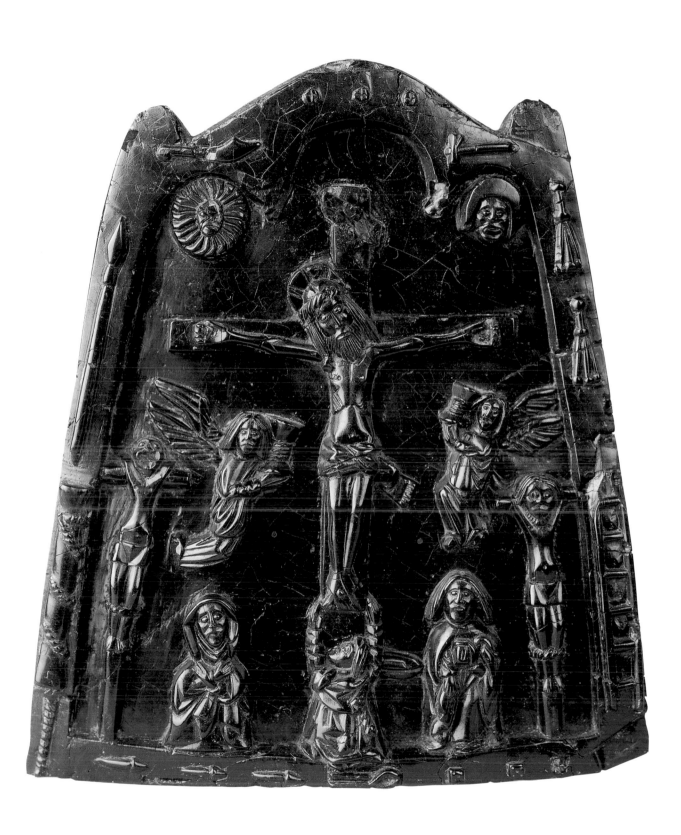

61 | Crucifixion

Galeazzo Mondella, called Moderno (1467–1528)
North Italian, early 16th century
Gilt bronze plaquette
5 x 3½ x ¼ inches (12.5 x 8.8 x .6 cm)

"Moderno" was the professional name of the Veronese goldsmith Galeazzo Mondella. He specialized in plaquettes, small narrative reliefs, modeled on one side and cast in bronze, or occasionally silver. In a sense, plaquettes are the sculptural equivalent of prints, with models reproduced in various formats for a widespread, if not necessarily popular, audience. Depending on size and shape, plaquettes assumed a variety of functions, such as pendants, hat badges, or decorative mounts on furniture and boxes, etc.[1] Given its subject matter, the *Crucifixion* served as an incitement to devotion. Like Moderno's *Man of Sorrows* (see cat. no. 64), the worshiper may have used it as a pax, a tablet bearing a sacred image that receives a ritual kiss of adoration.

The *Crucifixion* was one of Moderno's most popular designs, and numerous examples exist in various formats and materials. Unlike the many casts with rubbed surfaces, the Hall composition reads crisply, its brilliant gilding adding a further measure of clarity. The pathos Moderno has captured within this miniscule space no doubt accounts for the success of the composition. Compared to the writhing bodies of the thieves, Christ expires with utmost composure. The form and design of his body is remarkably close to the small bronze *corpus* attributed to Moderno's contemporary Riccio (see cat. no. 74). Christ's passing, however serene, unleashes total anguish and confusion among the witnesses. Mary collapses into the arms of her attendant. St. John clenches his hands, as he looks upward in despair. The Magdalene has bolted to the foot of the cross, her unfurled tresses having yet to catch up with her. Behind the principal mourners, Roman centurions, including one on horseback, press violently forward. In front of the cross, St. Longinus, having delivered the *coup de grace*, gazes at us, the would-be onlookers, invoking us to contemplate the supreme sacrifice. Like his great contemporary in painting, Andrea Mantegna (1431–1506), Moderno tempers an almost gothic intensity of expression with the antiquarian learning of the Renaissance. Longinus carries a Roman shield emblazoned with a gorgon's head. The otherwise inexplicable nudity of the soldier next to him reflects the vogue for classical sculpture. The exquisitely modeled posterior is almost a Mannerist artistic flourish.

With the compression of so many figures of different scales into a single plane, Moderno's composition is essentially pictorial. He likely based the design on a lost fresco of the *Crucifixion* in the Church of San Petronio, Bologna by the Ferrarese artist, Ercole Roberti (c.1482–6). In addition, widely circulated German prints of the period feature similarly contorted bodies of the thieves.[2] JU

Bibliography: William Wixon, *Renaissance Bronze from Ohio Collections*, exh. cat. (Cleveland, 1975), nos. 42, 43; Giuseppe Toderi and Fiorenza Vannel Toderi, *Placchette secoli XV-XVIII nel Museo nazionale del Bargello* (Florence, 1996), 83–4, cat. nos. 143–44; Charles Avery, *La Spezia, Museo civico Amedeo Lia: sculture bronzetti, placchette, medaglie* (Milan, 1998), 272–3, no. 192, with further references.

1 John Pope-Hennessy, "The Italian Plaquette," *The Study and Criticism of Italian Sculpture* (New York, 1980), 192–222.

2 On Moderno's pictorial sources see Douglas Lewis, "The Plaquettes of 'Moderno,'" in *Italian Plaquettes*, Studies in the History of Art 22 (1989): 107–8.

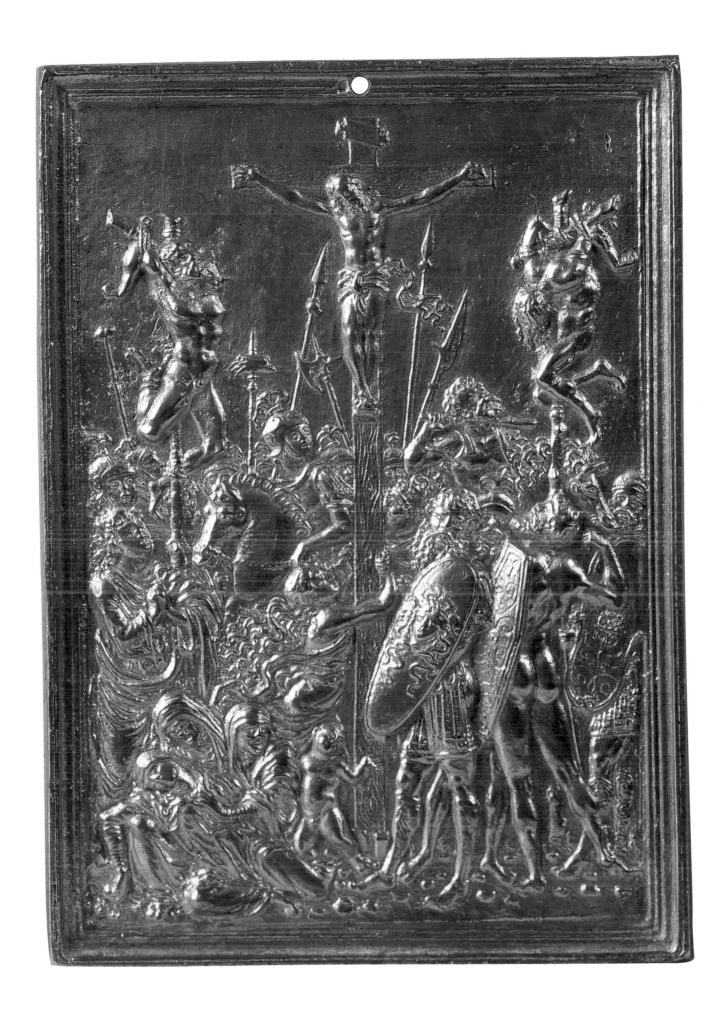

62 | Crucifixion

Giovanni Bernardi (1494–1553)
Italian, mid-16th century
Rock crystal intaglio
4⅓ inches diameter x ⅜ inch (11 cm diameter x 1 cm)
Signed: (bottom center) IOANNES

Giovanni Bernardi was, together with his older rival Valerio Belli, a very celebrated gem engraver of the second quarter of the sixteenth century. Vasari accorded them both fulsome biographies, for gem-engraving was a craft held in high esteem at the time because of its time-consuming technique and the rare materials employed. After a three-year sojourn at the court in Ferrara (not far from his birthplace in the Romagna), Bernardi reached Rome in 1530, where he worked for pope Clement VII, some cardinals, and the Emperor Charles V. Clement VII made him Papal Mace-Bearer and appointed him to the mint between 1534 and 1538. There he copied some of Michelangelo's presentation drawings in rock crystal.

In 1535 Bernardi entered the service of Cardinal Alessandro Farnese, for whom he executed many refined portraits. In 1539 Bernardi made for him a series of rock crystal plaques depicting the *Life of Christ* based on drawings by Perino del Vaga (a talented pupil of Raphael, c.1500–1547); and another of the *Passion of Christ*, completed in 1546–47. Of these crystals thirteen were later (1582) mounted translucently on a cross and a pair of silver gilt candlesticks by the goldsmith Gentile da Faenza for Cardinal Farnese (St. Peter's Treasury, Rome). Another eight also survive, four mounted on a casket (National Museum, Copenhagen) and the others in museums worldwide.

The present unpublished medallion in rock crystal is a variation on the theme of one of Bernardi's second series for Cardinal Alessandro Farnese, the *Passion of Christ*. A roundel bearing an image of the *Crucifixion* (Cabinet des Médailles, Bibliothèque Nationale, Paris; inv. no. H. 2964; 9 cm. diameter), of which Michael Hall owns a positive cast on the reverse of a medal of Christ (see cat. no. 93), enables a close comparison. While the figure of Christ on the central cross is the same, many details differ: the contorted poses of the two thieves are more or less reversed, as is the direction in which the Virgin Mary faints in the foreground, just above Bernardi's signature. There are fewer soldiers and other bystanders and their positions are different. The banner bearing the initials S.P.Q.R. and the distant view of the buildings of Jerusalem are suppressed. The general effect is that, by comparison with the plaque in Paris, the scene has more clarity. **CA**

Bibliography: Ernst Kris, *Meister und Meisterwerke der Steinschneidekunst in der Italienischen Renaissance* (Vienna, 1929), 71, 169, pl. 69, fig. 276; V. Donati, *Pietre dure e medaglie del Rinascimento: Giovanni da Castelbolognese* (Ferrara, 1989), 180; V. Donati, "Bernardi," J. Turner, ed., *The Dictionary of Art* (London, 1996), vol. 3, 817–18.

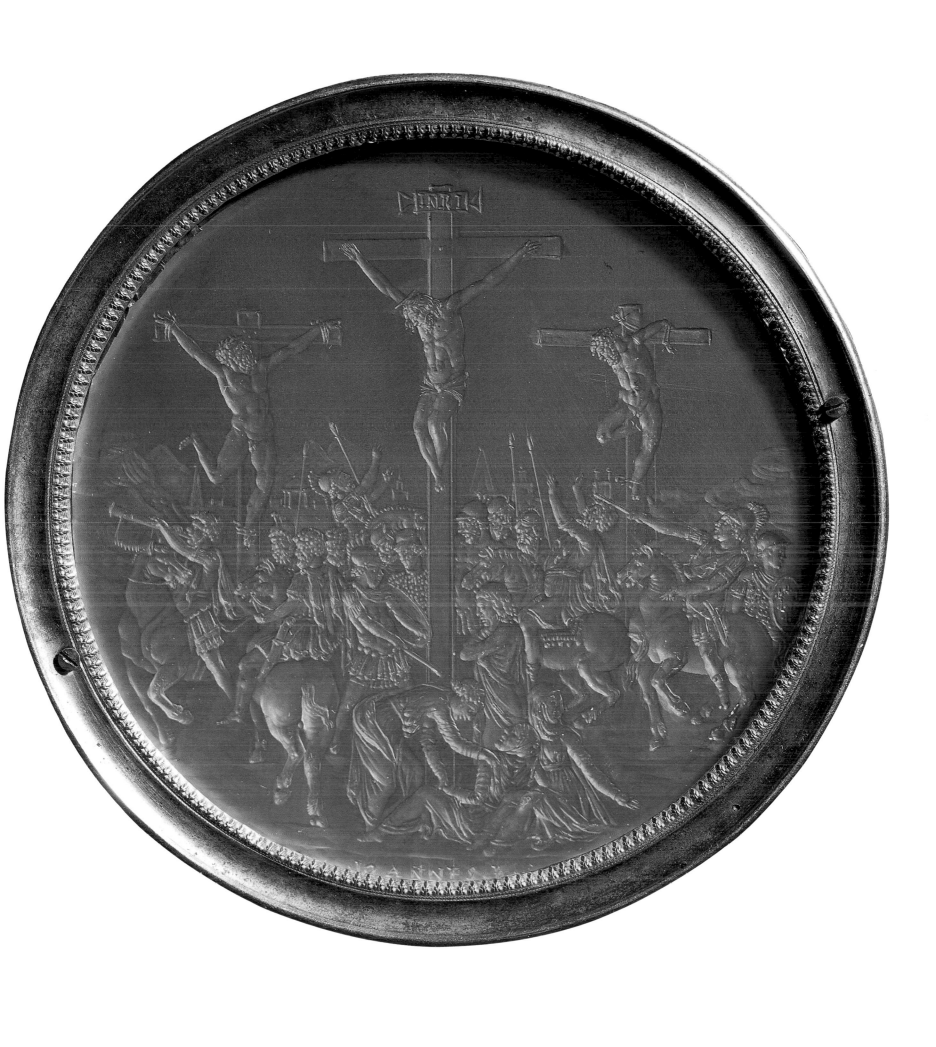

63 | Deposition

After Michelangelo Buonarotti (1475–1564), attributed to Daniele da Volterra (1509–1566)
Italian, mid-16th century
Gilted bronze relief
11½ x 8⅝ x 1½ inches (29 x 21.3 x 3.8 cm)

Two chalk drawings by Michelangelo provided the composition for this bronze (Teylers Museum, Haarlem: A 25r; British Museum, London: 1860–6–16–4). One depicts the body of Christ being lowered from the cross and forms the nucleus of the image. The other depicts St. John and one of the Marys sustaining the mourning Virgin. The idea for the composition was attributed, as early as 1610, to Michelangelo. Daniele da Volterra, an admirer of Michelangelo and a colleague of his in the master's later years, was probably responsible for adding figures and elaborating the gestures.

Several examples in various materials are known (see below). Recent scholarship has clarified the relationship among the various reliefs, including their authorship and dating. The present gilt bronze is delicately cast and chased and of equivalent quality to those previously known. The stucco relief in the Casa Buonarotti, Florence, appears to be a rough cast taken from the Museo Nazionale wax. On the basis of a newly discovered copy drawn by Vasari, Horster attributed the wax to Daniele da Volterra and dated it in the 1560s.[1] Meanwhile, the Pitti ivory is to be identified with one of several replicas that Nicolò Pippi (Nicolas Mostaert of Arras, active 1578–1601/4) made after an ivory relief, "sul disegno di Daniele da Volterra," ("based on the design by Daniele da Volterra") which was delivered to the Medici Guardaroba on May 13, 1579.[2] The Viceroy of Catalonia, Don Ermando de Toledo, received the original ivory (now lost) as a gift. The Vatican relief is probably another of the copies mentioned in the Florentine document. Stucco casts, such as the one in the Casa Buonarotti, would have provided guidance when carving such replicas. In any case the putative authorship of Daniele da Volterra is now confirmed. In the Vatican ivory, Michelangelo appears as an old man standing behind Mary. The ivory replicas of 1579 were commissioned as devotional objects, inspired by the desire to reproduce the master's compositions as Counter Reformation "icons." **CA**

Other examples GILT BRONZE: Berlin, Staatliche Museen zu Berlin (E. Bange, ed., *Die Italienischen Bronzen der Renaissance und des Barock*: ii, *Reliefs und Plaketten*, Berlin, 1922, p. 7, no. 41); London, Victoria & Albert Museum (J. Pope-Hennessy, *Catalogue of Italian Sculpture in the Victoria and Albert Museum*, London, 1964, no. 464 (A.2–1941; ex-Hildburgh, bt. Sotheby's, London, 20 May 1927, lot 40, for £4)); Santa Barbara, CA, U.C.S.B. Museum of Art, Morgenroth collection (U. Middeldorf and O. Goetz, *Medals and Plaquettes from the Sigmund Morgenroth Collection* (Chicago, 1944), no. 309; J. MacAgy, ed., *The Lively Arts of the Renaissance*, exh. cat., Museum of Fine Arts (Houston, 1960, no. 97). SILVER: Klosterneuburg Stift, Austria, made at Augsburg c. 1610 by Jan de Vos of Cologne (active 1582–1610). See O. Doering, *Philipp Hainhofers Beziehungen zum Herzog Philipp II von Pommern* (Vienna, 1896). STUCCO: Florence, Casa Buonarotti; Victoria and Albert Museum, London (J. Pope-Hennessy, *Catalogue of Italian Sculpture in the Victoria and Albert Museum*, London, 1964, no. 463 (A.1–1941; ex-Hildburgh, bt. Sotheby's, London, 20 May 1927, lot 39, for £4. 10s.). WAX: Museo Nazionale del Bargello, Florence. TERRACOTTA: Victoria and Albert Museum, London (J. Pope-Hennessy, *Catalogue of Italian Sculpture in the Victoria and Albert Museum*, London, 1964, no. 465 (D.3327, bequest of the Rev. Alexander Dyce, 1869)). IVORIES carved by Niccolo Pippi (active 1578–1601/4): Museo degli Argenti, Pitti Palace, Florence (see X. Barbier de Montault, *La Bibliothèque Vaticane et ses annexes*, Rome, 1867, pp. 44, 71, no. 310) and Museo Sacro, Biblioteca Apostolica Vaticana, Vatican City (inv. no. 2445, see C.R. Morey, *Gli Ogetti di Avorio e di Osso, Museo Sacra Vaticano, Citta del Vaticano*, 1936, pp. 42–50, 89, pl. XXXII).

Bibliography: C. de Tolnay, *Michelangelo, V, The final Period* (Princeton, 1971), 217, no. 241; O. Raggio, in *The Vatican Collections: The Papacy and Art*, exh. cat., Metropolitan Museum of Art (New York, 1982), 114, no. 53; C. Avery, in Christie's Sale Catalogue, London, 5 December 1989, lot 124.

1 M. Horster, "Eine unbekannte Handzeichnung aus dem Michelangelo-Kreis und die Darstellung der Kreuzabnahme im Cinquecento," *Wallraf-Richartz Jahrbuch*, 28, 1965, p.199.
2 See C. Piacenti Aschengreen, *Il Museo degli Argenti a Firenze* (Milan, 1968), 14, 152; and Archivio di Stato, Florence, Guardaroba, 79, p. 39.

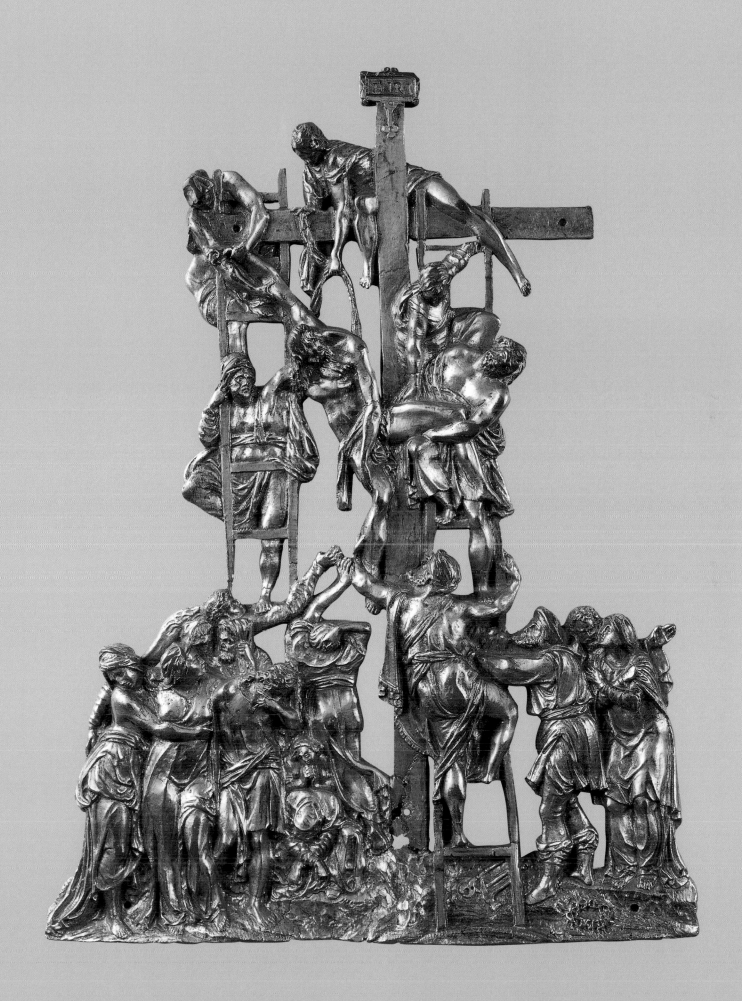

64 | Man of Sorrows with Virgin and Saint John (Pietà)

Galeazzo Mondella, called Moderno (1467–1528)
Italian, early 16th century
Gilt bronze plaquette
2¾ x 2⅛ x ¼ inch (7 x 5.5 x 0.6 cm)

The composition, known in metal and hardstone examples, is an original design by Moderno. He probably invented the compact image for a hardstone carving. As Lewis points out, the figure of Christ is closely related to Moderno's figures of Christ in the *Flagellation* (see cat. no. 51), the St. Sebastian from the silver *Madonna and Child with Saints* and the stone *Apollo* (all in the Kunsthistorisches Museum, Vienna).[1] Each reveals an image of the heroic male derived from classical sources, which Moderno knew from drawings and engravings. In the *Pietà* the figure of Christ resonates with a profound classicism and contrasts successfully with the raw emotion of the flanking figures of the Virgin Mary and St. John the Evangelist.

This plaquette is Moderno's last *Pietà*. Unlike his more pictorial narrative designs (fig. 1), it shows only the figures of the dead Christ, the wailing Virgin, St. John, and a *putto* under Christ's right arm. An example in variegated jasper in the Hermitage Museum, St. Petersburg, attributed to Moderno, probably predates all the metal versions.[2] Cardinal Sigismondo Gonzaga commissioned a *repoussé* silver version mounted as a pax, which is dated 1513 (Cathedral, Mantua). Another refined example in precious metals, silver, *niello* and gilt is also mounted as a pax (Hermitage, St. Petersburg).[3] This version bears an inscription on the reverse (HOC. OP[VS]. F.F. PR[O...]. F. B[ER]NARDIN. SENIOR. VERONE[NSIS]. EX SUIS HELE[M]OSINIS. 1521), suggesting that it was made for a Veronese patron, and, like the Mantua example, in Moderno's studio.

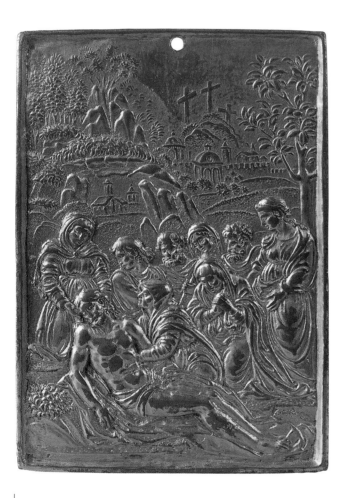

figure 1
Moderno
Lamentation
Gilt bronze, early 16th century
Michael Hall Collection

1 D. Lewis, "The Plaquettes of 'Moderno' and His Followers," *Italian Plaquettes. Studies in the History of Art* 22 (1989): 105–141, esp. 132, fig. 45.

2 Ibid., footnote 254.

3 M. Lopato, *Western European Plaquettes, XV-XVII Centuries, in the Hermitage Collections* (Leningrad, 1976), 20–1, no. 17.

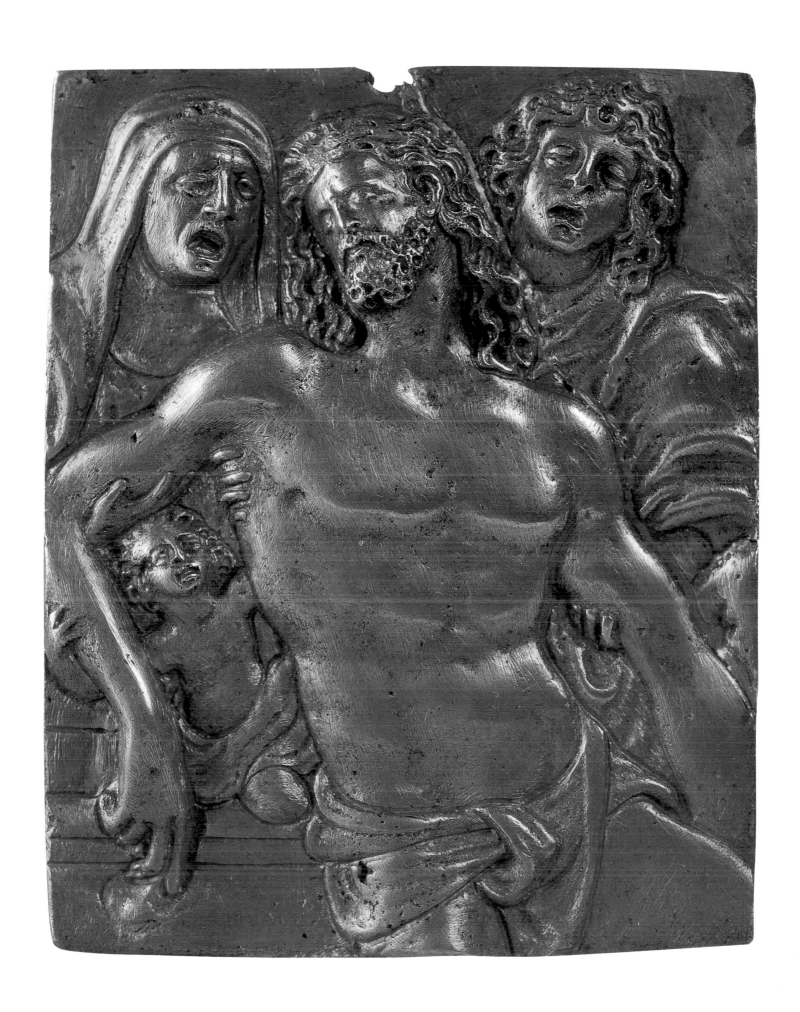

This gilt bronze example is trimmed more tightly around the group of figures, even cutting off Christ's projecting elbow. It is therefore smaller than the example in the Kress Collection in the National Gallery of Art, Washington, D.C. (no. A.451–174B) which measures 8.3 x 6.6 cm.

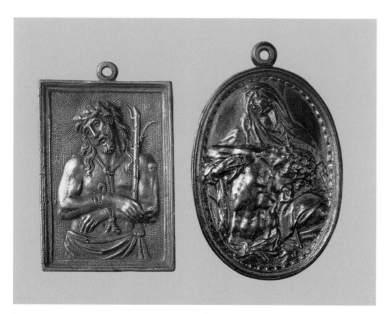

This design by Moderno became widely popular, and now exists in numerous collections and in different versions of later date, frequently adapted for use as a pax.[4] It may have inspired the unknown author of two bronze plaquettes depicting the *Ecce Homo* and the *Pietà* (fig. 2), which belongs to a series whose Netherlandish or Spanish origins are disputed. **CA**

figure 2 (left)
Ecce Homo
Spanish, late 16th century
Bronze plaquette
Michael Hall Collection

(right)
Pietà
Dutch, late 16th century
Bronze plaquette
Michael Hall Collection

Bibliography: J. Pope-Hennessy, *Renaissance Bronzes from the Samuel Kress Collection* (London, 1965), 48, no. 153, fig. 187; D. Banzato and F. Pellegrini, *Musei Civici di Padova: Bronzi e placchette* (Padua, 1989), 60–1, nos. 31–33.

4 Gilt bronze examples in Staatliche Museen, Berlin; Victoria and Albert Museum, London; Santa Barbara Museum of Art, Morgenroth collection. Silver relief in Klosterneuburg Stift, Austria (made in Augsburg, c.1610 by Jan Vos of Cologne). Stucco examples in Casa Buonarotti, Florence; Victoria and Albert Museum, London. A wax example in Museo Nazionale del Bargello, Florence, and one in terra cotta in Victoria and Albert Museum, London. Also extant is an ivory carved by Niccolo Pippi (active 1578–1601/4).

65 | Pietà

After Michelangelo Buonarotti (1475–1564)
Roman, late 16th century
Bronze
15⅖ x 13¾ x 9 inches (39.1 x 35 x 22.8 cm)

1 In marble by Lorenzetto for Santa Maria dell'Anima, Rome (1531); by Nanni di Baccio Bigio for Santo Spirito, Florence (1549); by Battista Vazquez for Avila Cathedral, Spain (1561); and in bronze by Gregorio de'Rossi for Sant'Andrea della Valle, Rome (1616).

2 Edinburgh, The Hon. John Clerk of Eldin, Winstanley & Sons, 25 March, 1833, Eleventh Day's Sale, lot 41: "A beautiful Terra-Cotta OF THE VIRGIN AND JESUS DEAD IN HER LAP, by MICHAEL ANGELO, original." Height 17 1/2 inches; Victoria and Albert Museum, London (8381–1863: purchased in Florence, 51.4 cm high); State Hermitage, St. Petersburg.

3 Berlin, former collection "A.W." (sold 7 December 1926, lot 21, 40 cm high; ill.); Kaiser-Wilhelm-Museum, Krefeld (from the Adolf von Beckerath collection, bought from Palazzo Sciarra, Rome); Luton Hoo, Wernher Collection (inv. No 453; W. Coll. 373; 41.3 cm); The Frick Collection, New York; Ashmolean Museum, Oxford.

The sculpture, which is in excellent condition, depicts the seated Virgin with left arm extended and head bowed, supporting the dead body of Christ on her knees. A dark-brown patina covers the chestnut-colored bronze, suggesting an alloy very rich in copper. The artist worked over the ground and some of the drapery with a small punch. The bronze, which is cast in one piece, is hollow in back.

The bronze is a reduced copy with some variations of the marble *Pietà* by Michelangelo in St. Peter's, Rome. Cardinal Jean Villiers de la Groslaye commissioned the marble group for the Church of S. Petronilla, Rome, probably in 1497; it was completed by 1500. Its fame was instant, inspiring full-size copies in marble as well as bronze.[1] Smaller copies in terra cotta[2] and in bronze[3] were also generated probably within the lifetime of Michelangelo, as well as afterwards.

The statuette must antedate 1736, for in that year the Virgin's left hand was incorrectly restored in marble with the ring and middle fingers less curled than they were originally or as they appear in this bronze. The latter bronze also differs from the marble in the treatment of drapery, flesh, and rock. They are somewhat more simplified than in the original, but more accurate than those of other early bronze copies. The sculptor has managed to capture – if not exaggerate – the intricacy of the folds around the Virgin's neck, the give of Christ's body around the Virgin's right hand, and the broken texture of the rock base, which is far rougher than that of the example now in The Frick Collection, New York. In addition, the present statuette does not provide a rock rest for all of Christ's left foot, as do the original and some copies, such as that in The Frick Collection. Nor are the positions of the heads identical to the original. In the bronze the heads are more vertical, and Christ's head is further from his right shoulder than in the original. But overall, the departures from the original are slight.

The composition may derive from early engravings, for example, those by Antonio Salamanca (1547), Giovanni Battista de' Cavalieri (1564), Adamo Scultore (1566), or Agostino Carracci (1579). The engraving by Salamanca may have created the impression of the raising of the Virgin's cowl, presumably by extra coils of hair or folds of drapery. This may be the source of

the same peculiarity in the present rendering, which differs markedly from that of the original marble.

The unusual technical feature of pitting all over the surface, on the nude body of Christ and on the drapery, is identical with the treatment of the surface of another bronze statuette after a Michelangelo marble. That statuette is in the Norton Simon Museum, Pasadena, CA (Inv. no. F. 65.1.122.S) and is a derivative of Michelangelo's statue representing *Day* in the New Sacristy, San Lorenzo, Florence. However, it is titled the *River Nile* because a sphinx has been inserted under one leg. Both statuettes are presumably by some admirer of Michelangelo belonging to a younger generation. **CA**

Bibliography: C. de Tolnay, *The Youth of Michelangelo* (Princeton, 1969), 149–50, figs. 176–80; J. Pope-Hennessy, *The Frick Collection, An Illustrated Catalogue, vol. III: Sculpture* (New York, 1970), 196–98 (inv. No. 16.2.39; h. 35.7 cm, 17th century); V. Krahn and J. Lessman, *Italienische Renaissancekunst im Kaiser-Wilhelm-Museum Krefeld* (Krefeld, 1987), 60–62, no. 16 (inv. No. 173/1901, h. 38 cm; early 17th century); N. Penny, *Catalogue of European Sculpture in the Ashmolean Museum: 1540 to the Present Day. Vol. I: Italian* (Oxford, 1992), 80–81 (14.6 cm high); D. Lewis, "Genius Disseminated: The Influence of Michelangelo's Works on Contemporary Sculpture," *Michelangelo: The Genius of the Sculptor in Michelangelo's Work*, exh. cat., Montreal Museum of Fine Arts (Montreal, Canada, 1992), 192.

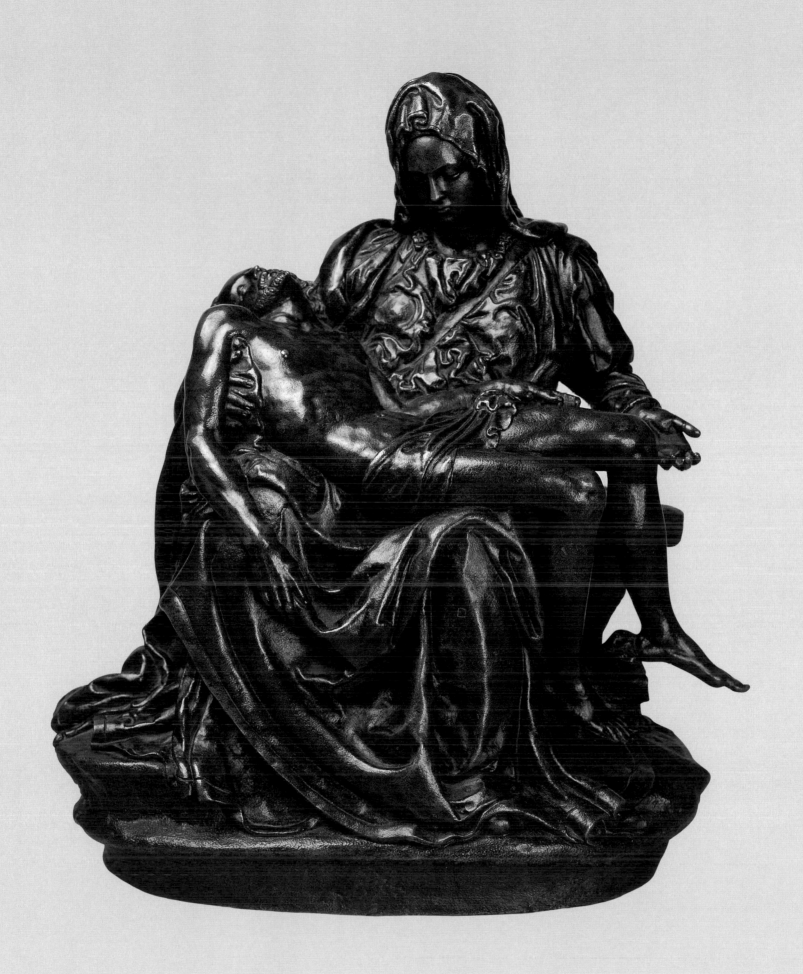

66 | Entombment of Christ

Andrea Briosco, called Riccio (1470–1532)
Paduan, early 16th century
Bronze plaquette
6¾ x 7¾ x 1 inch (12.6 x 19.7 x 2.5 cm)

The plaque, a heavy cast with the surface detail from the wax, bears no traces of afterworking. This is a cast from one of Riccio's best known and most widely diffused plaquettes, of which no signed example exists. It lacks the inscription on the sarcophagus which the finest examples have: "QVEM TOTVS NO: / CAP.ORB. / IN HAC / TVMBA. CLAVDIT" for "Quem totus non capit orbis, in hac tumba clauditur" (He whom the whole world could not hold is confined to this tomb). The iconography of the *Entombment*, a theme that recurs in a number of variants in Riccio's *oeuvre*, draws heavily on Donatello (1386/87–1466), for example the marble relief on the tabernacle of the Sagrestia dei Beneficiati in St. Peter's in Rome, and the large stone relief behind the high altar of the Basilica of St. Anthony's in Padua, as well as various derivative plaques. Ultimately, however, its compositional prototypes are to be found on Hadrianic sarcophagus reliefs representing the death of Meleager, which were accessible in Riccio's day. The plaquette is not a variant of Riccio's relief of the *Entombment* on his masterpiece – the *Paschal Candlestick* in the Basilica of St. Anthony's at Padua (1507–16) – which treats the subject as a strict narrative.[1] The symbolic content of the present image points to a mature work of the sculptor, reflecting instead the style and composition of Riccio's reliefs on the Della Torre monument in Verona (after 1527; original bronze reliefs now in the Louvre, Paris).[2] The present composition should therefore be dated within the last decade of Riccio's life. **CA**

Bibliography: L. Planiscig, *Andrea Riccio* (Vienna, 1927), no. 228, figs. 326–27; J. Pope-Hennessy, *Renaissance Bronzes from the Samuel Kress Collection* (London, 1965), 62, no. 207, fig. 101 (inv. A404.127 B, National Gallery of Art, Kress Collection); C. Avery, "Renaissance and Baroque Bronzes from the Alexis Gregory Collection," *Harvard University Art Museums Bulletin* IV, 1 (Fall 1995): 29–30, no. 4.

1 U. Middeldorf expresses a contrary view in *Medals and Plaquettes from the Sigmund Morgenroth Collection* (Chicago, 1944), no. 198.

2 See E. Bange, Staatliche Museen zu Berlin: *Die italienischen Bronzen der Renaissance und des Barock*, vol. II, *Reliefs und Plaketten* (Berlin, 1922), no. 358; and J. Pope-Hennessy, *The Study and Criticism of Italian Sculpture* (New York, 1980), 211, fig. 26.

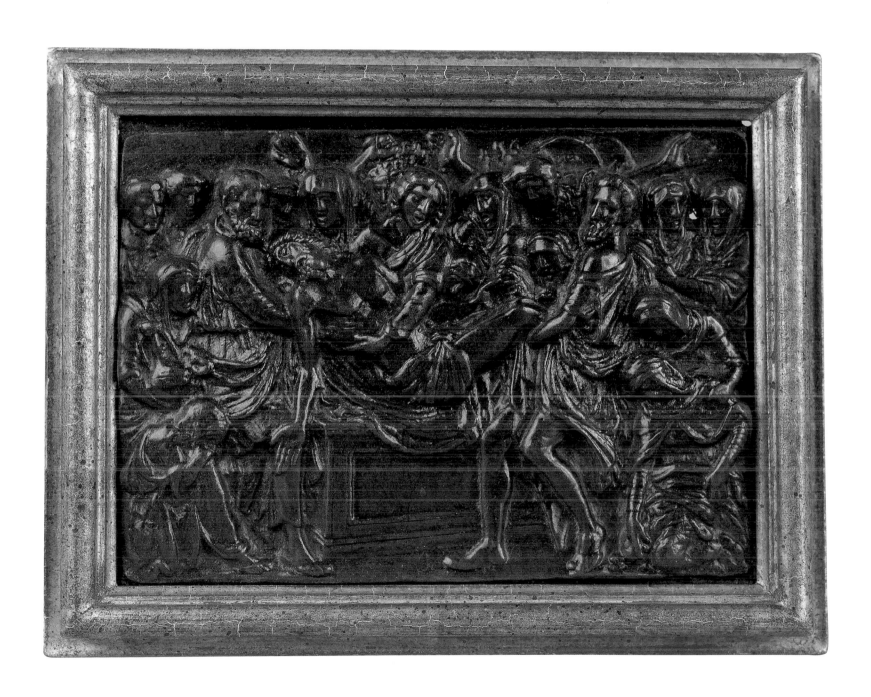

67 | Resurrection of Christ

Circle of Giovanni Bernardi (1494–1553)
Roman (?), mid-16th century
Rock crystal intaglio in a silver gilt mounting with an elliptically shaped carved rock crystal frame
3¾ x 3¼ x 1¼ inches (9.5 x 7.5 x 0.7 cm)

This rare rock crystal intaglio depicts the risen Christ emerging from the tomb flanked by two astonished Roman soldiers. The fluid design recalls rock crystal intaglio roundels by Giovanni Bernardi (see cat. no 62). The well-defined musculature and anatomy of Christ, with his radiant nimbus, and the bannered cross staff (symbolizing Christ's triumphal *Resurrection*) reflect similar designs by Bernardi, considered the master gem engraver of his time.

A bearded soldier wearing his helmet and protecting himself from Christ's apparition holds an unsheathed sword in his hand. His costume is beautifully detailed with scrolled boot tops, short sleeves with *panier* decoration and a leather cuirass. The soldier on the right shields himself from the risen Savior while holding a lance in his left hand. With his left foot Christ steps onto the lid of the sarcophagus, which bears two lion masks. This detail of the sarcophagus may be significant or may help to identify the work's patron. The carvings of gem engravers and medallists were often incorporated into caskets. During his service to Cardinal Alessandro Farnese, for example, Bernardi executed several engraved crystals with classical battle scenes, including the *Battle of Tunis* (Metropolitan Museum, New York), which was intended for the Farnese casket but was not used.[1]

While Bernardi was celebrated for the rock crystals he carved with narratives from classical antiquity – many of them patterned after drawings by Michelangelo – he also carved images with religious subjects. According to a letter the artist wrote to his patron, Cardinal Farnese, in 1547, Bernardi considered his *Conversion of St. Paul* (now lost) to be his greatest work.[2] He also made series of engraved rock crystals depicting episodes from the *Life of Christ* in 1539 (after drawings by Perino del Vaga) and episodes from the *Passion* in 1546–7. It is possible that the Hall *Resurrection* relates to this series. Several of Bernardi's surviving Christological images were on a cross and two silver-gilt candlesticks that Cardinal Farnese commissioned for St. Peter's in 1582. Four other engraved rock crystals by Bernardi are mounted on a casket dating from the seventeenth century (National Museum, Copenhagen). MH

1 Vilhelm Slomann, "Rock-crystals by Giovanni Bernardi," *Burlington Magazine* 48 (1926): 9–23.
2 A. Ronchini, "Maestro Giovanni da Castel Bolognese," *Atti e Memorie della RR. Deputazioni storia per le provincie Modenesi et Parmensi* 4 (1868): 1–28, where the author transcribes Bernardi's Farnese letters.

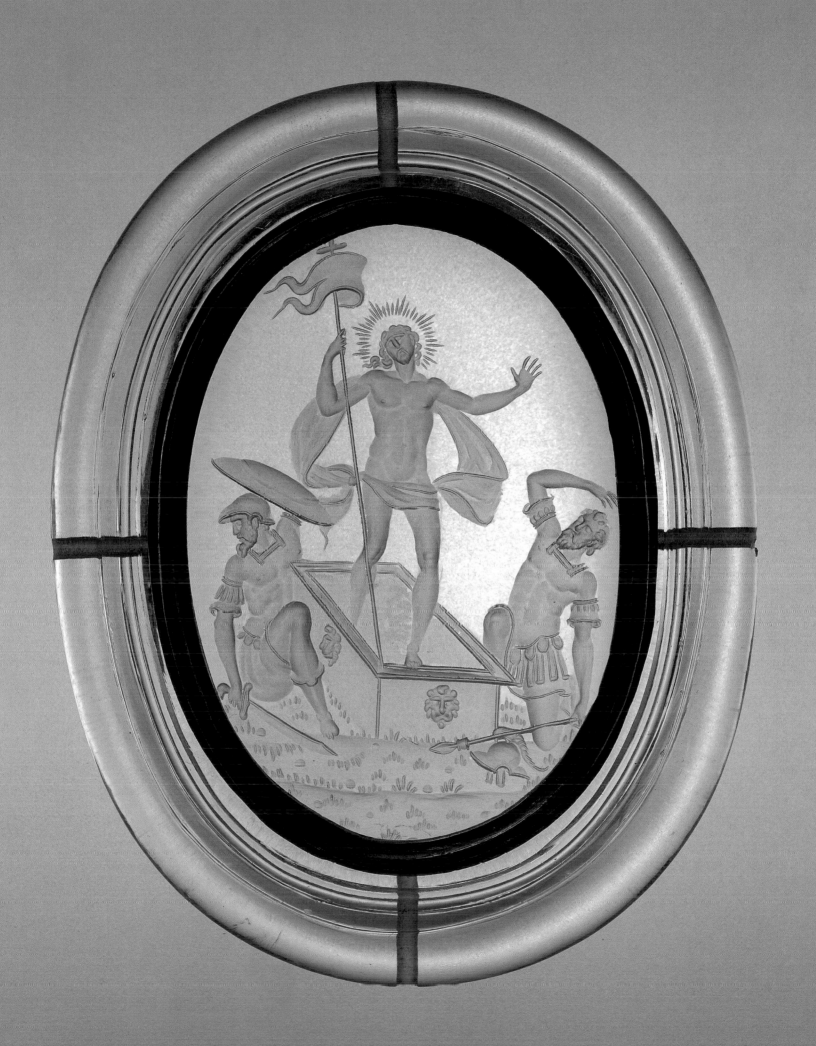

68 | Resurrected Christ Striding

Follower of Francesco Mochi (1580–1654)
Roman (?), mid-17th century
Fire gilded against partly patinated bronze
11 x 6½ x 7½ inches (28.2 x 16.5 x 19 cm)

The figure was probably made in the Rome of Bernini (1598–1680), when the visual arts, through theatrical and lively displays, sought to win and retain Catholic believers. This figure represents a Counter Reformation ideal. Images of Christ Resurrected usually depict him standing at his tomb, quietly triumphing over death, or appearing to Mary Magdalene, the doubting Thomas, or the men of Emmaus at supper. Here, he strides exuberantly forward, proclaiming his triumph through a vigorous gesture and confident movement.

The contrasting colors of fire-gilt drapery against the darkly patinated body reiterate the agitated movement and drapery. Such drapery sometimes appears in sculptures by Bernini, particularly the life-size marble *Bust of Louis XIV* he made in 1665 (Versailles).[1]

This figure of Christ may have been modeled in wax related to Bernini's plan for the bronze figures surmounting the altar of the Capella del Sacramento in St. Peter's (Rome). The altar, made in 1673–74, comprises two larger than life-sized angels flanking a gilt architectural model.[2] This gilt bronze Christ is based on Bernini's original design for the sculpture that was to have adorned the top of the *baldacchino*. The sculpture, however, proved too heavy to be supported by the bronze ribs of the canopy, which are now crowned with a globe and cross.

Alternatively, the Roman sculptor Francesco Mochi, a contemporary of Bernini whose works rendered movement in mid-action, could have executed the present *Resurrected Christ Striding*. He repeatedly used this style of drapery, which is swept forward, abruptly reverses itself, and flutters in multiple directions. The drapery of Mochi's marble *Veronica* gives the figure a sense that she rushes forward to the crossing of St. Peter's (Rome). Bernini criticized Mochi's use of movement in drapery; and upon seeing the *Veronica*, asked sarcastically "where the wind was coming from that blew the draperies with such force against the figure."[3] Mochi crafted similar draperies on the equestrian statues in Modena, where the folds seem to flutter in the forward direction, then contradict that direction by reversing. This is a trick rarely seen in Italian seventeenth-century drapery and may be Mochi's invention and idiosyncratic technique.

In addition, the extremely narrow waist of the Christ figure here, his full ribcage and well developed pectoral muscles have little to do with the physical attributes in Bernini's similar representations. There were many artists studying and working in Rome in the seventeenth century who could have created such an eccentric work after they returned to their homelands in Spain, Portugal, the Low Countries, or even France. MH

1 Rudolf Wittkower, *Gian Lorenzo Bernini: The Sculptor of the Roman Baroque*, 3rd edition (Ithaca, 1981), pl. 101, no. 70.

2 *Ibid*, pl. 119, no. 78.

3 Quoted in Jennifer Montagu, "A Model by Francesco Mochi for the Saint Veronica," *Burlington Magazine* 124 (1982), 430.

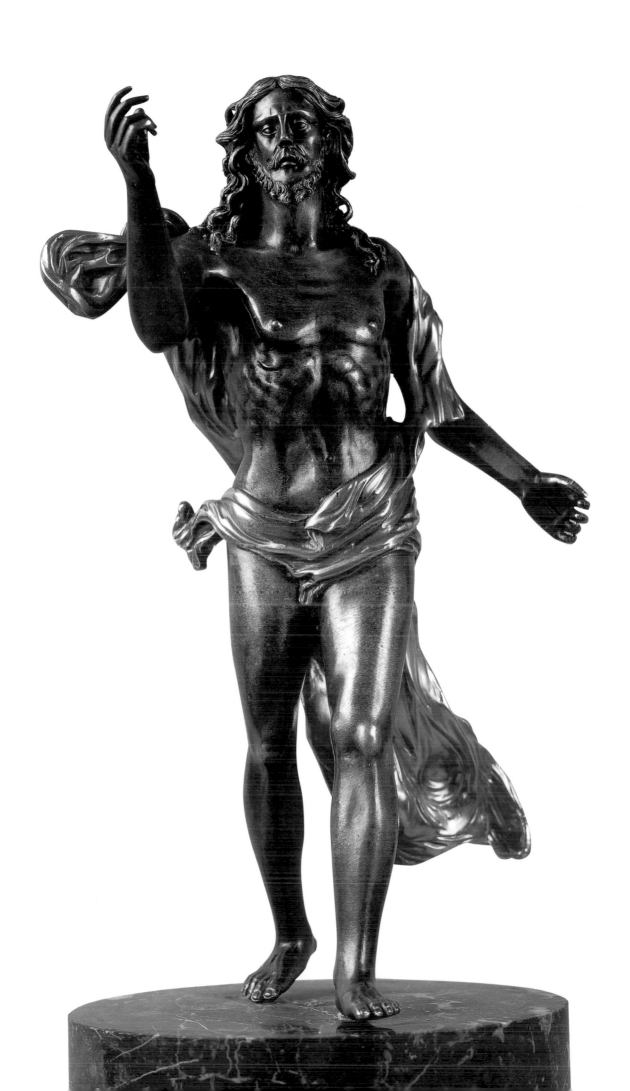

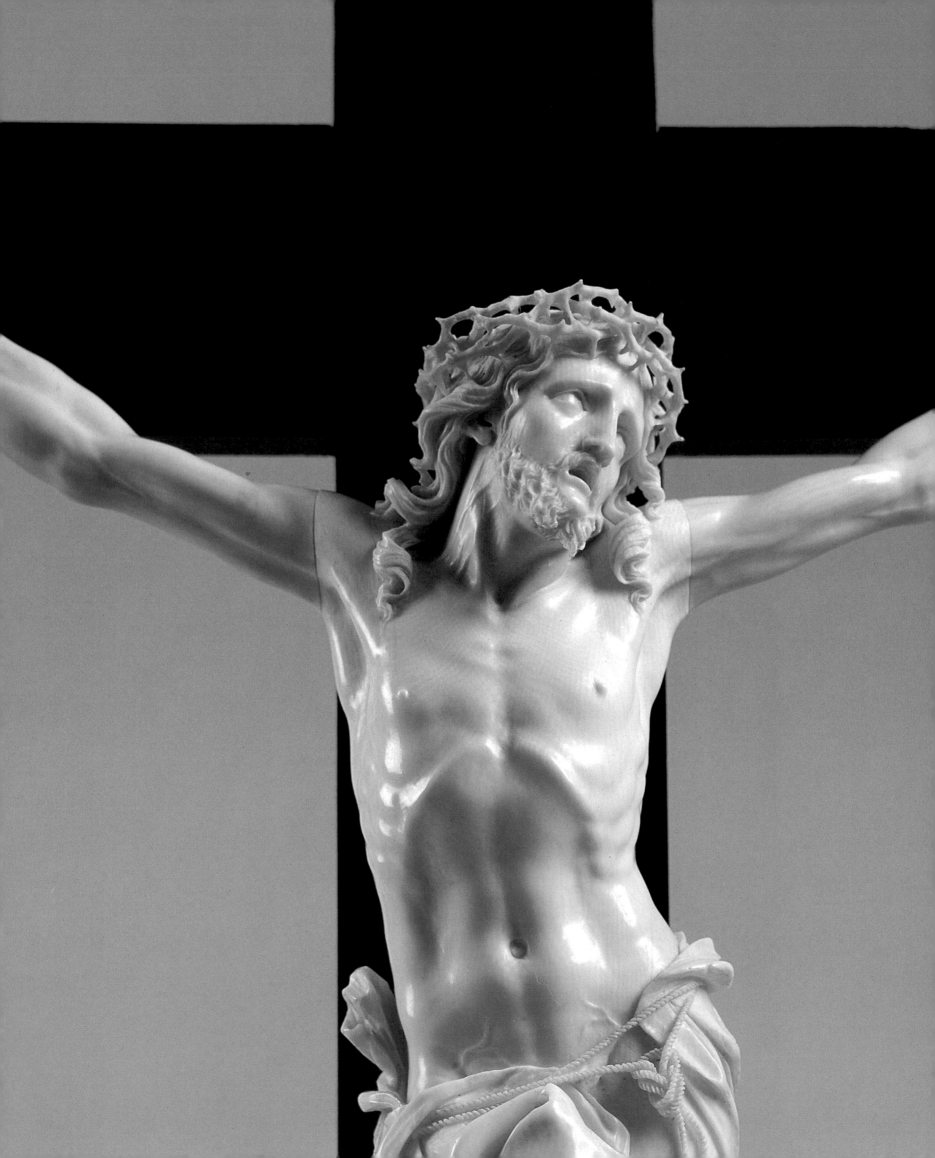

When they came to the place called "The Skull," they crucified Jesus there, and the two criminals, one on his right and the other on his left. Jesus said, "Forgive them, Father! They don't know what they are doing."

Luke 23.33–34

Early Christian art avoided depicting the *Crucified Christ* because of the degrading connotations of death by crucifixion, a horrible punishment reserved for slaves and non-Roman citizens. Only by the fifth century the cross became the symbol of the Christian church, and representations of Christ on the cross soon became ubiquitous. Since Jesus' martyrdom is the key to the salvation of human-kind, it is understandable that the *Crucifixion* is one of the most pervasive images in the history of western art.

Depicting the *Crucified Christ* allowed artists to portray Jesus both as fully human (suffering a slow, painful death, yet accepting his martyrdom with a dignity strengthened by faith) and the Son of God (confident in God's power). Different types emphasize his suffering or triumph. Early *Crucifixes* usually show Jesus still alive on the cross, with eyes wide open, often crowned as King of Heaven and dressed in a long robe. Starting in the ninth century, representations of the dead Jesus, with closed eyes and the crown of thorns on his head, covered only with a loincloth, start to multiply. Although there is only one possible identity for a crucified figure in Christian art, it is noteworthy that the facial features follow the tradition of a "recognizable" Jesus.

In this catalog we have used the term *Crucifix* for representations of Christ on the Cross, and *Corpus Christi* for those examples where the cross is no longer extant.

Eastern French, mid-12th century
Bronze
7¼ x 6⅛ x ⅞ inch (18.4 x 15.5 x 1.6 cm)

The *corpus* takes the form of the cross on which it would have originaly hung. Christ's outstretched arms bend slightly at the elbows. Holes pierce the large hands at their middle. Nails driven through them pegged the *corpus* to the cross (now missing).[1] Here, the figure's crowned head tilts slightly to the right. Braided fillets from the crown and single curled locks of hair drape forward over the figure's shoulders. Short, straight lines delineate the hair and beard which frame Christ's oval face with a broad, flat nose. Despite the body's slight S-curve suggesting the suppleness of the human form, the figure is otherwise characterized by its stylized treatment.

figure 1
Corpus Christi (Crucifix)
French, 12th century
Louvre, Paris, France

On the figure's torso, seven incised horizontal bands divided perpendicularly by a single incised line suggest the ribcage. Above this are uneven and roughly executed breasts. The *perizonium* has a flat, open, trapezoid-shaped fold at its center. Straight, flat drapery folds, which hang from the figure's waist and cover its thighs, are decorated with short horizontal lines alternating with dots. Chevrons decorate the middle fold. Inverted triangles mark the bottom of the folds just above the figure's knees. The feet rest on a corbel composed of an inverted pyramid of graded steps. The *corpus* would have been affixed to a crucifix through the hole at the corbel's base.

The *corpus* in the Michael Hall collection is markedly similar in style and form to others produced in France in the mid-twelfth century, such as *Figure d'applique: Christ en croix* (inv. OA 10840) in the Louvre, Paris[2] (fig. 1); another example is in the treasury of Troyes Cathedral, France.[3] In all three the crowned figure of Christ is posed identically; the torsos share the same stylized delineation of ribcage and breasts; the faces are characterized by the same broad features set on an oval face; and in each the *perizonium* is marked by the same open trapezoidal central fold and decorated with chevron and line designs. *Corpora* with similarly styled *perizonia* were produced in the mid-twelfth century in the Rhine region, southern Germany and in France.[4] A provenance in eastern France has been suggested for both the Louvre and Troyes *corpora*.[5] To this group I would add the *corpus* in the Michael Hall collection. PP

1 Though artistic renderings of the Crucifixion often depict nail holes through the palms, nails were actually driven through the forearms just above the wrists between the radius and ulna bones. See "Crucifixion," *New Catholic Encyclopedia* (Palatine, IL 1981), 485.

2 D.C.G., *Figure d'applique: Christ en croix*, Musée du Louvre Nouvelles acquisitions du département des Objets d'art 1980–1984, Ministère de la Culture, Editions de la Réunion des musées nationaux (Paris, 1985), 36–37.

3 Peter Bloch, *Bronzegeräte des Mittelalters*, Band 5, *Romanische Bronzekruzifixe* (Berlin, 1992), 98, 221 (v c 10). I thank Charles T. Little, The Metropolitan Museum of Art, New York, for this reference.

4 D.C.G., Musée du Louvre Nouvelles, 37 and also Bloch, *Romanische Bronzekruzifixe*, Köln corpus (v c 9), 221, 98; Former Frankfurt Corpus (v c 11), 97, 221.

5 D.C.G., Musée du Louvre Nouvelles, 37. To this I would add the corpus from Trier published by Bloch, *Romanische Bronzekruzifixe*, Trier corpus (v c 7), 220, 97, which is similar in style to the above-cited and which he identifies as French, mid-twelfth century.

70 | Corpus Christi

Swedish (?), first half of the 14th century
Silver
7½ x 4½ x 1½ inches (19 x 10.3 x 3.8 cm)

The image of the body of Christ crucified appears in uncountable media across time and fulfills numerous functions. This silver figure closely resembles those found attached to the bases of Swedish chalices, for which the *Corpus Christi* makes tangible the contents of the vessel: when the vessel is upturned, so is Christ's broken body, and his body becomes an integral part of the fountain of eternal life as the blood/wine pours out. This figure, however, is too large to have been used for this purpose and may have instead been incorporated on a crucifix that complemented the rest of the altar pieces: the chalice, paten, and cross.[1]

The arms of this sculpture, curve dramatically upward, may have been replaced or at least reattached. The musculature of the arms is less defined than that of the abdomen, suggesting that the arms may have been part of a different campaign of production. Nonetheless, they define the body of Christ in a form typical of Swedish production in the fourteenth century. Such curving arms appear, for example, on a painted retable from the cloister church in Cismar.[2] Swedish images of Christ Crucified from this period typically depict Christ's face with a serene expression, his head tilting gently to his favored right (or dexter) side, his legs situated so that the right crosses over the left with a single nail attaching both feet to the cross. His midriff is usually covered by a large opaque *perizonium* that hangs solidly about him.

One of the particular features of this Christ figure is its graphic lance wound on the right side. The strands of trickling blood reach down to form a gate over the wound, which was the locus of special devotion in Northern Europe at the end of the Middle Ages. Swedish silver patens from the period often depict the wounds of Christ in a quincunx pattern, with the chest wound at the center, in order to identify the Eucharistic wafers they support. **KR**

Bibliography: *Man, Glory, Jest, and Riddle: A Survey of the Human Form Through the Ages*, exh. cat., H. De Young Memorial Museum (San Francisco, 1964–65), no. 70; *Medieval Art from Private Collections*, exh. cat., The Metropolitan Museum of Art, The Cloisters (New York, 1968), no. 135.

1 Aron Andersson, *Silberne Abendmahlsgeräte in Schweden aus dem XIV. Jahrhundert*, 2 vols. (Stockholm/Uppsala, 1956), I, no. 75.
2 Andersson, I, 191, fig. 58.

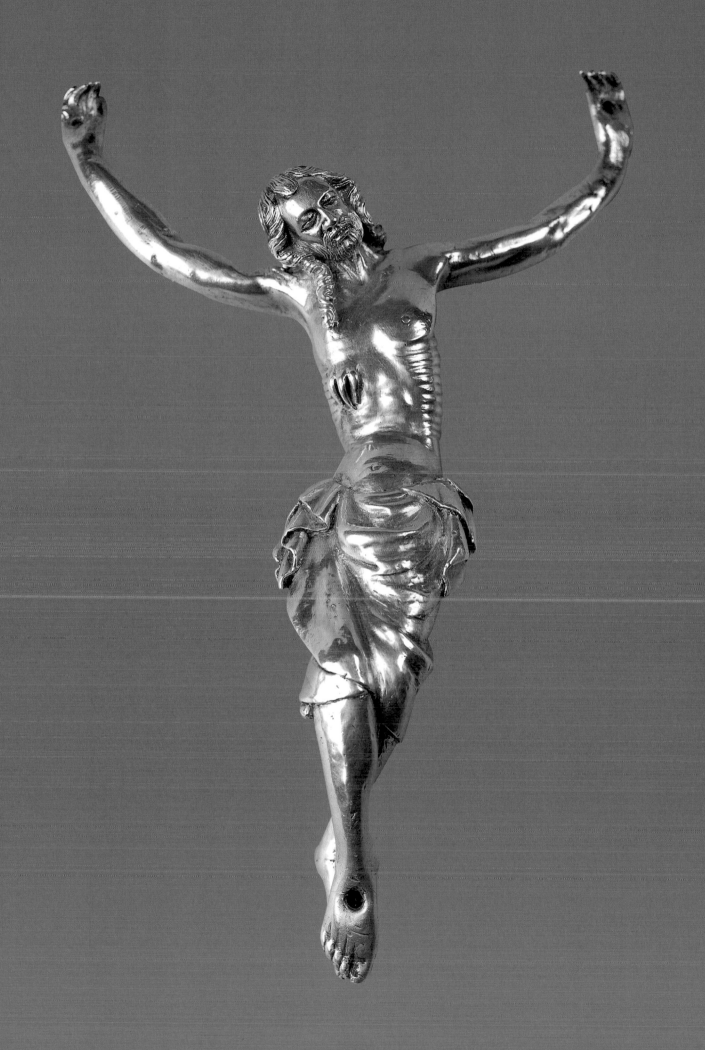

71 | Corpus Christi

Spanish or Italian (?), c. 14th/15th century (?)
Olive wood, polychrome
16¼ x 14⅝ x 2¾ inches (40.3 x 36.8 x 7 cm)

This figure of the crucified Christ is carved in the round. From the front, the head tilts to the left. A broad, smooth forehead, almond-shaped eyes, an aquiline nose, a stylized mustache and beard define the delicately modeled face. A single curled lock of hair falls forward over the figure's right shoulder; the hair is gathered at the back. The figure's body hangs straight down from its outstretched arms, which were separately carved and attached at the shoulders.

The torso is carved to suggest the weight of a body hung from its arms. The sharply defined pectoral muscles, the ribcage seen through the taut skin, and the concave modeling of the abdomen all convey the result of gravity exerting its pull. The absence of nipples, however, is curious in such a finely detailed figure. The *perizonium* descends from the figure's hips clinging to its thighs and buttocks. The single, flat flap of fabric folded over the *perizonium's* belt and its hem cut on a bias at the knees suggest the fabric's drape. The *perizonium* itself is chipped at the figure's knees (visible only from the back) and is richly decorated with gold quatrefoil designs. The *corpus* would have been affixed to the cross through the holes in the figure's palms and feet. The downward pointed feet are highly plastic. Carved bones, knuckles, muscles and tendons delineate the toes and insteps. Even the figure's toe nails are carefully detailed. Such attention is not lavished on the hands, both of which are poised in a gesture of blessing.

The entire figure of this *Corpus Christi* is painted. Thin trickles of blood fall down the figure's forehead, down its torso beginning at the collarbone and from the nail wounds on its hands and feet. The blood on the head and torso suggest the moments during Christ's Passion when he was whipped with scourges and crowned with thorns.

Direct comparisons for this figure of Christ have been difficult to find.[1] On the basis of the figure's modeling and the emphasis on a bleeding body, the *corpus* seems to fit into the artistic tradition begun in the fourteenth century, depicting more naturalistically the physical toll of Christ's suffering.[2] **PP**

1 I would like to thank Charles T. Little, Curator of Medieval Art, The Metropolitan Museum of Art, New York, and Patrick Lenaghan, Curator, The Hispanic Society of America, for taking the time to discuss this piece with me.

2 See for example Italian altarpieces such as *The Crucifixion*, c. 1350, Artist Unknown, Italian, Sienese School, in Linda Seidel, *Pious Journeys: Christian Devotional Art and Practice in the Later Middle Ages and Renaissance*, exh. cat., The David and Alfred Smart Museum of Art (Chicago, 2001), plate 6. See also Alberto di Betto da Assi, *Lamentation*, c. 1421, wood, Siena Cathedral in Leo Steinberg, *The Sexuality of Christ in Renaissance Art and in Modern Oblivion* (Chicago, 1996), 97. For the focus on Christ's humanity and suffering see Caroline Walker Bynum, *Jesus as Mother: Studies in the Spirituality of the High Middle Ages* (Berkeley, 1982).

Attributed to Baccio da Montelupo (1469–1535)
Florentine, early 16th century
Polychromed wood
16½ x 14 x 3 inches (42 x 35.5 x 7.6 cm)

Along with the great painter Fra Bartolomeo della Porta (1472–1517), Baccio da Montelupo is the Florentine Renaissance artist most intimately associated with Fra Girolamo Savonarola (1452–1498). In 1491, this reforming Dominican friar became the prior of the San Marco monastery in Florence. Over the next few years, he mesmerized much of the populace through his tirades against pagan culture and his apocalyptic preaching. Though perhaps more famous for ordering the destruction of works of art in his "bonfires of the vanities," Savonarola had an acute appreciation of the power of decorous religious images to inspire devotion.[1] In this spirit, Baccio executed a wooden *corpus* in 1496 for San Marco, where his brother, Benedetto, was a monk. Yet Savonarola's domination of Florence, his claims to be a prophet, and his zeal to

reform the Roman Church inevitably led to a clash with Pope Alexander VI, his excommunication, and public execution in 1498. Baccio's allegiance to the disgraced prior was such that he fled Florence for his safety and headed to Bologna. There, he fell deathly ill and remained in a coma for six months, until he awoke fully cured before a radiant vision of Savonarola.[2]

Apart from this miracle often cited in propaganda to beatify the friar, Baccio da Montelupo is perhaps best known for his collaborations with another pillar of Renaissance culture, Michelangelo (1475–1564). Baccio carved several of the statues in the Piccolomini altar Michelangelo designed for Siena Cathedral, and crafted the elaborate polychrome wooden frame for the *Doni tondo* (Uffizi, Florence).[3] The bust of Christ on this frame serves as the touchstone for assigning several poly-

chrome wooden *corpora* to Baccio and his workshop. Examples in Santa Maria in Campi and San Francesco al Bosco, both in Florence, share the same basic design of the Hall *corpus*, especially the hourglass shape of the torso, the position of the legs, the arrangement of the hair and forked beard.[4] Both also feature the hinged, adjustable arms, with strained biceps and ligaments of the figure in the collection.[5] Another version, with attached but immobile arms, in the Museo dello Spedale degli Innocenti, Florence, perhaps most closely approximates the Hall *corpus*.[6] The shape of the mouth and the prominent forehead and brow are almost identical, as is the articulation of the rib cage and the slightly distended stomach. The *perizonium* assumes a similar pattern in each work, in the Hall version it is made of cloth dipped into gesso seizing. In all of these *corpora*, the dead Christ appears serene and peaceful, his torments having finally ceased. The Hall *corpus*, at one point, probably had a wooden halo like the other works. JU

1 For an overview of Savonarola and his impact on Florentine artistic culture, see Ronald Steinberg, *Fra Girolamo Savonarola, Florentine Art, and Renaissance Historiography* (Athens, 1977).

2 On Baccio and Savonarola, see Francesca Petrucci, "Baccio da Montelupo a Lucca," *Paragone* (1984): 4–13; Riccardo Gatteschi, *Baccio da Montelupo: Scultore e architetto del Cinquecento* (Florence, 1993), 41–9. Baccio's miraculous cure is recorded in the hagiography of Pacifico Burlamacchi, written soon after Savonarola's death, when many already worshiped the prior as a martyr and saint.

3 On Baccio and Michelangelo, see Gatteschi, op. cit., 60–65.

4 Margrit Lisner, *Holzkruzifixe in Florenz und in der Toskana von der Zeit um 1300 bis zum frühen cinquecento* (Munich, 1970), 82–5, figs. 190–92.

5 The seperately carved arms are inserted into slots and hinged at the shoulders with a dowel-peg. They were designed for the ritual removal of the *corpus* from the cross and for the entombment on Good Friday.

6 Luciano Bellosi, *Il Museo dello spedale degli innocenti a Firenze* (Milan, 1977), cat. no. 14, pl. 18; Gatteschi, op. cit., 58–60.

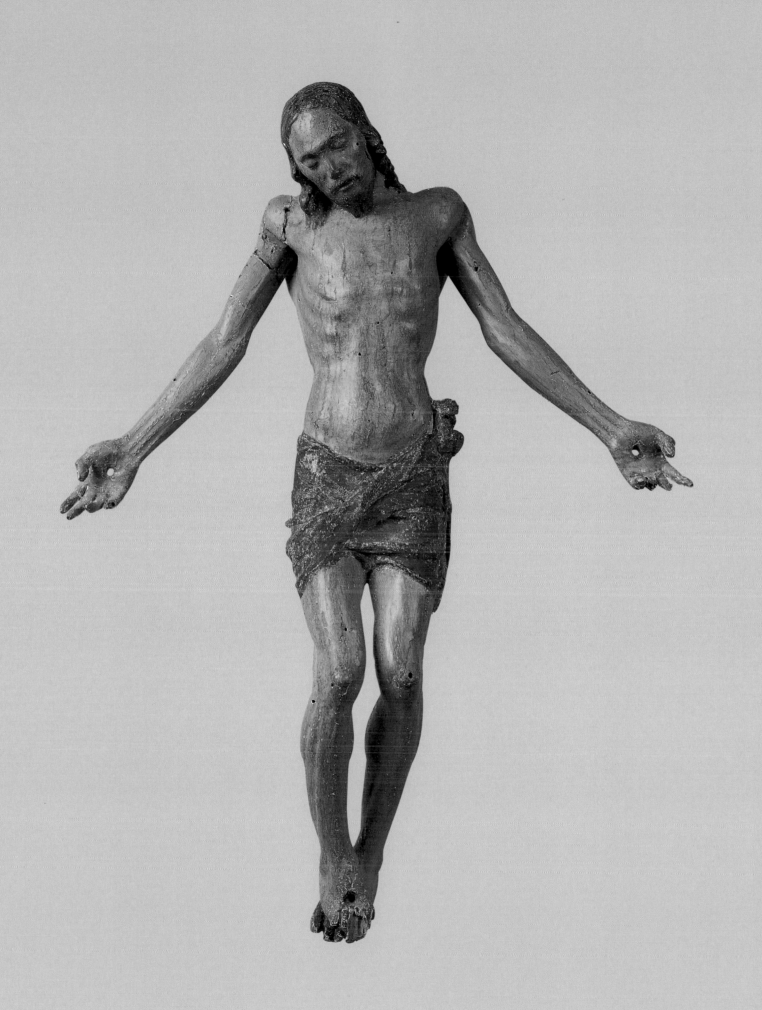

73 | Corpus Christi

African, Gold Coast, c. 1500
Gold
4⅛ x 3¾ x 1¼ inches (10.5 x 9.5. x 3.2 cm)

This figure of a *Corpus Christi* is a rare example of *cire perdue* (lost wax technique) gold sculptures in African Art. It dates most probably from the sixteenth century, and is Akan or Ashanti in origin, from the Ashanti kingdom of western Ghana. Christ, depicted with long straight hair and bifurcated beard and mustache, is decidedly European in type, which documents the impact of Portuguese colonists. The Portuguese explorers first came to the west coast of Africa at the beginning of the sixteenth century. They were successful traders for several hundred years, and remained dominant until the early nineteenth century.

This diminutive gold *corpus* has few parallels in early African sculpture. The extremely large head and feet with the reduced overall body size, and a somewhat schematic body construction point to the Gold Coast. The overall condition is excellent and the body is hollow cast (the end of the *perizonium* below the knot is missing) in the *cire perdue* process. The stylization of the modeling, chasing of the beard and further details are mostly cast from the original wax sculpture with little chasing except for polishing and cleaning of the overall surfaces. The present *corpus* does not reflect any of the other sophisticated tribes such as Benin, or Dahomey, that had cast metals with varying percents of copper. Few early figures of the Crucified Christ of African origin are known. **MH**

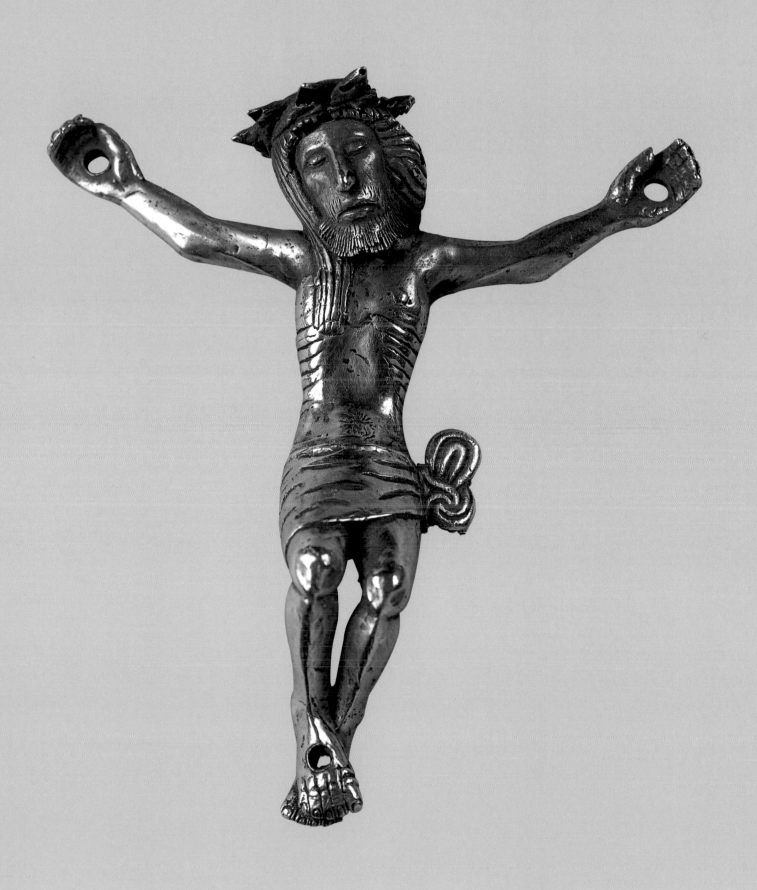

Attributed to Andrea Briosco, called Riccio (1470–1532)
Paduan, early 16th century
Bronze
5²⁄₅ x 4³⁄₈ x 1 inch (13.3 x 11.1 x 2.5 cm)

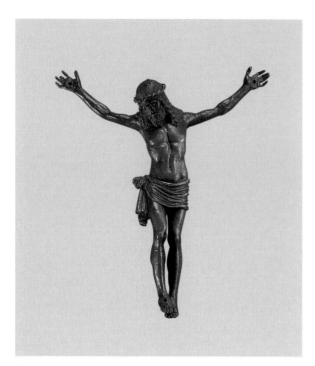

figure 1
Severo da Ravenna (Italian, 1496–1543)
Crucified Christ, c. 1500
Bronze (solid cast), worn light brown patina
The Cleveland Museum of Art, Ohio

This small *corpus* was most likely created for the personal devotions of a private client. The head, slightly erect, conveys Christ's failing condition. At the back of the head is a hole to attach a nimbus, now lost. The head is unusually large for the body size: the hair parted in the middle falls in soft wavy curls and his beard and mustache are of the same curling but loose modeling. There is no wound in his side and he is uncrowned.

The entire surface of the bronze has been carefully chiseled, worked, and polished. The musculature, especially in the abdomen and chest, resembles that of Donatello's large Paduan *corpus*, which hangs in the same position on the cross, with a single nail securing the right foot over the left.[1] The bronze is related to works by Donatello's follower Severo da Ravenna (fig. 1). Stylistically it is closer to Andrea Briosco, called Riccio, a protégé of Donatello's pupil Bellano. The strong classical nose, its bridge coming from the same plane as the forehead, and the heavy-lidded eyes relate to the male physiognomies in documented works by Riccio. The drapery in the back of the *corpus* shows a particular sensitivity in modeling and design, for example, the swag falling against the right leg. Translucent folds cover the buttocks. This small yet powerful *corpus* is a subtle and sensitive depiction, capturing the pathos of Christ's final moments. **MH**

1 Donatello's bronze Crucifix (1444–49) is in the Basilica del Santo, Padua. See Artur Rosenauer, *Donatello* (Milan, 1993), 202 and no. 47; H. W. Janson, *The Sculpture of Donatello* (Princeton, 1963), 194–98.

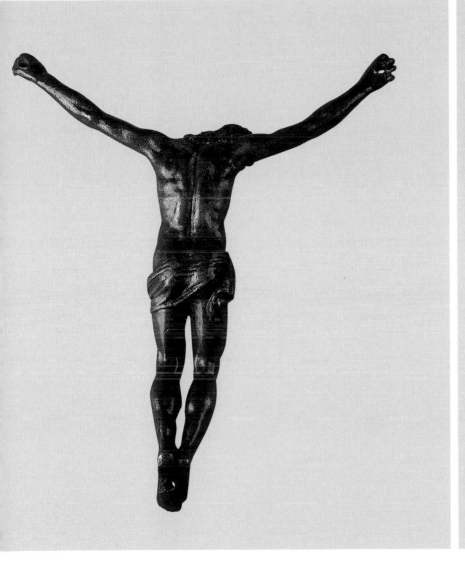 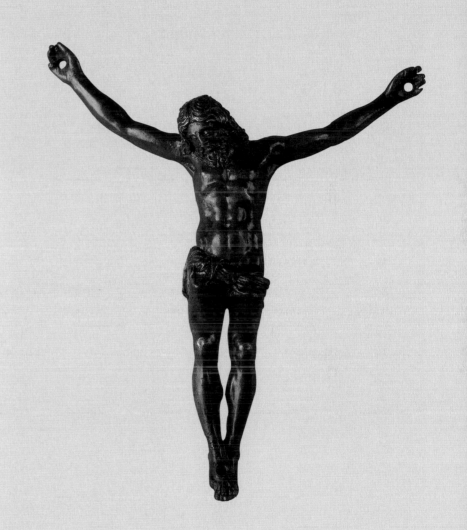

75 | Corpus Christi

Follower of Michelangelo Buonarotti (1475–1564), possibly Daniele da Volterra (1509–1566)
Italian, mid-16th century
Silvered bronze
18½ x 14⅜ x 3⅞ inches (47 x 36.5 x 8 cm)

This silvered bronze cast depicting the crucified Christ bears a strong resemblance to images of the same subject in works by Michelangelo. The figure's sagging body – with the hands raised above the head, the knees slightly buckled, the right foot fixed with a single nail – suggest a Michelangelesque form. The athletic musculature and weightiness of the body recall Michelangelo's drawing depicting *Christo Vivo* (British Museum, London).[1] Although the drapery in this *corpus* obscures the musculature, its controlled folds, the knot at the right hip, and the flowing ends of the *perizonium* are consistent with the sculptural style of the late works by the master.

1 Charles de Tolnay, *Michelangelo: Sculptor, Painter, Architect* (Princeton, 1975), no. 245.
2 de Tolnay, no. 21, 190, no. 98–99.
3 de Tolnay, no. 95–96.
4 de Tolnay, no. 50.

Unrelated to marble carving, works in bronze are first modeled in wax and are therefore closer in technique to terra cotta reliefs. Nevertheless, the large hands and carefully articulated toes closely resemble those same features in Michelangelo's marble *Pietà* in St. Peter's, Rome, the *Pietà* in Santa Croce, Florence, and the *Risen Christ* in Santa Maria Sopra Minerva, Rome.[2] The modeling of the feet, with the large toe bent, approximates the same feature of the right foot of Michelangelo's marble *Moses*, carved for the tomb of Julius II in San Pietro in Vincoli, Rome.[3]

The texture of the hair differs in each interpretation of Christ, in drawing, sculpture and painting. In this bronze the heavily tousled and curled locks on either side of the face resemble the beard of the marble *Moses*. The hair parted in the middle does not appear in other sculpted images of the crucified Christ; however, the same style does appear in Michelangelo's painted *Entombment* (National Gallery, London),[4] in which the rib cage, stomach muscles, and hips are modeled analogously. The heavy brow and deeply set eyes are signature features of Michelangelo's male physiognomy.

The back of the silvered bronze is completely finished and modeled with the same heavy musculature, and the calm drapery folds indicate the master's late style. If we accept the date of the present sculpture and its close affinity with the works of Michelangelo, we can assume that a close follower or pupil of the master constructed this *corpus*. One candidate is Daniele da Volterra, who modeled Michelangelo's death mask. This attribution is difficult to prove, because the artist left no documented sculpture. Another pupil, Niccolo Tribolo (1500–1550), worked in marble and bronze but left little sculpture that relates to the present *corpus*. Few other pupils had the stature to create such an accomplished bronze sculpture. MH

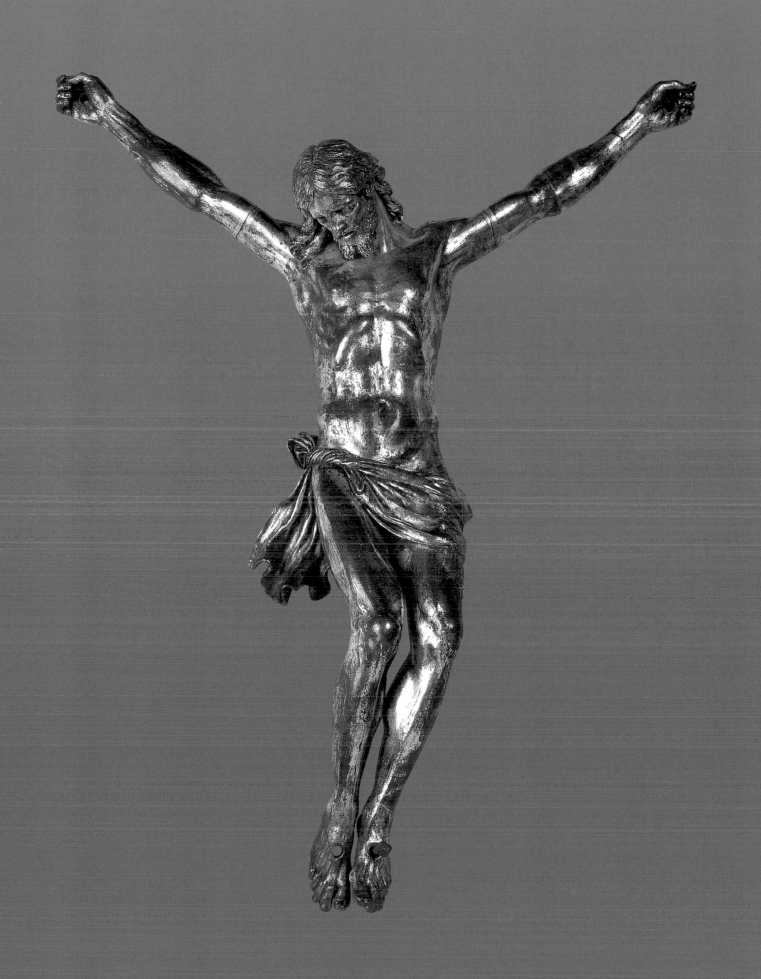

76 | Crucifix

Circle of Michelangelo Buonarotti (1475–1564), possibly Daniele da Volterra (1509–1566)
Italian, mid- to late 16th century
Fire gilded bronze
Solid cast high copper alloy; mounted on an olive wood Jerusalem cross, c. 1960
9¾ x 7½ x 1⅝ inches (24.8 x 19 x 4.1 cm)

Representations of the Crucified Christ by Michelangelo differ widely in their rendition of body shapes. The anatomy typically displays heavy musculature: prominent leg muscles in both upper and lower registers and a massive lower rib cage with a slightly smaller waist extending to a wide pelvic structure. By contrast, the arms are less developed.

The depiction of Christ in this work is reminiscent of Michelangelo's *Risen Christ*, dated to c. 1218–21, in Santa Maria Sopra Minerva, Rome. It is also strongly reminiscent of male physiognomy seen in many of Michelangelo's drawings. The drawing for the *Pietà* in the Louvre, Paris, which depicts a leaner body and a less characterized head of the dead Christ, is close in type to this small bronze.

Michelangelo certainly did not conceive this sculpture, but a close associate, such as his devotee and pupil Daniele da Volterra, could have. The many images of Christ Crucified throughout the centuries of Christian art are especially difficult to attribute. However, the flavor and spirit of the present small sculpture, with its exaggerated imploring look, suggests a Michelangelesque anatomy, posture and expression. **MH**

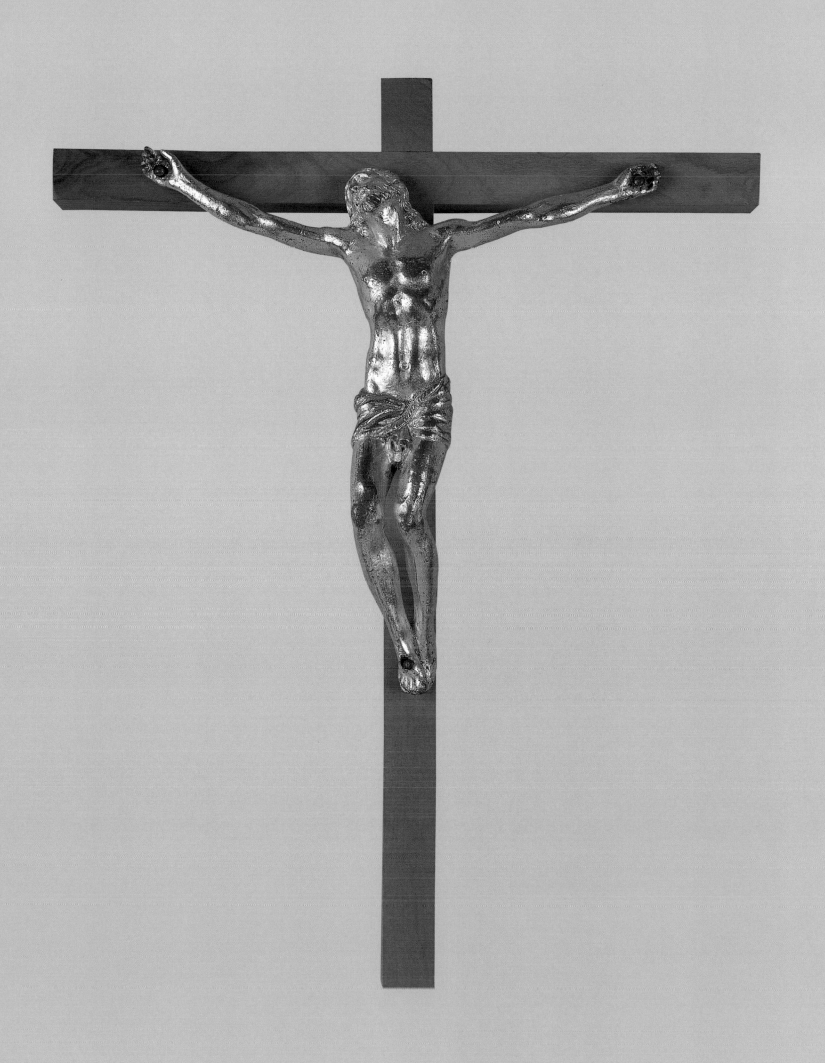

77 | Corpus Christi

Attributed to Germain Pilon (1535–1590)
French, c. 1560
Gilt bronze, high copper alloy with silvered bronze *perizonium*
13¾ x 16 x 4¼ inches (35 x 40.6 x 10.8 cm)

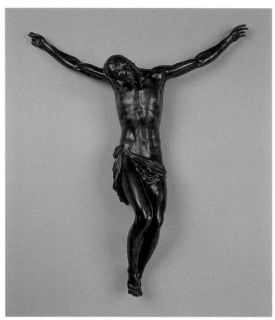

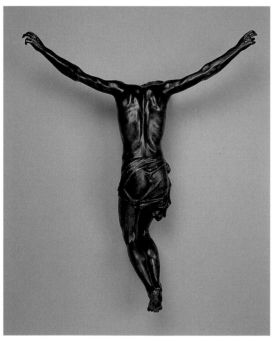

figure 1
Corpus Christi
Attributed to Germain Pilon (1535–1590)
French
Patinated bronze
Michael Hall Collection

This gilded bronze *corpus* with a silver-toned *perizonium* is closely related to a darkly patinated model of the same design and similar dimensions, also in the Hall collection (fig. 1).[1] Although the same in detailing, the two works are different enough to reveal that they are not from the same mold. Rather, each was remodeled separately. They both show an ideal muscular body with an extremely high arched thorax. The anatomy of the rib cage and pectoral muscles recalls Pilon's marble *Resurrected Christ*, as well as his bronze relief of the *Deposition*, both in the Louvre, Paris.[2]

Also similar is the terra cotta *gisant* body model for the figure of Henri II in the abbey of Saint Denis, Paris, whose upper body is emphasized by the head, which is thrown back, accentuating the protuberant chest.[3] The marble statue of Henri II exhibits the same physical type, and related physiognomy.[4] The heavy upper eyelids, the form of the strong but refined nose, and the overall elongated shape of the facial mask are extremely similar, as are the prominent upper lips and the soft curls of the beards.

The bronze *corpus* illustrates Pilon's refined modeling, especially in the chasing of the toes, back of the hands and fingernails, as well as the curly strands of hair on his neck, and the stippled finite pattern seen over the surface of the *perizonium*. The clever suspension device, joining both ends of the cloth, is achieved by a strap at the upper right hip.
MH

1 Ulrich Middeldorf suggested an attribution to Giacomo della Porta.
2 Babelon, (as in Bibl.), figs. 30 and 47.
3 Babelon, fig. 12.
4 Babelon, fig. 8.

Bibliography: Jean Babelon, *Germain Pilon* (Paris 1927).

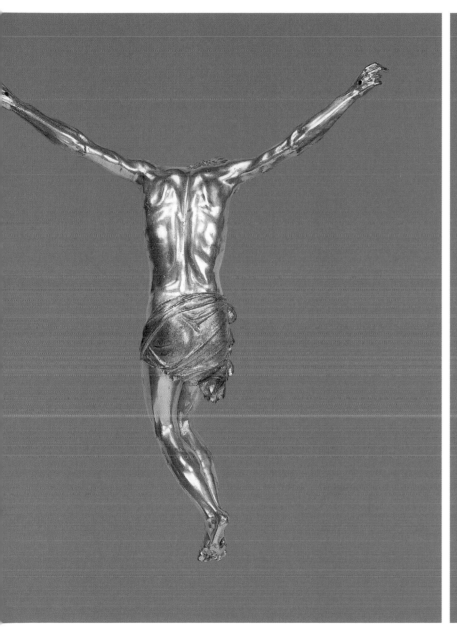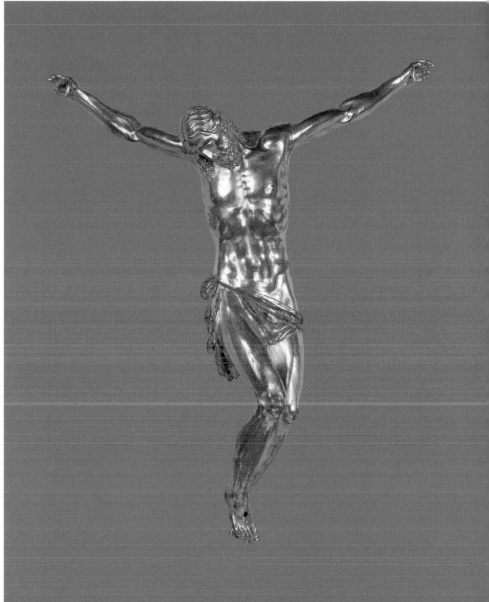

78 | Corpus Christi

Italian follower of Benvenuto Cellini (1500–1571)
Italian, mid- or late 16th century
Silver
8⅝ x 6½ x 2¼ inches (22 x 16.5 x 5.7 cm)

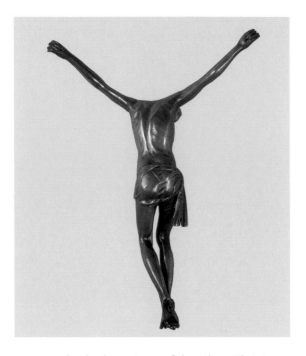

This silver *corpus* relates in many ways to the life-size marble *Cristo Morto* by Cellini, now in the Escorial in Spain.[1] The head, arms, legs, and overall form are similarly positioned in both sculptures. The arms in the silver and marble figures reach out the same way, although the fingers of the silver Christ are more extended and do not cup the nails, as they do in the marble. The arms of the marble Christ reveal tendons that are more deeply sculpted, and the rib cage above the abdominal musculature is less heavily muscled than in the silver version. The legs are arranged in a similar position but in this case are less heavily muscled than those of Cellini's monumental marble, which terminate in flexed toes rigidly pointing toward the viewer; conversely, the large toes of the silver Christ appear relaxed. The overall form of the body obviously depends on Cellini's marble.

The hair is similar in style to a gold *Corpus Christi* attributed to Giambologna, after Cellini, also in the Hall collection (see cat. no. 79).[2] This silver version, surely by an Italian artist, was probably made in Florence in the middle or late sixteenth century. **MH**

1 See the marble *corpus* in John Pope-Hennessy, *Cellini* (London, 1985), 252, pl. 137.

2 See also *Giambologna. An Exhibition of Sculpture by the Master and His Followers from the Collection of Michael Hall, Esq.* exh. cat., Salander-O'Reilly Galleries (New York, 1998), no 22.

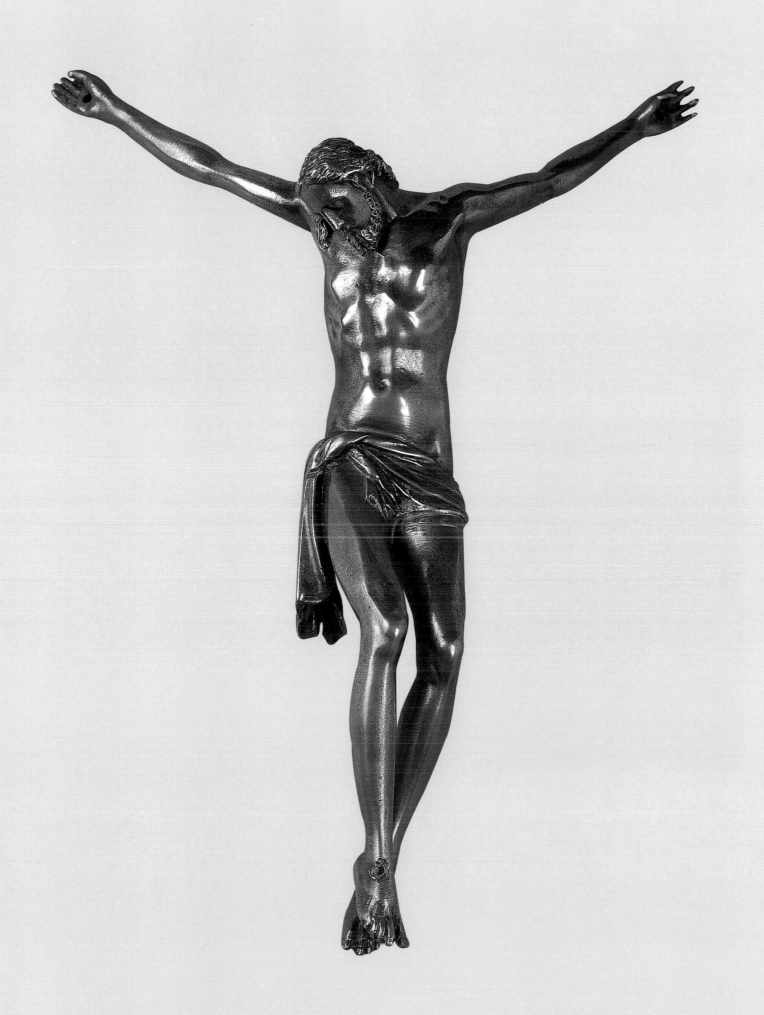

79 | Crucifix

Attributed to Giambologna (1529–1608), after Benvenuto Cellini (1500–1571)
Italian, early 17th century
Gold statuette: 22½ x 9⅝ x 2 inches (56.6 x 24.3 x 5 cm); base: 6 x 8½ x 5⅝ inches (15.2 x 21.6 x 14 cm)
Surmounted by a partially enameled gold cartouche reading ("I.N.R.I." "Jesus of Nazareth, King of the Jews")
The ebony base is decorated with a gold plaquette depicting the *Lamentation*

This crucifix corresponds in almost every detail to a famous gold *corpus* presented to the city of Rimini on 27 February 1612 by Cardinal Michelangelo Tonti.[1] Tonti, a native of Rimini, was a protégé of the Borghese family, notably of Pope Paul V who made him cardinal in 1608. Tonti was responsible for the erection of an honorific monument to Paul V in the Piazza del Comune (now Cavour). A large relief by Sebastiano Sabastiani set into the marble pedestal of the monument shows Tonti in audience with the Pope.

The crucifix in Rimini, its partially enameled gold cartouche, inscribed "I.N.R.I." (fig. 1), and the accompanying gold plaquette of the *Lamentation* (fig. 2), have been traditionally attributed to Benvenuto Cellini. However, the scholar P. G. Pasini has pointed out that it is in fact very close to the early crucifixes by Giambologna.

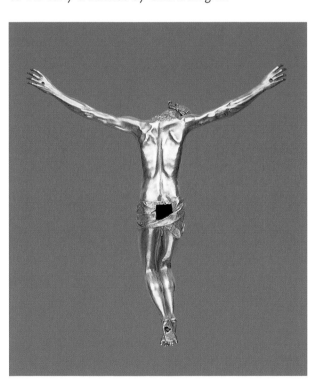

Although somewhat dented and damaged, the *corpus*, the polychromed enameled gold cartouche, and gold plaquette, are almost identical to the example in the Hall collection. However, there are slight differences: the draped end, at the right thigh of the present example, is less prominent and folds in closer to the leg. The *perizonium* of the present *corpus* is elaborately chased to resemble brocaded silk or cut velvet, with minute *fleur-de-lis* engraved throughout. This motif is associated with both the French crown and the city of Florence, where it was also occasionally incorporated into the coat-of-arms of the Medici grand-ducal family.

The present *corpus* retains its original gold crown of thorns and is attached to the cross with three gold-headed, threaded spikes. The ebony cross, inlaid with pure gold wire flattened to the level of the wood surface, is original. The general design of the wood stand is closely akin to architectural designs by Michelangelo. The cartouche is decorated in polychromed enamel of white, dark blue, deep red and light green, with black lettering surmounted by a pale blue *fleur-de-lis*. The entire surface is chased, burnished and stippled, resembling a *repoussé* Renaissance jewel (fig. 1).

1 Its recent history has been dramatized, recounting that it was dismantled in order to save it from destruction or theft, placed in a sealed lead casket and buried, first during World War I and twice more during World War II. The Rimini cross and stand are now modern copies of the lost original.

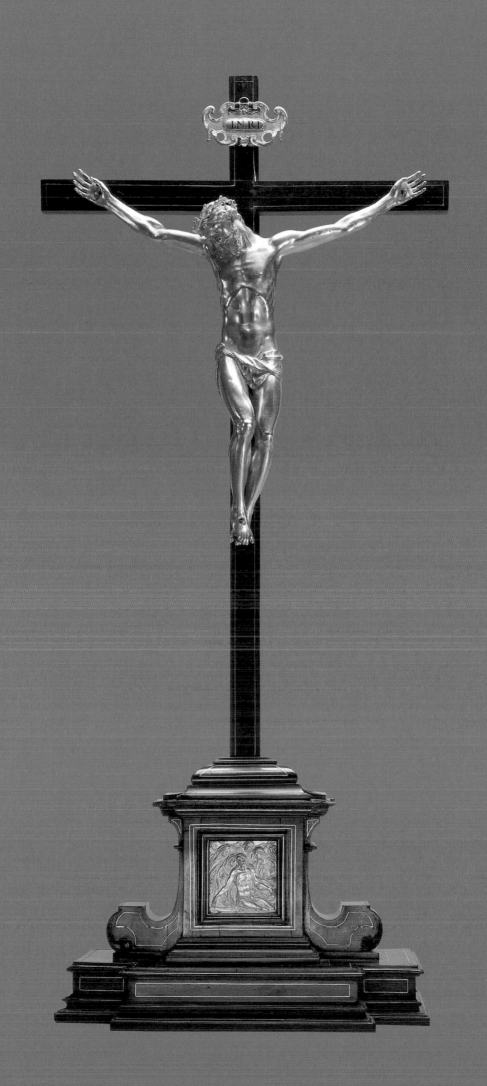

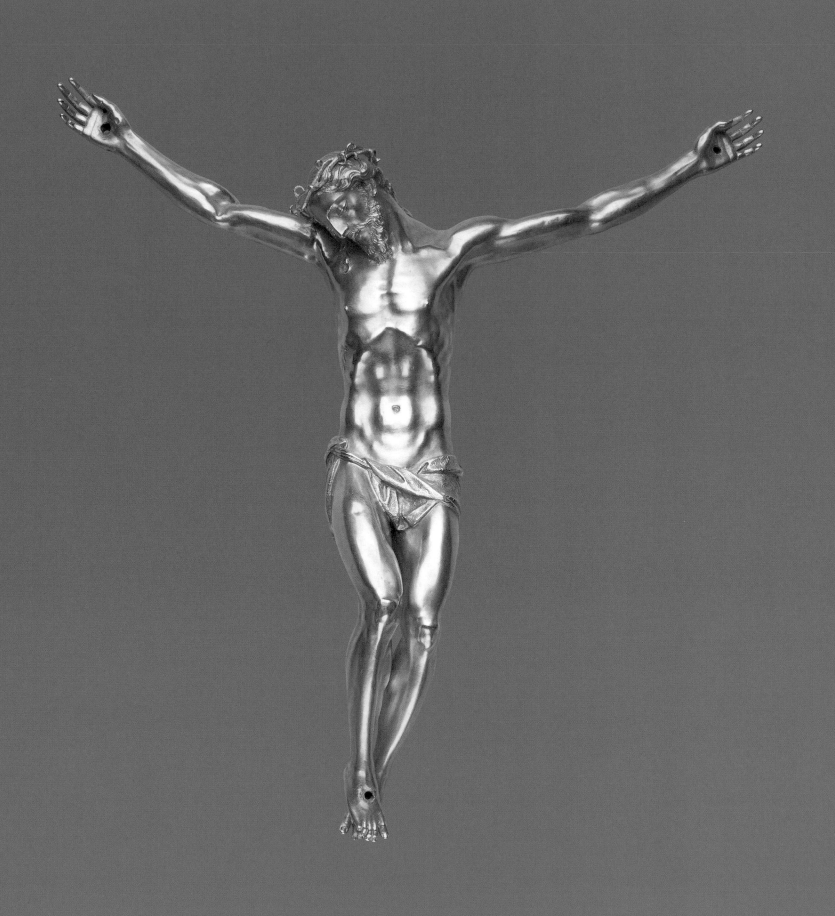

figure 1
Gold cartouche

figure 2
Gold plaquette

The plaquette of the *Lamentation* (fig. 2) in the present example seems to be more delicately finished than the Rimini version, with the hair elaborately chased, the costumes varying in texture, and the modeled and finished body of Christ more subtly refined. Christ is supported by the Virgin and St. John (on the right), who holds Christ's left arm. St. Anne stands to the left and a bearded male figure is visible behind the Virgin. A female head at the upper corner of the plaque wipes away a tear and a lamenting female figure with arms stretched out above completes the composition. In the Rimini plaquette the arms and hands of this figure are missing. The attribution of the plaquettes has not as yet been properly studied. MH

Bibliography: Pier Giorgio Pasini, "Il Crocifisso d'Oro della Città di Rimini, Note e schede per l'arte in Romagna," in: *Romagna arte e storia*, no. 19, 1987, 17–24.

80 | Crucifix

Attributed to Georg Petel (1601/2–c.1634)
German (Augsburg?), c. 1630–34
Ivory corpus mounted on ebonized wooden cross with original ivory banner cartouche
12⅜ x 9⅛ x 2¾ inches (31.3 x 23.3 x 7 cm)

The exceptional attention to the execution in the crown of thorns, hair, fingers, toes and facial expression make this one of the most accomplished ivory sculptures in Petel's *oeuvre*. Note the innovative design of the delicate cord holding the *perizonium* together, the verisimilitude of the anatomy, and the minute detailing. A complete and successfully balanced composition, this devotional object was likely created for a sophisticated and knowledgeable seventeenth-century connoisseur.

Petel traveled to Italy and the southern Netherlands in the 1620s. During his travels he befriended Peter Paul Rubens, for whom he created many gifts in ivory, including a *Crucifix* based on Rubens' *Crucifixion* panel of 1614 (Alte Pinakothek, Munich). Drawing on Italian baroque painting for its drama and realism, Petel completed another ivory *Crucifix* for a noble family when he lived in Genoa between 1622 and 1624 (Pallavicino Collection, Genoa).[1]

Petel seldom signed his carvings and as a result most ivory sculptures credited to him are based on attributions alone. The present ivory Christ is the successful result of Petel's artistic experience, placing its execution in the mature period of his short life.[2] **MH**

1 K. Feuchtmayr, "Jörg Petel und seine Kruzifixe," *Das Münster* 3 (1950): 134–44.
2 The author would like to thank Wolfram Koeppe of the Metropolitan Museum of Art for his kind assistance with this entry.

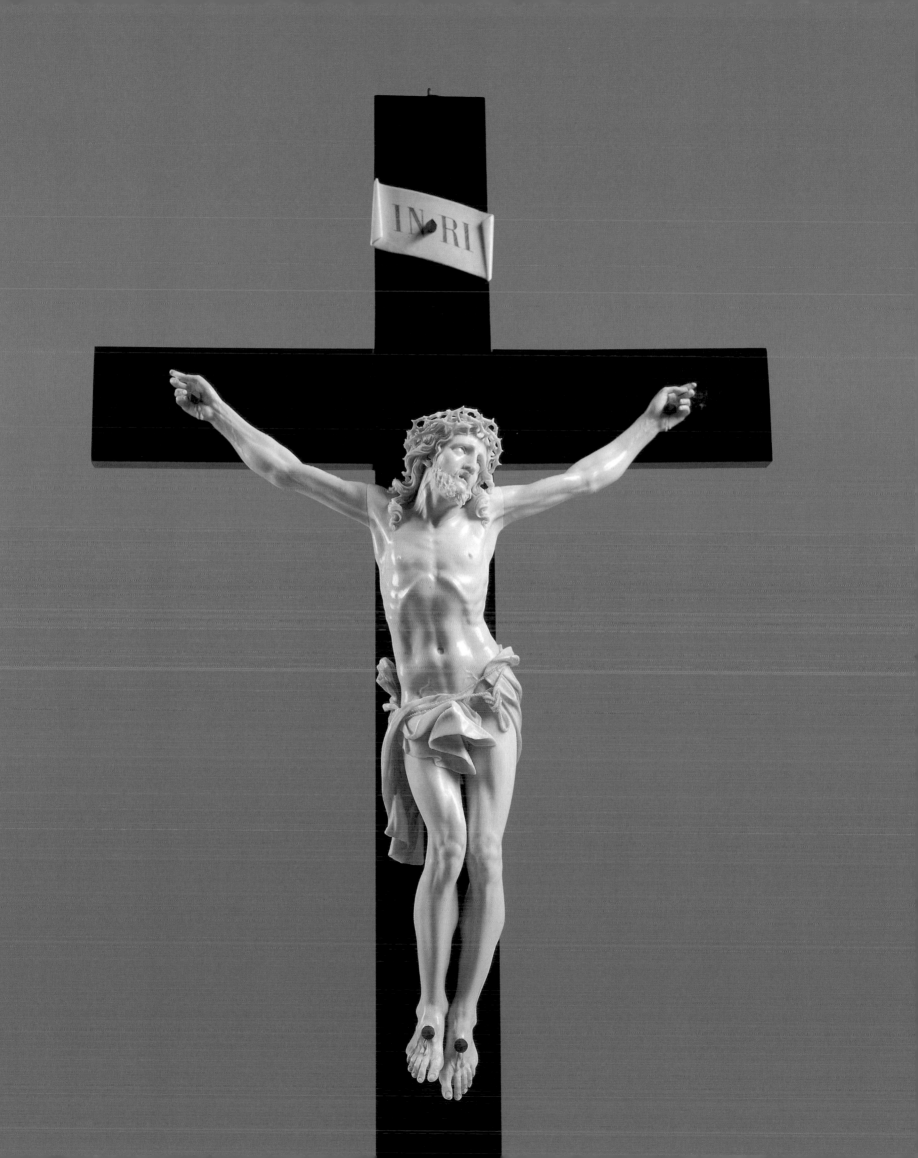

81 | Corpus Christi

German, early 17th century
Rhinoceros horn
6⅛ x 3⅜ x 1¼ inches (15.5 x 8.4 x 3.2 cm)

Mannerist artists sought increasingly exotic materials from which to construct exquisite collectable objects. The fashion for rhinoceros horn lasted from about 1580 to well into the eighteenth century. The 1750 inventory of the Habsburg *Schatzkammer* (treasury) lists several dozen objects made of the intractable material.[1] A live rhinoceros had first been brought from India to Europe in 1515 aboard a Portuguese ship. A woodcut by Albrecht Dürer, produced in Nuremberg in the same year, divulged its appearance, presumably on the basis of a sketch brought from Portugal. Its bizarre appearance (an animal wearing armour!) fascinated westerners. While live examples were for obvious reasons extremely rare in Europe, the nasal horns could be transported as wonders and natural curiosities more easily. The hollowed, conical shape was rather awkward, presenting a challenge to a craftsman, but it could be turned on the lathe into vessels, or cut into curved plaques and relatively small figures, such as the present piece.

The appeal of a sculpture such as this *Corpus Christi* lay in its exotic (and therefore expensive) material almost as much as in its craftsmanship. No parallels have been discovered, but the treatment of the loincloth as a great length of drapery, the tails of which are billowing out in the wind (the Gospels according to Matthew (27.45), Mark (15.33), Luke (23.44) tell of how on the day of the Crucifixion the "sky turned dark and stayed that way until the middle of the afternoon." (Luke 23.44)) typifies south-German production. The raised position of Christ's arms and the excellent knowledge of anatomy demonstrated by the anonymous carver indicate a date in the first quarter of the seventeenth century, the period when, thanks to Peter Paul Rubens (1588–1640), Anthony van Dyck (1599–1641) and François Duquesnoy (1597–1643), the baroque style of Rome was brought enthusiastically north of the Alps. **CA**

Bibliography: E. von Philippovich, *Kuriositäten/Antiquitäten* (Braunschweig, 1966), 460–68.

[1] T. H. Clarke, *The Rhinoceros from Dürer to Stubbs* (London, 1986), 118, 185–86, pls. XXII, XXIII.

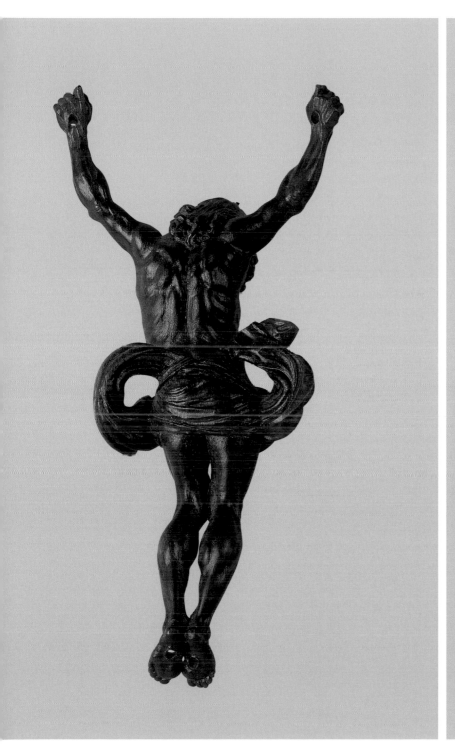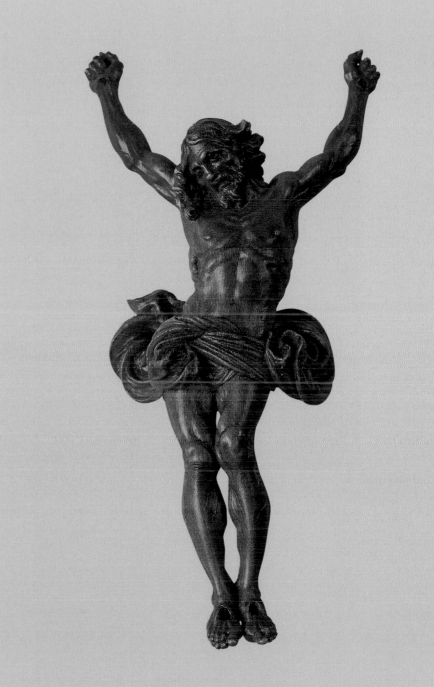

82 | Corpus Christi

Attributed to Leonhard Kern (1588–1662)
German, Hohenlohe, c. 1625–40
Bronze
7¾ x 7⅝ x 1½ inches (19.6 x 19.2 x 3.8 cm)

This highly unusual bronze *corpus* with strangely positioned arms and legs presents a balletic, writhing male figure. The arms are outstretched straight from the shoulders. The right hand is pierced, with the back of the hand positioned toward the cross. The left hand is twisted and the palm turned down. The head is thrown back with the eyes raised imploringly. The hips tilt violently, and the *perizonium* accentuates the upward movement. The eccentric position of the lower limbs presents a most unusual and almost exotic form.

This small bronze appears to be unique and could have been cast from a wood model. The style and characterization of the body are related to a prototype by Leonhard Kern made around 1625–30 (Kunsthistorisches Museum, Vienna).[1] The present sculpture exhibits Kern's international style influenced by his stay in Rome and his period in Naples around 1613. He also pursued architectural studies in Italy, traveled to North Africa and Venice, and worked in Forchtenberg, Heidelberg and Nuremberg. Until his death he supervised a large studio in Schwäbisch-Hall.[1] MH

[1] The author thanks Wolfram Koeppe of the Metropolitan Museum of Art for his kind assistance with this entry.

83 | Corpus Christi

Possibly circle of Georg Schweigger (1613–1690)
South German, first half of the 17th century
Ivory
11⅛ x 4¾ x 1½ inches (28.3 x 12 x 3.8 cm)

An engraving of a *Crucifixion* from 1508 made by Albrecht Dürer (1471–1528), the most influential German artist of the Renaissance, may have inspired this small ivory image. In particular, the unusual rendering of the crucified Christ, with the narrow arms stretched high underlining the body's slender proportions, reminds us of the engraving.[1] This finely carved sculpture is part of a group of South German small-scale objects dating from 1580–1650 that drew upon Dürer's iconographic and stylistic inventions.[2] Artists of this period, sometimes referred to as the "Dürer Renaissance" (or Dürer Revival), created some of the most important pieces in ivory, boxwood, and fruitwood for private devotion.

The spiral curls of the hair and the loose, multi-layered drapery of the loincloth, especially at the back, show the artist's knowledge and admiration of late Gothic models of around 1500–1520. One of the major representatives of this movement was Georg Schweigger in Nuremberg, who was deeply influenced by Albrecht Dürer, as well as by Veit Stoss (1450–1533).[3] **MH**

1 *Dürers Verwandlung in der Skulptur zwischen Renaissance and Barock*, exh. cat., Liebighaus (Frankfurt, 1981), 81, fig. 18.
2 See examples in *Dürers Verwandlung*, op.cit., pls. XI, XV, XIX.
3 Theodor Müller, "Veit Stoss. Zur Geltung seiner Werke im 17.Jahrhundert," *Zeitschrift des deutschen Vereins für Kunstwissenschaft* 9 (1942): 191; *Dürers Verwandlung*, op. cit., cat. nos. 162–163, pls. XI, XV, XIX; Dorothea Diemer, "Schweigger," J. Turner ed., *The Dictionary of Art* (London, 1996), vol. 28, 192–193. The author wishes to thank Wolfram Koeppe of the Metropolitan Mueseum of Art for his kind assistance with this entry.

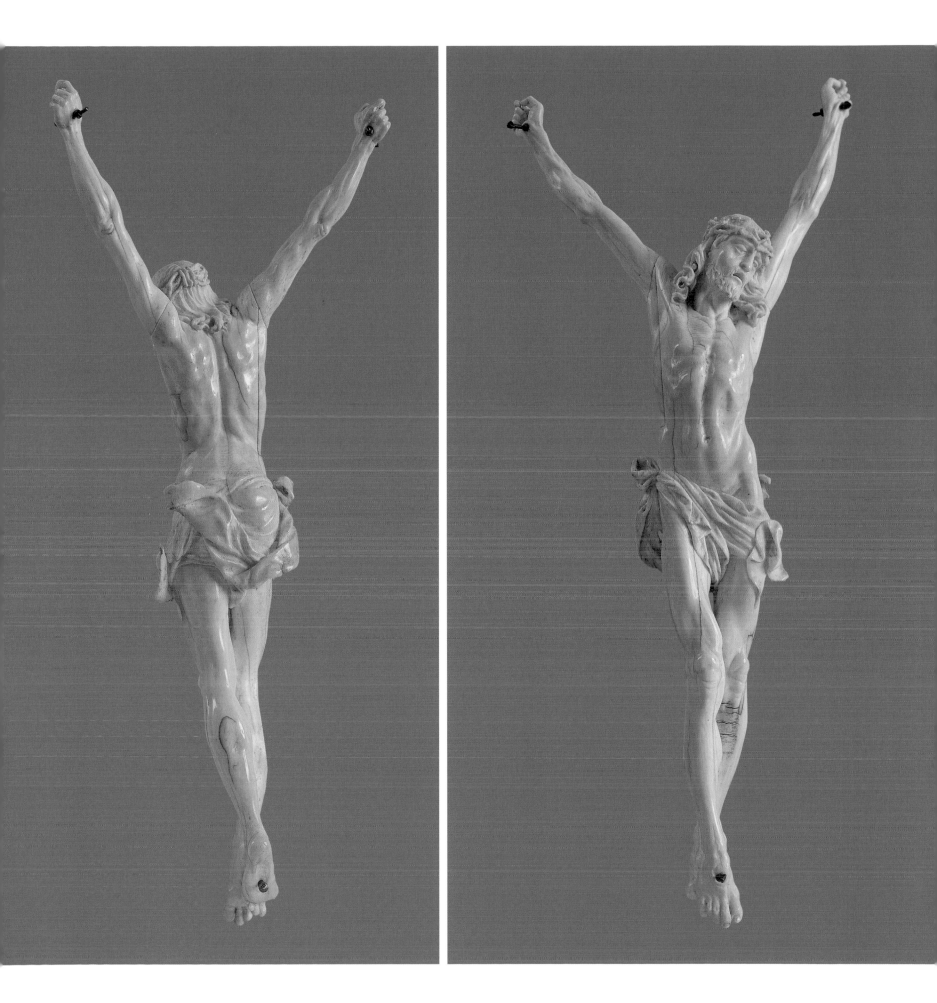

84 | Crucifix

Attributed to David Heschler the Elder (1611–1667)
German, mid-17th century
Limewood
39⅛ x 17¾ x 4¼ inches (99.4 x 45.6 x 10.8 cm); scroll 2⅛ x 4 x ⅝ inch (5.5 x 10.2 x 0.8 cm)

This limewood sculpture represents a magnificently sculpted, anatomically correct rendering of the tortured body of Jesus. Curved naturalistically with its narrow waist, highly pronounced rib cage and pectoral muscles, the figure is not as stylized as are most German *corpora* from the seventeenth century. The unusual positioning of the legs with the knees together, the well-formed thighs and particularly the calf muscles, present a carefully observed human form. The relaxed position of the arms, the facial expression and the erect body give the overall impression of hopelessness and a resignation to death. The rosewood cross appears to be original, as does the banner affixed to its upper arm, also carved in limewood.

The agony of the facial features and the tightly intertwined loincloth recall the style of the ivory and wood carver David Heschler, one of the most gifted sculptors in southern Germany after Georg Petel, who worked in Augsburg and Ulm (see cat. no. 80). Heschler was best known for his small-scale figures.[1] In the present sculpture the artist has worked with a larger size without giving up the sophistication and refinement usually associated with an object on a smaller scale. The result is a *corpus* of strong expression and deep compassion.[2] **MH**

1 Christian Theuerkauff, "Fragen zur Ulmer Kleinplastik im 17./18. Jahrhundert: David Heschler und sein Kreis", *Alte und Moderne Kunst/29.1984* (1984): 190–191 pl. 23; *idem*, "Addenda zur Kölner Holzstatuette des Ulmer Bildhauers David Heschler, 1611–1667", *Festschrift für Brigitte Klesse* (Berlin, 1994): 317–328; Claus Zoege von Manteuffel, "Eine neuentdeckte Elfenbeingruppe von David Heschler um 1650–1660", *Die Kunst und ihre Erhaltung: Rolf E. Straub zum 70. Geburtstag gewidmet* (Worms, 1990), 241–246.

2 Christian Theuerkauff, "David Heschler (1611–1667)", *Weltkunst* 71 (2001): 1704–1707 (with an extensive bibliography); Fritz Fischer, "Heschler," J. Turner, ed., *The Dictionary of Art* (London, 1996), vol. 14, 487–488. The author thanks Wolfram Koeppe of the Metropolitan Museum of Art for his kind assistance with this entry.

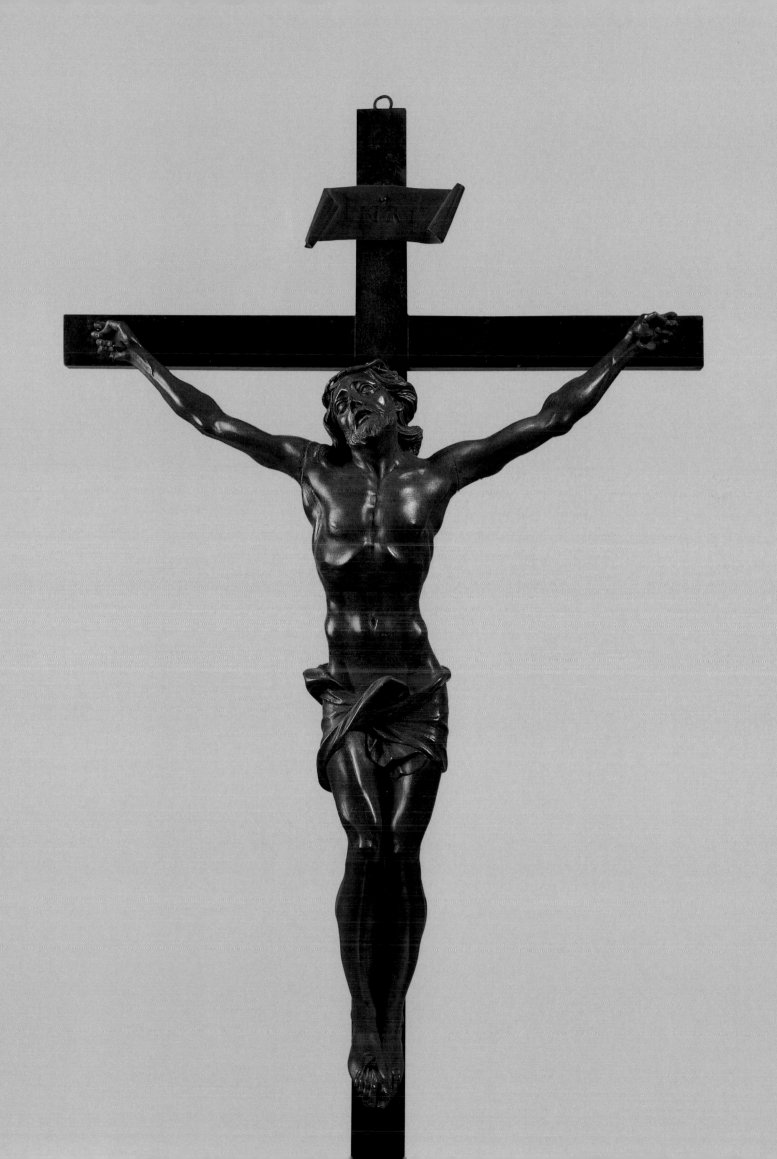

85 | Crucifix

German, first quarter of the 17th century
Bronze
24⅞ x 13⅝ x 3½ inches (62.6 x 34.3 x 9 cm)

The crucified figure of Christ, the cartouche (inscribed "I.N.R.I.") at the top of the cross, and the skull and crossbones at its base are designed and created by the same artist. The basic shape and detailing of the cartouche betrays its origin in the northern Renaissance. The flamboyant Italianate form reflects the sixteenth century Mannerist style. By contrast, the body of Christ lacks the overstated movement and muscularity typical of that style. The *perizonium* is also more constricted in form. The only Mannerist device is used in the depiction of the left knee, bent out and up, achieving a *contrapposto* with the two iron nails securing the feet to the cross.

The overall design of the figure recalls similar works by late sixteenth and early seventeenth century German sculptors clearly influenced by Italian art, such as Hans Reichle and Hubert Gerhard. Hans Reichle (1565/70–1642) worked in Florence as an assistant to Giambologna and, upon his return home, contributed much to spreading the Italian master's Mannerist style throughout southern Germany.[1] The work of Hubert Gerhard (1540/50–before 1621) also shows close affinities with Giambologna, as well as Benvenuto Cellini. At the same time, however, his sculptures do not strive to achieve Giambologna's multiple viewpoints, exhibiting a more conservative approach to three-dimensionality and the treatment of the human body.[2] This is consistent with the present *Crucifix*. The cartouche is also German in style and design; in essence it is a clue to the origin of the present work. MH

1 *The Dictionary of Art*, J. Turner, ed. (London, 1996), vol. 26, 103–5.
2 Ibid., vol. 12, 345–48.

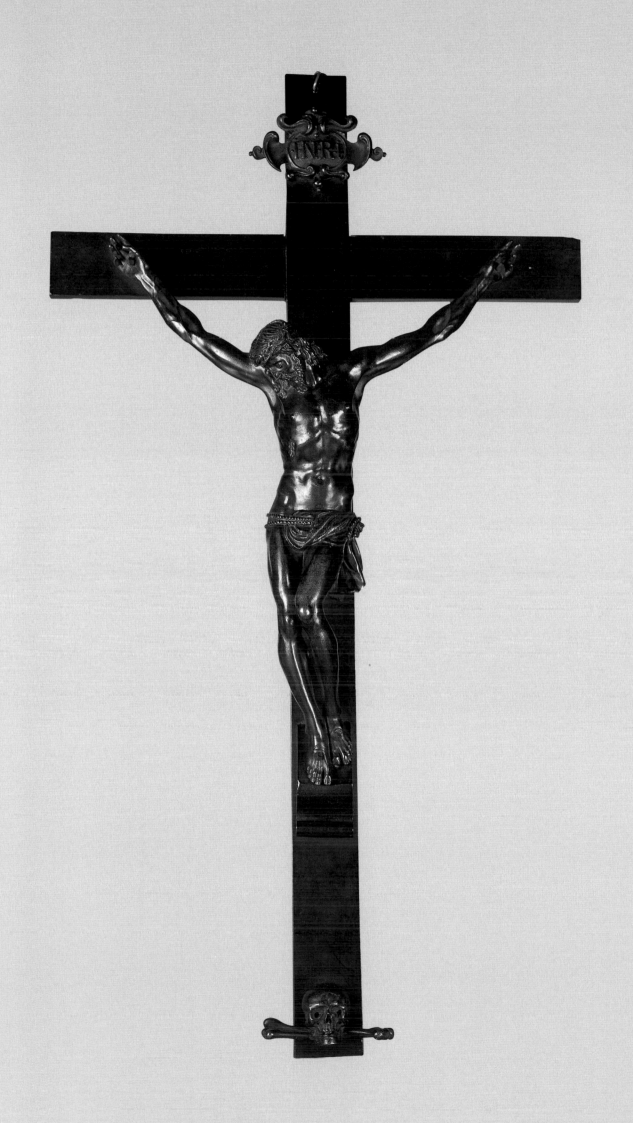

86 | Corpus Christi

Attributed to Gabriel Grupello (1644–1730)
German, c. 1700–1710
Ivory
13⅛ x 6 x 2¼ inches (33.3 x 15.2 x 5.8 cm): ivory scroll: 2⅛ x 1¾ x ½ inch (5.5 x 3.8 x 1.2 cm)

Born in Flanders in 1644, Gabriel Grupello began learning his craft at the age of 14 in the Antwerp workshop of sculptor Artus Quellinus I. Grupello traveled throughout Europe: he probably worked on the sculptural decoration for the Stadhuis in Amsterdam; he traveled in France and studied the sculptural decoration at Versailles in the 1660s; and he became master of the Guild of the Four Crowned Heads in Brussels in 1673. In 1688 he made the transition from municipal sculptor to court sculptor when he took a position in Madrid at the court of Charles II of Spain. In 1695 Grupello moved to Düsseldorf and worked as court sculptor for John William, Elector Palatine. Working primarily in marble, Grupello filled a variety of commissions for portraits and garden sculptures and drafted ideas for the *Neues Residenzschloss* in Düsseldorf, which was to surpass Versailles but was never executed. When the Elector died in 1716, Grupello returned to Brussels before taking a position, in 1719, as court sculptor to the Holy Roman Emperor, Charles VI. He became adept at carving monumental and architectural sculpture, as well as small, private devotional objects. It was in this late period that he carved an elegant ivory *Crucifix* (c. 1720; Redemptorist monastery St.-Truiden, Belgium), which is related to this *corpus*.

A larger *Crucifix* by Grupello in the Hermitage Museum in Saint Petersburg[1] and a version of lesser quality in the parish church of St. Cecilia in Düsseldorf-Benrath[2] are closely related to this small ivory sculpture. Grupello reveals his debt to Peter Paul Rubens (1577–1640), an artist who had been born in Germany but built his career in Flanders, the opposite of Grupello.[3] Both artists traveled widely, worked for distant courts, completed commissions in a variety of scales and media, and employed large workshops, all of which complicated attributions to them. Grupello's late sculpture, of which this ivory *corpus* may be a representative, draws upon Rubens' knotted, twisted forms: it displays the grandeur of a muscular physique while evoking a strong pathos. The loincloth, held together by two separated strings and resting precariously on Christ's curved hip, lends a kineticism to the figure, and is a sensuous example of post-baroque form.

MH

1 Inv.no.12264; *Westeuropäische Elfenbeinarbeiten, 11. bis 19. Jahrhundert aus der Staatlichen Ermitage Leningrad*, exh. cat., Staatliche Museen zu Berlin (East Berlin/ Prague, 1975), cat. no. 15; Stefan Krenn, "Unbekannte Kruzifixe von Gabriel Grupello," *Jahrbuch des Museums für Kunst und Gewerbe*, vol. 6/7 (Hamburg 1988), 87–115, fig. 1.

2 *Europäische Barockplastik am Niederrhein. Grupello und seine Zeit*, exh. cat. (Düsseldorf, 1971), p. 169, no. 79; Krenn, op. cit., fig. 2;

3 See *La Sculpture au siècle de Rubens*, exh. cat. (Museum of Ancient Art, Brussels, 1977), 118–25, 369–71. The author would like to thank Wolfram Koeppe of the Metropolitan Museum of Art for suggesting the relationship of this crucifix with works by Gabriel Grupello.

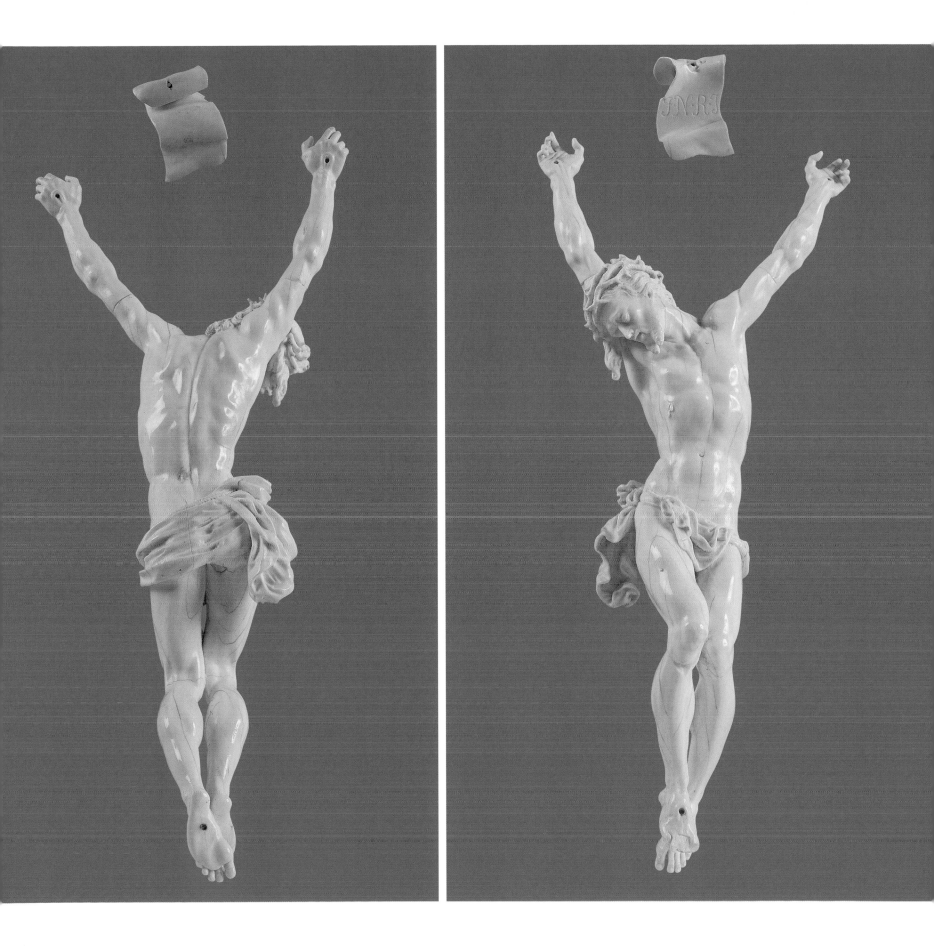

87 | Corpus Christi

Iberian or Spanish Colonial, perhaps Ecuadorian, 18th century
Polychromed wood
16 x 12½ x 2⅔ inches (41 x 31.8 x 6.8 cm)

This particularly gruesome *corpus* likely served as a processional crucifix. Its cross (not shown) features an oculus to display the unusual gaping wound on Christ's backside. Unless the crucifix was used in processions, revealing its reverse to the worshipers as it passed, this fetishized infliction would have remained unseen upon an altar. Yet the small scale of the sculpture suggests that its ritual context was an intimate one, not the massive public processions that involved floats and nearly life-size polychrome wood sculptures.[1] Despite the modest size of the figure, the artist has exploited the medium of polychromy to the fullest effect. Christ is drenched in the streams of blood issuing from the wounds on his hands, head (from the crown of thorns), and side. The rivulets gather between the thighs, before oozing down the legs. Yet the wounds of the crucifixion only begin to describe the suffering. In its last moments, the body has evidently writhed in pain. The broken legs have collapsed the lungs, inflating the chest cavity. The purplish bruises and wounds covering the surface, not to mention the raw flesh exposed on the backside, record the horrific scourge Christ endured before reaching Calvary. In a most idiosyncratic detail, Christ's forearms contain crater-like wounds, as if they simply had erupted under the strain. Contemplating this sanguineous spectacle, one wonders if a confraternity or church dedicated to the blood of Christ commissioned this crucifix.

Polychromed *corpora* proliferated in sixteenth- and especially seventeenth-century Spain. The greatest sculptors of the time, such as Juan Martinez Montañes (1568–1648) and Pedro de Mena (1628–88), produced *corpora* in collaboration with painters specializing in *encarnación*, or the rendering of flesh. Many of these were then exported to the colonies of New Spain (Mexico), Peru (including Bolivia, Argentina and Chile), and New Granada (Ecuador and Venezuela). As imports waned by the end of the seventeenth century, local schools emerged to create religious statuary. The city of Quito, in Ecuador, was the repository of numerous imported works by the most eminent Iberian masters and became a leading center of indigenous production in the eighteenth century.[2] Many Quito works are of modest scale and exhibit a refined sense of anatomical modeling, so evident in the Hall *corpus*. In addition, many Quito *corpora* show extreme degradation, with myriad welts and bruises supplementing the bloody wounds of the crucifixion.[3] Such vivid defilement characterizes the *corpora* and a famous prone *Dead Christ* (Museo Colonial, Quito) by the leading practitioner of the school, a quasi-legendary half native called Manuel Chili, or Caspicara (c.1750–c.1800).[4] JU

1 Susan Verdi Webster, *Art and Ritual in Golden Age Spain: Sevillian Confraternities and the Processional Sculpture of Holy Week* (Princeton, 1998), 57–110.

2 For the above, see Gabrielle Palmer, *Sculpture in the Kingdom of Quito* (Albuquerque, 1987).

3 Many of these works have recently been exhibited, see Magdalena Gallegos de Donoso, *17th and 18th Century Sculpture in Quito*, exh. cat. (Washington, 1994), cat. nos. 10–13; Alexandra Kennedy Troya and John Sillevis, *Passie en devotie Barok uit Ecuador*, exh. cat (The Hague, 2000), cat. nos. 2–3, 7–9. Palmer, op. cit., pl. 6.

4 Fray Augustin Moreno Proaño, *Caspicara* (Quito, 1976), 152–4.

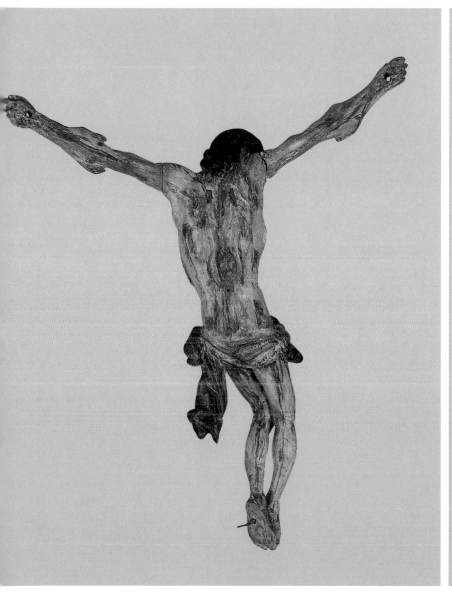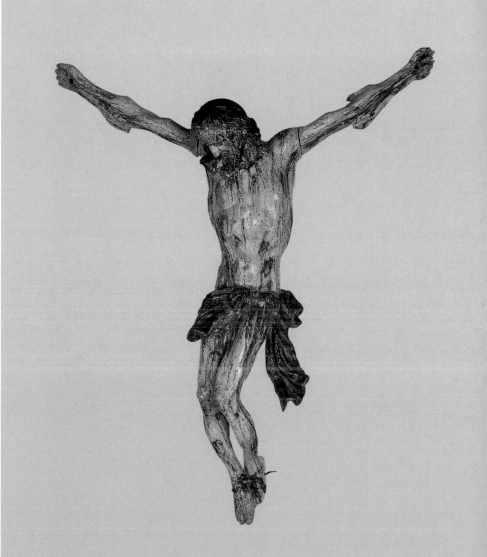

88 | Saint Jerome in the Desert

Desiderio da Settignano (c. 1429/32–1464)
Florentine, mid-15th century
Marble
17 x 21¼ inches (43 x 55.3 cm)

The present marble relief is almost identical with Desiderio's masterpiece of the same subject in the National Gallery of Art, Washington D.C.[1] The Hall version appears to be crisper and shows sharper details than the Washington version. This is perhaps due to the over cleaning of the latter, whose details have been softened overall. The present relief has severely suffered from attempts to eradicate rust stains, probably pitted with an acid solution.

Wittkower explains in his elaborate treatise on the two reliefs that a plaster cast version of the Hall relief was made in Florence by Oranzio Lelli in 1875.[2] After seeing both versions side by side, Wittkower wrote, "There are no indications whatsoever that the Hall version is a mechanical marble reproduction based on the cast. On the contrary, a careful study of it confirms one's conviction that it is a second contemporary version coming from the same workshop as the relief in the National Gallery... In our special case I believe that Desiderio made a terracotta or wax model that served him and his assistants, perhaps his sculptor brothers, working side by side. It would be difficult to decide at this point in time which of the two versions was *di sua mano* ("by his own hand"). It is the burden of my argument that when the two reliefs left the workshop, both showing the precision now only available in the old photograph of the cast, two patrons were convinced of having been equally well served by the sculptor."[3] Vines has also accepted the Hall version as an autograph original.[4] Butterfield considers this sculpture to be "the most complex and sophisticated *relievo schiacciato* (very low relief) by the artist..."[5]

The image of the crucified Christ, his head falling forward and the upper shoulders slouching away from the cross, is expertly depicted in true perspective. The face bears a heavy brow with the hair held back by the crown of thorns. The body shows a well-formed physique with the musculature lax and pendulous. The feet appear to be pierced together with one nail. The halos of both Christ and Saint Jerome are shown in the same skewed perspective seen in Desiderio's relief of the Madonna and Child in this exhibition (see cat. no. 5). This device, perhaps an invention of Desiderio's, illustrates the sculptor's ability to create true depth within a shallow relief. This accomplished investigation of depth rivals that of his master, Donatello. MH

Bibliography R. Wittkower, "Desiderio da Settingano's St. Jerome in the Desert," *Idea and Image* (London, 1978); A. Butterfield, *Masterpieces of Renaissance Sculpture. An Exhibition from the Collection of Michael Hall, Esq.* Salander-O'Reilly Galleries (New York City, 2000), cat. no 2.

1 R. Wittkower (as in bibliography), 147.
2 See *Donatello e il primo Rinascimento nei calchi della Gipsotecha* (Florence, 1985), no. 166.
3 Wittkower, 148.
4 D. Vines, "Desiderio da Settignano ", Ph.D. Dissertation, University of Virginia, 1981, 144–147.
5 A. Butterfield, *Masterpieces of Renaissance Sculpture. An Exhibition of Sculpture from the Collection of Michael Hall, Esq.,* Salander-O'Reilly Galleries (New York, 2000), 7.

89 | Saint Francis Adoring the Crucifix

Francesco Trevisani (1656–1746)
Roman, 1730
Oil on canvas
39¾ x 30 x 1 inches (101 x 76.2 x 2.5 cm)

Francesco Trevisani was one of the most prominent painters in Rome, and thus Europe, during the last flowering of the Baroque. Churches and aristocrats vied for his works, commissioning altarpieces, history paintings, portraits (especially of Britons on the Grand Tour), and images for private devotion, such as the *Saint Francis* in this collection. Trevisani shows the saint half-length, hunched over an open Bible. He gazes raptly upon a crucifix resting between his arms, clenching his hands in prayer. The dark wood enshrouds the saint's frocked body. Heavenly light descends from the left, bathing his hands and face in an opalescent glow. The saint's radiant profile contrasts with the skull in the foreground, eclipsed in shadow. The object of his meditation has just shifted from this symbol of death to one of eternal life, the *corpus* whose surfaces gleam in the light of redemption.

A nearly identical version of the painting is in the Accademia di San Luca, Rome. It dates to around 1708–15, based on stylistic similarities to Trevisani's devotional half-lengths of the *Mater Dolorosa*, the Magdalene, and St. Mary of Egypt.[1] The Hall version, however, bears the artist's monogram "FT" on the bookmark, and the date 1730 is inscribed on the open page. Trevisani occasionally signed and dated his works in this manner, suggesting that the Hall *St. Francis* is a later, but undoubtedly autograph, replica.[2] In all likelihood, Trevisani's reprisal of the theme coincided with one of his most important late commissions, an altarpiece of the *Ecstasy of St. Francis* for the principal Franciscan Church in Rome, Santa Maria in Aracoeli, in 1729. Ten years earlier, he had produced a *Stigmatization of St. Francis* for another altar in the same church.

The iconography of the *Meditation, Ecstasy,* and *Stigmatization of Saint Francis* interrelates. During the Counter Reformation, reformed Franciscan orders, such as the Capuchins, promoted a mystical communion with Christ through meditation. St. Francis himself furnished the obvious prototype. Having retreated to Mount La Verna in 1224, he witnessed a heavenly vision of a seraph-winged crucifix, whereupon his hands, feet, and side were imprinted with the wounds of Christ, called the stigmata. While this episode had typically been portrayed with great drama, the new iconographic types of the *Meditation* and *Ecstasy* internalized the spiritual communion. The Carracci school, in particular, popularized the format of St. Francis meditating upon a skull and cross through numerous paintings and prints. Trevisani continues this tradition. The fixation of the Saint's gaze upon the crucifix and the descent of heavenly light prefigure the miraculous apparition. The stigmata seem ready to erupt upon the tensely clasped hands. There can be no greater testimony to the power of the Crucified Christ as a devotional image. It transformed Francis into the image of Christ, the mirror of his suffering, and the beneficiary of his Salvation.[3]
JU

Bibliography: Frank Di Federico, *Francesco Trevisani. A Catalogue Raisonné* (Washington D.C., 1977), 59, cat. no. 72; Christie's, London, 19 March, 1982, lot 120 "A Franciscan in Meditation"; Giancarlo Sestieri, *Repertorio della pittura romana della fine del Seicento e del Settecento* (Turin, 1994), 1: 175.

1 Di Federico, (as in Bibl.) 49–50, 59, nos. 39–40, 72-3.

2 Trevisani used the "FT" monogram and dates inscribed on books to sign his works, see Di Federico, nos. 73, 84, 87. The Hall picture, known through the Christie's sale, was added to the *oeuvre* in Giancarlo Sestieri.

3 On the iconography of St. Francis after the Counter Reformation, see Pamela Askew, "The Angelic Consolation of St. Francis of Assisi in Post-Tridentine Italian Painting," *Journal of the Warburg and Courtauld Institutes* 32 (1969): 280–306; Claudio Strinati, "Riforma della pittura e riforma religiosa," in *L'immagine di San Francesco nella Controriforma*, exh. cat. (Rome, 1982), 35–56.

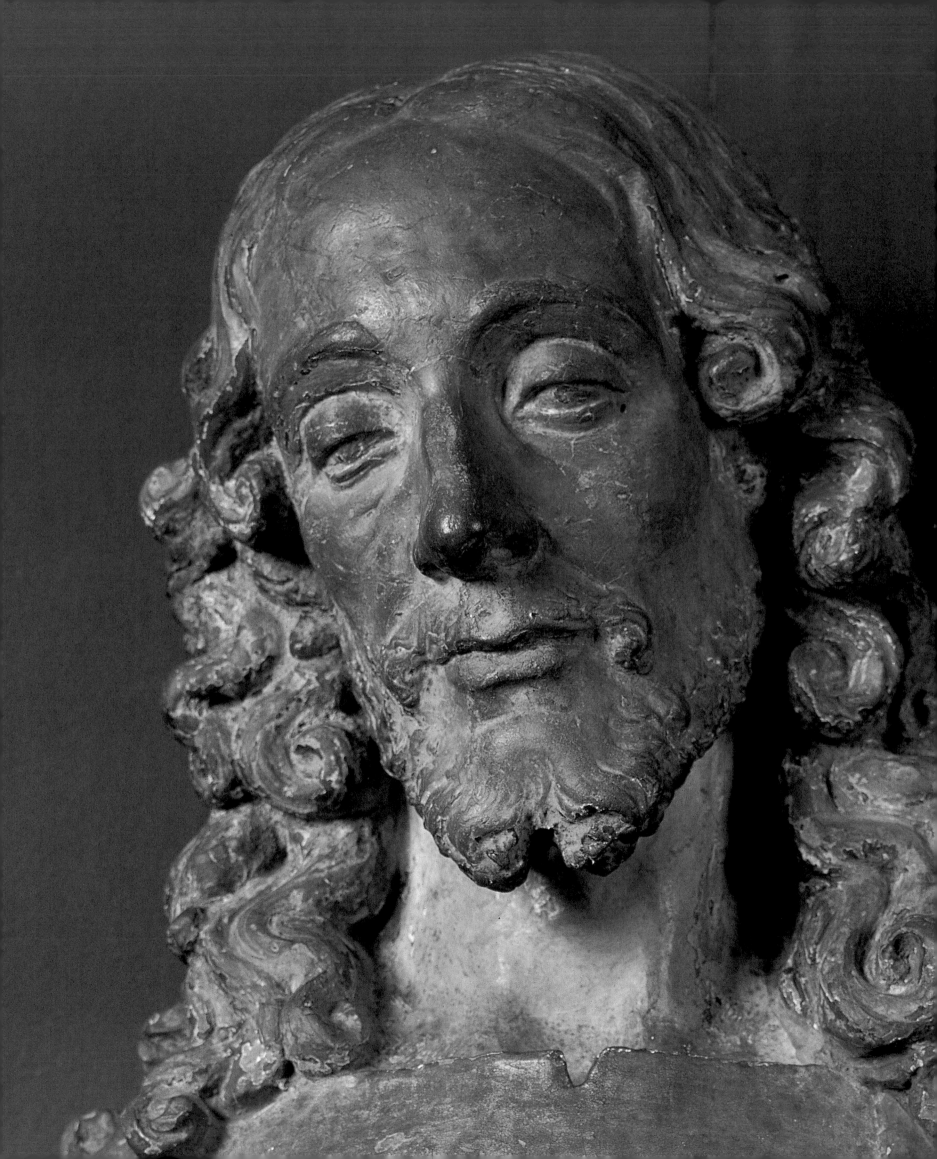

We do not know of his external appearance, or that of his mother.

— *St. Augustine of Hippo (354–430)*

The non-narrative images of Jesus included in this section illustrate his recurring portrayal, from the fifteenth through the seventeenth centuries, in accordance with the "true likeness" known from both literary and artistic sources. The evolution of this recognizable "portrait," even devoid of attributes or narrative props, is analyzed in the introductory essay of the catalog.

By contrast, the portrayal of the Virgin Mary reveals a different visual tradition. Consistent with depictions of her in a narrative context, iconic images do not use a consistent, recognizable facial type. Mary is identified by her attributes (the lily, a book, the deep blue mantle) and her special relationship to Christ. Thus, when depicted alone, we are sometimes hard pressed to identify the young woman praying, reading, or just gazing at us as the Virgin. A few of the works in this exhibition fall in this category. We identify them based upon the idealized features, the attitude of prayer and humility, or similarities with other representations known to be of the Virgin. But since there is no one dominant type, we cannot always be sure. In the context of our discussion about prototypes, this may well be due to the fact that the archetypal image of Mary, the *Virgin and Child* allegedly painted by St. Luke, was an iconographic type rather than a portrait per se.

90 | Good Shepherd

Italian, early 16th century
Bronze, solid cast
Inscribed on the front of the base: C.D.A.S (Christos Dominus Animorum Salvator) ("Christ the Lord, Savior of the Souls")
7 x 3¼ x 2½ inches (17.5 x 8.25 x 6.3 cm)

<div style="writing-mode: vertical">ICONS OR PORTRAITS?</div>

224

This small bronze statuette must derive its basic design from several early images of the same subject dating from the fourth century AD. This possibly unique bronze version depicts the young unbearded boy Christ as a shepherd with a lamb across his shoulders. Its motif finds its origins in early Christian iconography which represents Christ as the keeper of the flock (believers as the lambs of Christ). A nearly identical small marble sculpture is in Rome.[1] A second version in the Vatican Museums (fig. 1) is even closer in design format to the present sculpture. The Vatican marble is considerably restored and first documented in the nineteenth century. The two marble sculptures are similar in design and probably derive from a similar prototype.

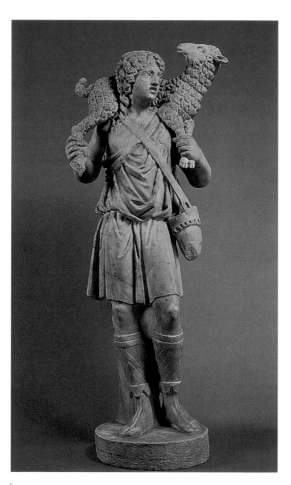

figure 1
The Good Shepherd, late 3rd / early 4th century
Marble
Museo Pio Christiano, Vatican Museums, Vatican State

The figure exhibited here gives every appearance of dating from the early 16th century and is close in type and style to several small Renaissance bronzes of the victorious *David*. One in the Philadelphia Museum of Art is attributed to Bartholomeo Bellano (1438–1497). Another in Edinburgh carries an attribution to Severo da Ravenna (1465–1538)[2], and yet another attributed to the same artist is in the Metropolitan Museum of Art in New York. All of the aforementioned derive their basic inspiration from the bronze *David* of Donatello, c. 1440 in the Bargello, Florence. Various arguments of attribution have been shifted back and forth for these small bronze sculptures from Bellano to Severo.

The drapery in the present bronze is very closely related to these small bronzes. The postures vary but the physical attributes appear very similar. The patination of the present *Good Shepherd* is also closely related, as is the overall chasing and finish.

It is possible that this miniature bronze could have come from the workshop of Severo da Ravenna? Because there is no other version of the present bronze and due to its unusual construction of casting and assembly, it is difficult to assign it to a particular Italian artist of the early Renaissance. MH

1 The piece of the collection of the Museo Nazionale di Roma was included in the exhibition *The Image of Christ* at the National Gallery in London, see Gabriele Finaldi et al, *The Image of Christ*, exh. cat., National Gallery (London, 1989), no. 1, 12–13.
2 *Donatello e il Suo Tempo*, exh. cat., Musei Civici (Padua, 2001), no. 35, 162.

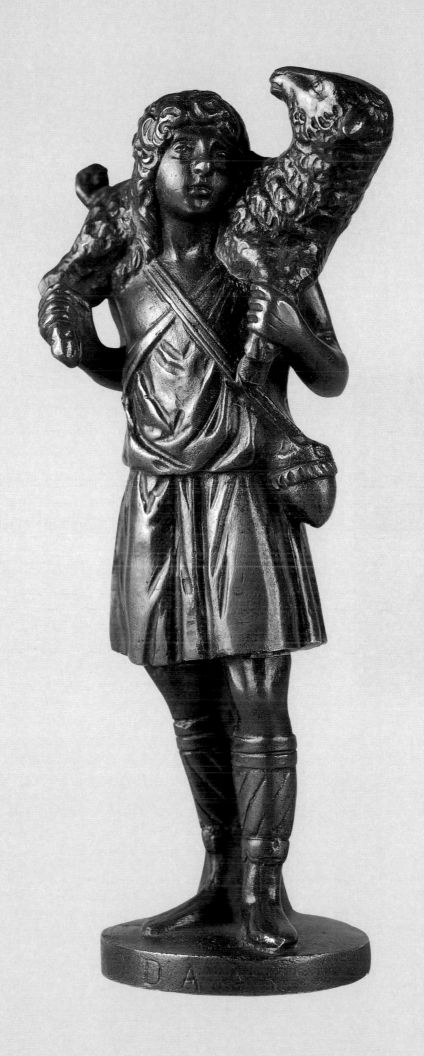

91 | Bust of Christ

Andrea del Verrocchio (1435–1488)
Florentine, after 1483
Gessoed, painted, and gilded terra cotta
26¾ x 28 x 16 inches (68 x 71.2 x 40.6 cm); base 3½ x 34 x 13 inches (8.9 x 86.3 x 33 cm)

No fewer than one hundred terra cotta busts of Christ survive from the final decades of the fifteenth century in Florence. Artists and workshops produced hundreds, if not thousands, of additional such works that are no longer extant. Many of these drew upon Andrea del Verrocchio's monumental bronze image of Christ, part of a figure group depicting the doubting St. Thomas about to touch the side wound that Christ exposes to him (fig. 1). The figures were displayed in an exterior niche of Orsanmichele (Florence) and gained fame instantly after their installation on 21 June 1483. On that day, the Florentine apothecary Luca Landucci wrote in his journal that

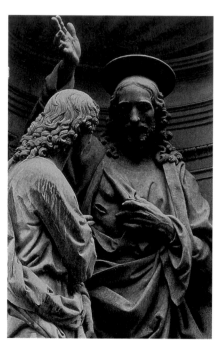

figure 1
Andrea del Verrocchio
***Christ and Saint Thomas*, 1483**
Orsanmichele, Florence

the bronze figure group "is the most beautiful thing and the most beautiful head of Christ ever made."[1] The highly public exterior location of the figure group and its enthusiastic reception brought fame to both the image and its maker and, no doubt, created a market for the terra cotta busts. Early collectors also prized Verrocchio's preparatory terra cotta models, and the Medici bought his terra cotta figure of St. Thomas so as "not to allow the sketch and source of so beautiful a work be damaged and perish."[2]

While the Christ in Verrocchio's bronze stands full-length and raises his right arm to reveal his side wound to Thomas, the terra cotta busts lack this narrative context. They are truncated at the torso with arms falling at the side. Also, the busts are life-size, while the bronze is larger; the terra cotta therefore could not have been cast from the bronze. The Hall bust is one of the most faithful to its prototype; it closely records the facial features of the bronze, including the ringlets of hair and beard. Although the terra cotta was pressed from a mold, fingerprints on the surface document the hand-modeling of the artist, likely Verrocchio himself.[3]

Other terra cotta busts were cast after the image of Christ in a relief that comprises part of the cenotaph for Cardinal Niccolò Forteguerri (Pistoia Cathedral), which Verrocchio designed in part.[4] In that image, Christ as judge looks down onto the Cardinal, while angels elevate the saved and hold up the mandorla from which Christ prevails. That image of Christ also conformed to the ideal image of him as described in the *Lentulus Letter* (see the introductory essay of this catalog). Verrocchio, who was master of two large and successful studios in Florence and Venice, met the needs of a collecting public who seems to have wanted to own a replica and souvenir of famous monumental sculptures. KR

Bibliography: Andrew Butterfield, *The Sculptures of Andrea del Verrocchio* (New Haven/London, 1997), 77, 212; A. Butterfield, *Masterpieces of Renaissance Sculpture*, exh. cat., Salander-O'Reilly Galleries (New York, 2000), no. 4.

1 See L. Landucci, *Diario fiorentino dal 1450 al 1516* (Florence, 1883).
2 John Pope-Hennessy, *Italian Renaissance Sculpture* (Oxford, 1958), 293–299.
3 A. Butterfield, *The Sculptures of Andrea del Verrocchio* (New Haven/ London, 1997), 212.
4 An example is the terra cotta bust of Christ in the Museo Civico, Pistoia. See C. Seymour, *The Sculpture of Verrocchio* (reprinted Greenwich, 1971), pl. 178.

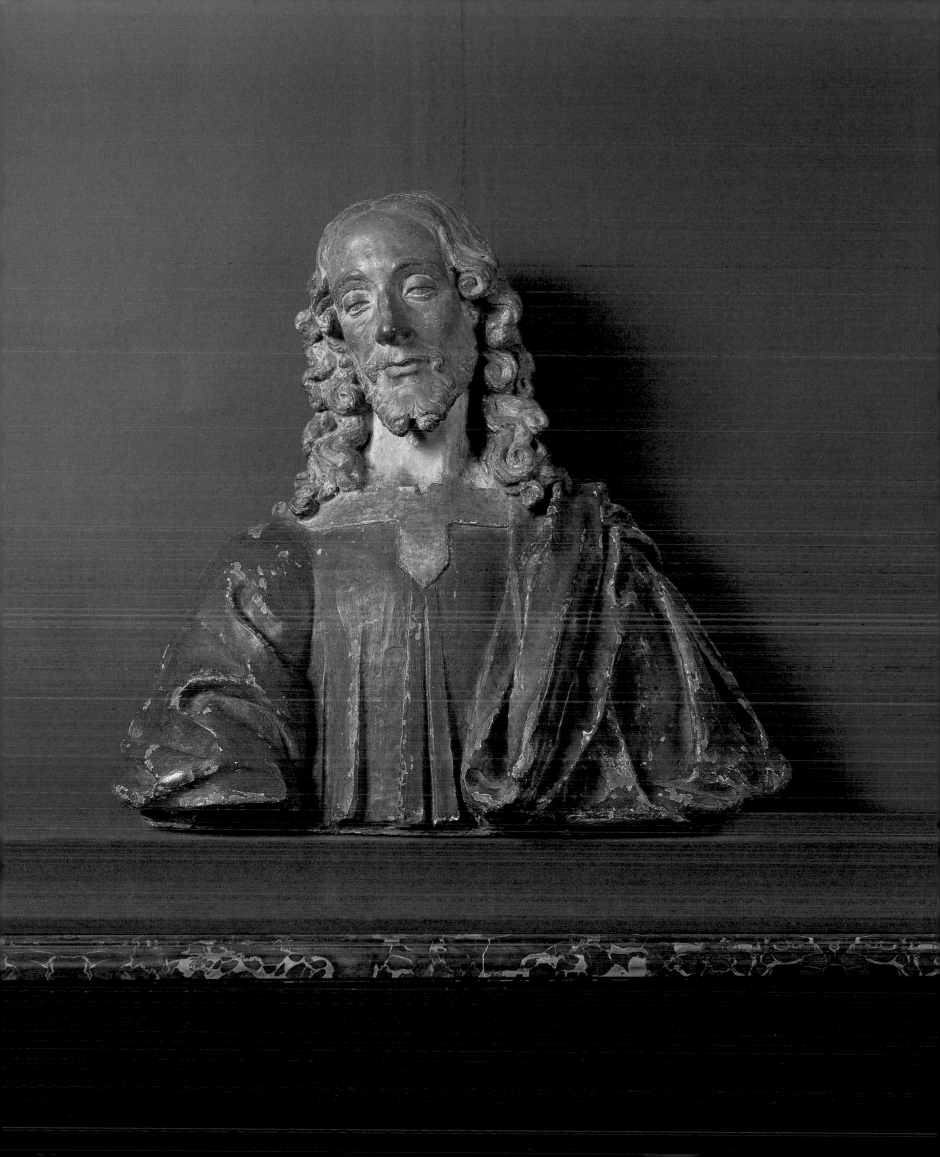

Attributed to Niccolò di Forzore Spinelli, called Niccolò Fiorentino (1430–1514)

Italian, late 15th century

Bronze medal

Obverse: Profile of Christ; reverse: Saint Paul

Diameter: 3¼ inches (8 cm) x ½ inch (1.25 cm)

Inscription: (obverse) .YHS.XPC.SALVA-TOR.MVNDI. (Jesus Christ Savior of the World); (reverse)+VAS.ELECTIONIS. PAVLVS.APOSTOLVS ("The vessel of election, Paul the Apostle")

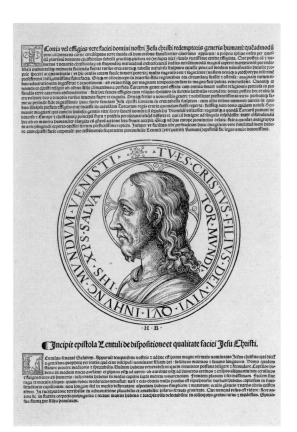

figure 1
Hans Burgkmair der Ältere
Die Büste des Erlösers (Bust of the Savior), c. 1515
Woodcut
Staatliche Graphische Sammlung München

On the obverse Christ is shown in profile to the left, with long, neatly combed, wavy hair and trimmed beard. His brow projects noticeably, his nose is pronounced and has a fleshy tip, while his lips are also fleshy, but his cheeks sunken. His shoulders are robed and his halo bears a cross in relief lines. This image was derived from what was believed to be a "True Likeness" carved on an emerald (see cat. no. 95). The emerald is lost, but its impact can be gauged from the immediate proliferation of the portraits in the principal media available for reproduction at the time, medals, plaquettes (see cat. nos. 96 and 102), and woodcut prints. Of the latter, the finest is Hans Burgkmair's of 1515 (fig. 1).

On the reverse, St. Paul the Apostle is shown in profile to the right with his traditional, long wavy beard and his hair close-cropped in the style of an ancient Roman citizen. He wears a toga clasped with a brooch on his shoulder and has a plain halo. The Latin inscription, "*Vas Electionis*," refers to the *Acts of the Apostles* 9.15: "The Lord said to him, 'Go, because I have chosen him to serve me, to make my name known to Gentiles and kings and to the people of Israel.' "

1 See the example in the Kress Collection, National Gallery of Art in G. Hill/ G. Pollard, *Renaissance Medals from the Samuel H. Kress Collection at the National Gallery of Art* (London, 1967), 47, nos. 243–44.

2 For which, see L. Dolcini ed., *Verrocchio's Christ and St. Thomas: A Masterpiece of Sculpture from Renaissance Florence*, exh. cat., Metropolitan Museum of Art (New York, 1993), 45.

Both images also appear as separate medals with appropriate biblical inscriptions on their reverses.[1] Neither Hill nor Pollard, the greatest experts on Italian medals in the twentieth century, attempted to define the authorship of these important representations, beyond calling them Roman, c. 1500. However, they are masterly portraits, and given their small scale, they distinctly recall the depictions of Christ by Verrocchio, notably the monumental group in bronze depicting *Christ and St. Thomas* (Orsanmichele, Florence, see cat. no. 91, fig. 1).[2] The coppery color of the alloy of the medal is also reminiscent of that employed by Verrocchio. These factors may indicate an origin in Florence, rather than Rome, as has been assumed, given the location of the emerald with the "True Likeness."

The best medallist in Florence at the time was Niccolò Fiorentino, who is documented several times and who occasionally dated his medals; unfortunately he did not sign them. His style is idiosyncratic and a large *oeuvre* has been attributed to him over the years, notably by George

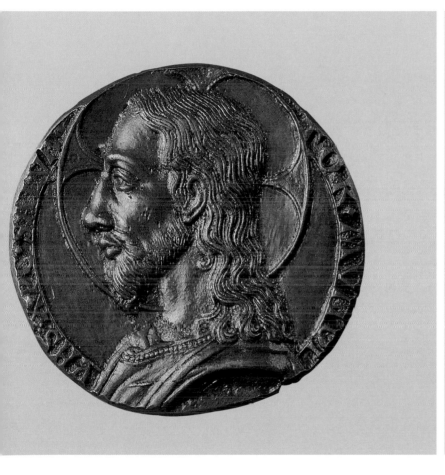 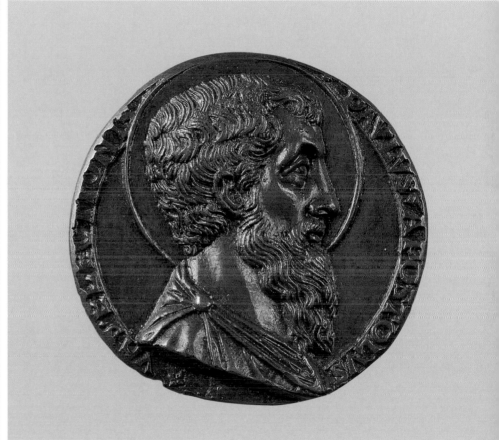

Hill. In 1485 Niccolò dated a splendid medal depicting Pope Innocent VIII, who some years later was to be the recipient of the gift of the emerald with the "True Likeness."[3] Already here Fiorentino attended to the accurate rendering of the pulpy flesh of the lips and to the fall of the delicate skin of the eyelids and sinuses around the eyes; these are also the predominant traits of the profile of Christ. Fiorentino also liked to penetrate the surrounding band of lettering with the truncated front of the bust.

In three of Fiorentino's attractive medallic portraits of youngish women, the formation of the slightly protuberant lips, raised eyebrows and the structure of the area around the eye are similar to those of the present face of Christ.[4] Features in this portrait of Christ are also analogous to other medals by Niccolò: a medal depicting Marsilio Ficino (d.1490) shows slightly sunken flesh over the cheeks; one bearing the likeness of Francesco Lancelotti treats a bearded face similarly; finally, a medal probably depicting the Abbot of Vallombrosa, Dom Baldassare, actually has on its reverse a reduced copy of the present medal of the "True Likeness."[5] These corroborate an attribution to Niccolò Fiorentino. **CA**

Bibliography: G. Hill, *The Medallic Portraits of Christ* (Oxford, 1920), 20–22, 32–43, figs. 10–11; G. Hill, *A Corpus of Italian Medals of the Renaissance before Cellini* (London, 1930), 231–32, no. 900.

3 G. Hill, *A Corpus of Italian Medals of the Renaissance before Cellini* (London, 1930), no. 927.

4 For these portraits, see S. Scher, ed., *The Currency of Fame: Portrait Medals of the Renaissance*, exh. cat., National Gallery of Art, Washington, D.C.,/Frick Collection (New York, 1994), 135–36, nos. 45–46.

5 See Hill nos. 974, 1049, and 1040, respectively.

Giovanni Bernardi (1494–1553)
Italian, mid-16th century
Bronze medal
Obverse: Profile of Christ; reverse: Crucifixion
3½ inches diameter x ⅜ inch (8.9 diameter x 1 cm)
Inscription (obverse): "EGO SVM VIA VITA VERITAS" (I am the way, the life and the truth)

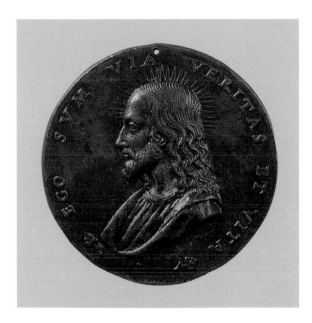

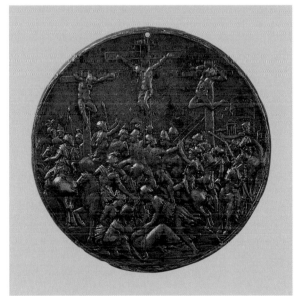

The obverse shows an elegant variant of the "True Likeness." The reverse is cast with a multi-figure scene of the *Crucifixion* that corresponds closely with – indeed is indirectly cast from – a roundel in rock crystal signed by Giovanni Bernardi in the Cabinet des Médailles, Bibliothèque Nationale, Paris (Inv. no. H/2964; 9 cm diameter). A signed variant is in the Michael Hall collection (cat. no. 62). The Paris example is part of a series of nine scenes from the *Passion of Christ* that Bernardi carved around 1547 and which Giorgio Vasari praised in his *Lives of the Artists* (1550). Whether Bernardi was also responsible for the image of Christ on the obverse is less certain. Attributions to Leone Leoni (c. 1509–1590), Giovanni Antonio de' Rossi (1517–after 1575) and Antonio Abondio (1538–1591) have also been suggested, but without great conviction.

A gilt bronze cast of the obverse is in the British Museum (Keary, no. 277: 88 mm diameter) and Hill lists others with a reverse of the *Crucifixion* formerly in the Whitcombe Greene and Lanna collections.
CA

Bibliography: G. Hill, *The Medallic Portraits of Christ* (Oxford, 1920), 62, no. 5, fig. 32; R. Varese, *Comune di Ferrara Placchette e Bronzi nelle Civiche Collezioni*, exh. cat., Ferrara/Pomposa, 1974–75 (Florence, 1975), no. 31; V. Donati, *Pietre Dure e Medaglie del Rinascimento: Giovanni da Castelbolognese* (Ferrara, 1989), 180.

94 | "True Likeness" of Christ with Saints Jerome and Francis

North Italian, early 16th century
Walnut
6½ x 6 x ½ inch (16.5 x 15.2 x 1.3 cm) (closed)
Inscription: "IHV ; XPC ; SALVATOR MVNDE MISERERE MIHI MVLC TVO"
("O Jesus Christ, Savior of the world, have mercy upon me ...")

The central panel of this extremely rare devotional triptych is integrally carved with a roundel of the "True Likeness" depicted in the bronze medal attributed to Niccolò Fiorentino (see cat. no. 92). This walnut medallion, however, lacks the cruciform halo and bears an expanded, variant inscription. The roundel is set within a square frame with elegant acanthus moldings filling the corners. Seven angels support the frame; five of them also bear the instruments of the Passion, while a cherub face with four radiating wings marks the top center of the design. The angels' wing tips and ends of their robes overlap the surrounding architectural molding that defines the picture, within the slab of walnut.

The side panels contain scenes from the lives of two important saints, perhaps the name-saints of the owner. On the left St. Jerome with his tame lion in the desert kneels in penitence before a crucifix, a favorite subject within the realm of Venice (including the Dalmatian coast). On the right St. Francis receives the stigmata from a crucifix, while a monk looks on from an arched tower in the background. The emaciated and balding physical type of St. Jerome and his rocky surroundings are similar to a small (39 x 37 cm) domestic relief depicting the saint carved in local limestone around 1480 by Andrea Alessi, now in the Art Gallery of Spalato (Split).[1] The appearance of the cherub face with four wings and intricate carving of the ornament above the flanking panels resembles the ornate wooden panelling of 1525 in Santa Maria in Organo, Verona.[2]

Another analogy for the central panel appears in the furniture of a sacristy: a *bancone* (sideboard with cupboards below) from the oratory of Redecesio (Milan), now in the Museo d'Arte Antica Milan, believed to date from the late fifteenth century. The intaglio carving of the square wooden panels on the doors, the flanking pair of which have a coat of arms framed within a circular stylised wreath, is similar.[3] Furthermore, its central door panel, carved with a geometrical device and a figure holding a ribbon with motto, is also analogous in technique.[4] These parallels corroborate an origin of the triptych in northern Italy and a date in the first quarter of the sixteenth century.

The same medal of Christ was also closely copied on a larger scale and in stone on a slab about 70 cm² by a French sculptor working at Bignoux (Vienne) in the early sixteenth century; this is in the Museum of the Société des Antiquaires de l'Ouest, Poitiers. Christ's head is tightly framed within a circular molding ornamented with acanthus leaves, in which the truncation and upper segment of the halo overlap, while the inscription has been transferred to a scroll outside this field. The whole is enclosed within classicizing pilasters, while a larger scroll, now blank, unfurls beneath, presumably once having borne a dedicatory inscription. **CA**

Bibliography: G. Hill, *The Medallic Portraits of Christ* (Oxford, 1920), 24, 26, fig. 15.

1 Joško Belamarić, *Tesori della Croazia restaurati da Venetian Heritage Inc.*, exh. cat., Church of San Barnaba (Venice, 2001), 69–70, no. 18.
2 G. Ferrari, *Il legno e la mobilia nell'arte italiana* (Milan, Collezione Artistica Hoepli, n.d.), pls. XXXIX–XL.
3 E. Bascheschi "Mobili Italiani del Rinascimento" in *Conoscere gli stili dei mobili* (Milan, 1964), 9.
4 M. Boroli and S. Broggi, *Il Mobile del Rinascimento, Italia* (Novara, 1985), 61.

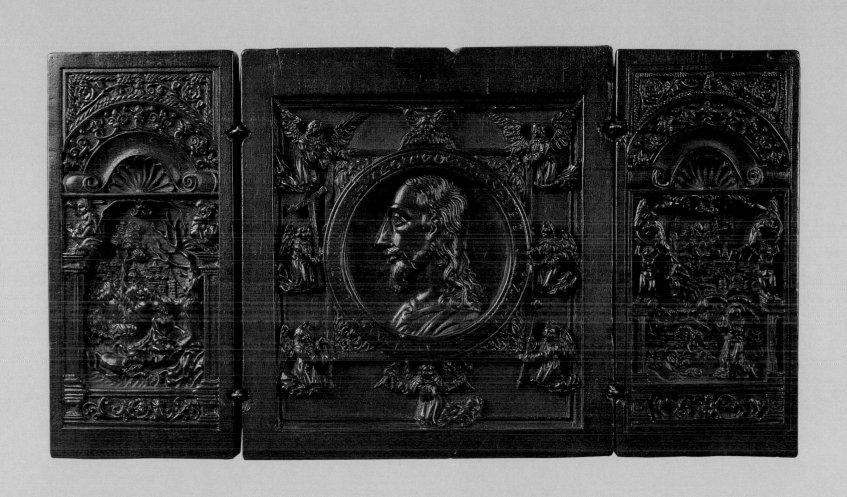

95 | Portrait of Christ

English, reign of Henry VII (r. 1485–1509)
Prepared oak panel
Oil and gilt background with gilt letters and inscription
14¼ x 11¾ x 1¼ inches (36.2 x 29.8 x 4.4 cm)
Inscribed on front: "THIS PRESENT FIGVRE IS THE/SIMILYTVDE OF OVR LORD IHS/OVR SAVIOR IMPRINTED IN AMI/RALD BY THE PREDECESSORS OF THE GREATE TVRKE AND SENT/TO POPE INNOCENT THE VIII FOR/A TOKEN TO REDEME HIS BRO/THER THAT WAS TAKYN PRISONER."

An English artist probably painted this rendition of the "True Likeness" of Jesus Christ. This famous profile portrait appears in many examples, one of which was recently exhibited in *The Image of Christ* at the National Gallery, London, and attributed to a Netherlandish artist of the late fifteenth century or early sixteenth century.[1]

George Hill, in his exhaustive study of the subject of the medallic portraits of Christ, discusses and illustrates many similar examples.[2] All of these derived from a carved emerald of legendary status, to which the inscription refers. The Grand Sultan of Constantinople, Bajazet II presented the emerald to Pope Innocent VIII to ensure that the Sultan's brother Ojem remained in Papal captivity. By doing so, Bajazet wished to prevent his brother from returning to the Sultanate and claiming the throne. The scribe has changed the meaning of the story by writing that the "Great Turk" wanted to "redeme (sic)" his brother, that is, to give the emerald to the Pope as ransom in exchange for his brother's return.

This painted portrait is more subtle than medals with the same subject (see cat. nos. 92, 93, 102). Christ's features here are more sleek: the nose has less bulbous nostrils and a more refined bridge. The eyes are not as deeply set, the lips are less fleshy, the mustache and beard well groomed, and the curled hair less unruly as it falls upon the shoulders. The ear is prominent and roseate. The neckline band, consistent in form with the early medallic portraits, folds over noticeably. **MH**

1 Alexander Sturgis, "Diptych with the Head of Christ and the Lentulus Letter," *The Image of Christ*, exh. cat., National Gallery (London/New Haven, 2000), 94–97, fig. 40. See also the introductory essay of this catalog.
2 G. Hill, *The Medallic Portraits of Christ* (Oxford, 1920).

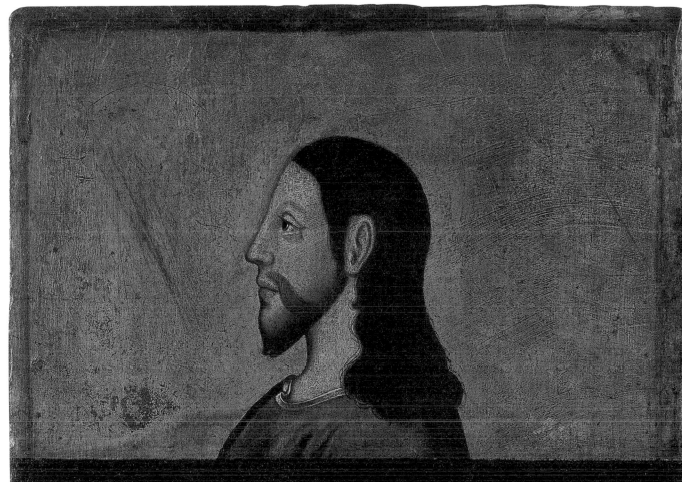

THIS PRESENT FIGVRE IS THE
SIMILYTVDE OF OVR LORD IHS
OVR SAVIOVR IMPRINTED IN A MI
RALD BY THE PREDECESSORS
OF THE GREATE TVRKE AND SENT
TO POPE INNOCENT THE viii FOR
A TOKEN TO REDEME HIS BRO
TER HAT WAS TAKYN PRISONER

96 | Profile of Christ

Antonio Abondio (1538–1591)
Italian, 1587
Oval silver relief
Obverse: Profile of Christ; reverse: Man of Sorrows
2¼ x 1½ x ⅛ inch (5.3 x 3.8 x 0.3 cm)
Initialled (lower center of obverse) AN.AB. Hebrew inscription on the right

The obverse portrait is based on the "True Likeness" recorded in earlier Italian medals of c. 1500, with the image ennobled and the hair curled into spiraling ringlets. The halo's zig-zag outline with radiating striations suggests rays of heavenly light. This piece is a variant of a similar oval silver medallion in the British Museum, London, that includes the crown of thorns, which Hill describes as a "piece distinguished by the refinement which is characteristic of [Antonio Abondio], the last of the great Italian medalists."[1] Weber records other casts in silver gilt in Berlin, London, Munich and Prague.[2]

The reverse is one of Abondio's most beautiful and moving designs. Christ as *Man of Sorrows* stands in a graceful pose looking down wistfully to the viewer's right. A pair of adolescent-looking angels spread out a cloak like a cloth of state behind him. They also support the column at which Christ was scourged (left) and the cross (right). The crossbar is greatly foreshortened, to conform approximately with the enclosing oval (as does the angel's wing). On the ground at Christ's feet lie other instruments of the Passion, including the three nails, the hammer, and the crown of thorns. The suave figure of the Savior deliberately recalls Michelangelo's marble statue of *Christ with the Cross* from the 1520s (Santa Maria sopra Minerva, Rome). **CA**

Bibliography: J. G. Pollard, "Abondio," in J. Turner, ed., *The Dictionary of Art* (London, 1996), vol. 1, 35.

1 G. Hill, *The Medallic Portraits of Christ* (Oxford, 1920), 68–69, fig. 41.
2 I. Weber, *Deutsche, Niederländische und Französische Renaissance Plaketten* (Munich, 1975), 287, no. 652, pl. 176.

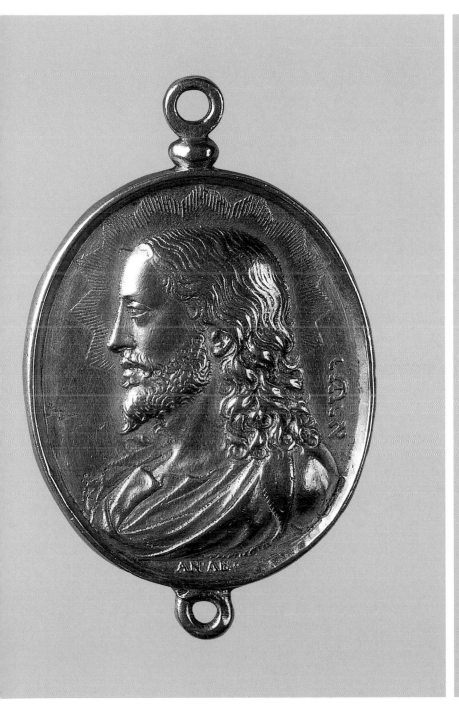

97 | Portrait Bust of Christ

Attributed to Antonio Abondio (1538–1591)
Italian, third quarter of the 16th century
Smoky agate or cloudy chalcedony
1¾ x 1⅝ x ¼ inch (4.5 x 4 x 0.6 cm)

This exquisitely carved "true portrait of Christ" is mounted in its original silver frame with a loop by which to hang it. The figure's heavily lidded eyes, highly bridged nose, heavy lower lip, shell-shaped ears, minutely carved strands of soft curled beard, and lanky locks falling to the shoulders portray a unique image in hard stone. The portrait is close in style to the profile seen in catalog number 96.

Antonio Abondio, who was born in Riva del Garda, Trento in 1538, was one of only a handful of Italian artists to forge a career north of the Alps. His work stands outside the development of the Italian portrait medal, and instead draws upon Italian, German, and Netherlandish sources. He worked for several Holy Roman Emperors, first Ferdinand II in 1565–66 in Innsbruck, then Maximilian II in Vienna and Rudolf II, whose court in Prague employed artists and scientists from all over Europe and encouraged experimental techniques and materials, such as this smoky agate or cloudy chalcedony.[1] Rudolf also gave Abondio a house in Prague and commissioned him to design the empire's new coinage. MH

1 See K. Schulz, *Antonio Abondio und seine Zeit*, exh. cat., Kunsthistorisches Museum (Vienna, 1988); J. J. W. Evans and J. Spicer, eds., *Prag um 1600: Kunst und Kultur am Hofe Rudolfs II*, exh. cat., Villa Hügel (Essen, 1988), esp. 575–94.

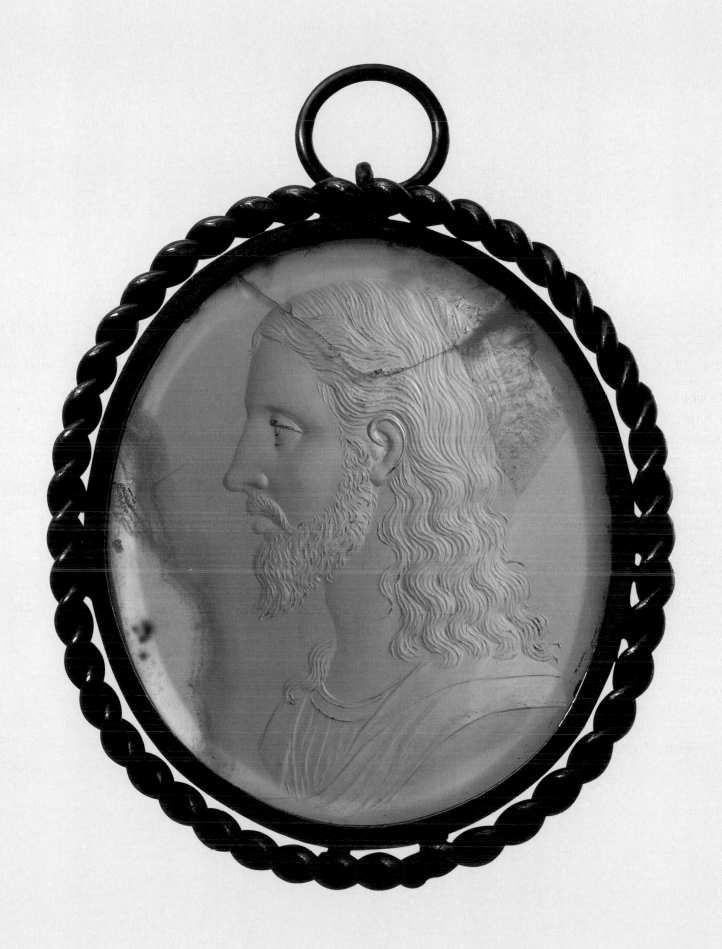

98 | Profile of Christ

Florentine (?), early 16th century
Bronze relief
2½ x 1¾ x ⅜ inch (6.5 x 4.2 x 1 cm)

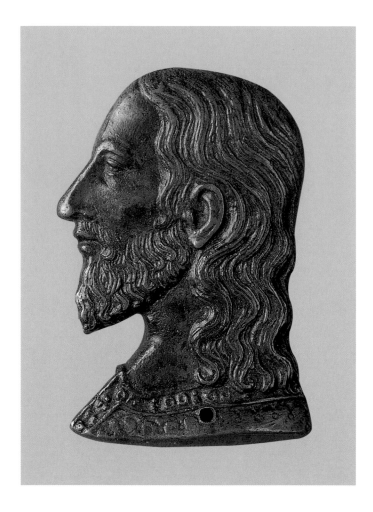

This silhouette profile seems to have no parallel in the medallic portraits of Christ.[1] The line of the eyebrow continues down the bridge of the prominent nose, and the upper lip protrudes above the lower, where the beard forms a wavy and very stylized pattern. The design does not relate to a medallic source, but rather to the format of a plaquette. Christ's profile was silhouetted and perhaps cut out from such a plaquette. It most probably was affixed to a background of some other material such as stone, wood, or cloth. It is painterly in conception and is drawn on a flat plane without three-dimensional modeling. The visage is closely related to Verrocchio's *Bust of Christ* in terra cotta in the present exhibition (see cat no. 91), from which it takes the boldly displayed features. The bronze silhouette is more stylized to conform to the two-dimensional context. In spite of its monumentality on such a small scale, this bronze profile is rudimentary in format and perspective; it is an early attempt at naturalism. Although clearly Italian, and datable to c. 1500, the portrait remains somewhat enigmatic and its origins most difficult to locate. MH

1 Hill, in his comprehensive survey of portraits of Christ, does not illustrate anything closely related to this piece. See G. Hill, *The Medallic Portraits of Christ* (Oxford, 1920).

99 | Profile of Christ

Italian, 15th century
Bronze
2½ x 1¾ x ⅜ inch (6.5 x 4.5 x 1 cm)

1 See Brian Spencer, *Pilgrim Souvenirs & Secular Badges; Salisbury & South Wiltshire Museum Medieval Catalogue, Part 2* (Salisbury & South Wiltshire Museum, 1990), with further references.

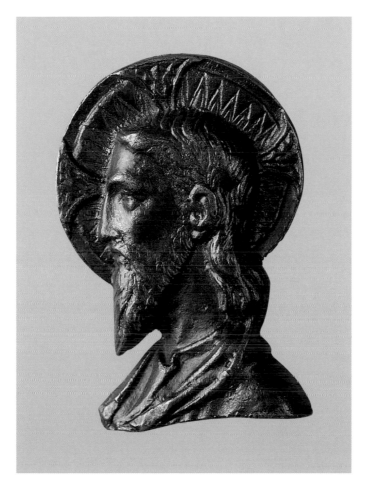

This portrait depicts Christ with a high straight brow, prominent eyebrows, and a rather serious expression. The bridge of the nose extends vertically from the plane of the eyebrows, and the pointed beard continues on the same vertical axis. The hair reveals the full ear and flows to the neckline in the back where it meets the drapery curls. A radiant cruciform nimbus circumscribes Christ's head.

Unlike other cast portraits of Christ, this one is not part of a coin, medal, or plaquette. Instead, Christ's features are cut in silhouette and stand free of a background. Despite his atypical physiognomy, the inexpressive profile view, and the absence of textual clues, the image unmistakably represents Christ.

The object resembles cast lead badges that pilgrims would purchase at shrines throughout Europe. These devotees wore the badges as souvenirs from their journey and amulets to guard against peril during travels.[1] A relief of the *True Likeness of Christ*, related to this example but cast on a lead medallion, was found in the cemetery of Sainte-Livrade, France. It is possible that family members buried the dead with enduring images of Christ for their apotropaic effects. MH

Bibliography: G. F. Hill, *The Medallic Portraits of Christ* (Oxford 1920), 12–16, figs. 3–6.

Venetian, mid-16th century
Bronze plaquette
5⅛ x 4 x ⅝ inch (13 x 10 x 1.3 cm)

figure 1
Andrea del Verrocchio
***Christ and Saint Thomas*, 1483**
Orsanmichele, Florence

This portrait of Christ recalls the image of Christ in Verrocchio's *Doubting Thomas* group mounted in an exterior niche of the Orsanmichele, Florence, in 1483 (fig. 1). This, however, was probably cast several decades later in Venice. The hair and face resemble a round medal attributed to Leone Leoni (1509–1590) in the British Museum, London, that displays a complex *Crucifixion* similar to one carved by Giovanni Bernardi (1494–1553) (see cat. no. 93).[1] What is striking about this variant is that Christ looks to his left side, considered to be the sinister side, the side on which tormented and eternally damned souls and the *Bad Thief* are always represented. In most other profile portraits of Christ, he looks to his right, or dexter side, toward the elect. It is not clear whether this was a motivated choice or an inadvertent result of the copying and casting processes.[2]
MH

1 G. Hill, *The Medallic Portraits of Christ* (Oxford, 1920), fig. 31.
2 Although unusual, this is by no means unique. A few other works in this exhibition repeat this format; see cat. nos. 101, 103, 106.

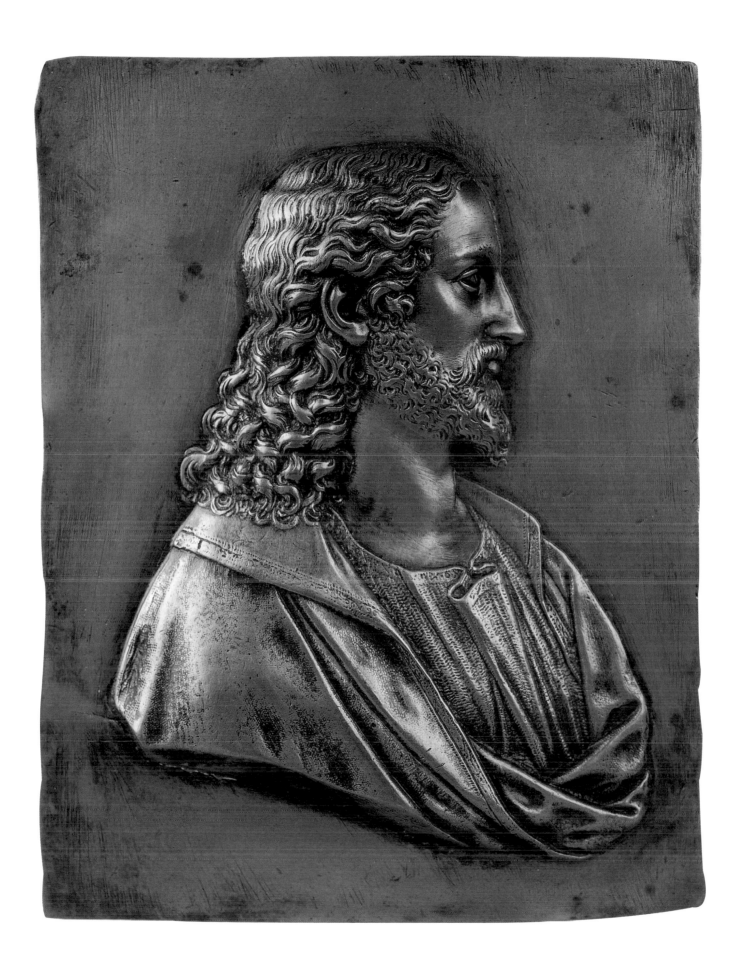

101 | Portrait of Christ

Circle of Germain Pilon (1528–1590)
French, mid-16th century
Marble medallion
14½ x 12¾ x 1½ inches (36.8 x 32.3 x 3.8 cm)
Inscribed: "Jean Goujon" (in ink on the reverse)

244

The physiognomy of this profile of Christ is clearly derived from the portrait that evolved during the Renaissance from the supposed "True Likeness." Only minor differences provide clues by which to determine its authorship. The profile of brow and nose is smoothed out and made more classical, though less psychologically forceful, while the long hair is considerably straightened, replacing the curly locks of some earlier images that were dependent on the stylization introduced by Verrocchio in the late fifteenth century.

An ink inscription gives the name of Jean Goujon (c. 1510–1565), a French sculptor of the middle third of the sixteenth century. However, a comparison with the profile of Christ on the large relief panel of the *Deposition from the Cross* carved around 1545 (now in the Louvre, Paris, inv. M.R. 1731) makes the connection unconvincing. Goujon's Christ has a much less elongated face, lower forehead and less pronounced chin, while the hair is more wavy as it runs back from the brow and falls in ringlets behind. The beard is also deeply sculpted by means of a drill.

On the other hand, the medallion bears a palpable relationship with similar subjects by Goujon's successor, Germain Pilon. A close resemblance appears in a larger than life-size *gisant* (effigy) depicting Christ, that Queen Catherine de Medici commissioned in 1560 (Louvre, Paris).[1] There too the long hair trails on the ground in slow, natural undulations (rather than in contrived curls), the silhouette of the forehead and nose is smoothed out, and the ear is pronouncedly featured. The eyes are of course closed, which precludes a direct comparison.

A later relief by Pilon depicting *Christ on the Mount of Olives*, dating from 1582–84 (Louvre, Paris), gives a consistent profile of Christ, though it is less distinct due to weathering and does not resemble the present head as much as the *gisant*.[2] This suggests a date of around 1560 for the medallion. **CA**

1 See J. Babelon, *Germain Pilon* (Paris, 1927), pl. XVIII; and M. Beaulieu, *Description raisonnée des sculptures du Musée du Louvre*, II, Renaissance française (Paris, 1978), 133, no. 204.
2 Babelon, pl. XLVII; Beaulieu, 139, no. 215.

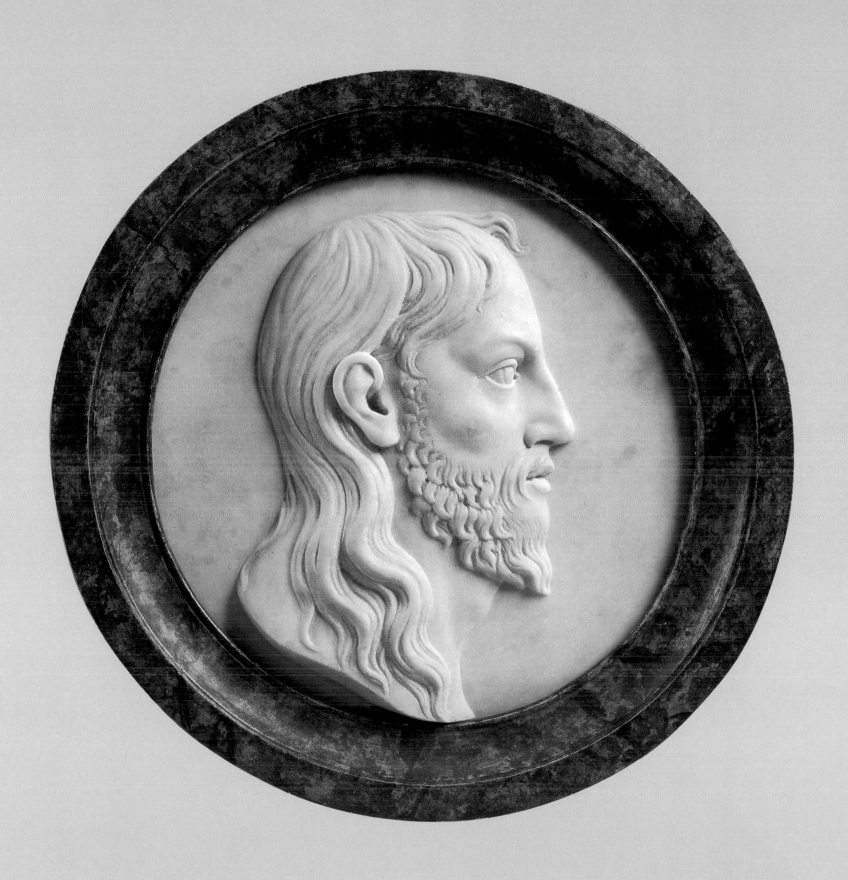

102 | "True Likeness" of Christ

Attributed to Antonio Abondio (1538–1591)
Italian, mid-16th century
Oval bronze medallion
Obverse: "True Likeness" of Christ: reverse: Hebrew inscription
1⅝ x 1⅜ x ½ inch (4.2 x 3.6 x 1.3 cm)

This medallion is a sixteenth-century derivative of the medals of the 1490s based on the Byzantine emerald in the papal collection (see introductory essay and cat. no. 95), combined with a Hebrew inscription. George Hill did not record this type when he wrote about the circular medals depicting Christ in 1920.[1] An attribution to Abondio is justified by the similarity of the head of Christ to that on, for example, his initialled silver relief in the Hall collection (see cat. no. 96).

Born at Riva di Trento, in northern Italy, Abondio was a modeler in wax and a medallist. His early work in Italy between 1552 and 1565 reveals the influence of Milanese, Emilian and Florentine artists, particularly of Leone Leoni. Abondio worked at the court of Vienna from 1565 in the service of Emperor Maximilian II and in Prague from 1576 for his successor, Rudolph II. The reverse of his medals often shows mythological figures in vigorous action or complex allegories. He also produced wax models and plaquettes in an archaic style deliberately recalling compositions by Albrecht Dürer, whose famous monogram "AD" he adapted into his own "AA." The *Toilet of Venus*, the *Virgin and Child* and *Christ's Head* are his most widely known subjects. **CA**

Bibliography: *Bulletin de la Société Nationale des Antiquaires de France* (1898), 276 ff., 281.

1 G. Hill, *The Medallic Portraits of Christ* (Oxford 1920), 47–57; G. Hill, *A Corpus of Italian Medals of the Renaissance Before Cellini* (London, 1930), no. 897, note.

103 | "True Likeness" of Christ

French (?), 17th century
Bronze medal
Obverse: "True Likeness" of Christ; reverse: Hebrew inscription
4½ diameter x ½ inch (11.4 diameter x 1.3 cm)

The "True Likeness" appears on the obverse of this medallion, copied from a unique uniface silver *repoussé* medal now in the Victoria and Albert Museum, London, and is inscribed *Viva Dei Facies et Salvatoris Imago* (The living face of God and likeness of our Savior).[1] The head was made separately and soldered onto the medallion, leaving a space in the back for a relic. That design is better known from a type of rectangular plaquette cast from it (probably in Rome c.1475–90), with the addition of the initials I.N.R.I. (Jesus of Nazareth, King of the Jews) on the background, the sun and moon at the upper corners, flanking the dove of the Holy Spirit.[2]

These plaquettes are quite common (with similar pieces listed in Berlin, London, Padua, Paris, Venice, and Washington D.C.) because devotees sought to call on the powers of the miracle-working image.[3]

The earliest record of a medal depicting Christ with a Hebrew inscription on its reverse appears in a book of 1539. The author, Theseus Ambrosius Albonesius, describes having seen the medal in the previous year when a woman traveler carried it through Ferrara on her way to Venice. Albonesius interpreted the Samaritan letters to mean "Messiah the King came in peace, God became man, or incarnate," though this is questionable.[4] This type was much replicated. Hill deemed it to date from the second half of the sixteenth century, while a French expert put its origin even later, in the seventeenth century. **CA**

Bibliography: G. Hill, *The Medallic Portraits of Christ* (Oxford, 1920), 12–16, figs. 3, 5; G. Hill, *A Corpus of Italian Medals of the Renaissance Before Cellini* (London, 1930), no. 897; M.G. Tholin, *Bulletin de la Société Nationale des Antiquaires de France* (1898), 276 ff.

1 G. Hill, *A Corpus of Italian Medals of the Renaissance Before Cellini* (London, 1930), no. 896.

2 Ibid, no. 897; G. Hill, *The Medallic Portraits of Christ* (Oxford, 1920), fig. 5.

3 J. Pope-Hennessy, *Renaissance Bronzes from the Samuel H. Kress Collection* (London, 1965), no. 277, fig. 31.

4 G. Hill, *The Medallic Portraits of Christ* (Oxford, 1920), 47–48.

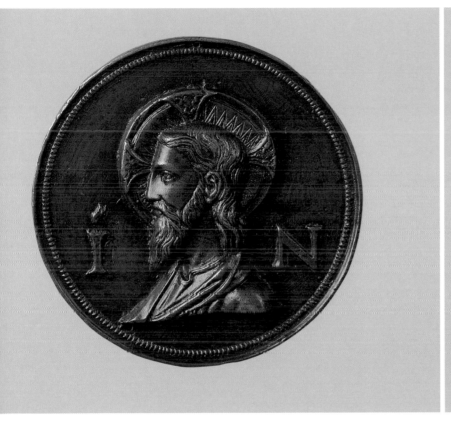

François Duquesnoy (1597–1643)
Roman, second quarter of the 17th century
Bronze
Jesus: 7½ x 4¼ x 3⅝ inches (19 x 10.2 x 8.5 cm)
Mary: 8½ x 5⅝ x 3½ inches (21.6 x 14.3 x 9 cm)

The Fleming François Duquesnoy was one of the most important sculptors in seventeenth-century Rome, though his art was a reaction against the exuberant baroque style of his contemporary, Gianlorenzo Bernini (1598–1680). He cultivated a more restrained and elegant aesthetic based on the study of ancient sculpture. But unlike most artists of the day, who turned to antiquity as a repository of dynamic poses and motifs, Duquesnoy sought to capture an ideal of proportion, contour, and general expression that he identified as specifically Greek. In concert with Nicolas Poussin (1594–1665), the pre-eminent classicizing painter of the age, the sculptor systematically studied and measured the famous ancient statues in Rome that fulfilled his Hellenic ideal. Their discriminating analysis predates Winckelmann's canonization of Greek art by over a century. According to his biographer, Giovanni Battista Passeri, Duquesnoy "wished to show himself a rigorous imitator of the Greek Style, which he called the true mistress of perfect procedure in art because it held within itself at one and the same time grandeur, nobility, majesty, and loveliness."[1]

figure 1
François Duquesnoy
Saint Susanna (detail), 1630
Marble statue
Santa Maria di Loreto, Rome, Italy

Duquesnoy applied this Greek aesthetic ideal to Christian subjects. His masterpiece is the monumental marble of Saint Susanna for the Church of Santa Maria di Loreto, Rome, begun in 1628 (fig. 1). The subdued expression, elegant proportions, and gently cascading folds of drapery on the figure established a new standard for the representation of female saints – in contradiction to the ecstatic expressions and agitated forms of Bernini's figures.[2] The two Hall bronzes relate both to the *Susanna* commission and more generally to Duquesnoy's stylistic agenda. The wavy strands of the Virgin's parted hair and the way she lowers her gaze in modesty evoke the sentiment and the larger physical context of the *Susanna*. Duquesnoy's Hellenism must have inspired his portrayal of Christ as a comely, clean-shaven youth. His thick unruly hair and large eyes relate to the "Greek" type of the sensuous adolescent, evident in such statues as the Vatican *Meleager* and *Antinuous*, which Duquesnoy studied and admired. Through his Greek style, sublime physical beauty becomes an expression of sanctity.

1 Giovanni Battista Passeri, *Vite de'Pittori, Scultori, ed Architetti*, in *Die Künstlerbiographien nach den Handschriften des Autors*, ed. J. Hess (Leipzig and Vienna, 1934), 112. On the emerging notion of "Greek style" in 17th-century Rome, see Charles Dempsey, "Greek Style and the Prehistory of Neoclassicism," in *Pietro Testa 1612–1650: Prints and Drawings*, ed. E. Cropper, exh. cat. (Philadelphia, 1988), xxxvii–lxv; Estelle Lingo, "The Greek Manner and a Christian Canon: François Duquesnoy's Saint Susanna," *Art Bulletin* LXXXIV (2002): 65–93.

2 For the *Susanna*, see Mariette Fransolet, *François Du Quesnoy, sculpteur d'Urbain VIII 1597–1643*, Mémoires de l'Académie Royale de Belgique, 2nd Series IX (Brussels, 1942), 99–109; Maria Giulia Barberini, in *L'Idea del Bello: Viaggio per Roma nel Seicento con Giovan Pietro Bellori*, exh. cat., Palazzo delle Esposizioni (Rome, 2000), 394–402, no.5; Lingo, op. cit. 70–86.

figure 2
François Duquesnoy
Busts of the Boy Christ and the Virgin Mary
Second quarter 17th century
Bronze
Michael Hall Collection

Duquesnoy's other biographer, Giovanni Pietro Bellori, notes that the artist produced terra cotta portrait busts of the Virgin and the young Jesus for Cardinal Francesco Barberini. Two sets were cast in silver and chased by the artist. The Cardinal presented one pair to Queen Henrietta Maria of England; the other appeared later in the collection of Cardinal Camillo Massimi.[3] While the silver casts are lost, numerous bronze pairs record the Duquesnoy model. The Hall busts relate closely in form and scale to examples in Vienna, Braunschweig, and Cambridge, Massachusetts.[4] Nonetheless, they exhibit a deeper, almost ebony-colored, patina and a more precise surface articulation than the other examples. The Hall collection also contains a later, somewhat larger, version of the busts. These feature a golden-brown patina, a broader swath of drapery over the truncated shoulders, and integral bronze mounts, exquisitely stippled and garlanded (fig. 2). JU

Bibliography: *Roman Baroque Sculpture. Five College Roman Baroque Festival*, exh. cat., Smith College Museum of Art (Northampton, 1974), nos. 1–4.

3 Giovan Pietro, "Vita di Francesco Fiamingho," *Vite dei pittori, scultori ed architetti* (Rome, 1672), E. Borea, ed. (Turin, 1976), 301–2.

4 On the examples in the Kunsthistorisches Museum, Vienna, the Herzog Anton Ulrich Museum, Braunschweig, and the Fogg Museum, Cambridge, see Fransolet, op.cit., 110, 176, pl. XXIII; Ursula Berger and Volker Krahn, *Bronzen der Renaissance und des Barock: Katalog der Sammlung* (Braunschweig, 1994), no. 106; Charles L. Kuhn, *German and Netherlandish Sculpture 1280–1800: The Harvard Collections* (Cambridge, 1965), nos. 57–8; and Barberini, op. cit., 402–3, nos. 7.1–7.2. The Hall and Harvard sets were exhibited together in *Roman Baroque Sculpture. Five College Roman Baroque Festival*, exh. cat., Smith College Museum of Art (Northampton, 1974), cat. nos. 1–4.

105 | Profile Portraits of Christ and the Virgin Mary

Probably by Guillaume Dupré (c. 1574–1642) or one of the Warins
French, second quarter of the 17th century
Bronze reliefs
7½ x 5½ x ⅝ inch (19 x 14 x 1 cm)

1 Similar examples of Italian origin also exist (fig. 1).
2 J. Fischer, *The French Bronze, 1500 to 1800*, exh. cat., M. Knoedler & Co. (New York, 1968), no. 15.
3 *Sculpture from the David Daniels Collection*, exh. cat., Minneapolis Institute of Arts (Minneapolis, 1979/80), no. 14.

This pair of plaquettes is unpublished and rare in this large size; only one other superb pair, gilded, is known (private collection, London). Another pair, also gilded, in the Ciechanowiecki collection, Warsaw, Poland, is distinctly smaller (15.5–16 cm high). The Hall pieces are larger by a segment of extra drapery, carefully modeled and folded around the lower circumference of the oval, i.e. across the shoulders and breast of the holy figures. This suggests that the Ciechanowiecki pair consists of reduced extracts from the Hall compositions. This is corroborated by other differences in detail. The robes of both those figures have a fringed edge, and the Virgin has a different and less convincing border of chevron pattern with interspersed dots; that border has replaced, probably for ease of chasing, the border of foliate rinceaux in the Hall example, which is much more in keeping with the seventeenth-century date of origin.

The compositions have previously been associated, not without some justification, with Guillaume Dupré, the sculptor-medallist of the courts of Tuscany and France.[1] More recently, similarities with a large bronze medallion of Jesus Christ dated 1628 and the remains of the letters WA, the first two letters of the surname of that other great dynasty of sculptor-medallists in Paris, the Warins, point in their direction (see the example formerly in the David Daniels collection, New York; and catalog 106, fig. 2). Alternative members of the family have been suggested as author of the plaques, Jean II Warin,[2] or Claude.[3] The appearance of the name of Pierre Goret on several medallions and the date 1628 on another pair in the possession of M. Alain Moatti of Paris, causes added complexity.

A renewed critical comparison between those medallions and the Hall examples makes it clear that they are not by the same hand. Furthermore, the Warin/Goret medallion is almost certainly derived from the Hall pair: notably, the artist of 1628 seems to have misunderstood the shallow

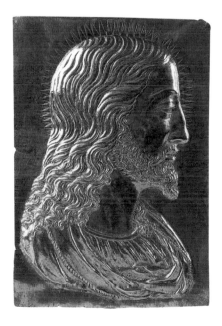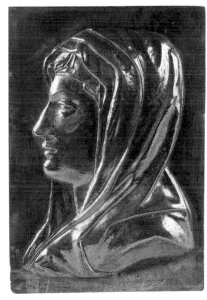

figure 1
Italian, Venetian (?)
Early 16th century
Gilt bronze
Michael Hall Collection

crease running diagonally down under Christ's luxuriant hair as the edge of his robe at that point, for he has marked it with an incised line elsewhere used to indicate the hem of the garment. The hair is also modeled in a more pedestrian fashion, flatter to the head and with parallel waves, and not in the subtle way of the original, where it is cunningly intertwined with a great understanding of plasticity.

These observations suggest that the date of 1628 on the circular medallion may well provide a *terminus ante quem* for the present, superior compositions. Their author is probably to be sought among the greater sculptors active in Paris at the turn of the century. CA

Bibliography: G. F. Hill, *The Medallic Portraits of Christ* (Oxford, 1920); *Sculpture in Miniature: The Andrew S. Ciechanowiecki Collection of Gilt & Gold Medals and Plaquettes*, exh. cat., The J.B. Speed Art Museum (Louisville, 1969), nos. 448–49.

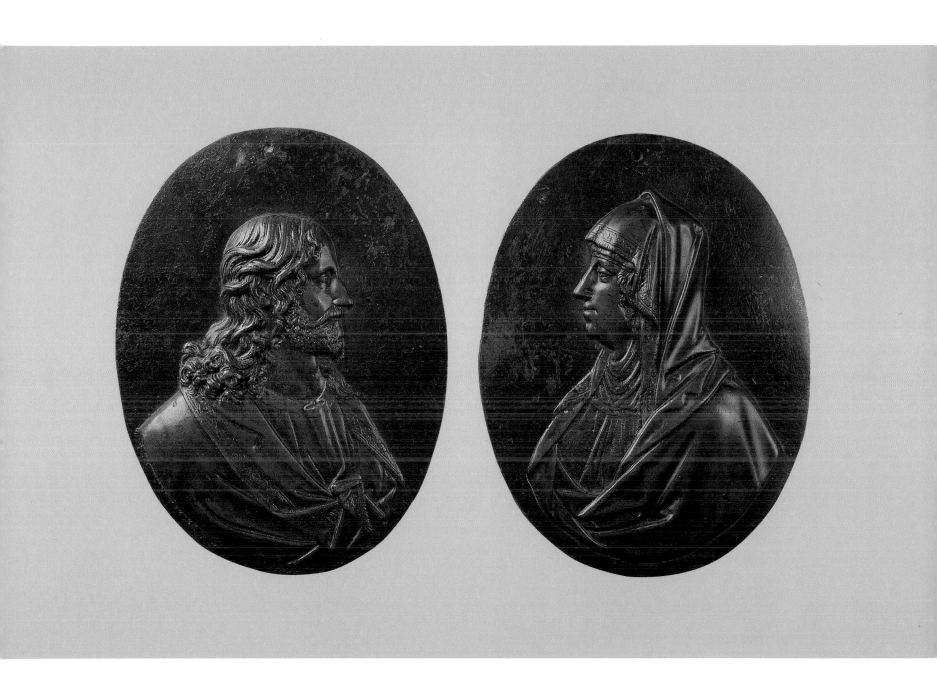

Pierre Goret (active early 17th century)
Franco-Flemish, second quarter of the 17th century
Bronze medallions
9¾ x 7½ x ½ inch (25 x 19 x 1.3 cm)
Inscription: (Christ) "EGO SUM VIA VERITAS ET VITA." ("I am the way, and the truth, and the life") (Mary) "FECIT MIHI MAGNA QVI POTENS EST"; ("For the mighty one has done great things to me") and smaller "P. GORET F." ("Made by Pierre Goret") (flanking the truncations)

figure 1
P. Goret
Portrait of the Virgin Mary (detail), 1628
Medallion
Collection Alain Moatti, Paris

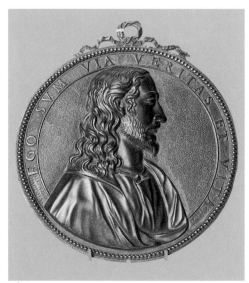

figure 2
After Claude Warin (active 1620–54) (?)
Christ
Medallion
Michael Hall Collection

This piece is similar to a medallion depicting Christ (formerly in the David Daniels Collection, New York) that is dated in relief with the year 1628 and has traces of the beginning letters of a signature, WA. This may point to Claude Warin, member of a dynasty of bronze founders, who specialized in portrait-busts and medals. On the other hand, the appearance of the name P. Goret cast prominently in relief opposite the date on both of the present medallions raises the question as to whether he, instead, was the designer. It is possible that the faint letters beneath the truncation on the Daniels' example are not the traces of Warin's signature. Alternatively, Claude Warin may have designed the compositions, but Goret cast them into bronze.

Another similar pair of medallions belonging to M. Alain Moatti, Paris, have on their reverse traces of Goret's signature, with the same date, 1628 (fig.1), though on the obverses the relief lettering has been carefully erased. This might be taken to indicate some dispute over sharing the credit for the design. There was no law of copyright in the seventeenth century and infringements of artists' notional rights by today's standards were quite normal. Simply by taking aftercasts of a plaque, medal or even statuette, a subsequent foundryman could claim credit. This may be the case with another, later example of the Christ figure in the Hall collection, which is inscribed "A. Lenard Martois/Faite en 1704" (fig. 2). **CA**

Bibliography: L. Forrer, *Biographical Dictionary of Medalists*, (London, 1904), II; Thieme und Becker, *Allgemeines Lexikon der bildenden Künstler von der Antike bis zur Gegenwart* (Leipzig, 1909–66), 37 vols., XIV, 399; J. Fischer, *The French Bronze, 1500–1800*, exh. cat. (New York, 1968), no. 15; *Sculpture from the David Daniels Collection*, exh. cat., Minneapolis Institute of Arts (Minneapolis, 1979/80), no. 14.

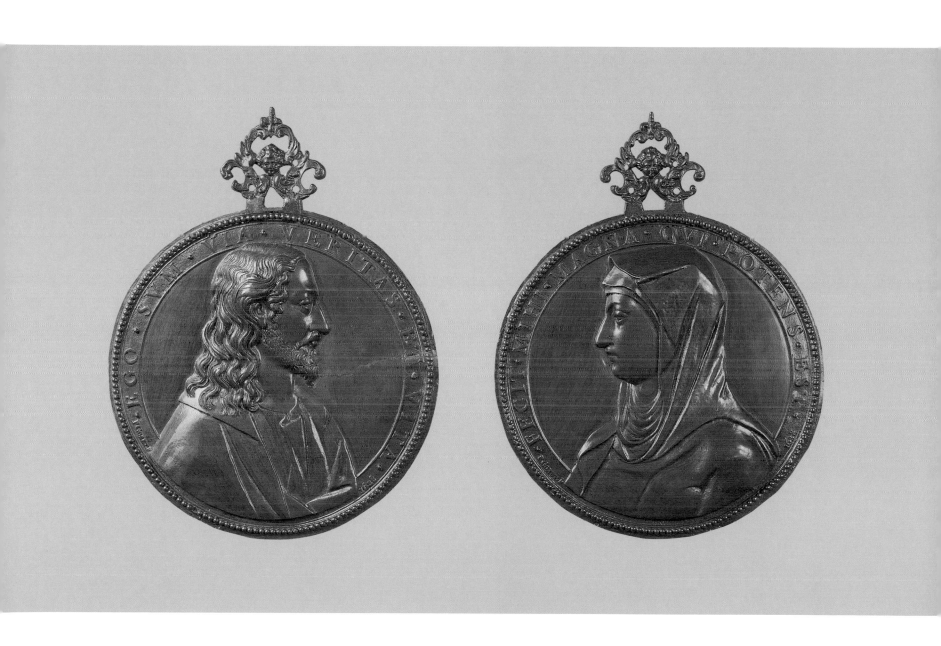

Italian or Spanish, 17th century
Oil on olive wood, with gilt and gessoed integral frame
8¼ x 5 x 1 inch (21 x 12.5 x 2.5 cm)

The Veil of Saint Veronica is the most important "true image" of Christ in the Western Church. The name of the saint derives etymologically from the phrase, "vera icona," or true icon. As such, the Veronica veil forms a counterpart to the *mandylion* of Edessa as the most authentic likeness of Christ. The Veronica image has an even more illustrious origin in the Passion. As Christ struggled under the Cross on the way to Calvary, the maiden Veronica attempted to wipe the sweat of his brow. When she removed the cloth, it revealed the Holy Face. By 1300, this legend became associated with the relic of a cloth stained with the sweat of Christ, called the *sudarium*, in the Vatican (for a discussion of the "True Likeness" and the history of the Veil of Veronica, see the introductory essay of this catalog).[1]

While Byzantine copies of the *mandylion* exhibit total fidelity to the icon, images after the Veronica increasingly conform to Western artistic practices. Especially during and after the Renaissance, artists balanced convention and variation, thereby blurring the distinction between icon and portrait. With the relic serving as a notional "sitter," artists aimed for an "ideal portrait" of Christ, incorporating individual variations of expression, emphasis, even physiognomy.[2] The painting in the Hall collection respects the general typology of Veronica images, but also achieves the immediacy of a portrait. The striking blue eyes deviate from many representations of the relic. Instead, the artist follows the medieval literary description of Christ attributed to Publius Lentulus, the Governor of Judea, which records "his eyes, blue-grey, clear and quick."[3]

While the style of the frame dates the Hall painting to the 1600s, the deliberate archaism of Christ's face defers to the conventional representations of the relic. This deference hinders attempts at attribution. The general format of the face follows a number of alleged copies after the relic from the fifteenth century, before the *sudarium* was desecrated and lost during the Sack of Rome in 1527.[4] Following the earliest representations, there is no crown of thorns on the image, often added to emphasize the connection of the *sudarium* to Christ's Passion. Below a broad forehead, Christ gazes outward intently. He has a long thin nose and small mouth with full lips. His beard is forked. Long tresses frame the face. As in many images of the *sudarium*, Christ's head stands out from the folds of the cloth, projecting three-dimensionally. The convex surface of the pictorial field enhances this effect, creating an almost holographic apparition. The elaborate gilt ornamentation of the frame enshrines the Holy Face as a precious relic. JU

1 On the interrelationship of the *mandylion* and the Veronica veil, see Hans Belting, *Likeness and Presence: A History of the Image before the Era of Art* (Chicago, 1994), 208–24. See also section III on the mandylion by Herbert Kessler, and section IV on the Veronica by Gerard Wolf in Giovanni Morello and Gerhard Wolf, *Il Volto di Cristo*, exh. cat., Palazzo delle Esposizioni (Rome, 2000), 67–99. III.1–III.13; 103–211, cat. nos. IV.1–IV.65. A summary of these legends is also found in Alexander Sturgis's contributions to *The Image of Christ*, exh. cat., National Gallery (London, 2000), 75–93.
2 Belting, op. cit., 222, 430.
3 Sturgis, op. cit., 94, no. 40.
4 See the numerous examples in Wolf, op. cit., nos. IV.19–20, IV.26, IV.31–33, IV.44.

108 | Christ with Sacred Heart

Goan, 17th century
Sandalwood
9¾ x 3¼ x 1¾ inches (24.7 x 8.2 x 4.5 cm)

When the Portuguese conquered the city of Goa – a trading city on the west coast of the Indian subcontinent – they began to convert Goans to Christianity with pious zeal. Alfonso de Albuquerque, who led the conquest, brought in Dominican friars, who immediately built churches. One of them was dedicated to St. Catherine, because it was on her feast day that the Portuguese first took the city in 1510. Franciscans followed, as did members of the newly formed Society of Jesus, also known as the Jesuits. St. Francis Xavier, one of its founding members, came to Goa, both to convert Goans and to preach to the colonists. He is buried in one of the most ornate Goan churches, the Basilica of Bom Jesus, built from 1594 to 1605.[1]

Goan art and architecture combines Counter Reformation styles typical of Jesuit art of Italy and the Iberian peninsula, with indigenous techniques, materials, and forms.[2] This small image is made from sandalwood, a hard, light-colored, heartwood celebrated for its fine grain and sweet smell. It is used for carving and as an ingredient in incense. Its name derives from "kand," an Indo-European word meaning "to gleam." As this small sculpture demonstrates, buffing and handling cause sandalwood to gleam and shine.

The image here depicts Christ holding the sacred heart in his left and offering the sign of benediction with his right. The intense facial expression shows Christ as judgmental, warning the beholder that final reckoning is to come. His wavy hair, parted in the middle, cascades down on both sides and falls below the shoulders at the back in a stylized Indian pattern. The swirling draperies of the cloak at the front are reminiscent of Greco-Roman folds seen on Buddhist sculptures from the northwest regions of the subcontinent. These stylized and calm drapery forms are derived from canons of style seen in cloth folds of Greek sculpture introduced by followers of Alexander the Great, whose journeys had included the Indus River valley. **MH**

1 See José Nicolau da Fonseca, *An Historical and Archaeological Sketch of the City of Goa* (Bombay, 1878), 63–67.
2 See Subrahmanya Rajagopalan, *Old Goa* (New Delhi, 1975).

109 | Profile of the Young Madonna

Attributed to Desiderio da Settignano (1429/32–1464)
Florentine, mid-15th century
***Pietra serena schiacciato* relief**
23 x 16 x 2¼ inches (58.4 x 40.5 x 5.7cm)

ICONS OR PORTRAITS?

262

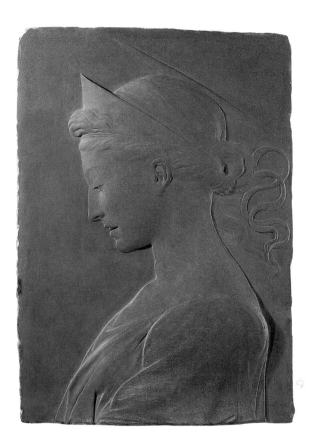

figure 1
Profile Head of Saint Cecilia
Italian, 19th century
Stone
Toledo Museum of Art, Ohio

This low relief profile bust probably represents the young Virgin Mary, although it has been compared to a marble relief of approximately the same dimensions in the Toledo Museum of Art, usually identified as St. Cecilia (fig. 1).[1] The traditional attribution of the Toledo relief to Desiderio or his circle has often been questioned; more recently, it is considered to date only from the nineteenth century. In general, attributions to Desiderio are difficult since he left no documented works at the time of his early death in 1464 at the age of 34.[2] The *schiacciato* technique of the Hall example, however, resembles other low relief carvings attributed to Desiderio. The meandering ribbons fluttering beyond the head are much more deliberately and subtly modeled in this relief than in the one in Toledo. The position of the head and neck in the Hall version suggests an introspective Virgin. The slightly parted lips, exposing the teeth, give the impression that the young Madonna is about to speak, or sigh in anticipation of her fated joys and miseries. The calm serenity revealed in the subtle design of the relief is unsurpassed. This tenderness of expression and delicacy of execution make a compelling case for Desiderio's authorship of the Hall work.

1 Ida Cardellini, *Desiderio da Settignano* (Milan, 1962), 85, no. 56.
2 See Ulrich Middledorf, "Two Florentine Sculptures in Toledo," *Art in America* 28 (1940): 24; and Deborah Strom, "Desiderio and the Madonna Relief in Quattrocento Florence," *Pantheon* XL (1982): 130–35.
3 Cardellini, 151, figs. 126–8.
4 Before it was purchased from the Rothschild estate in Mentmore, this relief hung in the servants' quarters. Its edges suffered considerable delaminating due to the thick coating of stove blocking paint that covered the relief.

Desiderio particularly admired the soft, fine grained, grey sandstone called *pietra serena*, a Tuscan stone that closely resembles slate. He employed it in a number of works, such as the somewhat higher relief depicting San Giovannino in profile, now at the Bargello Museum, Florence. This work also features a similar frame, fashioned integrally from the same slab.[3] It seems likely that the artist considered how best to exploit the actual layered grain of the stone in conceiving the design and carving the relief.[4] MH

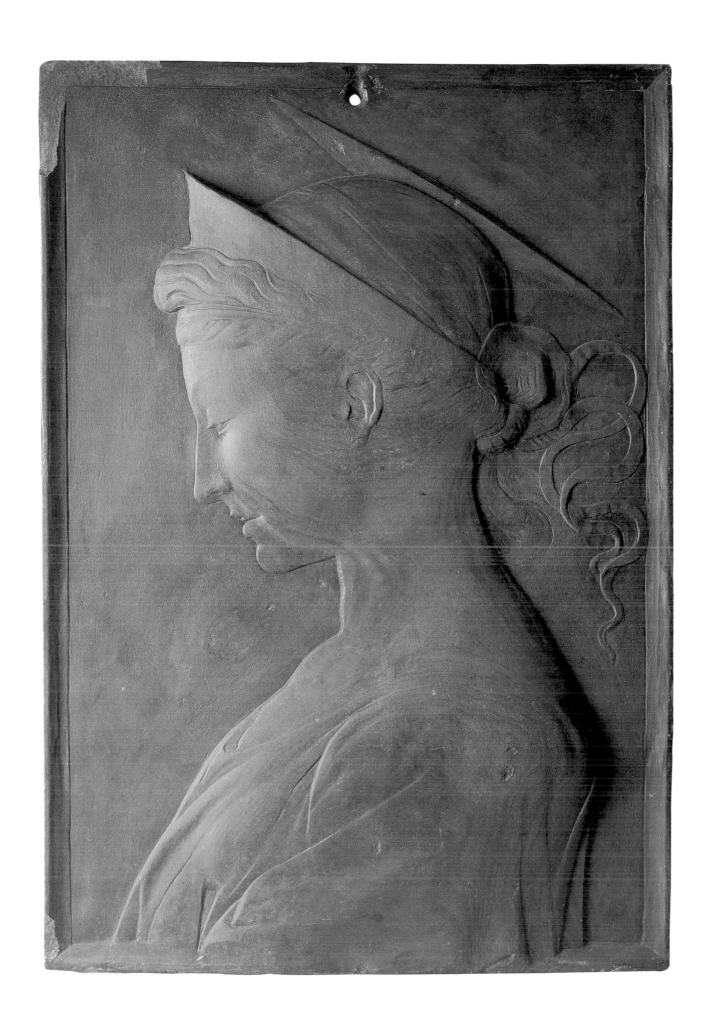

110 | Virgin in Prayer

Attributed to Francesco di Simone Ferrucci (1437–1493)
Italian, late 15th century
Marble relief
31½ x 24 x 5 inches (80 x 60.5 x 12.6 cm)

The figure of the Virgin has been cut around the silhouette and inserted into the brocaded background and frame molding. It is not clear whether she originally stood on her own or formed part of a larger composition, either a standard rendering of the *Madonna and Child* or, in view of her hands being joined in prayer, an *Annunciation* or *Adoration of the Christ Child*. There are touches of gilding in the halo, brocade and frame. It may be that the relief is a remnant of a larger panel that was damaged accidentally, so that only the head and shoulders of the Virgin could be saved. Such a theory is partly supported by the noticeable dent along the gray veining in the marble over her upper arm. It would also account for various anomalies and discrepancies in the carving and in the details of the cuffs and hem of her robe.

The head and shoulders of the Virgin are closely related to a marble relief of the *Madonna and Child with an Angel* (Museum of Fine Arts, Boston), dated to the 1470s and attributed to an artist in the immediate circle of Andrea del Verrocchio (1435–1488), possibly Francesco di Simone (1437–1493).[1] This sculptor from Fiesole, near Florence, probably received training from his father and later from Desiderio da Settignano (c.1429/32–1464). He matriculated in the sculptors' guild in 1463 and established a workshop in Florence in 1466. Vasari names him as a pupil of Verrocchio, whom he probably assisted in the 1470s. By the date of the only work that Francesco actually signed, the tomb of Alessandro Tartagni (d. 1477), he had adopted from Verrocchio a style of depicting draperies as though they were inflated. The Virgin's profile and facial features, as well as the angle of the head, also relate to a drawing in black chalk by Verrocchio in the Picture Gallery of Christ Church, Oxford.[2] **CA**

Bibliography: D. Covi, "Ferrucci," J. Turner, ed., *The Dictionary of Art* (London, 1996), vol. 11, 26–27.

1 G. Passavant, *Verrocchio: Sculptures, Paintings and Drawing, Complete Edition* (London, 1969), 204–5, appendix no. 9.
2 Passavant, pl. 100; A. Butterfield, *The Sculptures of Andrea del Verrocchio* (New Haven/London, 1997), pl. 244.

Circle of Bernard Palissy (1510?–1590)
French, 16th century
Ceramic
15 ¾ x 12 ¼ x 2 ¼ inches (40 x 31.1 x 5.6 cm)

figure 1

Virgin with Christ and Saint John
Charles-Etienne Leguay
After a design by Raphael (1483–1520), signed
"Chas Leguay 1837 (Sèvre 1762/Paris 1846)"
Michael Hall Collection

This unusual profile portrait of the Virgin, if not an original conception by Palissy himself, certainly exhibits many close connections with his workshop. The portrait may derive from a medallic (metallic) source. There are many examples of this kind of small-scale images of Mary. They were used mainly for religious devotions. The faience plaque has a pierced integral projection on the back for hanging.

The serene, idealized Greco-Roman profile is characterized by a high forehead, a straight Greek nose with a pronounced bridge, and a small chin – all framed by the Virgin's hair and her blue mantle. The head is surmounted by a radiant nimbus of yellow-gold projections raised above a light blue background with blue striations between them. The concave ground behind the nimbus is colored a manganese blue and stippled. White cockleshells of the same tonality as Mary's face frame the plaque.[1] These were probably cast from nature.[2]

Palissy's association with Protestant reformers did not inhibit him from accepting commissions from Catholic patrons: his primary royal benefactor, Queen Catherine de Medici, was France's main defender of the Roman church. The almost whimsical shell frame lightens the more serious image of the Mother of God. MH

1 The cockleshell directly opposite her mouth may be a nineteenth-century replacement.
2 On shell symbolism, see Ian H. Cox, ed., *The Scallop: Studies of a Shell and its Influences on Humankind*, (London 1957).

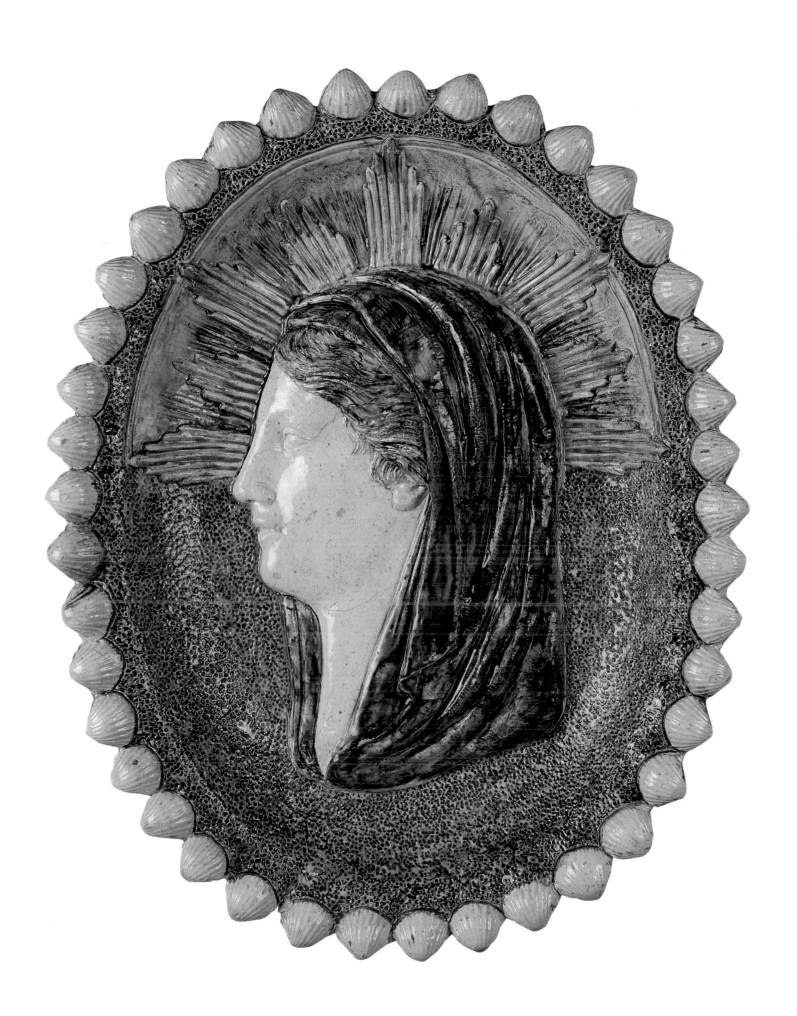

112 | Portrait of the Veiled Virgin Mary

Exact date of manufacture undetermined (c. 12/13th century?)
Rock crystal, modern gold mount
3⅝ x 3 x 1¾ inches (9.2 x 7.2 x 4.4 cm)

This veiled portrait, presumably of the Virgin Mary, bears the iconographic and sculptural characteristics popular throughout the Christian East during the Byzantine Age. A skilled lapidarist has ground, carved, drilled, and polished the crystal surface to create this deceptively simple composition of sharp planes, arranged in a rigorous symmetry. The sculptor has reduced the face to its geometric essence, emphasizing the large, bulbous eyes, the broad arc of the brow, and the prismatic folds of the veil. The wavy striations describing the hair provide the only deviation from this stark abstraction of form. The flawless clarity of this specimen of rock crystal only enhances the purity and simplicity of the artistic conception, itself a reflection of an arduous mechanical process.

In the tenth through thirteenth centuries figuratively carved rock crystal came primarily from Fatimid Egypt, where crystal-cutting expertise far exceeded that of the West. Most intricately sculpted figurative rock crystal objects depict secular or zoological subjects, such as the ibex or fish. Christian metalworkers often incorporated these objects into reliquaries, crosses, or ostensoria. The rock crystal face of Mary is unusual because of its overtly Christian iconography. Since such examples are extremely rare, further research is needed in order to determine the date and place of manufacture of this exquisite piece with any degree of certainty. MH

113 | Bust of a Young Girl – The Virgin Mary (?)

Italian, probably Florentine
Date of manufacture undetermined
Terra cotta
12½ x 10 x 8 inches (31.7 x 25.4 x 20.3 cm)

This beautiful yet enigmatic bust of a young woman is most probably meant to depict the very young Virgin Mary. The work has been variously attributed to Desiderio da Settignano (in light of stylistic similarity to his bust of Saint Lawrence, now in the Medici Chapel in San Lorenzo, Florence), Mino da Fiesole, and several other prominent Florentine Renaissance sculptors.[1] Two thermoluminescence tests (conducted in 1995 and 2001) have produced results inconsistent with a date of manufacture previously thought to be of the Renaissance.[2]

Further research (and perhaps new and improved technology) is needed in order to be able to ascertain an exact date and origin for this bust. Whether it is a modern work trying to emulate the style of the Renaissance, a fake, or a genuine Renaissance work, it is presented here as a touchingly beautiful portrait that finds its place in the rich tradition of idealized representations of the young Virgin Mary. MH

[1] I. S. Zuraw, "The Sculpture of Mino da Fiesole," Ph. D. Dissertation, New York University, 1993, fig. 210.

[2] The bust was a gift to the present owner from Paulette Goddard-Remarque, who had inherited it from her husband Erich Maria Remarque. This terra cotta bust was unique in Remarque's extensive collection dominated by impressionist paintings, Chinese bronzes, and oriental carpets. According to Ms. Goddard, the bust was acquired from a Swiss collector (c. 1948) who explained that it had come from a building destroyed by fire during World War II.

114 | Virgin in Prayer

African, first quarter to mid-20th century
Ivory
10 x 2⅝ x 1¾ inches (25.4 x 6.6 x 3.4 cm); shallow wood base ⅞ x 2⅝ x 2⅜ inches (2.2 x 6.6 x 6.1 cm)

Christian missionaries arrived in Africa in the fifteenth century and immediately had an impact on imagery produced along the sub-Saharan coast. Objects produced by African artists included brass and copper crucifixes, called *Nkangi*, as well as sculptures representing saints and copies of liturgical objects. In the seventeenth century, production of such objects ceased, as Christianity there waned; yet the objects retained value as royal insignia. European colonists in the late nineteenth century, who divided the map of the continent, paved roads that brought missionaries into Africa's interior. Christianity became the major religion in sub-Saharan Africa by the late nineteenth century, especially in eastern Nigeria, Uganda, and areas with a strong European colonial influence. In the twentieth century a new wave of Catholic and Protestant missionaries once again brought Christian iconography to the vast region and established several art schools.[1] Missionaries from the Church of England established an art school in Zimbabwe in 1936. The African Mission Society, a Catholic organization, founded art schools in Yorubaland, Nigeria, in 1947 and commissioned Yoruba artists to produce accouterments for the Catholic church at the University of Ibadan.[2]

This figure brings together West African and European sculptural traditions. The calmly disciplined form, the undulating line, and the expressive serenity of the figure find their echoes in European sculpture. Yet the Madonna's facial features are distinctly those of sub-Saharan African women. In Christian sculpture made in West Africa, often minor figures are depicted with African garments,[3] while Christ and Mary are depicted in clerical robes, as is the case with this image, which represents a woman, possibly the Virgin, in prayer. **MH**

1 Marshall Ward Mount, *African Art: The Years Since 1920* (Bloomington/London, 1973), Chapter II, Mission-Inspired Art, 22–38; D. J. Fleming, *Each with His Own Brush: Contemporary Christian Art in Asia and Africa* (New York, 1938).

2 Kevin Carroll, *Yoruba Religious Carving: Pagan and Christian Sculpture in Nigeria and Dahomey* (London, Dublin, and Melbourne, 1967); J. B. Waite, "The African Art Museum of the S.M.A. Fathers," *African Arts* 21/1 (1987): 64–7, 88.

3 Marshall Ward Mount, op. cit., 32.

Checklist of the Exhibition

I MADONNA AND CHILD

1 *Madonna and Child*
Venetian, 13th century
Gilt copper *repoussé*
11 x 5 x ⅛ in. (27.7 x 12.7 x 0.4 cm)
Integral frame: 14 x 12 x 5½ in. (35.5 x 30.5 x 14 cm)

2 *Madonna and Child with Music Making Angels*
Donatello (1386–1464)
Florentine, 1430s
Pigmented stucco in original frame (gessoed, painted, and gilded)
15⅛ x 11⅝ x 2¾ in. (38.5 x 29.5 x 7 cm)
With frame 24¼ x 18¼ x 2¾ in. (61.6 x 47.6 x 7 cm)

3 *Madonna and Child*
School of Jacopo della Quercia (c. 1374–1438)
Italian, early 15th century
Marble
24 x 6¾ x 6¾ in. (61 x 17.2 x 17.2 cm)
(including integral base)

4 *Madonna and Child Enthroned with Saints*
Follower of Donatello (1387–1466)
Paduan, 1450–1475
Bronze plaquette
4¾ x 3⅜ x ⅛ in. (12.2 x 8.8 x 0.3 cm)

5 *Madonna and Child*
Desiderio da Settignano (c. 1430–1464)
Florentine, mid-15th century
White Marble
12⅞ x 9 x 1 in. (32.7 x 22.8 x 2.5 cm)

6 *Madonna and Child*
After Desiderio da Settignano (c. 1430–1464)
Florentine, late 15th/early 16th century
Marble relief
17⅜ x 13¾ x 3 in. (44 x 35 x 7.6 cm)

7 *Madonna and Child with Cherubim*
Circle of Agostino di Antonio di Duccio (1418–after 1481)
Italian, late 15th century
Stucco relief, polychromed
40¼ x 39 x 4¾ in. (102.2 x 99 x 12 cm)

8 *Madonna and Child with Goldfinch*
Paduan, late 15th century
Terra cotta
27 x 19½ x 8½ in. (68.6 x 49.5 x 21.6 cm.)

9 *Madonna and Child*
Follower of the Master of the Marble Madonnas
Italian, late 15th century
Marble relief
20⅞ x 16⅝ x 4 in. (52.5 x 42 x 10 cm)

10 *Madonna and Child*
Italian, late 15th/early 16th century
Marble
24 x 16½ x 6 in. (61 x 42 x 15.3 cm)

11 *Madonna and Christ Crowned and Enthroned*
German, early 16th century
Gilt copper *repoussé*
7 x 6 x ⅜ in. (17.3 x 14.5 x 0.9 cm)

12 *Madonna and Child with Angels*
Circle of Hans Schwarz (1492–1532?)
German, 16th century
Brass plaquette
5⅛ x 3⅞ x ¼ in. (13 x 9.6 x 0.6 cm)

13 *Madonna and Child with Radiant Nimbus*
German, 16th century
Bronze plaquette
5¼ x 4¼ x ⅜ in. (13.1 x 10.6 x 0.9 cm.)

14 *Virgin Hodegetria*
Italian, 16th century
Tempera on wood
9⅛ x 7 x 2¾ in. (23.2 x 17.8 x 7 cm)

15 *Madonna and Child with Saint John*
Pierino da Vinci (1503–1574)
Italian, mid-16th century
Polychromed stucco
13½ x 9¼ x 1¼ in. (34.2 x 23.4 x 3.2 cm)

16 *Madonna and Child with Saints*
Circle of Jacopo Sansovino (1486–1570)
Venetian, mid-16th century
Bronze relief
8⅛ x 6½ x 1⅜ in. (20.6 x 16.7 x 3.8 cm)
Integral frame 12⅝ x 10⅞ x 1¾ in. (32 x 27.8
x 4.5 cm)

17 *Madonna and Child with the Young Saint John*
Follower of Jacopo Sansovino (1486–1570)
Venetian, second half of the 16th century
Bronze gilt plaquette, rectangular within a
scrolling, *ajouré* frame.
7⅞ x 5 x ⅜ in. (19.5 x 12.6 x 1 cm)

18 *Madonna and Child with the Young Saint John*
Attributed to Battista Pittoni of Vicenza
(c. 1520–c. 1583)
Paduan, mid-16th century
Hand-modeled terra cotta plaque
23½ x 23½ x 3½ in. (59.7 x 59.7 x 9 cm)
(with integral frame)

19 *Madonna of the Rosary*
Venetian, second half of the 16th century
Bronze, chestnut brown patina, oval, with
ajouré border and loop for suspension
7 x 3¾ x ½ in. (17.8 x 9.8 x 1.3 cm)

20 **(a & b)**
Madonna and Child
Circle of Gianlorenzo Bernini (1598–1680)
Roman, mid-17th century
Gilt bronze reliefs
4 x 5¼ x ¼ in. (10.2 x 13.3 x 0.6 cm)

21 *Madonna and Child*
From the circle of Pierre-Etienne Monnot
(1657–1733)
Franco-Roman, late 17th/early 18th century
Ivory relief
4½ diameter x ¾ in. (10.8 cm dia. x 1.8 cm)

22 *Madonna and Child*
Venetian (?), late 17th/early 18th century
Horn or tortoise shell relief, with mirrored
cut glass mounts
5⅛ x 3⅞ x ¾ in. (13 x 9.8 x 1.9 cm)

23 *Madonna and Child*
Alexandre-Louis-Marie Charpentier
(1856–1909)
French, late 19th century
Bronze plaquette
12¼ x 7⅜ x ½ in. (31 x 18.7 x 1.3 cm)

24 *Madonna and Child (Guanyin)*
Chinese, late Ming Dynasty (1580–1644)
Ivory
9¾ x 4 x 2¾ in. (24.8 x 10.2 x 7 cm)
Rosewood base: 1¼ x 5¼ x 3½ in.
(3.1 x 13.3 x 8.9 cm)

25 *Female and Child – Madonna and Child
(Guanyin)*
Chinese, late Ming Dynasty (?) (1580–1644)
Reflecting Tang style
Bronze
7¼ x 5⅛ x 2½ in (18.4 x 13 x 6.3 cm)

**II MARIAN AND CHRISTOLOGICAL
NARRATIVES**

26 *Birth of the Virgin*
Circle of Pierre II Veyrier (active 1528–1558)
French, Limousin, mid-16th century
Limoges enamel
8⅜ x 11 x ⅝ in. (21.2 x 27.8 x 1.3 cm)

27 *Annunciation*
French, 17th century (?)
Oil on copper
7½ x 6½ in. (19.5 x 16.5 cm)

28 *Annunciation and Holy Family pilgrim's flask*
Chinese, late Ming, c. 1620
Enamel on copper
3⅞ x 3¼ x 1⅝ in. (13 x 8.3 x 4.1 cm)

29 *Visitation*
After Carlo Maratta (1625–1713)
Italian (?), late 17th century
Copper *repoussé*, mounted in modern
gilt frame
13 x 11½ x 1¼ in. (33 x 29.2 x 3.2); framed:
12¾ x 11½ (32.4 x 29.2 cm)

30 *Infant Christ in Swaddling Clothes*
Circle of Andrea della Robbia (1435–1525)
Florentine, late 15th century
Bronze statuette
4¼ x 2⅞ x 1¼ in. (10.8 x 6.8 x 3.2 cm)

31 *Infant Christ Lying on Cross with Skull*
Leonhard Kern (1588–1662)
South German, mid-17th century
Ivory
7⅛ x 3½ x 2 in. (20 x 9 x 5 cm);
base: 9½ x 4¾ x 2¾ in. (24.2 x 12.2 x 7.2 cm)

32 *Infant Christ as Salvator Mundi*
Manner of Alessandro Algardi (1598–1654)
Roman, late 17th century
Bronze
13¾ x 6½ x 5 in. (35 x 16.5 x 12.7 cm)

33 *Infant Christ as Salvator Mundi*
Circle of Ercole Ferrata (1610–1686)
Italian, late 17th/early 18th century
Sliver, with gilt nimbus and orb
14 x 7½ x 5 in. (34.3 x 19 x 12.7 cm)

34 *Adoration of the Magi*
Attributed to Matteo Cesa of Belluno
(c. 1425–c. 1495), or his son Antonio (active
c. 1500), after Galeazzo Mondella, called
Moderno (c. 1467–1528/29)
North Italian, mid-16th century
Polychromed wood
19¾ x 14½ x 2¼ in. (50.2 x 36.83 x 5.7 cm)

35 *Adoration of the Magi*
After a design by John Flaxman (1755–1826)
British, c. 1800
Bronze relief, cold gilding
14⅛ x 20 x 1⅛ in. (35.8 x 51 x 2.8 cm)

36 *Rest on the Flight into Egypt*
Alessandro Algardi (1598–1652)
Roman, 1632–37
Bronze
13¾ x 11⅝ x in. (34.5 x 29.6 cm)
Integral marble frame: 18¾ x 20½ x 3⅛ in.
(47.6 x 52 x 7.9 cm)

37 *Holy Family adored by Saints John
the Baptist, Francis, Anthony (?) and
George (Rest on the Return from Egypt)*
Attributed to Francesco di Virgilio Fanelli
(1577–1661)
Genoese (?), early 17th century
Bronze plaque
9½ x 7¾ x 1½ in. (24.1 x 19.6 x 3.8 cm)
(in integral frame)

38 *Christ in the Temple*
Circle of Donatello (1386/87–1466)
Florentine, 15th century
Limestone
12½ diameter x 1½ in. (31.8 dia. x 3.8 cm)

39 *Baptism of Christ*
Follower of Bernard Palissy (1510?–1590)
French, 17th century
Lead glazed ceramic
19½ x 15 x 3 in. (49.5 x 38.1 x 7.5 cm)

40 *Christ and Saint John the Baptist*
Follower of Giambologna (1529–1608)
Florentine (?), 17th century
Silvered bronze
Christ: 8½ x 4 x 2¼ in. (21.6 x 10 x 5.8 cm);
John: 8 x 3½ x 2 in. (20.3 x 8.8 x 5 cm)

41 *Transfiguration*
Master B. F. (Francesco Binasco, ca. 1486–1545)
Lombardic, early 16th century
Illumination on vellum
14¼ x 14 x 3 in. (36.2 x 35.5 x 7 cm)

42 *Dormition of the Virgin*
French or Italian (?), exact date of
manufacture unknown (c. 1300?)
Ivory
5 x 8⅗ x ¼ in. (12.6 x 22 x 0.4 cm)

43 *Assumption of the Virgin*
Attributed to Valerio Belli (c. 1468–1546)
Italian, 16th century
Agat intalglio with plaster in cameo
3 x 2¼ x ³⁄₁₆ in. (7.5 x 5.5 x .05 cm)

44 *Coronation of the Virgin with Musical Angels*
After Guido Reni (1575–1642)
Italian, 17th century (?)
Oil on copper
26½ x 19 in. (67 x 48 cm)

III PASSION NARRATIVES

45 *Christ at the Column*
Circle of Guglielmo della Porta (1500–1577)
Italian, Roman, mid-16th century
Silver figurine, silver gilt column in original
tabernacle of ebony wood with gilt bronze
and silver *appliqués*
Figurine 3⅛ in. (8 cm); column 5⅛ in. (13 cm);
tabernacle 12½ in. x 8 x 2¾ in. (32 x 20 x 7 cm)

46 *Christ at the Column*
Circle of Jacopo Sansovino (1486–1570)
Venetian, mid-16th century
Gilt bronze
6½ x 2½ x 2¾ in. (16.5 x 6.3 x 7 cm); ebony base
2 x 4 in. (5.1 x 10.2 cm)

47 *Christ at the Column*
Attributed to the Master of the Furies
South German (or Salzburg?), early 17th
century
Ivory
8 x 2½ x 1¾ in. (20.3 x 6.3 x 4.5 cm)

48 *Christ at the Column*
Alessandro Algardi (1598–1652)
Roman, c. 1630
Silver gilt
8½ x 3½ x 3¼ in. (21.5 x 9 x 8.3 cm);
marble base: 2 x 4½ x 4½ in. (5.1 x 10.8 x
10.8 cm)

49 *Christ at the Column*
After a model by François Duquesnoy
(1597–1643)
French (?), late 17th or 18th century
Ivory
8¾ x 3½ x 3 in. (22.3 x 8.9 x 7.5 cm)

50 *Bust of Christ*
Circle of Jerome II Duquesnoy (1602–54)
Italo-Flemish, mid- to late 17th century
Marble
7¼ x 5½ x 5 in. (18.5 x 14 x 12.5 cm)

51 *Flagellation*
After Galeazzo Mondella, called Moderno
(c. 1467–1528/29)
Italian, 16th or 17th century
Partially gilted silver plaquette
5½ x 4½ x ¼ in. (14 x 10.3 x 0.7 cm)

52 *Christ at the Column*
After Michiel van der Voort (1667–1737)
Franco-Flemish, 18th century
Ivory
10½ x 3½ x 2¾ in. (26.5 x 8.9 x 7 cm);
ebonized wood base 5¼ in. (13.3 cm) high,
6 in. (15.2 cm) diameter

53 *Christ at the Column*
Barthélémy Prieur (1540–1611)
French, early 17th century
Bronze, solid cast
10¾ x 3¼ x 3¼ in. (27.3 x 8.3 x 8.3 cm)

54 *Head of Christ Crowned with Thorns*
After Matteo di Giovanni Civitale (1436–1501)
Florentine, date uncertain
Terra cotta, with traces of polychrome
14 x 15⅝ x 8 in. (35.5 x 39.4 x 20.3 cm)

55 *Head of Christ Crowned with Thorns*
Italian, Naples (?), third quarter 18th century
Shell cameo
2¼ x 1¾ x ⅜ in. (5.4 x 4.5 x 1 cm)

70 *Corpus Christi*
Swedish (?), first half of the 14th century
Silver
7½ x 4½ x 1½ in. (19 x 10.3 x 3.8 cm)

71 *Corpus Christi*
Spanish or Italian (?), c. 14th/15th century (?)
Olive wood, polychrome
16¼ x 14⅝ x 2¾ in. (40.3 x 36.6 x 7 cm)

72 *Corpus Christi*
Attributed to Baccio da Montelupo (1469–1535)
Florentine, early 16th century
Polychromed wood
16½ x 14 x 3 in. (42 x 35.5 x 7.6 cm)

73 *Corpus Christi*
African, Gold Coast, c. 1500
Gold
4⅛ x 3¾ x 1¼ in (10.5 x 9.5 x 3.2 cm)

74 *Corpus Christi*
Attributed to Andrea Briosco called Riccio
(1470–1532)
Paduan, early 16th century
Bronze
5⅖ x 4⅜ x 1 in. (13.3 cm. x 11.1 x 2.5 cm)

75 *Corpus Christi*
Follower of Michelangelo Buonarotti
(1475–1564), possibly Daniele da Volterra
(1509–1566)
Italian, mid-16th century
Silvered bronze
18½ x 14⅜ x 3⅛ in. (47 x 36.5 x 8 cm)

76 *Crucifix*
Circle of Michelangelo Buonarotti (1475–1664),
possibly Daniele da Volterra (1509–1566)
Italian, mid- to late 16th century
Fire gilded bronze
9¾ x 7½ x 1⅝ in. (24.8 x 19 x 4.1 cm)

77 *Corpus Christi*
Attributed to Germain Pilon (1535–1590)
French, c. 1560
Gilt bronze
13¾ x 16 x 4¼ in. (35 x 40.6 x 10.8 cm)

78 *Corpus Christi*
Italian follower of Benvenuto Cellini
(1500–1571)
Italian, mid- or late 16th century
Silver
8⅝ x 6½ x 2¼ in. (22 x 16.5 x 5.7 cm)

79 *Crucifix*
Attributed to Giambologna (1529–1608),
after Benvenuto Cellini (1500–1571)
Gold statuette on ebony cross with a partially
enameled gold cartouche, and a gold plaquette
depicting the Lamentation
22½ x 9⅝ x 2 in. (56.6 x 24.3 x 5 cm);
base: 6 x 8½ x 5⅝ in. (15.2 x 21.6 x 14 cm)

80 *Crucifix*
Attributed to Georg Petel (1601/2–c. 1634)
German (Augsburg?), c. 1630–34
Ivory *Corpus* mounted on ebonized wooden
cross with original ivory banner cartouche
12⅜ x 9⅛ x 2¾ in. (31.3 x 23.3 x 7 cm)

81 *Corpus Christi*
German, early 17th century
Rhinoceros horn
6⅛ x 3⅜ x 1¼ in. (15.5 x 8.4 x 3.2 cm)

82 *Corpus Christi*
Attributed to Leonhard Kern (1588–1662)
German, Hohenlohe, c. 1625–40
Bronze
7¾ x 7⅝ x 1½ in. (19.6 x 19.2 x 3.8 cm)

83 *Corpus Christi*
Possibly circle of Georg Schweigger (1613–1690)
South German, first half of the 17th century
Ivory
11⅛ x 4¾ x 1½ in. (28.3 x 12 x 3.8 cm)

84 *Crucifix*
Attributed to David Heschler the Elder
(1611–1667)
German, mid-17th century
Limewood
39⅛ x 17¾ x 4¼ in. (99.4 x 45.6 x 10.8 cm);
scroll: 2⅛ x 4 x 5/8 in.(5.5 x 10.2 x 0.8 cm)

100 *Profile of Christ*
Venetian, mid-16th century
Bronze plaquette
5⅛ x 4 x ⅜ in. (13 x 10 x 1.3 cm)

101 *Portrait of Christ*
Circle of Germain Pilon (1528–1590)
French, mid-16th century
Marble medallion
14½ x 12¾ x 1½ in. (36.8 x 32.3 x 3.8 cm)

102 *'True Likeness' of Christ*
Attributed to Antonio Abondio (1538–1591)
Italian, mid-16th century
Oval bronze medallion
Obverse: 'True Likeness' of Christ; reverse:
Hebrew inscription
1⅝ x 1⅜ x ½ in. (4.2 x 3.6 x 1.3 cm)

103 *'True Likeness' of Christ*
French (?), 17th century
Bronze medal
Obverse: 'True Likeness' of Christ; reverse:
Hebrew inscription
4½ diameter x ½ in. (11.4 dia. x 1.3)

104 *Busts of the Boy Jesus and the Virgin Mary*
François Duquesnoy (1597–1643)
Roman, second quarter of the 17th century
Bronze
Jesus: 7½ x 4¼ x 3⅜ in. (19 x 10.2 x 8.5 cm)
Mary: 8½ x 5⅝ x 3½ in. (21 3/5 x 14 1/4 x 9 cm)

105 *Profile Portraits of Christ and the Virgin Mary*
Probably by Guillaume Dupré (ca. 1574–1642)
or one of the Warins
French, second quarter of the 17th century
Bronze reliefs
7½ x 5½ x ⅜ in (19 x 14 x 1 cm)

106 *Profile Portraits of Christ and the Virgin Mary*
Pierre Goret (active early 17th century)
Franco-Flemish, second quarter of the 17th century
Bronze medallions
9¾ x 7½ x ½ in. (25 x 19 x 1.3 cm)

107 *Veronica's Veil*
Italian or Spanish, 17th century
Oil on olive wood, with gilt and gessoed integral frame
8¼ x 5 x 1 in. (21 x 12.5 x 2.5 cm)

108 *Christ with Sacred Heart*
Goan, 17th century
Sandalwood
9¾ x 3¼ x 1¾ in. (24.7 x 8.2 x 4.5 cm)

109 *Profile of the Young Virgin Mary*
Attributed to Desiderio da Settignano (1429/32–1464) Florentine, mid-15th century
Pietra serena schiacciato relief
23 x 16 x 2¼ in. (58.4 x 40.5 x 5.7 cm)

110 *Virgin in Prayer*
Attributed to Francesco di Simone Ferrucci (1437–1493)
Italian, late 15th century
Marble relief
31½ x 24 x 5 in. (80 x 60.5 x 12.6 cm)

111 *Portrait of the Virgin*
Circle of Bernard Palissy (1510?–1590)
French, 16th century
Ceramic
15¾ x 12¼ x 2¼ in (40 x 31.1 x 5.6 cm)

112 *Portrait of the Veiled Virgin Mary*
Exact date of manufacture undetermined (c. 12/13th century?)
Rock crystal, modern gold mount
3⅝ x 3 x 1¾ in. (9.2 x 7.2 x 4.4 cm)

113 *Bust of a Young Girl – The Virgin Mary (?)*
Italian, probably Florentine
Date of manufacture undetermined
Terra cotta
12½ x 10 x 8 in. (31.7 x 25.4 x 20.3 cm)

114 *Virgin at Prayer*
African, first quarter to mid-20th century
Ivory
10 x 2⅝ x 1¾ in. (25.4 x 6.6 x 3.4 cm); wood base ⅞ x 2⅝ x 2⅜ in. (2.2 x 6.6 x 6.1 cm)

Photographic Acknowledgements

Page 13
©Scala/Art Resource, NY

Page 14
Foto Pontificia Commissione di
archeologia Sacra

Page 15
Dumbarton Oaks, Washington, DC

Page 16
Sinai Archive, University of Michigan
Reproduced through the courtesy of the Michigan-
Princeton-Alexandria Exhibition to Mount Sinai

Page 17
©Erich Lessing/Art Resource, NY

Page 19
© Staatliche Graphische Sammlung Munchen

Page 34
© Foto Marburg/Art Resource, NY

Page 44
©Alinari/Art Resource, NY

Page 58
©Victoria & Albert Museum, London/
Art Resource, NY

Page 60
©Alinari /Art Resource, NY

Page 68
Photograph: Soprintendenza per i beni artistici
e storici di Roma

Page 70
Photograph: Jennifer Montagu

Page 71
Photograph: Photographic Survey, Courtauld
Institute of Art

Page 102
©The British Museum

Page 134
©KIK, Brussels

Page 139
©KIK, Brussels

Page 178
©Reunion des Musées Nationaux/Art Resource, NY

Page 188
©The Cleveland Museum of Art, 2002, John L.
Severance Fund, 1982.127 (28.6 x 23.5 cm)

Page 224
© Scala/Art Resource, NY

Page 226
Photograph: Kathryn Rudy

Page 228
© Staatliche Graphische Sammlung München

Page 242
Photograph: Kathryn Rudy

Page 250
©Scala/Art Resource, NY

Page 256, figure 1
Photograph: Alain Moatti, Paris

Page 262
Photograph: Toledo Museum of Art
Purchased with funds from the Libbey Endowment,
gift of Edward Drummond Libbey, 1938.122 (22½ x
.15 inches).

Copyright for all other images:
© 2001, American Bible Society

All biblical quotations are from
Good News Translation, ©1992, American Bible Society.